SANTERÍA
AESTHETICS

SANTERÍA AESTHETICS

IN CONTEMPORARY LATIN AMERICAN ART

Edited by Arturo Lindsay

Smithsonian Institution Press
Washington and London

CONTRA COSTA COLLEGE
LIBRARY
SAN PABLO, CALIFORNIA

Copy Editor: Frances Kianka
Production Editor: Duke Johns
Designer: Linda McKnight

Library of Congress Cataloging-in-Publication Data
Santería aesthetics in contemporary Latin American art / edited
 by Arturo Lindsay.
 p. cm.
 Includes bibliographical references and index.
 ISBN 1-56098-615-8 (alk. paper)
 1. Art and religion—Latin America. 2. Santería in art.
3. Yoruba (African people)—Religion—Influence. 4. Art,
Modern—20th century—Latin America. I. Lindsay, Arturo.
N72.R4S26 1996
701′.04—dc20 95-21186

British Library Cataloguing-in-Publication Data is available

Manufactured in the United States of America
03 02 01 00 99 98 97 96 5 4 3 2 1

♾ The paper used in this publication meets the minimum requirements of the American National
Standard for Information Sciences—Permanence of Paper for Printed Library Materials ANSI
Z39.48-1984.

ELEGGUÁ ABRE LA PUERTA QUE YA COMIENZA

CONTENTS

CONTENTS

FOREWORD

This book is an important work for scholars and practitioners who are well versed in Santería aesthetics and contemporary Latin American art. Dr. Arturo Lindsay, a highly respected artist and professor in Spelman College's art department, has assembled the analyses of an impressive group of scholars, artists, and religious leaders. Their critical conversations among each other will surely be of great importance to their ongoing work. But that is not why I am most excited about this publication, and proud that a Spelman College professor of art has assembled this collection of essays. I am convinced that the ideas, rituals, and aesthetics analyzed here are a significant metaphor for our times. Before I explain what I mean by that statement, let me offer a brief sojourn into the very ideas, rituals, and aesthetics that are Santería.

The contributors to this volume tell us about Santería, a religious system, in the words of Ricardo Viera, "known for its inherited richness of symbolism and rituals." Born of the syncretism of traditional Yoruba religion and Catholicism, Santería is practiced today in Cuba and in many urban areas in the United States. In Brazil it is known as Candomblé.

There is much that is aesthetic in Santería as it is practiced throughout these New World societies. Indeed the instrumental music, song, dance, carved images, dress, foods, special language, and ritual are

x

all about an aesthetic. But this aesthetic is then taken by artists of the African Diaspora and used as a driving force, an inspiration, and as material expressions in their own New World creations.

Santería, or Afro-Cuban Orisha worship, the term Miguel Ramos prefers, is thus found, from mere echoes of expression to bold statements, in the work of Caribbean artists, Latin American artists, and artists of African ancestry in the United States. In the 1940s and 1950s, Santería as practiced in Cuba was expressed in Cubist and Surrealist idioms in the works of Wifredo Lam.

In the 1960s and 1970s, during the period of the black and Latino consciousness movement that sprang from the Civil Rights movement launched by Rosa Parks and led by Dr. Martin Luther King, Latino and in some cases African American artists began to place Santería aesthetic concerns in their avant-garde work. Included in that community of artists were Juan Boza, Arturo Lindsay, Ana Mendieta, Raquelín Mendieta, Jorge Luis Rodriguez, Angel Suarez-Rosado, and Jonas dos Santos. As Arturo Lindsay has put it, these artists did not have to go too far to find their roots. Let me make it clear that I see a double meaning here, for "roots" means both their cultural origins and identity and the very roots, herbs, and other materials of their people's religious practices. To find their roots, they had but to go to the *botánicas* on their block, the homes of their Cuban neighbors, and the *bembés* in basements.

With this brief journey into that arena that is captured in the very title of this book, I return to my assertion that there is in this work a mighty metaphor for our times. For in these essays there is little about art or religion narrowly conceived. The scholars and practitioners who here share with us their ideas, talents, and practices speak of the art in religion and the religion that is in art. In these pages, we are moved between and among the fields of anthropology, history, philosophy, religion, art, music, drama, and dance. And, in the process, what is declared as important is not the source of information in terms of the field or discipline it comes from, but the usefulness of the analysis in explicating what we need to understand. Is this not what we strive for in the academy? Should we not accept the fact that so much of what is new and path-breaking and genuinely useful is not to be found these days dead in the center of biology or chemistry, or physics or genetics, but indeed in fusions that we call biochemistry, physical chemistry, and molecular biology? Is it not the case that it is in such interdisciplinary approaches as environmental studies, women's studies, African American studies, Latino studies, and ethnomusicology that some of the most intriguing and significant discoveries about human conditions are being made?

It is not only in the academy that we find value in this emphasis on pluralism rather than singularity, in crossing boundaries and moving to the periphery rather

than hovering in the dead center, in fusions rather than pure forms. This is what the call for respecting diversity in America and throughout the world is all about. This is the spirit of multiculturalism.

Here then is a "dual-purpose" book. For the artists, scholars, religious leaders, and devotees who are already steeped in the complex and rich forms and rituals of Santería, there is a highly sophisticated discourse here. For all of us, there are the lessons that can be learned from Santería aesthetics: that creativity often erupts from those places where more than one art form rests; that every culture has its own authenticity, and that includes those made from the fusion of cultures as we see them in the New World; that there is more than one way of looking at and interpreting any phenomenon; and that there is strength and beauty in a diversity of peoples and beliefs no less than in a diversity of religious rituals and artistic forms.

Johnnetta B. Cole
President, Spelman College

PREFACE

This book has its genesis in a conversation I had with Julia Fenton in the fall of 1991, shortly after arriving in Atlanta to teach at Spelman College. Julie was then director of City Gallery at Chastain and had invited me to give a gallery talk on Santería to accompany my solo exhibition *Las Siete Potencias: Mestizaje and the Aesthetics of Santería*, which she was curating for inclusion in the 1992 National Black Arts Festival. I countered Julie's suggestion of a gallery talk with a proposal for a symposium entitled *Santería Aesthetics in Contemporary Latino Art*. The exhibition and symposium were a success, and the Smithsonian Institution Press agreed to publish the participants' work, together with contributions from other scholars who have special insights that broaden the scope of our inquiry to include the work of artists in Cuba and Brazil. Like the symposium, the primary objective of this book is to examine a genre of contemporary art by looking at its aesthetic evolution from its origins in Africa[1] to its postmodern manifestations using a hybrid method of aesthetic inquiry.

The history of Modern art and contemporary art has generally been taught with a view fixed on the aesthetic terrain of Western Europe and the United States with appearances of "other" views emerging only at those historical crossroads where European or Euro-American avant-garde artists introduce nonwestern perspectives or elements of design into their work in order to challenge the prevailing west-

ern aesthetic canons. Two early European modernist examples are the influence of Japanese art on the Impressionists and Post-Impressionists, and that of West African sculpture on the Cubists. Since Modern artists seldom delved below the surface qualities or design elements of nonwestern art, it may not be necessary to conduct critical analysis of the status, context, or function of these objects in their native cultures in order to develop a more informed opinion of Modern art. This is not the case, however, in the postmodern era in pluralistic societies where interest in "self" and fascination with "others" have led artists to mine their nation's rich cultural heritage.

While the debate over the origins of postmodernism continues in the ivory towers and intellectual circles, I can find no clearer indication of the end of what had become the era of "Modern America" and the beginning of a new, postmodern era than December 1, 1955 when Mrs. Rosa Parks was arrested in Montgomery, Alabama. Mrs. Parks, an Afro-North American woman, was arrested for refusing to surrender her seat in the "black section" of a public bus to a white man. Mrs. Parks' refusal to continue accepting the *status quo* of racism prompted a group of local black women to rise up in her defense and demand an end to the degrading conditions of segregation and racism. They galvanized their ministers into staging the now famous Montgomery bus boycott on the 5th of December 1955. Recalling a meeting held after the first day of the boycott, Martin Luther King wrote:

> Without manuscript or notes, I told the story of what had happened to Mrs. Rosa Parks. Then I reviewed the long history of abuses and insults that Negro citizens had experienced on the city buses. "But there comes a time," I said, "that people get tired. . . ."
>
> Then came my closing statement. "If you will protest courageously, and yet with dignity and Christian love, when the history books are written in future generations, the historians will have to pause and say, 'There lived a great people—a black people—who injected new meaning and dignity into the veins of civilization.'"[2]

This "injected new meaning and dignity" ushered in the civil rights and human rights "revolution" that significantly changed the world, in particular the African Diaspora, and affected every aspect of this nation's fiber by giving a booster shot to the women's movement, Latino consciousness, the American Indian movement, gay rights, and the student anti-war movement. The immune system of arts institutions, however, proved much more resilient to change than Jim Crow laws. The afterimage of the "WHITES ONLY" signs that once hung over bathrooms in museums continued to be the policy that governed museum boardrooms and curatorial decisions. Artists

of color attempting to exhibit their work categorically faced rejection for years to come. More than three decades after the Montgomery bus boycott, Howardena Pindell presented the findings of her research on racism in the art world at the Agencies for Survival conference sponsored by the Association of Hispanic Arts and the Association of American Cultures at Hunter College in New York on June 27, 1987: "There is a closed circle which links museums, galleries, auction houses, collectors, critics, and art magazines . . . Black, Hispanic, Asian, and Native American artists . . . with a few, very few exceptions [are] systematically excluded." [3]

Pindell's findings for museums from 1980 through 1987 were shocking. She discovered that during this period the Guggenheim Museum had no one-person exhibitions of artists of color; out of 242 exhibitions listed at the Museum of Modern Art, there were only 2 one-person exhibitions of works by artists of color; and out of 91 one-person exhibitions at the Whitney Museum of American Art, there were only 8 exhibitions of people of color. Women, regardless of race, also faced exclusionary policies. In an interview with Suzi Gablik, a Guerrilla Girl summed up the origins of the group: "In 1984, the Museum of Modern Art opened with an international painting and sculpture show. There were 166 people in that show, and only 16 were women—so that was 10 percent or less. . . . So we started the Guerrilla Girls because we felt that critics, artists, curators and dealers are all responsible for this problem—the underrepresentation of women in the art world." [4]

Finding themselves in a postmodern Salon des Refusés, women and artists of color began working in informal coalitions to bring about change. In recent years the Guerrilla Girls have broadened their attack on the art world to include statistical information on artists of color. Largely due to the efforts of feminists, artists of color, and progressive members of the College Art Association, the racial, ethnic, and gender composition of the board of directors and panelists at annual conferences have become more diverse. Although a great deal of work remains to be done, these coalitions have done much to alter the way a generation of arts professionals see and teach art and art history, resulting in a more optimistic future.

As the second millennium draws to a close, it has become imperative that art professionals, who are responsible for the interpretation and judgment of contemporary art, achieve a wider view of the aesthetic terrain to include Africa, Asia, Latin America, and Eastern Europe. They, too, must delve below the surface of the art and the cultures that today's artists are researching in order to appraise their work from an informed position. In so doing, new multidisciplined research methods must be developed. For this reason, this work on Santería aesthetics in contemporary Latin American art investigates its subject from various vantage points including those of artist-priests, Santería practitioners, linguists, art historians, folklorists, cultural historians, native anthropologists, art critics, and fine artists.

Part One presents an overview of the history and development of the Yoruba-Cuban culture and art from which contemporary Santería aesthetics evolved. Scholars of Yoruba art and culture, most notably William Fagg and Frank Willett, have done extensive research on Yoruba antiquity, suggesting their origins to be "several thousand years old."[5] Linguistic evidence, archaeological finds, and Yoruba mythology support this thesis. However, more field research and archaeological digs need to be done in order to date the origins of the Yoruba scientifically. In "From Africa to the Americas: Art in Yoruba Religion," Babatunde Lawal, a Yoruba art historian, joins Fagg and Willett in calling for further research of an ancestral connection between the Yoruba and the much earlier Nok culture of northern Nigeria. In his historical overview of the Yoruba from Nok to the New World, Lawal raises the possibility of discussing a Yoruba aesthetic dating to at least the first millennium B.C. Lawal also discusses the complex nature of Yoruba religion; the metaphysical aspects of art in Yoruba thought; Yoruba ethics and aesthetics: the role and function of art in *oriṣa* worship; and the arrival of the Yoruba religion and its aesthetic concerns in the New World. Lawal's description of art in Yoruba religion and culture provides the information and language needed to better understand and discuss Yoruba aesthetic thought. It also provides an important framework for discourse on contemporary Latino art because a number of Latino artists use Yoruba terms and concepts when discussing their work.

The unyielding perseverance of the Yoruba in preserving their religion while enduring the horrors of the Middle Passage, the brutality and degradation of slavery, and attempts to destroy their spiritual and family life is responsible for the continuation of their traditions today. In the New World, the ingenuity of the Yoruba is evidenced in the methods of subterfuge they developed to counter the religious indoctrination imposed by *Las Leyes de Indias* (*The Laws of the Indies*):

> We order and command to all those persons who have Slaves, Negroes and Mulattoes, that they send them to the Church or Monastery at the hour which the Prelate has designated, and there the Christian Doctrine be taught to them; and the Archbishops and Bishops of our Indies have very particular care for their conversion and endoctrination, in order that they live Christianly, and they give to it the same order and care that is prepared and entrusted by the Laws of this Book for the Conversion and Endoctrination of the Indians; so that they be instructed in our Holy Roman Catholic Faith, living in the service of Our God our Master.[6]

In "From Ulkumí to Lucumí: A Historical Overview of Religious Acculturation in Cuba," Isabel Castellanos, a Cuban-American linguist and Afro-Cuban folklorist, recounts the history of cultural resistance, centering her discussion on family struc-

ture, the institution of *cabildos* (African cultural and linguistic associations), education, and religious assimilation. Castellanos uses the transformation of the Yoruba term Ulkumí to the Cuban Lucumí as a metaphor to discuss the historical acculturation of the Yoruba in Cuba and the origins of Santería. She thus provides a valuable account of the origins of Cuban Santería as a New World religion.

Understanding the intricacies of a religion other than one's own, or one that is foreign to one's culture, requires delicate interpretation that will allow suspension of cultural biases in order to see and feel what practitioners know about their religion. In "Afro-Cuban Orisha Worship," Miguel Ramos provides such an interpretation from the point of view of a Cuban-American *oriate* (master of ceremonies of initiation rituals), a religious leader in Afro-Cuban Orisha worship (a term he prefers to Santería), and an emerging ethnographer. As anthropologist Johnnetta B. Cole writes: "In studying others the anthropologist is seeing, feeling, knowing for the first time what it is to be a part of a culture. In studying ourselves we learn to see, feel, and know anew as we systematically examine and analyze those institutions, processes, and emotions of which we are a part." [7] Ramos combines Yoruba and Santería *patakís* (legends) and oral history with historical and anthropological accounts to retell the story of the arrival of the Yoruba in Cuba and the process of acculturation that ensued. He describes the characteristics of major orishas and concludes with a description of the role and function of priests, initiates, and practitioners. Ramos' descriptions will prove useful to scholars and critics as artists often adhere to this information in creating their art.

Ramos' essay is also important because of the voice he uses to discuss his religion. His is not the voice of an outsider attempting to see, feel, or know what it means to be a practitioner of Afro-Cuban Orisha worship, but the voice of an insider using contemporary ethnographic methods of participant observation along with oral and written history and personal experiences to discuss the culture of which he is a part. Delmos J. Jones argues: "The problem . . . is that there are native anthropologists, but there is no native anthropology. By this I mean there is little theory in anthropology which has been formulated from the point of view of tribal, peasant, or minority peoples." [8] Ramos' essay lays the groundwork for the development of theories that could lead to the construction of a Santería "native anthropology."

The aesthetic decisions of traditional artist-priests/priestesses are generally overshadowed by investigations of the function or status of the objects they make. In Santería, an important function of religious objects is to please the orishas aesthetically. As a result, David Brown's "Toward an Ethnoaesthetics of Santería Ritual Arts: The Practice of Altar-Making and Gift Exchange" is groundbreaking. There has been a good deal of scholarly work done in this area on traditional African artist-priests,[9] but only superficially on New World artist-priests. Brown's

art historical, ecclesiological, and anthropological interests are wedded in his research methods that carefully analyze minute details in very large altars and thrones; the texture of vestment fabrics for the orishas; and details of the financial decisions of his informants in making purchases for their ritual objects. In his discussion Brown relies on information gained from extensive interviews with two priestesses and often quotes them directly, making us privy to the thinking involved in their aesthetic decisions. A heated aesthetic disagreement between the two women regarding a birthday throne built by a fellow artist-priest reveals a great deal about how they construct criteria for aesthetic criticism.

Brown's discussion of exchange between the orisha and the priestess is seminal to our understanding of the role of aesthetics in fulfilling sacred and secular preferences and needs. It becomes clear that the orishas have "personalities and preferences that are aesthetic," and the priestess has earthly needs that the orisha can fulfill. Intrinsic to this relationship, however, is the unselfish sacrifice of the priestess in sparing no cost to honor or please the orisha. The priestesses in Brown's essay very clearly inform us of the risks involved in a *quid pro quo* approach to the orishas.

Brown's essay is particularly important to our understanding of contemporary Latino artists, since the thrones and ritual objects he discusses are exemplary of the thrones, altars, and objects the artists experience in their religious life, when visiting friends or neighbors, or in their field research of Santería. Santería thrones and altars are the archetype of many contemporary art installations, and the ritual objects are models for sculptural objects.

Part Two focuses on how contemporary Latino artists have created their personal artistic vernacular by recycling elements of Yoruba and Santería aesthetics along with prevailing Western European and Euro-American aesthetic thought. For many Latino artists studying the history of Modern art, Wifredo Lam was the first internationally recognized artist of color whose work spoke directly to them. A number of contemporary artists who are blending and mixing cultural traditions and aesthetics in their work credit Lam as the progenitor of this genre of art. Wifredo Lam therefore is the Elegguá (the orisha responsible for opening doors to all possibilities) for generations of Latino artists. Julia P. Herzberg, an independent curator and Wifredo Lam scholar, focuses on Lam in "Rereading Lam." Herzberg redefines Lam by discussing his similarities to and differences from international Surrealism and contrasts his approaches to those of the New York School who were also influenced by the Surrealists. This contextual discussion is important because it dispels commonly held misconceptions of the artist's influences. Since many mod-

ernist scholars often dismissed the Santería iconography in Lam's art as "African superstition" or "Cuban Voodoo," Herzberg's "rereading" of the artist's work within the context of Santería iconography and beliefs sheds new light on his work and provides a more accurate understanding of this master of twentieth-century art.

A generation later, Ana Mendieta was at the forefront of the avant-garde, exploring new aesthetic terrain and methods of articulating her findings. Mendieta's work literally took her from exploring the physical landscape as well as her body as a canvas on which to make her markings, to the spiritual world of Santería from which she wanted to harness *ashé* (the divine life-force). In "*Ashé* in the Art of Ana Mendieta,"[10] Mary Jane Jacob, a Chicago-based independent curator and writer, focuses on the Santería-inspired art of Ana Mendieta. Jacob recounts the difficult adolescent years of the artist; her interest in Santería aesthetics for personal healing and to aid in her search for gender, cultural, and national identity; and her place in the vanguard of contemporary art. Jacob's in-depth discussions of the legends, icons, politics, images, and iconography that informed Mendieta's art sets the stage for a more meaningful interpretation of the artist's work. This is not an easy task since Mendieta's work is multilayered and rich with influences from many cultures, religions, periods, and styles. Nevertheless, Jacob skillfully isolates each issue for discussion, then synthesizes them in the context of the artist's work. Jacob's research methods are exemplary: she employs a variety of disciplines for gathering information in her efforts to interpret Mendieta's work.

The unexpected news in 1991 of Juan Boza's death shocked the New York art world, in particular the Latino artist community which was still grieving Ana Mendieta's untimely death a few years earlier. Like Mendieta at the time of her death, Juan Boza was quickly approaching the zenith of his career and was receiving major recognition as a pioneer artist creating a new artistic vernacular. Cuban American artist and curator Ricardo Viera and New York writer and art dealer Randall Morris collaborate to allow Boza to speak for himself in "Juan Boza: Travails of an Artist-Priest, 1941–1991." Boza's last known artist statement, written two months before his death, and excerpts from a lengthy interview with Viera in 1987 are translated and edited by Viera and Morris, and presented together with their discussions of the artist. Morris' poetic style of writing contexualizes Boza by exploring the spirit world and the metaphysical world of contemporary artist as shaman or priest, capturing Boza's aura and the *ashé* of his work. Viera concludes with personal observations of Boza, his friend, and a scholarly discussion of his art.

Although orishas are an Afro-Cuban manifestation, devout Santería practitioners claim that the orishas are not the "property" of a single race or ethnic group. As the Cuban diaspora expanded, so too has the practice and influence of the religion.

In places such as New York City, Miami, Chicago, Washington, D.C., and Los Angeles, it is not uncommon to find believers and practitioners of different racial and ethnic groups belonging to the same Santería family. Not surprisingly, Santería aesthetics has emerged in the art of non-Cuban Latinos who have shared in this Afro-Cuban experience in Latino *barrios* (neighborhoods). In "Orishas: Living Gods in Contemporary Latino Art," I discuss the fertile crossroads where the orishas, Afrocentricity, and postmodernism have been meeting for the last three decades and where a select group of Latino artists have been creating a neo-Yoruba genre of contemporary art.

As much as possible, I quote the artists and allow them to speak for themselves as they discuss their experiences with Santería and their artistic intent. These discussions also include the philosophical, political, cultural, and artistic impact of contemporary society on the artists and their work. I end by contextualizing the study with a discussion of the similarities and differences among these artists and their postmodern contemporaries.

In the final section, three essays survey the presence of New World Yoruba aesthetics and iconography in contemporary art and video in Cuba and traditional architecture, religious art, and fine art in Brazil. Gerardo Mosquera, Cuba's leading contemporary art critic, dedicates his "Elegguá at the (Post?)Modern Crossroads: The Presence of Africa in the Visual Art of Cuba" to the *eggun* (ancestral spirit) of Lydia Cabrera, the foremost Cuban ethnographer, whose early work documenting the religion has been invaluable to scholars, practitioners, and artists. According to Cabrera, she encouraged Wifredo Lam to investigate and paint about his Afro-Cuban culture.[11]

Mosquera's semantic argument against using the terms "influence" or "impact" when discussing the cultural contributions of Africans in the Americas is essential in constructing a realistic view of their importance in contemporary cultures of the Americas. He presents the ideological and conceptual reasons for using a more representative term while dismissing the "melting pot" paradigm for the *ajiaco* (a Cuban soup) proposed by Fernando Ortiz. In so doing, Mosquera establishes the context for his discussion of Cuban artists whose works manifest the presence of Santería.

Mosquera offers a revealing portrait of Wifredo Lam from an insider's point of view. His discussions of the evolution of the artist's work upon returning to Cuba in the 1940s, as well as Lam's influence on his Cuban contemporaries and on art in general, fill an information gap on Lam. Mosquera also introduces us to some very important but less well known Cuban artists who followed Lam, and culminates with a survey of important contemporary Cuban artists.

Gloria Rolando's presence at the symposium, and now in this book, I am convinced was ordered by the orishas, probably Elegguá. Harry Lefever, a friend and colleague, lent me a copy of *Oggún Eternally Present*, a video by Gloria Rolando, to review one weekend. I was left speechless by the power of the video. I remember thinking, "God, I would love to meet her." On Monday when I arrived at my office, there was a message on my voice mail: "Dr. Lindsay, my name is Gloria Rolando. I am a Cuban filmmaker, and I would like to talk to you about showing my video *Oggún* at your Santería symposium."

Besides being "ordered" by the orishas to include Rolando's work, I felt it important to dedicate at least one chapter to an artist speaking for herself about her own work. Rolando was a perfect candidate because her medium, video, captures the essence of Santería as a living tradition in rituals, dance, music, performance, storytelling, costume, spectacle, and spirit possession. In "Oggún: Proposals Starting from a Video," Rolando discusses how she was able to use the voice of Lázaro Ross, a highly revered *cantante* (orisha praise singer) to reveal the *patakís* in the video. She recounts how, through interviews with Ross and his reminiscence of his life in the religion, she was able to document these oral legends and the *tambor* (sacred drumming ceremony). Rolando also discusses technical aspects of the filming in order to produce special effects.

Yoruba religious traditions and aesthetics also played a significant role in shaping Brazilian cultural identity and continues to occupy an important role in contemporary popular and fine art. In "Signifyin' Saints: Sign, Substance, and Subversion in Afro-Brazilian Art," art historian Henry John Drewal discusses "multi-consciousness and transculturalism" as distinctive strategies for survival that shaped present-day Afro-Brazilian and Brazilian art and culture. Drewal cites sixteenth- and seventeenth-century accounts of African slaves constructing replicas of Portuguese churches, under the watchful eyes of priests and architects, yet managing to introduce their own aesthetic preferences, iconography, and brown-skinned virgins and cupids. He goes on to reveal the flourishing of artistic inventiveness during the Brazilian baroque period of the eighteenth century and discusses Aleijadinho, a "man of color," considered by many to be Brazil's greatest artist and architect. Drewal brings this early architectural history to a close with a series of penetrating questions and a call for further research into this "hidden" Brazilian history.

Attempts by the Brazilian government to "Europify" the country in the nineteenth century resulted in religious "repression" and cultural "suffocation." In spite of the marginalization and repression of Brazil's Africanism, Drewal informs us that Afro-Brazilian cultures went "underground" to survive and remained there until recent years when Brazilian authorities began viewing it as a commodity to attract tourist dollars. This cultural and historical backdrop contextualizes the discussion

that follows as Drewal examines contemporary Brazilian religious and fine art, providing a portrait of the artists and an analysis of their work.

The contributors to this book have on occasion presented diverging points of view, research methods, writing styles, and even spelling, resulting in a very eclectic compilation. Although this can at times be somewhat puzzling, I welcome this pluralistic approach to aesthetic inquiry and have not given primacy to any position, thus allowing the broadest reading on the subject. Unlike artist-priests, Latin American artists, as do their postmodern contemporaries, ground their work in simulations and metaphors. Paradigms, archetypes, signs, symbols, and iconography from the pages of history, theology, archaeology, and anthropology merge with popular culture and technology requiring postmodern hermeneutic readings.

Postmodern art theory and criticism must move beyond the modernist search for a universal "truth" in art, arrived at by using one set of ethnic- and/or gender-based criteria, to an understanding that cultural and gender interpretations reveal many "truths." Estella Lauter writes: "Formalism defines art in terms of properties, qualities, and principles and arranges those elements in an hierarchical order to privilege those least useful to daily life. . . . Art is a continuum of objects, enactments, concepts, and environments. It concerns life, but neither 'art' nor 'life' can be discussed as totalities; boundaries between art and culture or art and nature are identifiable but shifting." [12]

Meaning in postmodern art, and particularly Latino art, is also no longer the domain reserved for modern art iconologists, elite art patrons, and educated connoisseurs. The "closed circle" of museums, galleries, critics, curators, and art magazine editors has been slightly widened, yet not fully opened. There is still a large segment of the art world and the general public that subscribes to and promotes monistic and hierarchical points of view in art. But the orishas will change that.

Alafia!

NOTES

1. The oversimplification of this statement is due to the need to be brief in the text. I do not mean to imply that contemporary Latino artists are following an unbroken Yoruba aesthetic tradition. The ravages of slavery, colonialism, and racism robbed all New World Africans of a continuous history of art and aesthetics. Traditional artist-priests, in the process of preserving their religion, also preserved the Yoruba color symbolism and iconography that evolved into Santería aesthetics. They are more closely following an ancient African tradition since they are making religious art. Latino artists today are less concerned with religious practice than with recycling this aesthetic tradition with contemporary issues and aesthetic concerns into contemporary art.

2. Martin Luther King, "The Day of Days, December 5," *Stride toward Freedom* (New York: Harper and Row, 1958); quoted from *Chronicles of Black Protest*, ed. Bradford Chambers (New York: Mentor, 1969), 183–84.

3. Howardena Pindell, "Art World Racism: A Documentation," *New Art Examiner*, March 1989.

4. Suzi Gablik, "'We Spell It Like the Freedom Fighters': A Conversation with the Guerrilla Girls," *Art in America*, January 1994.

5. William Fagg, "The Yoruba and Their Past," in *Yoruba Sculpture of West Africa*, ed. Bryce Holcombe (London: William Collins Sons & Co., 1982), 25.

6. Herbert S. Klein, "Anglicanism, Catholicism and the Negro Slave," *Comparative Studies in Society and History* 8 (1965–66): 300.

7. Johnnetta B. Cole, "The Practice and Ethics of Fieldwork," in *Anthropology for the Nineties*, ed., with introductions by Johnnetta B. Cole (New York: Free Press, 1988), 9.

8. Delmos J. Jones, "Towards a Native Anthropology," in *Anthropology for the Nineties*, 31.

9. See Daniel Biebuyck, ed., *Tradition and Creativity in Tribal Art* (Berkeley: University of California Press, 1969), and Warren L. d'Azevedo, ed., *The Traditional Artist in African Societies* (Bloomington: Indiana University Press, 1973).

10. This chapter first appeared as a catalogue essay for a solo exhibition at Galerie Lelong in New York City, December 1991.

11. Conversation with Lydia Cabrera, January 1991, Miami.

12. Estella Lauter, "Re-enfranchising Art, Feminist Interventions in the Theory of Art," in *Aesthetics in Feminist Perspective*, ed. Hilde Hein and Carolyn Korsmeyer (Bloomington: Indiana University Press, 1993), 31. In her notes to this essay, Lauter writes that the quotation marks on *art* and *life* "indicate a challenge to any universal construction of the term enclosed."

ACKNOWLEDGMENTS

My debt to the many who have contributed to this book is enormous. I only hope that I have truly expressed my gratitude to each individually. However, I am especially indebted to the following:

The Orishas
All *babalawos* and *santeros*—past and present
Nana Dr. Kobina Nketsia
Johnnetta B. Cole
Glenda Price
Ruth Simmons
Lev T. Mills
Spelman College
Casa de Africa
The chapter contributors and artists
My parents—Arthur and Louise Lindsay
My sons—Urraca, Joaquín, and Javier
My grandson—Joaquín

Finally, I thank my friend, wife, partner, and spiritual companion, Melanie Pavich-Lindsay, whose love and support make what I do possible.

Arturo Lindsay

A NOTE ON ORTHOGRAPHY

Yoruba is a tonal language with three pitch levels for vowels and syllabic nasal tones. Although the language has been preserved to some degree in Santería, over the centuries very little was written, and Spanish, Portuguese, and now English accents have resulted in a variety of pronunciations and spellings of the same words. The contributors to this book were allowed the freedom to choose their own spellings, thereby reflecting the plurality that is found in the field. To assist the reader, variant spellings of selected terms are included in the Glossary.

PART

THE HISTORY AND DEVELOPMENT OF YORUBA-CUBAN CULTURE

ONE

BABATUNDE LAWAL

FROM AFRICA TO THE AMERICAS
ART IN YORUBA RELIGION

During the Atlantic slave trade between the sixteenth and nineteenth centuries, hundreds of thousands of the Yoruba were exported to the New World to work on plantations. Although they adapted to new ways of life, Yoruba slaves succeeded in preserving a significant part of their cultural heritage, which has since become an important aspect of the American experience. According to William Bascom, one of the leading scholars of African Diaspora culture, "no African group has had greater influence on New World culture than the Yoruba" (1969:1). This influence is most prominent in religion. For example, Yoruba divinities (òrìṣà) constitute the driving force behind new religions known as Candomblé and Macumba in Brazil, Shangó in Trinidad and Tobago, Grenada, and Barbados, Kele in Saint Lucia, and Santería in Cuba, Venezuela, the United States, and other countries. Yoruba influence is also evident in other New World "Africanisms" such as the Voodoo of Haiti and Òrìṣa-Voodoo of Ọ̀yótúnjí, South Carolina.[1] By focusing on the dynamics of art in Yoruba religion as practiced in Africa, I hope to provide a framework for gaining deeper insights into the aesthetics of Santería and other Yoruba-related institutions in the Americas.

Numbering more than 20 million people and divided into several semi-autonomous kingdoms, the Yoruba of West Africa live in the southwestern region of Nigeria and some parts of the republics of Benin and Togo (see map). They are well known for their urbanism and cultural achievements. By the

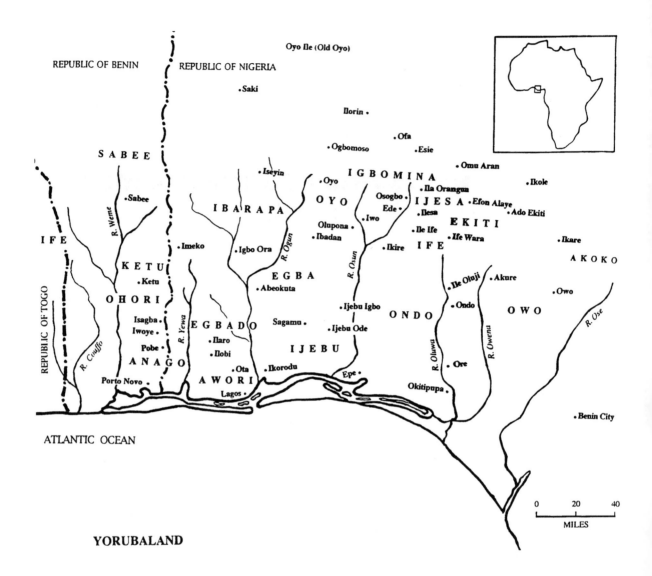

REPUBLIC OF BENIN

REPUBLIC OF NIGERIA

Oyo Ile (Old Oyo)

•Saki

Ilorin •

•Ofa

•Ogbomoso •Esie

•Omu Aran

•Ikole

IGBOMINA

SABEE

•Iseyin

•Oyo

OYO

Osogbo IJESA •Efon Alaye
Ede• •Ado Ekiti
•Ilesa

•Sabee

R. Weme

IBARAPA

•Iwo

EKITI

•Ile Ife

R. Ogun

Olupona•
•Ibadan

IFE

R. Osun

•Ikire IFE

•Ife Wara

•Ikare

AKOKO

•Imeko

•Igbo Ora

KETU

•Ketu

EGBA

•Abeokuta

•Ile Oluji •Akure

•Owo

OHORI

REPUBLIC OF TOGO

R. Yewa

•Ijebu Igbo

ONDO

•Ondo

OWO

R. Ose

Isagba•
Iwoye•

EGBADO

Sagamu •

•Ijebu Ode

R. Couffo

Pobe•

•Ilaro

IJEBU

R. Oluwa

R. Owena

ANAGO

•Ilobi

•Ota

•Ikorodu

•Ore

Porto Novo •

AWORI

Epe•

Okitipupa •

Lagos •

•Benin City

ATLANTIC OCEAN

0 20 40

MILES

YORUBALAND

beginning of the second millennium A.D., Ilé-Ifè, their most sacred city, had become a major urban center with highly developed religious, social, and political institutions. The ancient arts of Ilé-Ifè include extremely naturalistic terracotta, brass, and brass/bronze sculptures dated between the eleventh and sixteenth centuries A.D., hinting at an era of economic prosperity and intense cultural activities (figs. 1.1, 1.2). Because some Ifè figures display hairstyles and body adornments similar to those of the Nok terracotta from northern Nigeria (dated between 500 B.C. and A.D. 200), some scholars suggest that the two art centers may be stylistically related (e.g., Fagg 1963; Willett 1967, 1971). In view of the legend that Odùduwà, the divine progenitor of the Yoruba, emigrated to Ilé-Ifè from somewhere in the "northeast," this possibility cannot be ruled out altogether, although there is as yet no concrete

evidence to support a genetic stylistic relationship between Ifẹ̀ and Nok art (for details, see Lawal 1977b).

Be that as it may, after Odùduwà had consolidated his position as the king of Ilé-Ifẹ̀, the people of the Benin kingdom, about a hundred and fifty miles to the southwest, reportedly petitioned him to send one of his sons to rule them. As a result, Odùduwà sent Ọ̀rànmíyàn (fig. 1.2), who founded the Eweka dynasty that has ruled that kingdom from the late thirteenth or early fourteenth century to the present day. At the height of its political power between the sixteenth and the seventeenth centuries, the Benin empire extended west to Lagos, north to Ọ̀tùn in Ekìtìland, and east to the Niger delta. According to one Benin tradition, a caster from Ilé-Ifẹ̀, called Igueghae, taught Benin artists the technique of brass casting (Egharevba 1968:11). Notwithstanding, Benin art developed its own distinct styles in terracotta, wood, brass, and ivory sculptures for which it is world famous. After a short sojourn in Benin, Ọ̀rànmíyàn reportedly traveled north and founded the city of Old Ọ̀yọ́ (north of Ilé-Ifẹ̀, near the Niger River) which, between the seventeenth and early nineteenth centuries, became one of the richest and most powerful kingdoms in West Africa, controlling a vast empire that included some non-Yoruba groups.[2] Although destroyed by the Fulani about 1837 (its refugees founded present-day Ọ̀yọ́), Old Ọ̀yọ́ is fondly remembered today not only for its economic prosperity, military prowess, magnificent palaces, and colorful festivals, but also for its divine kings, most especially Aláàfin Ṣàngó, who was later deified and identified with lightning and thunder.

FIGURE 1.1.

Head of Olókun, the goddess of the sea and of wealth. Brass. H. 36.8 cm (14½ in.). Museum of Antiquities, Ilé-Ifẹ̀, Nigeria. Photo: Babatunde Lawal.

THE NATURE OF YORUBA RELIGION

Traditional Yoruba religion centers on a belief in life after death and on the worship of divinities called òrìṣà, who mediate between the Supreme Being (Olódùmarè) and humanity (ènìyàn). Olódùmarè (a.k.a. Ọlọ́run = "Owner of Sky") is regarded as the source of existence and the wielder of the power (àṣẹ) that activates and sustains the universe. After completing the act of creation, Olódùmarè reportedly delegated

FIGURE 1.2.

Opa Oранmíyàn (Orànmíyàn's Staff), an iron-studded staff in memory of Oрànmíyàn, the great Ifè warrior and founder of the ruling dynasties in Benin and Oyò. Ilé-Ifè, Nigeria, 1995. Photo: Babatunde Lawal.

the responsibilities of administering the earth to the *òrìṣà*, giving each a specific duty.) Thus Èṣù is the divine messenger and the link between Olódùmarè and the *òrìṣà*, on the one hand, and between the latter and humanity, on the other. Ọbàtálá is in charge of creativity; Ògún, in charge of hunting, warfare, and iron implements; Òsanyìn, in charge of herbal medicine; Ọrúnmìlà, in charge of Ifá divination; Òrìṣà Oko, in charge of agriculture; Yemọja has maternal responsibilities over the *òrìṣà* as well as all living things, and so on. Because of this delegation of responsibilities, Olódùmarè is rarely worshiped directly but through the *òrìṣà* who represent different aspects of his essence. Thus it is to the *òrìṣà* that altars are built and sacrifices offered.

Many of the *òrìṣà* are believed to have once incarnated as human beings, displaying unusual powers by which they were posthumously recognized as divinities in disguise. For example, Ògún once settled in Ilé-Ifè and not only distinguished himself as the greatest blacksmith in the Yoruba country, but also set the standard for acts of heroism and warfare. Ọrúnmìlà is remembered as a great sage and philosopher who introduced the art of Ifá divination for revealing some of the secrets of the universe. Òsanyìn was renowned for his medical and pharmaceutical skills. Òṣun was a great midwife. Ṣàngó was the great Aláàfin of Ọ̀yọ́ who spat fire when he spoke and had the power to attract lightning to punish criminals and traitors. Hence he became associated with social justice. As there is hardly any of them who has not once lived on earth, most of the *òrìṣà* are conceptualized as human and therefore venerated as culture heroes or deified ancestors. Some (like Yemọja, Ọbàtálá, Ọrúnmìlà, Òṣun) are regarded as gentle, cool-tempered, and generous, while others (such as Ṣàngó, Ògún, and Ọya) are reputed to be aggressive and hot-tempered. Being the divine messenger, Èṣù is unpredictable. However, each of the *òrìṣà* has both pleasant and unpleasant sides. For instance, when angered, even the coolest and most benev-

FIGURE 1.3.

Symbol of the Head (*Ìborí*). The abstract style signifies the concealed nature of an individual's destiny. Cowrie shells and leather. H. 14 cm (5½ in.). Ọbáfẹ́mi Awólọ́wọ̀ University Art Collection, Ilé-Ifẹ̀, Nigeria. Photo: Babatunde Lawal.

olent one like Yemọja can be extremely vindictive, whereas, when properly appeased, a highly temperamental *òrìṣà* like Ṣàngó can be generous, almost to a fault. Thus, knowing the do's and don'ts of the *òrìṣà* is the key to securing their goodwill and support.[3]

Although there are several *òrìṣà* in the Yoruba pantheon (about 401, if not more), most are of regional importance, comprising deified ancestors and tutelary spirits identified with the geographical features of a given area such as hills, caves, and rivers. However, some *òrìṣà*—Ògún, Ọrúnmìlà, Èṣù, Ọbàtálá, and Yemọja—are venerated almost everywhere partly because of their association in Yoruba cosmology with the beginnings of life on earth. A person normally worships the tutelary *òrìṣà* of his or her family; but circumstances such as illness, persistent misfortunes, trances, or spirit-possession may cause an individual (on the recommendation of a diviner) to add another *òrìṣà* or switch completely to a new one whose placation is necessary to solve particular problems. This is possible because, as a Yoruba divination priest puts it, "All the *òrìṣà* are emanations from the same Olódùmarè"—a phenomenon that not only minimizes rivalry among them and aggressive proselytization in Yoruba religion, but encourages flexibility and creativity.

In summary, *òrìṣà* worship is a reciprocal affair. By paying the *òrìṣà* their due through worship (*isìn*), prayers/supplication (*èbè*), and sacrifice (*ẹbọ*), the devotee expects in return not only their spiritual protection but also their support in the existential struggle. For good luck, one must also venerate one's "spiritual head" (*orí*), being the seat of one's personal life-force, controlling the individual personality and destiny. Since the *orí* represents the *àṣẹ* of Olódùmarè (the Supreme Being) in the individual, its approval is necessary before any *òrìṣà* can act in one's favor.[4] Hence the popular saying: "kò sí òrìṣà tí í dá ni í gbè lẹ́hìn orí ẹni" (No *òrìṣà* supports a person without the consent of his or her head) (Abimbọla 1971:81). The spirit of the head is usually localized in a cone-shaped object (*ìborí*) wrapped in leather and adorned with cowrie shells (fig. 1.3).

METAPHYSICS OF ART

In order to appreciate the functions and significance of art in *òrìṣà* worship, we must be aware of its metaphysics in Yoruba thought. The Yoruba equivalent of the word "art" is *ọnà*, that is, the creative skill or design manifest in an object, making its form unique and attractive. However, because of the special skills involved in its creation, art is often associated with the supernatural and thought to embody a kind of *àṣẹ*. Although Olódùmarè is the greatest artist and the creator of the universe (hence he is known as Ẹlẹ́dà, "the originator"), the *òrìṣà* are responsible for the minute details of the process.[5] The principal artist-deity is Ọbàtálá (also called Oòṣálá or Òrìṣálá). He is often assisted by Ògún, the patron deity of blacksmiths and carvers,

who is in charge of iron, the material used in manufacturing knives, adzes, cutlasses, and other art tools. Òṣun (a river goddess) and Ìyá Màpó (a hill goddess) are in charge of female crafts such as pottery and dyeing. Ọbàlùfọ̀n is responsible for brass casting, and Olókun (a sea goddess) for beadworking. As a result, Yoruba artists and artisans (ọlọ́nà)[6] ply their crafts under the spiritual guidance of patron-deities. Art is so entrenched in Yoruba culture and social psychology that it is considered a *sine qua non* of life. From the decoration of the human body, architecture, and utilitarian objects to communicate taste or high status, to the use of sculpture, leatherworks, beaded objects, and ritual emblems for social, political, and religious purposes, art is used by the Yoruba not only to make the spirit manifest, but also to enhance appearance and celebrate the joy of living.

The inseparability of art and life in Yoruba thought is illustrated by one of their myths on the origin of humankind. According to this myth, when Olódùmarè decided to create the first human being, he commissioned the artist-deity Ọbàtálá to mold the physical body (ara) from divine clay. Olódùmarè later infused the finished sculpture with a soul (èmí), thus making it human. This event is recalled in the following Ifá divination verse (Odù Èjìogbè):

Ọbàtálá

O dá'mọ, dá'yà á

O ṣe baba lóore tán

O ránṣẹ s' ọmọ

Kó wá gb'ore . . .

Òun ló dá pẹ́tẹ́ ọwọ́

Òun ló dá pẹ́tẹ́ ẹsẹ̀

Òun ló dá àyà jààkàn

Tí à npè ní igbá àyà

Òun ló dá omi lójólójó

Tí a npè l'ójú

Òun ló dá orù rébété

Tí a npè l' átàrí

Ọbàtálá

The molder of the child and its mother

After doing good to the father

He sent for the child

To come and collect its own gift . . .

He molded the palm of the hand

He molded the sole of the foot

He molded the great mound

Known as the chest

He created the water balls

Known as the eyes

He molded the small pot

Known as the skull.[7] (my translation)

That the human body is a divinely inspired work of art is implied in the following greeting addressed to a pregnant woman:

Kí Òrìṣà ya ọnà 're ko ni

May the Òrìṣà (Ọbàtálá) fashion for us a good work of art. (Idowu 1962:62)

Another creation myth claims that after Ọbàtálá had finished molding the human body, he passed it on to Ògún who added the finishing touches, that is, tattooing the body, putting lineage markings on the face, performing circumcision, and other such operations that may be necessary to keep the body in good shape and make an individual socially acceptable in Yoruba society (ibid.:87). Here we are reminded of the final stage of the Yoruba carving process (fínfín) when the carver uses a sharp knife to delineate and refine forms. However, before the newly created human being is born onto the earth, it must go to the workshop of Àjàlá Alámọ̀, the heavenly potter, to choose a destiny which, as the "inner head" (orí inú), not only determines one's personality and destiny on earth but also mediates between the individual and the òrìṣà. This accounts for the emphasis on the head in Yoruba art and rituals (Lawal 1985).

To the Yoruba, therefore, existence (ìwà) has two aspects: the physical or tangible and the spiritual or intangible. The human body (ara)—the sculpture created by the artist-deity Ọbàtálá—represents the physical; the àṣẹ (also called èmí) injected into it by Olódùmarè signifies the spiritual. The sculpture remains animated as long as the èmí resides in it. Withdrawal of the èmí results in death; the sculpture becomes static and decomposes when buried. However, from the Yoruba perspective, death is not the end of life. It is merely a dematerialization of the èmí and a transition from earthly to spiritual existence where the èmí could remain forever or return to earth through reincarnation. This is why a child born soon after the death

of a parent of the same sex may be interpreted as a reincarnation of the deceased in a new body to start a new life. Such children are called Babátúndé (Father comes back) or Yétúndé (Mother returns). At any rate, the myth that the human body is a work of art not only implies that the human being (ènìyàn) is a rational, divinely ordered creation and an embodiment of reason, but has encouraged the Yoruba to use sculpture in various media as a substitute for localizing the spirit of an òrìṣà and subjecting it to human reasons and emotions. Although conceptualized as human in essence, Olódùmarè is never represented in sculpture, being regarded as the sum total of existence.

ETHICS AND AESTHETICS

Art looms large in Yoruba life and religion not only because of its implication in the existential process, but also because it generates ẹwà (beauty) (Lawal 1974). Ẹwà is a quality of the well-formed, stimulating a pleasant experience. Being perceived through the eyes, it is often described as "oúnjẹ ojú" (food for the eye) and "oún t'ójẹ ojú ní gbèsè" (something to which the eye is indebted). Consequently, any object or person radiating ẹwà is influential. However, to the Yoruba, beauty has two aspects: ẹwà òde (external beauty) and ẹwà inú (internal beauty).[8] Ẹwà òde has to do with quality of form that immediately attracts the eyes, while ẹwà inú refers to intrinsic worth (or "inner quality"), which ultimately determines the value attached to the object or person. For example, the beauty of a carved stool lies in a combination of its design and structure/functional qualities. Conversely, an elegantly carved but fragile stool is worthless. Similarly, the physical beauty of a person pales into insignificance as soon as admirers discover that he/she is a bad character. This aesthetic principle is summed up in the popular Yoruba saying: "Ìwà l'ẹwà" (Character determines beauty). In view of Wándé Abímbọ́lá's observation (1975:393–94) that ìwà (character) derives from the root verb wà (to be or to exist), some scholars have concluded that "Iwa has no moral implications; rather it refers to the eternal constancy, the essential nature, of a thing or person—it is the specific expression of ase. Thus when art captures the essential nature of something, the work will be considered 'beautiful.' This is the significance of the saying iwa l'ewa—'essential nature is beautiful'" (Drewal, Pemberton, and Abiọdun 1989:39–41).

First of all, the Yoruba term for the "essential nature" or inborn characteristic of a creature is àbùdá, not ìwà (essence of being). Second, the saying "Ìwà l'ẹwà" is an abbreviation of "Ìwà l'ẹwà ọmọ ènìyàn" (Character determines the beauty of a person); thus ìwà in this phrase does not apply to arts and crafts, though the latter may possess ẹwà (beauty). Third, Wándé Abímbọ́lá, whose work provides the basis for this hypothesis, has been careful to point out that, while it may mean "character" or "existence," the Yoruba define ìwà in ethical and moral terms (1975:394, 417). According to him, "Ìwà (character) is needed to achieve dignity, purpose, and

meaning in life. Any person who lacks ìwà is . . . a failure" (1977a:238). Conversely, the gift of immortality awaits only those who have led a qualitative or heroic life; hence the Yoruba saying "ire àìkú parí ìwà" (immortality is the ultimate existence) (1975:393). Put differently, ìwà (character) refines èdá, a creature and its "essential nature" (àbùdá), lending it ẹwà (beauty) (see Lawal, forthcoming).

However, as I have pointed out elsewhere (Lawal 1974), the òrìṣà are above the human notion of morality because they enjoy a kind of "divine license." For example, Olódùmarè gave life to all the human bodies molded by Ọbàtálá, notwithstanding the fact that the artist-deity sometimes created deformed beings under the influence of alcohol;[9] the stability of the cosmos depends on Èṣù, yet he delights in mischief; and Ọbalúayé inflicts smallpox on humanity and still expects relatives of deceased victims to express gratitude for his actions.[10] This phenomenon reflects a view of the cosmos as a mystical union of opposites: "Tibi, tire la dá ilé ayé" (The world evolved out of good and evil). In other words, life is full of inherent contradictions that must be taken in their stride, as there is little humanity can do to prevent certain unfavorable events in nature. This attitude is summed up by the popular Yoruba dictum "Iṣẹ́ Olódùmarè, Àwámárídí" (Olódùmarè's action is unfathomable). Thus humanity must carry on with the struggle of living and hope for the goodwill of Olódùmarè and the òrìṣà in making the physical world (ilé ayé) a pleasant place in which to live.

ART IN *ÒRÌṢÀ* WORSHIP

Before examining the role of art in òrìṣà worship, it is necessary to stress the fact that the visual arts often combine with poetry, music, and dance to create the right atmosphere for worship.[11] A priest invites the spirit of an òrìṣà to descend on the altar by chanting its praise poetry (oríkì), often to the rhythm of a gourd-rattle or metal gong. After the chanting, sacrifices and prayers would be offered. On special occasions, dancing takes place within or outside the shrine during which a priest or one of the devotees may be "mounted" or possessed by the òrìṣà. The annual festival in honor of each of the principal òrìṣà is celebrated with much feasting and merrymaking. At times, images from the altar of an òrìṣà may be carried on the heads of worshipers and "danced" in a public procession, as during the Yemọja and Erinlè festivals in Abẹ̀òkúta and Ìlobú respectively.

The extent to which art may be used in worship depends on a variety of factors such as wealth, individual taste, social status, and the position of an individual in the hierarchy of a given òrìṣà cult. Accordingly, altars owned by senior priests, chiefs, kings, and the rich often have more elaborate artistic programs than those belonging to the common people. If an individual attributes his/her success in life to an òrìṣà, he/she reciprocates not only with rich sacrifices, but also by making the altar of an òrìṣà as "beautiful" as possible (Lawal 1974:242). Festivals in honor of reputedly

11

generous *òrìṣà* such as Ṣàngó, Ọ̀ṣun, Yemọja, and Ìyá Nlá are usually very colorful. This open demonstration of gratitude (either at the personal or communal level) is expected to inspire an *òrìṣà* to be more benevolent. A closer examination of the various uses of art in *òrìṣà* worship reveals three main functions: the honorific, representational, and communicative.

HONORIFIC FUNCTION

When used with honorific intent in the worship of an *òrìṣà*, art is described as *ohun ọ̀ṣọ́* (adornment/ornament). Popular Yoruba names like Ọnàyẹmí (Art befits me), Ọnàwùmí (Art pleases me), and Ọnàníyì (Art has prestige) attest to the high value placed by the Yoruba on art (*ọnà*) as a desirable and image-enhancing phenomenon. Being anthropomorphized, the *òrìṣà* are expected to have artistic tastes similar to those of humans. Art is therefore used not only to attract their attention but also to dignify their images. In some cases, the carver delivers a commissioned work already painted; but more often a devotee repaints or adds new colors and embellishments when renovating the shrine for a major celebration or the annual festival in honor of a given *òrìṣà*. Most shrines (*ilé òrìṣà*) are specially constructed and adorned with murals, carved posts, and doors that easily set them apart as sacred enclosures (fig. 1.4); others are not as elaborate. The altar (*ojúbọ*) of a major shrine usually occupies a whole room. A few feet from the entrance, there is a raised platform (*pe-*

12

FIGURE 1.4.

Carved posts of Ṣàngó shrine, demarcating sacred from secular space. Agbeni, Ìbàdàn, Nigeria, 1989. Photo: Babatunde Lawal.

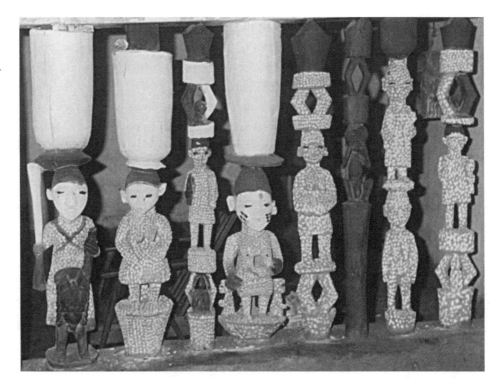

FIGURE 1.5.

Ṣàngó female caryatid figure (*Arugba Ṣàngó*). The face on the container reinforces the human essence of the deity, vivifying his presence at the moment of invocation. Wood, pigment. Ọbáfẹ́mi Awólọ́wọ̀ University Art Museum, Òṣogbo, Nigeria. Photo: Babatunde Lawal.

FIGURE 1.6.

Ṣàngó ritual staff (*Oṣé Ṣàngó*). Emblematizing the fire power of the thunder deity, the staff also identifies an individual as a devotee of Ṣàngó. Wood, pigment. H. 56 cm (22 in.). Hood Museum of Art, Dartmouth College, Hanover, New Hampshire; Gift of Ethel and Robert Asher, Class of 1931.

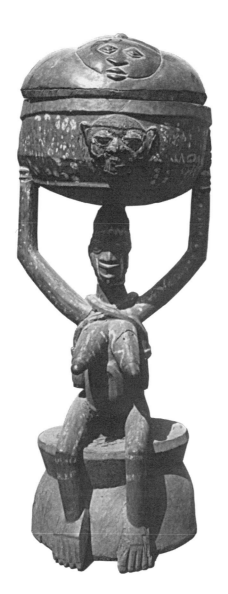
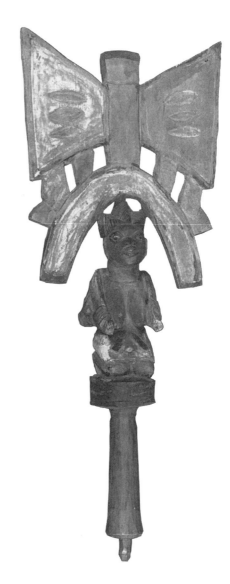

pele) on which various ritual objects are displayed. The altar furniture is more often ornamented with symbolic motifs.

What immediately strikes an observer about a typical altar is the hierarchic arrangement of ornamental objects. The sacred symbol of an *òrìṣà* (or an anthropomorphized image) almost always occupies the center of a profusion of cult paraphernalia and sacrificial remains, all of which invest the altar with a numinous aspect. The common practice is to place the centerpiece on a pedestal (*àgbélé*), so that it commands attention. On altars dedicated to Ṣàngó, the thunder deity, for example, the pedestal is in the form of an elaborately carved inverted mortar (*odó*).

FIGURE 1.7.

Equestrian statuette representing Èṣù, the divine messenger. The whistle motif under the chin underscores his role as the coordinator of rituals. Wood, leather, cowrie shells. H. 27.3 cm (10¾ in.). National Museum, Lagos, Nigeria. Photo: Babatunde Lawal.

Sometimes the mortar may be replaced with a kneeling caryatid female figure (*arugbá*) holding aloft a bowl containing the sacred thunderbolts (fig. 1.5). Murals and/or wall hangings combine with this hierarchic arrangement to suggest a royal court where Ṣàngó is invisibly enthroned to receive tribute and petitions from worshipers and retainers. The latter are often represented on the altar with carved figures of devotees, kneeling women, gift-bearers, nursing mothers, drummers, hunters, animal mascots, and warriors.[12] The prominence of certain iconographic motifs (such as the double-ax motif in Ṣàngó statuary and the pipe-smoking/whistle-blowing figure in that of Èṣù makes it easy to differentiate the art of one *òrìṣà* from another (figs. 1.6, 1.7).

Priests and devotees wear special costumes to honor their *òrìṣà*. For example, Ifá divination priests (*babaláwo*) wear colorful attire, have yellow and green beads on their wrists, and often carry a carved ivory rattle (*ìróké*) or an iron staff (*òsùngàgà*) as an emblem of office (figs. 1.8a,b). Their divination trays (*opón ifá*) usually have elaborately carved designs (fig. 1.9b). The Ògbóni/Òṣùgbó (community elders and devotees of Ilè, the earth goddess) are easily identified in public by a colorful sash (*ìtagbè*) worn over the left shoulder and a pair of brass staffs joined by an iron chain (*ẹdan*) worn round the neck (fig. 1.10) (see Lawal 1995). The priests of Ọbàtálá wear immaculate white attire, plain white beaded necklace (*ṣẹ́ṣẹ́ ẹfun*), lead bangles (*kerewú òjé*), and sometimes carry an iron staff rattle (*òpá òṣòorò*) as emblem of office (fig. 1.11). The priests of the river goddess Òṣun are distinguished by white attire, brass bangles (*kerewú idẹ*), and a brass fan (*abẹ̀bẹ̀ idẹ*).

The priests of Ṣàngó, the thunder deity, are usually the most elaborately costumed in Yorubaland (fig. 1.12). They are easily identified by their elaborate hairdo, necklace of red and white beads (*kélé*), red garments, and a double-ax staff of office (*oṣé*) (fig. 1.6). While dancing to *bàtá*, Ṣàngó's sacred music, a male or female priest may be possessed by the deity. Thereafter, the possessed priest is taken into an enclosure and costumed in an elaborate cowrie-embroidered vest (*ẹ̀wù owó*) and multicolored appliqué skirt (*wàbì*). Returning to the dance arena, the possessed priest, looking majestic in the new costume, assumes the identity of Ṣàngó and is greeted with "ká-á-bí-yè-sí" (Your Royal Highness) to recall the legend identifying Ṣàngó as

FIGURE 1.8a.

Ifá divination priest (*ba-baláwo*) and his entourage during the annual Ifá festival, Ilé-Ifè, Nigeria, 1984. Note the birds atop his iron staff (*òsùngàgà*). Photo: Babatunde Lawal.

FIGURE 1.8b.

Ritual staff of a divination priest (*òsùngàgà*). The bird motif signifies *àṣẹ*, divine authority. Iron. Ọbáfẹ́mi Awólọ́wọ̀ University Art Museum, Òṣogbo, Nigeria. Photo: Babatunde Lawal.

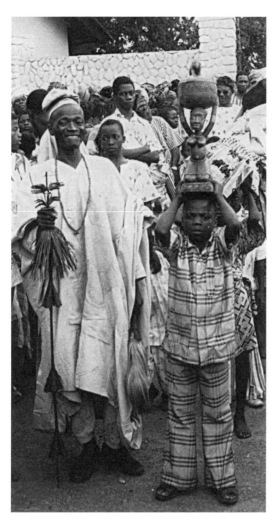

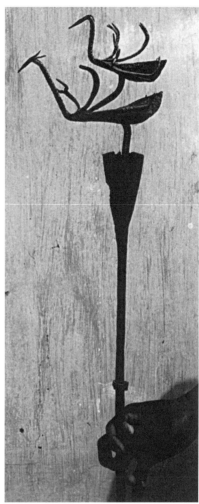

15

one of the kings of the ancient kingdom of Ọ̀yọ́. Surrounded by male and female devotees, some of whom chant his praises and address him as Ṣàngó, the *òrìṣà*-incarnate moves about like a monarch, receiving gifts, blessing members of the audience, and praying for the well-being of the community. The important thing to note in the costume tradition of Ṣàngó priests is that the most prestigious regalia is worn only after the spirit of Ṣàngó has possessed the priest (*ẹlẹ́gùn*). This is to emphasize Ṣàngó's royalty.

Another use of costuming to enhance the image of an incarnated spirit occurs in the Egúngún mask, which represents the disembodied soul of a deceased ancestor who is visiting the earth to interact physically with the living (fig. 1.13). Masks representing the ancestors of the ruling houses and other important culture heroes are generically known as Eégún Nlá (Great Mask) or Eégún Àgbà (Senior Mask). The

FIGURE 1.9a.

Bowl for storing divina-
tion palm-nuts (*Ọpón
Igede*). Wood. Ọbáfẹ́mi
Awólọ́wọ̀ University
Art Museum, Òṣogbo,
Nigeria. Photo: Ba-
batunde Lawal.

16

FIGURE 1.9b.

Divination tray (*Ọpón
Ifá*). The circular form
alludes to the Yoruba
cosmos whose cre-
ation was witnessed by
Ọ̀rúnmìlà; hence his ap-
pellation *Ẹlẹ́rí Ìpín* (Wit-
ness of Destiny). He is
the "All-Knowing
One," guiding human-
ity with his knowledge
of the past, present,
and future. Wood. Na-
tional Museum, Lagos,
Nigeria. Photo: Ba-
batunde Lawal.

costume of a typical Eégún Nlá consists of several layers of expensive multicolored cloth and ornate appliqué panels which increase the girth of the mask, projecting wealth and importance. In comparison, the costumes of the less important masks are not as elaborate. The slow, dignified dance of the senior masks (partly due to the elaborate costumes) has given rise to the popular Yoruba saying "Pẹ̀lẹ́ pẹ̀lẹ́ l'eégún àgbà njó" (lit., Gently, gently dances the senior mask). Although this saying is often used to warn an elderly person of the dangers of strenuous activities, it also alludes

FIGURE 1.10.

Ògbóni staff (*Ẹdan Og-bóni*). The male and fe-male figures allude to the ambivalent nature of the earth goddess. Brass. H. 30.5 cm (12 in.). Judith Hollander Collection. Photo: Sarah Wells 1994; courtesy of Eric Robertson, African Art, New York.

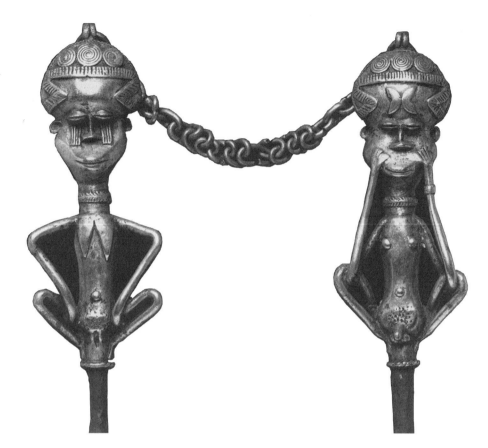

to the dignified carriage expected of a person of importance. Thus, even if a youth is appointed to don an Eégún Àgbà, he must behave like an elder to elicit the traditional honor due to a senior ancestor.

The emphasis on the aesthetic in Yoruba religion is most pronounced in the Gẹ̀lẹ̀dẹ́ ceremony staged by the Ẹ̀gbádò/Kétu Yoruba to appease all the supernatural forces in the universe, most especially Ìyá Nlá, Mother Nature (frequently identified with Yemọja). The ceremony has two aspects: an all-night concert (*èfẹ̀*) and a diurnal dance (*ijó ọ̀sán*). During the all-night concert, a special, elaborately attired mask called Ẹ̀fẹ̀ (fig. 1.14) invokes the blessings of Ìyá Nlá and all the *òrìṣà* and entertains them with songs and dances.[13] A good part of the concert is devoted to satirical sketches intended not only to put Ìyá Nlá and all the *òrìṣà* in good humor, but also promote unity and good conduct in the community. The diurnal dance lasts between seven and fifteen days in the course of which colorful masks perform in the market square, displaying intricate dance steps in front of an orchestra of master drummers. A typical Gẹ̀lẹ̀dẹ́ mask is made up of a carved headdress and a costume of multi-colored fabrics. The headdress is in the form of a realistic human head; some may

FIGURE 1.11.

Ritual staff for Ọbàtálá (Ọ̀pá Ọ̀ṣòorò). When rattled, the staff lends divine authority (àṣẹ) to prayers. Iron. Ọbáfẹ́mi Awólọ́wọ̀ University Art Museum, Òṣogbo, Nigeria. Photo: Babatunde Lawal.

FIGURE 1.12.

Ṣàngó possession priest (Ẹ̀lẹ́gùn) dancing. Ẹ̀dẹ, Nigeria, 1989. The colorful costume recalls the popular image of Ṣàngó as a handsome and fashionable òrìṣà. The female hairdo metaphorically converts the priest into a "wife" of Ṣàngó. Photo: Babatunde Lawal.

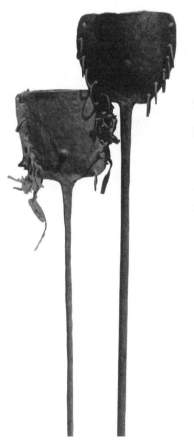

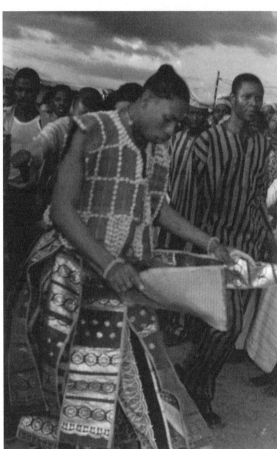

carry a flat wooden tray displaying carved visual aphorisms meant to amuse or educate the public. The costume often reflects the theme on the headdress. The male mask (akọ igi) looks bulky and rotund, while the female (abo igi) sports huge breasts and buttocks, emphasizing the Yoruba association of size with wealth and social importance.

REPRESENTATIONAL FUNCTION

As already noted, the Yoruba conception of the human body as a work of art embodying the soul has resulted in their use of sculpture for a similar purpose. A popular example is ère ìbejì, the carved memorial for a deceased twin (fig. 1.15). To the Yoruba, twins are inseparable. So, if one of them should die, a statuette (ère) is commissioned to localize the soul and keep it in close contact with the surviving twin. If this is not done, it is believed that the surviving twin could also die and return to the spirit world. To acknowledge the presence of the soul in it, the statuette is treated

FIGURE 1.13.

The Egúngún mask usually represents the spirit of a deceased ancestor who is visiting the earth to interact with living relatives. Ipetumodu, near Ilé-Ifẹ̀, Nigeria, 1972. Photo: Babatunde Lawal.

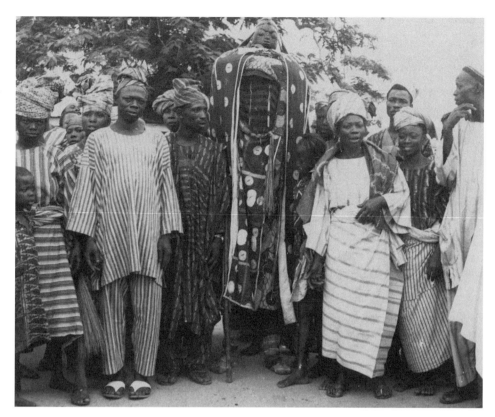

FIGURE 1.14.

Ẹ̀fẹ̀ mask during night performance. The elaborate costume reinforces the image of the mask as the "king" of the night. Ìjió, Nigeria, 1991. Photo: Babatunde Lawal.

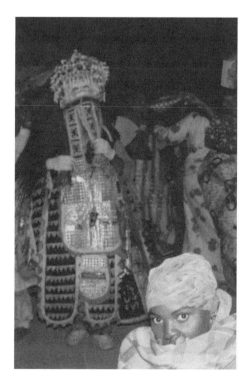

FIGURE 1.15.

Ìbejì statuette (*Ère*
Ìbejì) representing the
spirit of a deceased
twin. Wood. National
Museum, Lagos, Nige-
ria. Photo: Babatunde
Lawal.

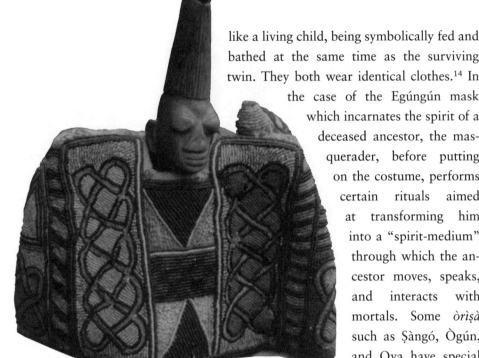

like a living child, being symbolically fed and
bathed at the same time as the surviving
twin. They both wear identical clothes.[14] In
the case of the Egúngún mask
which incarnates the spirit of a
deceased ancestor, the mas-
querader, before putting
on the costume, performs
certain rituals aimed
at transforming him
into a "spirit-medium"
through which the an-
cestor moves, speaks,
and interacts with
mortals. Some *òrìṣà*
such as Ṣàngó, Ògún,
and Ọya have special
masks for this purpose.

The fact that most of the *òrìṣà* are either deified ancestors or personifications of
nature spirits easily explains the presence of human representations on their altars.
These representations can be divided into two main groups. In one group are those
portraying the *òrìṣà* in person (fig. 1.16) and, in the other, those depicting priests,
devotees (fig. 1.17), and subjects from everyday life, including animals.

Although the most sacred altar symbol of an *òrìṣà* is usually a nonfigurative ob-
ject such as a collection of sanctified stones, metals, or any other material, some
òrìṣà (e.g., Ṣàngó, Èṣù, Yemọja, Erinlè, and Òrìṣà Oko) may occasionally be anthro-
pomorphized in sculpture[15] to emphasize their humanity and enable their wor-
shipers to deal with them in human terms. Even where an *òrìṣà* is not represented in
person but by a nonfigurative symbol, the latter is often concealed in a container
which may have a stylized human head or face carved or inscribed on the body or
cover (fig. 1.5). Alternatively, the symbol could be buried in the ground or hidden
behind a screen of anthropomorphic images. During worship, libation is poured on
both the nonfigurative symbol and the anthropomorphized statue of an *òrìṣà*. But if
solid food is offered as sacrifice, a symbolic feeding of the statue or the carved face
on the container which conceals the symbol may suffice; otherwise the offering may
simply be left on the floor in front of the statue (Lawal 1985:100).[16] These gestures
clearly show that, in addition to objectifying the presence of an *òrìṣà* on the altar,
the anthropomorphized statue functions as a kind of "spirit-medium," vivifying the

FIGURE 1.16.

Equestrian statue representing Ṣàngó (*Ère Alafin Ṣàngó*). Wood. H. 121.9 cm (48 in.). Carved before the 20th century, the statue is said to have been brought to New Ọ̀yọ́ from Old Ọ̀yọ́. National Museum, Lagos, Nigeria. Photo: Babatunde Lawal.

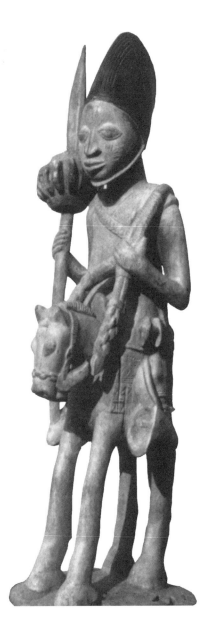

FIGURE 1.17.

Kneeling female shrine statue flanked by two smaller figures. Wood. National Museum, Lagos, Nigeria. Photo: Babatunde Lawal.

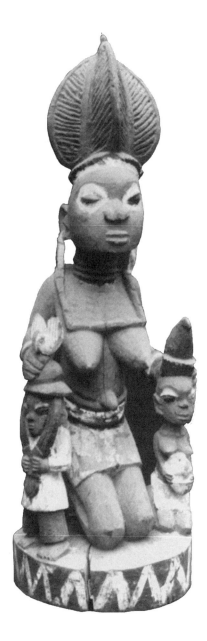

presence of the *òrìṣà* at the moment of invocation (ibid.). A somewhat similar function is performed by an Egúngún mask or a "possessed" priest who physically receives gifts ultimately meant for an *òrìṣà*. One major difference, though, is that while the Egúngún mask and "possessed" priest can dramatize the presence of the *òrìṣà* by moving and speaking, the altar statue remains stationary (though it is expected to be active metaphysically); the only exception that I have come across is a special puppet

of Ọsanyìn (the herbal deity) which moves and squeaks to indicate the presence of the òrìṣà in it.[17]

The altar statue (ère òrìṣà) is often stylized to reflect the nonmaterial state of an òrìṣà or deified ancestor. It resembles a human being only insofar as it hints at the human essence of an òrìṣà, rather than physical reality. In almost all cases, the head of the statue is enlarged. This immediately recalls the Yoruba conception of an altar as ojúbọ which can be etymologized as ojú = face; ibọ = deity. The òrìṣà are known as ibọ because they are pacified with ẹbọ (sacrifice). Another name for the altar is ojú òrìṣà, which means "the face of the òrìṣà." Since the word ẹbọ (sacrifice) derives from the root verb bọ, which means "to feed" or "to worship," the altar is also known as ojúbọ òrìṣà, "the face for feeding/worshiping an òrìṣà."[18] Thus, at one level, an anthropomorphized altar statue provides an òrìṣà with a human face, making it more approachable. For the "face" connotes access in Yoruba thought, and what has a face is controllable.[19] At another level, the enlarged head of the altar statue sensitizes an òrìṣà to human prayers. To the Yoruba, the head (orí) has two aspects, the physical and the metaphysical. The physical or the "outer" head (orí òde) is the seat of such vital organs as the brain, eyes, nose, mouth, and ears which determine awareness, sanity, taste, intelligence, and reason, among others. The metaphysical or "inner" head (orí inú) is the locus of the vital force (àṣẹ) that regulates existence and individual destiny. Both aspects of the head interact in an anthropomorphic representation to stimulate an òrìṣà to empathize with human aspirations and existential struggles.[20]

The depiction on the altar of devotees and subjects from everyday life performs two major functions. Figures depicting priests and priestesses highlight their role as intermediaries between the òrìṣà and the community, while most of the others are intended to communicate to an òrìṣà the deep devotion as well as the aspirations and wishes of their donors. Certain animal motifs are often used to allude to supernatural powers that the human figure cannot adequately express. The most popular motif in Yoruba art for this mysterious power is the bird (ẹyẹ). According to Yoruba cosmogony, it was a bird—a five-toed chicken given by the Supreme Being to Odùduwà (the progenitor of the Yoruba)—that spread the divine sand over the primordial waters at Ilé-Ifẹ̀ (the cradle of Yoruba civilization), thus creating solid earth.[21] When the first batch of òrìṣà was about to leave heaven for the earth, Olódùmarè gave the only female among them (Odù) a special power in the form of a bird enclosed in a calabash—apparently to counterbalance the male majority (see Verger 1965:141–243). On earth, she used this power so effectively, for both good and evil, that all the male òrìṣà were obliged to reckon with her. The powerful women of Yoruba society known as àjẹ́ are thought to wield a similar power whose negative

FIGURE 1.18.

Ritual staff for Ọ̀sanyìn,

the *òrìṣà* of herbal

medicine. Iron.

Ọbáfẹ́mi Awólọ́wọ̀ Uni-

versity Art Museum,

Òṣogbo, Nigeria.

Photo: Babatunde

Lawal.

aspect is equated with witchcraft, a phenomenon highly feared by the Yoruba. Mysterious and chronic illnesses, sudden deaths, and persistent misfortunes are often attributed to the evil machinations of a witch whose soul is thought to change into a bird at night and fly out to attack sleeping, unsuspecting victims who will consequently develop incurable illnesses or simply die suddenly without falling sick (cf. Prince 1974:92).

By and large, given its implication in Yoruba cosmogony and in the myths on the origin of witchcraft, the bird motif is, without a doubt, a metaphor for *àṣẹ* (the enabling power), which accounts for its prominence in Yoruba religion and rituals. For example, as Ọrúnmìlà and Ọsanyìn, *òrìṣà* of divination and herbal medicine respectively, specialize in finding solutions to human problems in general and those of witchcraft in particular, their ritual staffs usually have bird motifs conspicuously displayed on them as though to proclaim the vantage positions of these *òrìṣà* in the Yoruba cosmos and the preeminence of their *àṣẹ*, which they often use to promote human welfare. Made of iron, the staff of Ọrúnmìlà (*òsùngàgà* or *ọ̀pá ọ̀rẹ̀rẹ̀*)[22] has one or two iron birds (*ẹyẹ kan*)[22] on top standing on a flat disk resting on inverted cones or bells which rattle when the staff hits the ground (fig. 1.8b). The iron staff of Ọsanyìn (*ọ̀pá Ọsanyìn*), on the other hand, is more elaborate in design, featuring a circle of iron birds (usually sixteen) above which towers a giant bird (fig. 1.18).[23] This arrangement seems to convey a hierarchy of forces all subject to the power of the big bird on top. A similar design is found on the *adé*, the conical, beaded crown with veil worn by Yoruba kings (*ọba*) on ceremonial occasions which displays a gathering of smaller birds on the sides and a big one at the apex of the cone. This design projects both the divine status of the Yoruba king as a living embodiment of all the deified ancestors (hence he is called "aláṣẹ èkejì òrìṣà," the

23

wielder of divine power and a deputy of the *òrìṣà*) and his spiritual ability to attract goodness to his subjects and neutralize the evils of witchcraft.[24] Other prominent displays of the bird motif occur on the ritual staffs of Erinlẹ̀ (a river deity associated with healing), Ilẹ̀ (earth goddess), and Ṣàngó.

Other animals such as the snake (*ejò*), lizard (*alángbá*), pangolin (*arika*), ram (*àgbò*), fish (*ẹja*), crab (*akàn*), tortoise (*alábahun*), and snail (*ìgbín*), among others, are often rendered as iconographic motifs not only to empower altar furniture and ritual implements, but also communicate with an *òrìṣà*.

24

COMMUNICATIVE FUNCTION

The worship of the *òrìṣà* involves supplication and offering. These devotional actions are often reflected in the gestures of some of the sculptural representations on the altar, thus underscoring their significance as *àrokò* (coded message).[25] Much value is placed on the kneeling pose (*ìkúnlẹ̀*) in Yoruba culture because it communicates greeting, respect, courtesy, begging, and worship (fig. 1.17). Therefore, the most effective way to seek the favors of a deity is by kneeling down; hence the *òrìṣà* are collectively known as *àkúnlẹ̀bọ* (beings to be worshiped with the kneeling pose). This phenomenon has resulted in the placement of carved kneeling figures on altars to function as surrogates symbolically praying to the *òrìṣà* on behalf of their donors. For example, a housewife anxious to have a child may be advised by a diviner to commission a kneeling figure holding a child, bowl, or carved sacrificial animal and place it on the altar of a particular *òrìṣà*. In other circumstances, a similar figure may be used as a votive offering to thank an *òrìṣà* for giving a petitioner a child and also for placing both mother and child under the continuous protection of a deity (cf. Bascom 1969:111). In cases such as this, the child is usually named after the *òrìṣà*, that is, Fábùnmi (Ifá gave me this child) or Ògúnbíyí (Ògún has given me this child).

Sometimes the statue of a nursing mother may be placed on an altar to oblige an *òrìṣà* to meet the daily needs of a devotee or the community as a whole to the same degree as a mother does for her beloved child. A similar request can be couched in the form of a woman holding her breasts to communicate maternal affection and a mother's inexhaustible willingness to give. Another common motif is that of a female holding a child on her back, recalling the popular Yoruba taboo: "Ọmọ kìí jábọ́ léhìn ìyá rẹ̀" (A child must not fall off its mother's back). In other words, the devotee expects from the *òrìṣà* the type of security a child enjoys on its mother's back. Frequently, a female *òrìṣà* such as Lájomi, Yemọja, or Ọ̀ṣun, reputed for maternal generosity and the power to give children, may be depicted as a mother with big breasts (fig. 1.19) or a female nursing a child. The image of Ọ̀ṣun as an epitome of fertility and generosity is reflected in the following invocation to her:

Ore yèyé ò

Ọgbadagbádá lọyàn

Amúdẹ rẹmọ . . .

Yèyé wẹmọ yè, gbọ́mọ fún mi jó . . .

Àyílà, gbà mí o, ẹni aní ní í gbani. (Simpson 1980:29)

Most gracious mother

The one with the voluminous breasts

Who appeases children with brass ornaments

Mother, who bathes and cares for the young, give me a child to dance with

The savior, help me, one expects help from one's helper. (my translation)

FIGURE 1.19.

A priest carrying a carved image of Lájomi, a river goddess associated with fertility who collaborates with Ọ̀ṣun. Ọ̀ṣun festival, Òṣogbo, Nigeria, 1972. Photo: Babatunde Lawal.

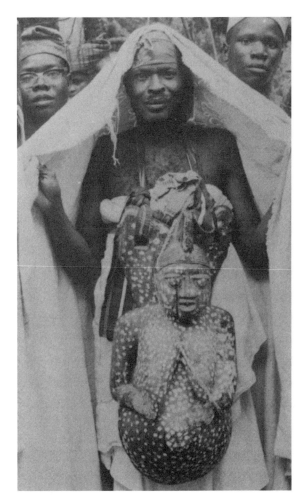

In Yorubaland, the male òrìṣà are sometimes represented standing, sitting, or riding a horse (fig. 1.16). Some of the figures hold knives, lances, or guns which identify them as warriors (*jagunjagun*) or defenders of the helpless (Olúgbani). Although such figures might have been inspired by scenes from everyday life and do recall the heyday of the cavalry-using Ọ̀yọ́ kingdom as well as the Yoruba civil wars of the nineteenth century, they also express the belief of devotees that the òrìṣà will protect them in times of danger. The following invocation to Ṣàngó is instructive:

26

Ọkọọ̀ 'yáà mi Onlogbò

Dákun, má febi pẹṣin rẹ

Jẹ́ ká róde lọ

Ká rílé bọ̀ sí

Má jẹ̀ẹ́ kó hun ún o

Ìbà lọ́ọ́ Aláṣekò o

Ọkọọ̀ 'yáà mi Onlogbò

Dákun o

Ṣe làákàyè o

Onlogbò [Ṣàngó], husband of my mother

I pray you, let not your horse go hungry

Make the town peaceful for us to move freely in it

And make us dwell safely in our homes

May I never regret my actions

I pay homage to the-ever-successful-architect

Onlogbò, my mother's husband

I beg you, please

Be understanding. (Isola 1973:19–20)

No examination of the role of art in Yoruba religion would be complete without discussing, however briefly, the high frequency of female motifs in Yoruba religious art, especially in sculptures dedicated to male òrìṣà (cf. Odugbesan 1969). This phenomenon is also reflected in the female dress of male priests (figs. 1.12, 1.20). There are several reasons for this. One, the sex appeal of the female is held to have a compelling influence on most of the male òrìṣà.[26] Two, the initiation of a male or female worshiper into the priesthood commits the individual to be as dedicated to an òrìṣà

FIGURE 1.20.

Òṣun priest wearing a
female hairdo (*agògó*
style) and tying a baby
sash (*òjá*) to his waist.
Òṣun festival, Òṣogbo,
Nigeria, 1972. Photo:
Babatunde Lawal.

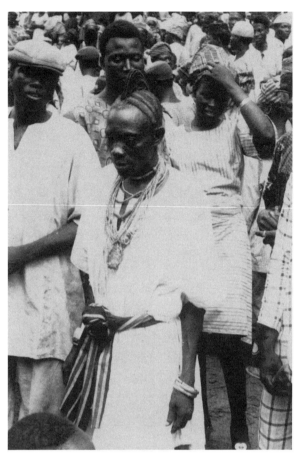

27

as a wife is to her husband. Hence priests are sometimes described as *iyàwó òrìṣà* (*òrìṣà*'s wives) regardless of gender. Three, the male principle (*akọ*) signifies "hardness/hotness," and the female (*abo*), "softness/coolness."[27] As a result, the female principle is believed to have a positive, pacifying, and assuasive influence in the ritual process. Hence the popular Yoruba saying: "Ọwọ́ èrò̀ l'ọwọ́ obìnrin" (Soothing are the hands of the female) (Odugbesan 1969:209). The crucial word in this phrase is *èrò̀*, meaning "that which pacifies and cools." In a ritual context, *èrò̀* is synonymous with *ètùtù* (an action designed to placate) or *ẹbọ* (sacrifice offered to pacify, reconcile, or generate a positive influence). This assuasive potential abides not only in the "feminine mystique" but also in the self-sacrifice associated with motherhood. Since the life of a woman in labor is on the line, Yoruba mothers often use the kneeling posture (*ìkúnlẹ̀ abiyamọ*) to invoke this crucial moment of birth to plead for a rare favor. Ordinarily, this invocation carries with it a veiled threat of retributive justice should anyone disrespect the sanctity of motherhood (cf. Lawal 1971:39). Even though they enjoy a "divine license," the *òrìṣà* are expected to honor the sanctity of motherhood, as they themselves have a symbolic mother in the person of Yemọja. Four, the female, in her role as a mother, signifies love, tenderness, generosity, nurture, and protection, all of which a devotee wants from an *òrìṣà* and therefore communicates through the "mother-and-child" image. Finally, the *òrìṣà* command a larger following among women whose concern with fertility and for the health of their children, both young and old, oblige them to petition the *òrìṣà* more frequently than the men.[28] As a result, a good number of the votive sculptures reflect the gender and aspirations of their donors.

SANTERÍA: THE *ÒRÌSÀ* IN THE GUISE OF CHRISTIAN SAINTS

Yoruba religion survived the ravages of slavery in the New World not only because of its intrinsic values, especially its promise of spiritual power (*agbára*), good health and longevity (*àláfáà àti èmí gígùn*), fertility (*ire omo*), wealth (*ire owó*), and immortality (*ire àìkú*), but also because of certain similarities it shares with the Catholic faith, the dominant religion in Central and South America and the Caribbean. For example, both make use of devotional images and venerate sacred personages known as the *òrìsà* (in Yoruba religion) and the saints (in the Roman Catholic Church). By consciously identifying them with Roman Catholic saints of similar attributes, Yoruba slaves continued to worship the *òrìsà* in the guise of these Christian figures. The most sacred symbols of the *òrìsà* were placed on an altar concealed among Christian images such as crucifixes, madonna statues, chalices, and the chromolithographs of the appropriate Christian saints. Seeing how it seemed to have met both the spiritual and material needs of African slaves and enabled them to survive under the most trying conditions, non-Africans soon embraced the worship of the *òrìsà*.

In Cuba, following their identification with Catholic saints, the *òrìsà* assumed the name *oricha* or *santos*; hence the term *Santería* (the worship of the saints). The *òrìsà* have retained much of their Yoruba identity and rituals mainly because of the peculiar nature of Cuban society in the era of the slave trade. For instance, African slaves were organized into groups called *naciones* (nations) that enabled them to preserve some of their African heritage. Each group had a distinct name. Members of the Yoruba *nación* were known as *Lucumí*, a term probably derived from the Yoruba greeting *Olùkù mi*, meaning "My friend." Moreover, the Catholic Church introduced into Cuba the Spanish institution of *cabildo*, a fraternity designed to facilitate religious indoctrination, mutual aid, and group participation in carnivals and public processions in honor of the saints. The African *cabildos* were not only organized along ethnic lines corresponding to the *naciones*, but were encouraged to adapt some of their African traditions to a Christian context,[29] and this gave the Lucumí an opportunity to continue the worship of their *òrìsà* in the guise of Catholic saints. Also contributing to this phenomenon was the large-scale importation of Yoruba slaves into Cuba between the mid-eighteenth and mid-nineteenth centuries, making them the largest ethnic group on the island (Brandon 1990:120) and enabling them to consolidate their African heritage, so much so that some Afro-Cubans of Yoruba descent speak the Yoruba language today, though in a creolized form. In any case, the practice of Santería is no longer confined to the Lucumí. It has since evolved into a multiracial religion with thousands of devotees in Central America, the Caribbean, and the United States. It has also inspired new artistic forms. Of the Yoruba divinities transplanted to Cuba, the following are the most popular.

1. OLÓDÙMARÈ

The Supreme Being, the creator (Ẹlẹ́dàá), source of Àṣẹ (Aláṣẹ), the source of existence (Olú Ìwà), the source of life (Ẹlẹ́mìí), the Owner of the sky (Ọlọ́run) and Lord of Heaven (Ọlọ́fin Ọ̀run).

Sacred Symbol: None

Cuban Name: Olofin

Christian Equivalents: God the Father and Jesus Christ (God the Son)

Attributes: Protection, justice, vitality, survival, immortality.

2. ORÍ

Personal head, source of individual life, vitality, and destiny (ẹlẹ́dàá ẹni).

Sacred Symbol: Cone-shaped object (ibọrí) wrapped in leather and adorned with beads or cowrie shells, serving as a shrine to the head (fig. 1.3).

Cuban Name: Eledá

Saint: Personal guardian angel

Attributes: Protection, dynamism, survival, good luck.

3. ỌBÀTÁLÁ

Also called Òrìṣà Nlá (Great Òrìṣà), Bàbá Nlá (Great Father), Òrìṣà Funfun (deity of purity and whiteness), Alàbá làṣẹ (wielder of divine authority), and Oosa (the Deity). Ọbàtálá is one of the most senior Yoruba òrìṣà. He is associated with purity, divine authority, gentleness, coolness, justice, peace, and creativity.

Sacred Symbols: White cloth (Aṣọ funfun); white chalk (ẹfun), lead (òjé), iron staff (ọ̀pá òṣòorò) (fig. 1.11), iron bell (àájà), and white calabash (igbá orí), among others.

Cuban Name: Obatalá

Saints: Because of his seniority and peaceful nature, Obatalá is associated with many holy figures such as Jesus Christ, St. Joseph, and St. Sebastian. But he is commonly identified with Our Lady of Mercy (fig. 1.21).

Attributes: Justice, purity, morality, power, leadership.

FIGURE 1.21.

Ọbàtálá in the guise of Our Lady of Mercy (*Señora de las Mercedes*). Plaster. H. 36.8 cm (14½ in.). Photo: courtesy of Robin Poyner.

4. ṢÀNGÓ

Òrìṣà of lightning and thunder, fire, water, dynamism, fertility, social justice.

Sacred Symbols: Thunderbolts (ẹdùn àrá) and red cloth (aṣọ pupa).

Cuban Name: Changó

Saint: St. Barbara (According to one legend, St. Barbara's father killed her because she had become a Christian. But just as the father beheaded her, lightning struck him dead, thereupon St. Barbara was

identified with the thunderstorm and eventually with Changó).
Attributes: Lightning and thunder, fire, dynamism, justice.

5. ỌYA
Ṣàngó's wife and goddess of dynamism, tornadoes, and the Niger River.
Sacred Symbols: Thunderbolts (*ẹdùn àrá*) and buffalo horns (*ìwo ẹfọ̀n*).
Cuban Name: Oyá
Saint: Our Lady of Candlemas (an aspect of the Virgin Mary honored with a candlelight procession stopping briefly at a cemetery on its way to the church. The candles and cemetery recall Ọya's association with lightning and death respectively).
Attributes: Controller of tornadoes, gales, hurricanes, and thunderstorms.

30

6. ỌṢUN
Ṣàngó's wife, goddess of the Ọ̀ṣun River, fertility, healing, grace, and generosity.
Sacred Symbols: White cloth (*aṣọ funfun*), stones from the river (*ọta*), brass (*idẹ*), small pots containing water (*àwẹ̀*), ivory combs (*òòyà íyùn*).
Cuban Name: Ochún
Saint: Ọ̀ṣun's generosity and flair for fashion facilitated her identification with Our Lady of la Caridad del Cobre, the Virgin of Charity and patron saint of Cuba (fig. 1.22).
Attributes: Goddess of fertility, wealth, sex, love, beauty, fashion.

7. ỌRÚNMÌLÀ
Òrìṣà of divine knowledge, witness of creation, and lord of the Ifá divination system containing the secrets of the universe, he is the problem-solver and the knower of human destiny.
Sacred Symbols: Sixteen palm nuts (*ikin*), iron staff topped by birds (*òsùngàgà*).
Cuban Name: Orunlá
Saint: St. Francis of Assisi (famous for his search for divine knowledge).
Attributes: Wisdom, knowledge, divination, fate, healing.

8. ÈṢÙ-ẸLẹ́GBÁRA
The custodian of *àṣẹ*, agent of dynamism, messenger of all the òrìṣà, the link between them and Olódùmarè, and between the òrìṣà and humanity. Hence he is associated with gates and crossroads. He is an unpredictable and ambivalent character—a child and an adult at the

FIGURE 1.22.
Ọ̀ṣun in the guise of Our Lady of Charity (*Señora de la Caridad del Cobre*), the patron saint of Cuba. Plaster. H. 41.9 cm (16½ in.). Photo: courtesy of Robin Poyner.

same time—and yet crucial to the maintenance of justice, as well as cosmic and social equilibrium.

Sacred Symbols: Black cloth (*aṣọ aró*) and laterite (*yàngí*).

Cuban Name: Eleggúa

Saints: Associated with many saints such as the Holy Child of Atocha (reflecting Èṣù's ability to manifest as a child), the Lonely Spirit of Purgatory (reflecting Èṣù's role as a messenger), and St. Anthony of Padua (like Èṣù, a miracleworker and lover of small children).

Attributes: Divine messenger, guardian of fate, justice, gates and crossroads, protector of the poor.

9. ÒSANYÌN

Òrìṣà of herbal medicine.

Sacred Symbols: Iron staff with bird symbols (*ọpá Òsanyìn*) (fig. 1.18).

Cuban Name: Osaín

Saints: Because of his popular image as a solitary, powerful, deformed and one-legged creature of the forest (*àròní ẹlẹ́sẹ̀ kan*), Òsanyìn is associated with the solitude, asceticism, and charisma characterizing the lives of saints such as St. Sylvester, St. Joseph, St. John the Baptist, and St. Anthony the Abbot, among others.

Attributes: Magic and herbal medicine.

10. ERINLẸ̀

River deity associated with healing.

Sacred Symbols: Iron staff with birds (similar to *ọ̀pá Òsanyìn*) and pot containing water and pebbles from the river.

Cuban Name: Inlé

Saint: Archangel Raphael, associated with healing.

Attributes: Fertility and curative medicine.

FIGURE 1.23.

Yemọja in the guise of Our Lady of Regla (*Señora de Regla*), the patron saint of Havana harbor, Cuba. Plaster. H. 37.5 cm (14¾ in.). Photo: courtesy of Robin Poyner.

11. YEMỌJA

Sea goddess and mother of all the òrìṣà.

Sacred Symbols: White cloth (*aṣọ funfun*), stones (*ọta*) from the river, seashells (*ajé, òkòtó*), and pots containing sacred water.

Cuban Name: Yemayá

Saint: Our Lady of Regla, patron saint of Havana harbor and protector of fishermen and sailors (fig. 1.23).

Attributes: Maternal generosity; giver and sustainer of life.

12. ÒGÚN

Òrìṣà of iron, hunting, and warfare.

Sacred Symbols: Iron implements and fresh palm fronds.

Cuban Name: Ogún

Saint: St. Peter, the custodian of keys forged from Ogún's metal.

Attributes: Dynamism, industry, warfare, and related phenomena.

13. ÒṢÓÒSÌ

Ogún's companion and òrìṣà of hunting.

Sacred Symbols: Metal bow and arrow shaped like a crossbow (*ọfà ati ọrún*) and palm fronds (*màrìwò*).

Cuban Name: Ochosí

Saints: St. Norbert and St. Hubert, the latter being a patron saint of hunters.

Attributes: Hunting, protection, initiatives, alertness.

14. ỌBALÚAYÉ

Òrìṣà of pestilence, especially smallpox; also called Ṣòpọ̀ná.

Sacred Symbols: cowrie-studded staff (*kerénse*) and pots containing water and pebbles collected from the foot of a hill.

Cuban Name: Babalú-Ayé

Saint: St. Lazarus, patron of the sick and poor.

Attributes: Embodiment of smallpox, measles, and all infectious diseases which he also cures, if properly appeased.

15. ÌBEJÌ

Òrìṣà of twins.

Sacred Symbols: Twin statuettes (*ère ìbejì*) (fig. 1.15).

Cuban Name: Ibeji

Saints: Cosmas and Damian, patrons of twins.

Attributes: Good luck and protection from evil machinations of enemies.

ARTISTIC PARALLELS

The honorific, representational, and communicative functions of art in Yoruba religion found their counterparts in the Roman Catholic Church with its emphasis on architectural sculpture, altar images and paintings, representations of angels and saints, Mass, Easter parades, Nativity displays, and festivals. The kneeling pose of supplicants in the church recalls the votive images in the shrines of the òrìṣà, while the bird symbol of the Holy Spirit has a parallel in the Yoruba use of the bird motif

to signify *àṣẹ*, divine power and authority. The emphasis on the female aspect in Yoruba art and rituals found a subterfuge and survived in the "Madonna and Child" icons, so much so that male *òrìṣà* such as Ṣàngó and Ọbàtálá are often represented as female. However, the identification of these two *òrìṣà* with St. Barbara and Our Lady of Mercy respectively is a mere camouflage and does not necessarily detract from their maleness. Altars dedicated to the *òrìṣà* in the New World are often shaped like a Roman Catholic throne or baldachin adorned with colorful cloths, beadwork, ceramics (*soperas*), fly whisks (*rabo*), fans (*abanico*), and emblems sacred to the deity.[30] In any case, through the combination of African and Roman Catholic art forms, Santería religion attempts to harness and maximize the powers of the *òrìṣà* and the saints for the benefit of devotees.

By and large, art in *òrìṣà* worship is a form of ritual pacifier (*etutu*). Like sacrifice (*ẹbọ*), it attracts attention, communicates respect, embodies wishes, and elicits positive responses. In Yoruba thought, the power of art lies in its *ẹwà* (beauty), a quality admired by both the human and the divine. As one Yoruba incantation declares, "Ojú kì í r'árẹwà k'ó má kí i" (Never will the eyes fail to greet the beautiful one) (Fabunmi 1972:7). Moreover, art, to the Yoruba, is a vital part of being. Not only is the human image a masterpiece by the artist-deity Ọbàtálá, but the *òrìṣà* themselves assumed human forms to facilitate interaction with mortals. By functioning as a metaphor for enriching earthly existence, embodying the soul, and projecting human aspirations onto the cosmic plane, art not only links the human with the divine, the visible with the invisible, the physical with the metaphysical and the present with the past; it reinforces the human confidence in the future, affirming, nourishing, and sustaining the human spirit.

NOTES

This study is based on fieldwork in Nigeria, Brazil, and the United States between 1970 and 1990. I wish to thank the University of Ifẹ̀, Ilé-Ifẹ̀ (now Ọbáfẹ̀mi Awólọ́wọ̀ University), Nigeria, for funding the project.

The orthography used in this chapter is that of modern Yoruba, which records most of the phonemic sounds and at the same time eliminates superfluous letters that characterize the old orthography. Thus, *Òrisha* (deity) now becomes *Òrìṣà*, and *aiyé* (world) is now simplified as *ayé*. On the other hand, a word like *ogùn* (medicine) now becomes *oògùn*. The old orthography is, however, retained in quoted passages. Personal and place names are tone-marked where necessary for special emphasis.

1. See Bastide 1971; Bascom 1972; Hunt 1979; Verger 1981; Thompson 1984, 1993; Omari 1991; Murphy 1993.

2. According to the 1992 Nigerian census figures, the Yoruba in Nigeria alone number

more than 18 million. For a good introduction to Yoruba history and culture, see Johnson 1921; Ojo 1966; Smith 1969; Thompson 1971a; Drewal, Pemberton, and Abiọdun 1989.

3. For a good introduction to Yoruba religion, see Idowu 1962; Abimbọla 1977a; Pemberton 1977.

4. For more details on the Yoruba concept of *orí*, see Abimbọla 1971:73–79; Lawal 1985; Abiọdun 1987.

5. The "spiritual head" (*orí*) is also called *ẹlẹ́dàá*, implying a link between it and Olódù-marè. For more details, see Lawal 1985.

6. They are also known as *oníṣẹ́ ọnà*, lit., "art worker."

7. Interview with Awótọ́lá Òjó of Ọ̀gbá Àga, Gbọ̀gán, Ọ̀ṣun State, Nigeria, May 1981. See also Lawal 1981:102–3.

8. For more on the Yoruba concept of *ẹwà*, see Lawal 1974; Thompson 1973; Abiọdun 1983.

9. Ọbàtálá's popular epithet is "A dá ni b'ó ti rí" (He who creates as he chooses). See Idowu 1962:72.

10. Hence Ọbalúayé's epithet, "Alápa dúpẹ́" (One who kills and is thanked for it). See Idowu 1962:97.

11. For an excellent study of the interrelationship of the visual and performing arts in Africa, see Thompson 1974.

12. For illustration, see Beier 1959:pl. 61).

13. For more on Gẹ̀lẹ̀dẹ́, see Thompson 1971a; Lawal 1978, forthcoming; and Drewal and Drewal 1983.

14. For more detail on twin statuettes, see Thompson 1971b:18–31; Houlberg 1973:20–27; Lawal 1989.

15. For illustrations, see Beier 1957:pl. 2; Ojo 1966:pl. 14; Thompson 1993:pl. 245.

16. This phenomenon was once mistaken for idol worship by Christians and Muslims. It is not. Even if prayers are addressed and libation is given to the image or the nonfigurative symbol, the ultimate "receiver" is the *òrìṣà*. The "medium" to which it is literally given is no more than a vehicle, linking the visible world of the living with the invisible realm of the *òrìṣà*. By itself, the sculpture has no life of its own. In fact, at a more secular level, it is regarded as an art object which can easily be discarded or replaced when damaged.

17. Some scholars associate the sound and movement of the puppet with ventriloquism; see Thompson 1984:44.

18. In this respect, the term *ojúbọ* also means "the face (*ojú*) for feeding (*bọ*) an *òrìṣà*."

19. For a more detailed discussion of the Yoruba association of the "face" with accessibility, see Lawal 1985:100–101.

20. For more details, see Lawal 1985.

21. See Idowu 1962:19 and Abimbọla 1977b:iii.

22. *Ẹyẹ kan* is often identified as the pigeon which many *babaláwo* (priests of Ọrúnmìlà) keep as a pet. It is a symbol of peace and tranquility. For more on the symbolism, see Abiọdun 1975:450–51 and Drewal, Pemberton, and Abiọdun 1989:pl. 36.

23. The bird is sometimes identified by Yoruba herbalists as *ológèéṣá* or *ológoṣẹ́* (African pied wagtail). Because of its swiftness, this bird is an important ingredient in "quick-acting" medicines.

24. For more on the symbolism of the *adé*, see Thompson 1970.

25. Ordinarily, *àrokò* is an abstract symbol or combination of objects concealing a message which can be deciphered only by the addressee or an *àrokò* expert.

26. Male *òrìsà* like Ṣàngó and Ògún are portrayed in their praise poems (*oríkì*) as having a soft spot for women.

27. However, an aggressive goddess like Ọya (tornado deity) combines both characteristics.

28. See also Odugbesan 1969:203.

29. For more details, see Murphy 1993:28–35; Brandon 1993:37–78.

30. For details, see Thompson 1993:147–280 and Brown 1993.

REFERENCES

Abimbọla, Wande. 1971. "The Yoruba Concept of Human Personality." In *La notion de la personne en Afrique noire, Paris: Colloques Internationaux du Centre National de la Recherche Scientifique*, no. 544, pp. 73–89.

———. 1975. "Ìwàpèlè: The Concept of Good Character in Ifá Literary Corpus." In *Yoruba Oral Tradition*, ed. W. Abimbọla. Ifẹ: Department of African Languages and Literatures, University of Ifẹ, pp. 389–420.

———. 1977a. "Yoruba Traditional Religion." In *Contemplation and Action in Yoruba Religion*, ed. Y. Ibish and I. Marculescu. Seattle and London: University of Washington Press, pp. 218–42.

———. 1977b. *Awọn Ojú Odù Mẹ́rẹ̀ẹ̀rìndínlógún*. Ibadan: Oxford University Press.

Abiọdun, Rowland. 1975. "Ifá Art Objects: An Interpretation Based on Oral Tradition." In *Yoruba Oral Tradition*, ed. W. Abimbọla. Ifẹ: Department of African Languages and Literatures, University of Ifẹ, pp. 421–64.

———. 1981. "Orí Divinity: Its Worship, Symbolism and Artistic Manifestation." In *Proceedings of the First World Conference on Orisa Tradition*. Ile-Ifẹ: Department of African Languages and Literatures, University of Ifẹ, pp. 484–515.

———. 1983. "Identity and the Artistic Process in the Yoruba Aesthetic Concept of Ìwà." *Journal of Cultures and Ideas* 1(1):13–30.

———. 1987. "Verbal and Visual Metaphors: Mythic Allusions in Yoruba Ritualistic Art of Ori." *Word and Image* 3(3):252–70.

Bascom, Williams. 1969. *The Yoruba of Southwestern Nigeria*. New York: Holt, Rinehart and Winston.

———. 1972. *Shango in the New World*. Austin: African and Afro-American Research Institute, University of Texas at Austin.

Bastide, Roger. 1971. *African Civilizations in the New World*. New York: Harper and Row.

Beier, Ulli. 1957. *The Story of Sacred Wood Carvings from One Small Yoruba Town*. Lagos: Nigeria Magazine.

———. 1959. *A Year of Sacred Festivals in One Yoruba Town*. Lagos: Nigeria Magazine.

Brandon, George. 1990. "Sacrificial Practices in Santería, an African-Cuban Religion in the United States." In *Africanisms in American Culture*, ed. J. E. Holloway. Bloomington-Indianapolis: Indiana University Press, pp. 119–47.

———. 1993. *Santería from Africa to the New World*. Bloomington-Indianapolis: Indiana University Press.

Brown, David H. 1993. "Thrones of the *Orichas*: Afro-Cuban Altars in New Jersey, New York, and Havana." *African Arts* 24(4):44–59, 85–87.

Drewel, Henry J., and Margaret T. Drewal. 1983. *Gèlèdé: Art and Female Power among the Yoruba*. Bloomington: Indiana University Press.

Drewal, Henry J., John Pemberton III, and Rowland Abiọdun. 1989. *Yoruba: Nine Centuries of African Art and Thought*. New York: Center for African Arts.

Egharevba, J. 1968. *A Short History of Benin*, 4th ed. Ibadan: Ibadan University Press.

Fabunmi, M. A. 1972. *Àyájọ́ Ìjìnlè Ohùn Ifè*. Ibadan: Onibọnoje Press.

Fagg, William B. 1963. *Nigerian Images*. London: Lund Humphries.

Gonzalez-Wippler, Migene. 1992. *Powers of the Orishas. Santería and the Worship of Saints*. New York: Original Publications.

Houlberg, Marilyn H. 1973. "Ìbejì Images of the Yoruba." *African Arts* 7(1):20–27, 91–92.

Hunt, C. M. 1979. *Oyotunji Village: The Yoruba Movement in America*. Washington, D.C.: University Press of America.

Idowu, E. B. 1962. *Olódùmarè: God in Yoruba Belief*. London: Longmans.

Isola, A. 1973. "Ṣàngó-Pípè: One Type of Yoruba Oral Poetry." M.A. thesis. University of Lagos, Nigeria.

Johnson, Samuel. 1921. *The History of the Yorubas*. London: Routledge & Kegan Paul Ltd.

Lawal, Babatunde. 1971. *Ṣàngó Sculpture in Historical Retrospect*. Ann Arbor: University Microfilms.

———. 1974. "Some Aspects of Yoruba Aesthetics." *The British Journal of Aesthetics* 14(3):239–49.

———. 1977a. "The Living Dead: Art and Immortality among the Yoruba." *Africa* 47(1):50–61.

———. 1977b. "The Present State of Art Historical Research in Nigeria: Problems and Possibilities." *Journal of African History* 18(2):193–216.

———. 1978. "New Light on Gèlèdé." *African Arts* 2(2):65–70, 94.

———. 1981. "The Role of Art in Orìṣa Worship." In *The Proceedings of the First International Conference on Òrìṣà Tradition*. Ile-Ifè: Department of African Languages and Literatures, University of Ifè, pp. 100–119.

———. 1985. "Orí: The Significance of the Head in Yoruba Sculpture." *Journal of Anthropological Research* 41(1):91–103.

———. 1989. "A Pair of Ère Ìbejì in the Kresge Art Museum." *Kresge Museum Bulletin* 4:10–15.

———. 1995. "À YÀ GBÓ, À YÀ TÓ: New Perspectives on Edan Ògbóni." *African Arts* 28(1):36–49, 98–100.

———. forthcoming. *The Gèlèdé Spectacle: Art, Gender, and Social Harmony in an African Culture*. Seattle: University of Washington Press.

Murphy, Joseph M. 1993. *Santería: African Spirits in America*. Boston: Beacon Press.

Odugbesan, C. 1969. "Femininity in Yoruba Religious Art." In *Man in Africa*, ed. M. Douglas and P. M. Kaberry. London-New York: Tavistock Publications, pp. 199–211.

Ojo, G.J.A. 1966. *Yoruba Culture: A Geographical Analysis*. London: University of London Press.

Omari, Mikelle S. 1991. "Completing the Circle: Notes on African Art, Society, and Religion in Oyotunji, South Carolina." *African Arts* 24(3):66–75, 96.

Pemberton III, John. 1977. "A Cluster of Sacred Symbols: Orìṣa Worship among the Igbo-

mina Yoruba of Ila-Orangun." *History of Religions* 17(1):1–28.

Poyner, Robin. 1983. "Introduction." In *Thunder over Miami: Ritual Objects of Nigerian and Afro-Cuban Religion*. Gainesville: Center for African Studies, University of Florida.

Prince, Richard. 1974. "Indigenous Yoruba Psychiatry." In *Magic, Faith and Healing*, ed. A. Kiev. New York: Free Press, pp. 84–120.

Simpson, G. E. 1980. *Yoruba Religion and Medicine in Ibadan*. Ibadan: University of Ibadan Press.

Smith, Robert. 1969. *Kingdoms of the Yoruba*. London: Methuen.

Thompson, Robert Farris. 1970. "The Signs of the Divine King: An Essay on Yoruba Bead-Embroidered Crowns with Veil and Bird Decorations." *African Arts* 3(3):8–17, 74–80.

———. 1971a. *Black Gods and Kings: Yoruba Art at UCLA*. Los Angeles: University of California Press.

———. 1971b. "Sons of Thunder, Twin Images of the Yoruba." *African Arts* 7(3):8–13, 77–80.

———. 1973. "Yoruba Artistic Criticism." In *The Traditional Artist in African Societies*, ed. W. d'Azevedo. Bloomington: Indiana University Press, pp. 19–61.

———. 1974. *African Art in Motion*. Los Angeles: University of California Press.

———. 1984. *Flash of the Spirit: African and Afro-American Art and Philosophy*. New York: Vintage Press.

———. 1993. *Face of the Gods: Art and Altars of Africa and the African Americas*. New York: Prestel and the Museum of African Art.

Verger, Pierre. 1965. "Grandeur et décadence du culte des Iyami Osoronga (Ma Mère la Sorcière) chez la Yoruba." *Journal de la Société des Africanistes* 35(1):141–243.

———. 1981. *Orixas: Deuses Iorubas na Africa e no Novo Mundo*. Salvador, Brazil: Editora Corrupio.

Willett, Frank. 1967. *Ife in the History of West African Sculpture*. New York: McGraw-Hill.

———. 1971. *African Art, an Introduction*. London: Thames and Hudson.

Wippler, Migene. 1973. *African Magic in Latin America: Santería*. New York: Julian Press.

ISABEL CASTELLANOS

FROM ULKUMÍ TO LUCUMÍ
A HISTORICAL OVERVIEW OF RELIGIOUS ACCULTURATION IN CUBA

To this day, the origin of the term *Lucumí*, used in Cuba and other former Spanish possessions to denote the Yoruba, remains largely a mystery. As Bascom (1951:14) explains: "In Cuba, the Yoruba speaking people are known as Lukumi (Lucumi). . . . In some very early maps of West Africa, the kingdom or people of Ulkamy is placed to the north and northwest of Benin, but I have not been able to find any place or people in this part of Nigeria who are today known by a name like Lukumi." More than forty years after Bascom wrote, we are no closer to resolving the issue. An impressive number of antique European maps and books make reference to this word or others closely related to it. For example, Olfert Dapper, in his *Description de l'Afrique* (1686:307), describes the kingdom of Ulcami or Ulcuma, a country situated between Arder and Benin, toward the northeast. He also provides two maps. In the first one, entitled *Africae Accurata Tabula*, we detect a region designated as "Ulcuma" to the west of the kingdom of Benin. In the second one, called *Nigritarum Regio*, this same region is designated as Ulkumi.

Some years later, Captain William Snelgrave (1734:89) mentions a nation he calls "Lucamee," and on one of the maps contained in his book we find the kingdom of Ulcuma or Ulcami. An eighteenth-century French map (*Afrique*, Publiée sous les auspices de Monseigneur le duc d'Orleans, Premier Prince du Sang, par le Sr. d'Anville. Paris, 1749) clearly shows an area between Ardra and the kingdom of Benin designated as "Ulcumi." Finally, an undated French map of the Gulf of Benin (fig. 2.1) places the kingdom of "Oulcoumi" in what is known today as Yorubaland.

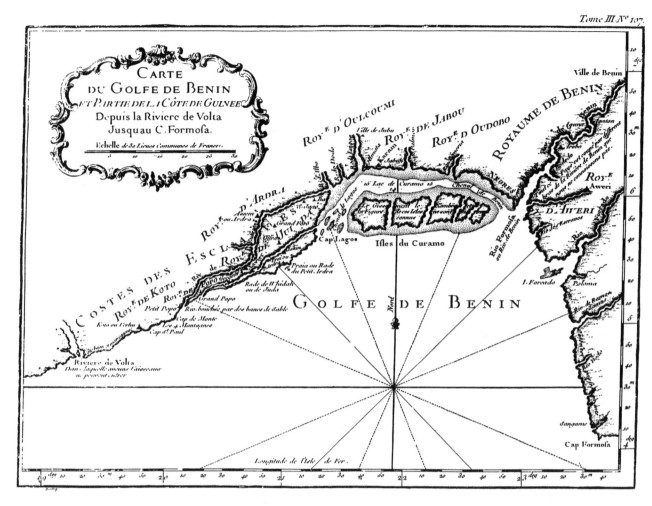

FIGURE 2.1.

Map of the Gulf of Benin from the Volta River to the Cape of Formosa. Undated. Collection of the author.

Despite this abundant documentation, no references to the ancient name are to be found in contemporary descriptions of West Africa, and no mention of the modern term "Yoruba" appears in the early sources. Rómulo Lachatañeré (1939) has provided strong arguments in favor of his theory that Ulkami or Ulkumí was a name given by the Portuguese to the Oyo kingdom, and Robin Law (1977:16) concedes that "these (terms) should probably be taken to relate to Oyo," but conclusive evidence is still lacking. As Law (1977:4–5) writes:

> The name Yoruba is today applied to a group of peoples who inhabit a large area of southwestern Nigeria (in terms of modern political geography, the Oyo, Ondo, and Ogun States, most of the Lagos State, and a part of the Kwara State) and parts of the neighboring Republics of Benin (formerly Dahomey) and Togo to the west. . . . The Yoruba are distinguished primarily on linguistic criteria, the various groups

speaking closely related, if not wholly mutually intelligible, dialects. They also share to a degree a common culture, and most of them have traditions of a common origin by migration from the southern Yoruba town of Ile Ife, though this tradition is also shared by the non-Yoruba kingdom of Benin, in the Bendel state of Nigeria to the south-east of Yorubaland. But the application of the name Yoruba to this large group is a modern application. . . . Originally the name designated only the Oyo, being the name by which the Hausa of northern Nigeria referred to the Oyo kingdom. The extension of the term to its present general signification, to refer to the linguistic group, was the work of the Christian missionaries in Sierra Leone who first studied these languages, among freed slaves of Yoruba origin there, in the nineteenth century.

41

In the Cuban language of the slave trade, the term "Yoruba" was unknown and the people who originated in today's Yorubaland were collectively known as "Lu-cumí." Even nowadays, and in spite of a common core of traditional meanings and practices, Yoruba culture is far from homogeneous, and important regional differences still exist. The worship of certain orishas, for instance, has been and still is highly localized in Yorubaland: the adoration of Yemoja (Yemayá in Cuba) originated among the Egba subgroup of the Yoruba, and her principal temple is located in Abeokuta (Verger 1957:291); the veneration of Oṣun (Ochún in Cuba), on the other hand, is primarily concentrated in the town of Oshogbo. As N. A. Fadipe (1970:261) has explained:

> Of the large number of oriṣa worshipped in Yorubaland, the majority are of only local importance, their worship being confined to local communities. A small number, however, are of national importance. Of the local oriṣa, some are tutelary ones, the patrons and guardians of the communities concerned; others are frankly acknowledged to be ethnic heroes; and others are local heroes because they are identified with some objects in nature which are located in the particular territories in which they are worshipped.

In this study I examine only a few of the many dynamic forces that promoted religious acculturation in Cuba, as part of the general process of evolution that transformed African into Afro-Cuban culture on the island. Immediately after they arrived at their destination in America, slaves were submitted to a brutal system of cultural change. They were forced to acquire a new language; to reshape their dressing, eating, and working habits; to rearrange their social and political organization as well as their family structure; and to modify their religious beliefs. The Middle Passage, however, could not take their memories away from them. Side by side with the process of transformation there was one of cultural resistance, by which slaves

were able to retain what they could of their past. The result of this dialectical interplay was the emergence of a large number of syncretic social forms, each displaying a different ratio of European and African influences.

In studying the transition from Yoruba religion to Cuban Santería (or Regla de Ocha), we must distinguish two types of intimately related agents: the nature of Yoruba society and religion, the internal traits that helped to shape the ways in which the transformations occurred; and the sociohistorical conditions in which this traditional African religion found itself in an entirely alien territory. Both types of factors need to be explored in order to understand the passage from Ulkumí to Lucumí in the field of religion.

The fact that not all orishas had an equal status in Yoruba society is crucial for understanding the development of Yoruba beliefs in the New World.[1] In general, pan-Yoruba deities, such as Obatalá and Ogún, survived and retained in Cuba their original importance, with some modifications. Two opposite outcomes awaited the more localized orishas. Many were undoubtedly lost on the journey (the Yorubas, after all, claim that there are at least 401 orishas, and in Santería they number much less than that). Others, like Changó, Ochún, and Yemayá, who happened to be revered by groups substantially represented in the slave trade, not only survived but their cult actually expanded in their new environment, to the point that they eventually became some of the most widely venerated orishas in Cuba.[2] Some of the orishas worshiped in Yorubaland, for example, Oṣumare (Ochumare: the rainbow), are still remembered and known in Cuba, but their cult has largely been lost. In other words, one important adaptation of Yoruba religion in Cuba is in the number of orishas that survived and flourished, and these tend to be generalized (rather than localized) in the Afro-Cuban religious community.

Another crucial factor in the transformation of Yoruba religion on the island was the collapse of the traditional African family structure. In Yorubaland kinship is patrilineal, and sons are expected to bring their wives to live in their father's *ilé* (house). As Pemberton (1977:3) says: "the compound is thus the essential space in terms of which one understands himself and his relation to other persons, groups, and the world." This "essential space," however, was completely destroyed by the slave trade, causing profound spiritual, psychological, and sociological traumas. Africans were brought to Cuba and the rest of the Americas as individuals, not as family members, a fact that had important religious consequences. In Yorubaland the veneration of the orishas was and still is intimately related to lineage and kinship. People "inherit" the worship of their parents' orishas, although a deity may also claim someone as his or her own through other means, such as dreams and divination (Bascom 1944). This chain of religious transmission based on lineage was severed by the brutal conditions of slavery. For this reason, in Cuba the patron ori-

sha of a man, woman, or child, that is, his/her "guardian angel," "chooses" someone as a son or daughter on an individual basis. The adoration of a particular orisha is not inherited.

Nevertheless, the notion of lineage still plays a very important role in modern Santería, although now it is based on spiritual kinship rather than on consanguinity. An initiated member belongs to the *ilé* of his godmother or godfather, and godparents must be able to trace back their ancestry "in Santo" to an established old house. The notion of an exclusive canon or theological orthodoxy is foreign to African religious thought.[3] In Cuba, different *ilé*s may vary in their practices, according to their customs and traditions. Yet *los improvisados* (those who cannot trace their spiritual lineage back in time) are frequently shunned by serious *santeros*. In other words, among practitioners of Santería we find two parallel kinship systems: one based on blood, organized according to the models of society at large; the other based on Santo (a spiritual bond), which remains a dynamic, if transformed, presence of the old African family patterns, transplanted into a new land. When modern Cuban faithful honor the spirits of their ancestors (*sus muertos*), they must salute both their blood forebears and the souls of their spiritual kin in Santo, thus ritually acknowledging their allegiance to this dual Afro-Cuban family pattern.

The imposed break with Yoruba family structure effected by slavery was also crucial in promoting new forms of religious syncretism. The circumstances that shaped the slave family varied a great deal in Cuba and in other plantation societies. In some regions and in some periods, the social conditions of slaves were such that they conspired against the establishment of stable family groups. The disproportion between the sexes was just one of these conditions. In 1817, for instance, only 32 percent of all Cuban slaves were female. By 1861, just 40 percent of slaves were women (Kiple 1976:app.). It is true that the situation was different for free blacks (after 1827, the number of free black women was always slightly higher than that of free black men), but we must remember that the vast majority of Africans (at least 752,000) arrived in Cuba between 1764 and 1868 (Marrero 1983:1) and that plantation owners preferred to "mix" Africans of diverse provenance, thus diminishing (or so they thought) the probability of uprisings.

In spite of these and many other adverse circumstances, ample documentary evidence shows that stable family ties were indeed formed and recognized among slaves in Cuba, even if they were not always sanctioned by law (Scott 1985; Klein 1986; Marrero 1988). However, such families were often of mixed African heritage, and therefore various religious systems coexisted in the same household. This is an important factor in the process of *cruzamiento*, or coalescence, which affected particularly Regla de Ocha (Santería) and the Reglas Congas, collectively known in Cuba as Palo. Santo and Palo are still considered separate entities, with different

traditions and purposes. Yet the two have strongly influenced each other and consti-
tute, for all purposes, complementary rather than antagonistic religious systems. A
graphic example of this is provided by Lydia Cabrera in *El Monte*, when she quotes
one of her informants, an old woman whose father was Congo and her mother
Yoruba:[4]

44

> Cuando yo llegaba de la escuelita, dejaba el Cristo A B C . . . y mi padre que era
> mayombero, musunde, y mi madre que era iyalocha, me esperaban con la otra car-
> tilla . . . la de allá, de Akú y de Kunansiá. . . . En la casa tenía que hablar yéza y
> congo, y a la par que iba aprendiendo a rezar y el catecismo, aprendía a rezar, a
> saludar y a rogar en lengua. . . . Se aprendía lo de aquí, pero lo de allá también era
> obligatorio. (1971:42)

> When I arrived from school, I would leave the "Christ ABC" . . . [words that began
> the *cartilla* or primer], and my father who was a *Musunde mayombero* [a Congo
> priest] and my mother who was an *iyalocha* [a Lucumí priestess] would wait for me
> with the other primer . . . the one from over there, from Akú and Kunansiá. . . . At
> home I had to speak Yeza and Congo, and just as I would learn the catechism and
> the prayers, I would also learn how to pray, salute, and worship in *lengua* (an
> African language). . . . One would master that which was proper here, but knowl-
> edge about "over there" was also required.

The home domain, in most cases a context of intra-ethnic resistance and retention,
thus became a very propitious environment for the development of a cultural re-
alignment, particularly in the area of religion.

The *cabildos* (legally recognized associations formed in colonial Cuba by blacks
from roughly the same ethnic background) were instrumental as well in the preser-
vation and transformation of Afro-Cuban religious practices. If the *barracón* (com-
munal slave household) promoted cultural sharing and intermingling among slaves
of widely diverse origin, the *cabildos* were places where people of similar cultural
and linguistic origin could worship, relax, and interact. During the nineteenth cen-
tury the functions and prerogatives of *cabildos* gradually expanded: membership
eventually included not only African slaves but *criollos* (slaves born in Cuba), as well
as free men and women of African descent. In addition, they were able to collect
fees, to acquire land and houses for meetings, to organize celebrations, to participate
in carnival festivities, to assist members in need, and, on occasion, even to buy the
manumission of a particular member of the group. In other words, they were mutual
help societies as well as religious associations serving important ritual purposes.

Africans who had been forcibly de-ethnicized, who had lost their kinship, lin-
guistic, economic, and religious ties, would find in the *cabildo* a new center of cul-

tural gravitation, capable of providing a dose of collective identity in the midst of a hostile environment. The *cabildo* was a true refuge for these men and women who had lost in the passage to the New World the institutions that held the cultural fabric together: their clan, their family, and their religious societies of several kinds. Yet, despite being important agents of African religious retention, *cabildos* were not immune to the influence of European culture. Even in this institution we find the interaction of dialectical forces, some pushing for retention, others for displacement. We must remember that *cabildos* were official associations, recognized by both church and state, and this recognition would have been impossible unless they conformed, at least externally, to customs and laws required by the dominant group. Thus *cabildos* were legally considered Catholic *cofradías* (brotherhoods) which were placed under the patronage of a Catholic saint. They were registered in the corresponding parish church, and had an acknowledged place in processions and other religious festivities. Underneath this Christian and European facade, the old African mores continued to flourish, but this dualism led inevitably to acculturation, to the transition from Ulkumí to Lucumí.[5]

Two important and intimately related notions of Yoruba religion, the concepts of *orisha* and *ashé*, were also pivotal in the dynamics of religious transculturation. Much has been written about the orishas, the Yoruba deities—Afro-Cubans do not call them *dioses* (gods) but *santos* (saints)—that rule the world and human life by the will of Olodumare or Olofi, the Supreme Being. Quite often, however, orishas are portrayed as unidimensional entities, without any further analysis of the multitude of meanings that they and their avatars convey. The African or Afro-Cuban notion of "orisha" is far from simplistic. Each orisha rules over one or more aspects of cosmological reality and human existence. His or her being reflects and expresses the infinite nuances that constitute a particular realm of life. Let us take, as an example, Ochún, the goddess of love. On the one hand, Ochún is Ochún Yeyé Moró (also called Yeyé Karí): a sensuous saint, all full of *joie de vivre*, knowledgeable in the art of lovemaking, fond of music, beautiful clothes, and dance. Together with Changó, she epitomizes the fullness of life. At the other end of the spectrum, Ochún is Ochún Kolé-Kolé (also called Ibú-Kolé). Poor, owner of a single faded dress, this Ochún eats only what Mayimbe, the vulture, brings to her door. Another Ochún, Ochún Awé or Galadé, according to an old informant of Lydia Cabrera (1980: 71–72), is intimately related to death: "Ochún Awé," he told Cabrera, "is a sad Ochún." At the center of the continuum sits Ochún Olólodi or Olodí, who is very serious and domestic. She is not a dancer and, like Yumú, she is fond of sewing and keeping house. All the other Ochúns fall somewhere between the two ends of the continuum.[6]

The faithful believe that these multiple *caminos* or "paths" of the orishas reflect

different moments of their personal history and their spiritual development (*desarrollo espiritual*). In fact, they do much more than that. The *caminos* serve to express the multiplicity of meanings contained within the specific domain of human life ruled by an orisha. Thus sensual love may be both a source of joy and happiness and a cause of sadness and misfortune. It may be an affirmation of life or the bearer of death. It may be promiscuous or monogamous. It may be generous and selfish at the same time. In many *patakís* (Afro-Cuban myths), Ochún is portrayed as a savior and a civilizing force through the power of love, often symbolized as her "honey" or *oñí*. For example, she seduced the hermit Ogún into working once again for the good of the people. She obtained from Olofi the resurrection of Babalú-Ayé. She is generous to a fault. At the same time, Ochún may be demanding and capricious like love itself. All these different shades of meaning are dynamic elements that interact within the concept signified by Ochún.[7] The faithful, then, may always relate their own love affairs, the erotic facet of their lives, to one or another representation of Ochún's personality and thus find comfort and experienced advice. The orishas, then, reflect back to the faithful the complexity of their own human lives. Each one of the deities is not a singular being but a plural entity. As Sandra T. Barnes (1989:19) says: "Extremes make the point. The universe, as we view it through a deity's eyes, is revealed by the ways in which extreme thoughts and extreme deeds complement and balance one another."

An important corollary of looking at the orishas as having multiple meanings rather than as univocal entities is that it explains how their meanings may change through time. Barnes (1989:13) correctly points out: "One of the most useful implications of being able to think of meanings in the plural is that we can, by extension, visualize the processes by which some meanings remain unchanged while, at the same time, other meanings can be added, subtracted, or altered, little by little, over time and space." In Cuba, for instance, the role of Oricha Oko as a ruler of agriculture was weakened. Slaves, after all, did not cultivate their own lands but those of their masters. In addition, contemporary practitioners of Santería are primarily urban dwellers, never involved in planting and harvesting activities. On the other hand, Oricha Oko's association with fertility, with the vital connection between humans and the earth, and with the fruitfulness of human labor have been emphasized. In other words, depending on the social characteristics of time and space, one or more traits of the orishas may be foregrounded whereas others recede.

The orishas are malleable; they can grow and adapt to changing conditions. This, in part, explains their survival in spite of the decidedly unfavorable conditions in Cuba and now in the United States. Ogún, as in Africa two centuries ago, is still the owner of iron. Eventually he came to rule over steel, railway tracks, and jumbo jets. He also leads the hand that holds the scalpel in modern surgeries. In Cuba,

again, both Oyá and Oba lost their fluvial aspects, whereas other modes of meaning remained and developed. At present, Babalú-Ayé controls not only leprosy and smallpox but also AIDS. This plasticity allowed many European traits to be incorporated, without any conflict, into the meanings and symbols that define the orishas. Thus, for instance, one of Yemayá's traditional "tools" is a clearly western ship helm, and the *otanes* (sacred stones) reside in American, Cuban, Spanish, or Italian *soperas* (soup tureens).

Of equal importance in the process of religious acculturation in Cuba is the notion of *ashé* (*aché* in Cuba), which lies at the very root of Yoruba and Lucumí religion. *Aché* means first and foremost a vital energy, a force that is present in every animate and apparently inanimate object, be it a human being, a plant, an animal, a mountain, a rock, a chant, or a word. It is an ecumenical force: it is not restricted to objects associated with the Yoruba, their environment, and their rituals. *Aché* is also a transforming power, and some entities and individuals possess it in a greater degree than others. It is also susceptible of increasing or decreasing depending on a number of factors, such as experience and conduct. There are priests and lay persons, for instance, who are loaded with *aché*, whereas others are weaker in this respect.

Afro-Cuban religion is inclusive and not exclusive in its system of beliefs and practices. It is open to other religious experiences and is never reluctant to resort to them if it is deemed necessary. Everything that exists has a share of the divine *aché*. Thus, for instance, if a *santero* must resort to a *cazuela de palo* (a Congo cauldron) to seek protection from evil, it is not only permissible but fitting to do so, without any conflict of interests. This notion of *aché*, then, which promotes flexibility and inclusiveness, has been an important internal factor in promoting the process of religious syncretism and acculturation. As Margaret Thompson Drewal (1992:27) has said: "The malleability of Yoruba ritual practice has enabled it to tolerate both Christianity and Islam. It also had the capacity to survive in the oppressive slave societies in which it landed in the New World, operating clandestinely initially and now more openly."

Many other factors from the changing social milieu have modified traditional Afro-Cuban practices in Cuba. Santería has traditionally been practiced by members from the lower socioeconomic classes, in other words, people with little formal instruction. Nowadays, however, it has made inroads among literate and educated individuals, and this has had important consequences in several ways, for example, its mode of transmission. Traditionally an oral religion, Regla de Ocha has gradually increased its dependence on writing as a way of preserving and conveying knowledge. Novices, after their *itá* (the divination ritual that follows initiation), receive a written notebook which records the predictions and norms of conduct defined in the

ceremony. *Libretas de santo* ("notebooks" containing prayers and narratives) prolif-
erate and may be bought in *botánicas* (stores that sell religious articles) and book-
stores. Educated *santeros* receive the most recent catalogues from university presses
listing scholarly books, often in English, about African and Afro-American topics. A
group of believers in Miami founded an association called *Cabildo Afrocubano
Omó Oricha*, but unlike the members of original *cabildos*, they published a regular
newsletter and held seminars to teach novices how to interpret the Dilogún, one of
the many forms of oracular divination.

As Mintz and Price (1976:1) explained: "We would argue that no group, no
matter how well equipped or how free to choose, can transfer its way of life and the
accompanying beliefs and values intact, from one locale to another." Cultural
losses, additions, or modifications are inevitable. In the liturgical field, for instance,
borrowings from Catholicism and Spiritism have substantially transformed Santería
rituals. Acculturation goes well beyond the popular syncretizing of Catholic saints
with Yoruba orishas. The adoption, for example, of the extremely syncretic rite
called *misa espiritual* as a preamble of the Asiento or Kari-Ocha (initiation cere-
mony) may be a good illustration. The "spiritual mass" takes place around an altar
upon which such diverse objects as a crucifix, a bottle of Cuban-American eau de
cologne, a container with holy water obtained from a Catholic church, a few cigars,
and so forth may be found. The liturgy begins with the sign of the cross and includes
the recitation of poems and prayers (Our Father, Hail Mary . . .) all in Spanish, and
the invocation of the *egungunes* (ancestors) and other spirits. When these spirits "re-
turn to earth," they usually communicate with the faithful in *bozal* (a Cuban creole
language) through a medium. This medium, in typical spiritist fashion, advises the
iyawó (initiate) about his/her present and future, and even identifies his/her "spiri-
tual guides," some of whom may be deceased American Indians.[8] The old Kari-
Ocha has been transformed from an African rite into an Afro-Cuban celebration.
The original *ashé* of the Yoruba religion is enriched with the *aché* of the Catholic
Church and the forces of spiritism.

Transformation, then, is the rule when two or more cultural groups come to-
gether, in close contact, for a prolonged period of time. In Cuba, Ulkumí became
Lucumí. This study has shown the role that family structure, the institution of the
cabildo, access to education, as well as internal traits of Yoruba society such as the
notions of *orisha* and *ashé* have played in the process of religious acculturation. Yet,
paradoxically, the deeper one digs into the Afro-Cuban system of beliefs, the more
one is confronted with the surprising fidelity to the essence of their original sources.
Like old wine poured into new vessels, the traditional spirit of Africa animates the
way these modern Cubans—or Puerto Ricans, or Colombians, or Americans—view
reality. Santería is not an African religion exported to Cuba, but an *Afro-Cuban*

faith. Being a product of intense transculturation, it is to be found at the root of many aspects of contemporary Cuban society: music, literature, and art. From Africa to the Caribbean, from Ulkumí to Lucumí, and from there to Cubans, and now to Cuban Americans and to other populations in the United States, the process of cultural transformation and synthesis inexorably marches on.

NOTES

1. On this topic see Cros Sandoval 1975:50–51; also Castellanos and Castellanos 1992:22–25.

2. For a discussion of this process in Brazil, see Walker 1990:109–11.

3. This does not mean, however, that rituals lack strict norms of conduct. For an insightful discussion of the inclusive, rather than exclusive, orientation of Yoruba religion, see Barnes 1989:10–12.

4. Cabrera's contact with this informant dates back to the 1930s or early 1940s since another version of this paragraph appears in an initial version of *El Monte* published as a long essay in 1947. See Cabrera 1947:66.

5. The most widely cited explanation of religious syncretism in Cuba attributes the Catholic, European elements of Santería to an attempt on the part of slaves to conceal and protect their African faith from the wrath of the official authorities. This "shielding" intention undoubtedly played a role in the process of religious acculturation. The transformations, however, were not merely superficial and cosmetic. For a discussion of this issue, see Cabrera 1954.

6. The faithful presently recognize five main ritual "paths" (*caminos*) of Ochún: Ibú-Kolé, Ololodí, Yumú, Ibú Añá, Ibú Akuaro. Other "paths" or advocations of Ochún are recalled in oral tradition. Dornbach (1993:92) writes: "Verdad que raras veces, pero siguen mencionando aún la figura de Yeyé Moro, considerada muy coqueta." ("Although rarely, they [the faithful] still mention the figure of Yeyé Moro, considered as very coquettish"; translation mine.) See also Cabrera 1980:69–72.

7. For an illuminating discussion on the meanings of the orishas, see Pemberton 1977 and Barnes 1989, particularly her introductory essay.

8. The incorporation of American Indian spirits as "spiritual guides" is another example of the ecumenical, inclusive character of Regla de Ocha. Afro-Cuban believers consider American Indians as being attuned to nature and knowledgeable in otherworldly affairs. These deceased "Indians," therefore, are believed to possess a great deal of *aché*. Generally speaking, Indian "spiritual guides" tend to be perceived in stereotypical terms, and are often represented by "conventional" pictures or sculptures which portray a fictionalized, "ideal" Native American wearing a feathered headdress.

REFERENCES

Barnes, Sandra T. 1989. "Introduction: The Many Faces of Ogun." In *Africa's Ogun: Old World and New*, ed. Sandra T. Barnes. Bloomington: Indiana University Press, pp. 1–26.

Bascom, William. 1944. "The Sociological Role of the Yoruba Cult-Group." *Memoirs of the American Anthropological Society* 63.

———. 1951. "The Yoruba in Cuba." *Nigeria Magazine* 37:14–20.

Cabrera, Lydia. 1947. "Eggüe o Vichichi Finda." *Revista bimestre cubana* 60, 2nd semester:47–120.

———. 1954. "El sincretismo religioso de Cuba. Santos, orisha, ngangas. Lucumís y Congos." *Orígenes* 11 (36):8–20.

———. 1971. [1954]. *El Monte.* Miami: Ediciones C.R.

———. 1980. *Yemayá y Ochún.* New York: Ediciones C.R.

Castellanos, Jorge, and Isabel Castellanos. 1992. *Cultura afrocubana*, vol. 3. Miami: Universal.

Cros Sandoval, Mercedes. 1975. *La religión afrocubana.* Madrid: Playor.

Dapper, Olfert. 1686. *Description d'l'Afrique.* Amsterdam: Wolfgang, Waesberge, Boom, and Van Somereu.

Dornbach, Mária. 1993. *Orishas en soperas.* Szeged, Hungary: Centro de Estudios Históricos de América Latina, Attila József University.

Drewal, Margaret T. 1992. *Yoruba Ritual.* Bloomington: Indiana University Press.

Fadipe, N. A. 1970. *The Sociology of the Yoruba.* Ibadan: F. O. and O. O. Okediji.

Kiple, Kenneth F. 1976. *Blacks in Colonial Cuba, 1774–1899.* Gainesville: University Presses of Florida.

Klein, Herbert S. 1986. *African Slavery in Latin America and the Caribbean.* New York-Oxford: Oxford University Press.

Lachatañeré, Rómulo. 1939. "El sistema religioso de los Lucumís y otras influencias africanas en Cuba." *Estudios Afrocubanos* 3:28–90.

Law, Robin. 1977. *The Oyo Empire c. 1600–c. 1836.* Oxford: Clarendon Press.

Marrero, Leví. 1983. *Cuba: Economía y sociedad*, vol. 9. Madrid: Playor.

———. 1988. *Cuba: Economía y sociedad*, vol. 14. Madrid: Playor.

Mintz, Sidney W., and Richard Price. 1976. *An Anthropological Approach to the Afro-American Past: A Caribbean Perspective.* Philadelphia: Philadelphia Institute for the Study of Human Issues.

Pemberton III, John. 1977. "A Cluster of Sacred Symbols: Orişa Worship among the Igbomina Yoruba of Ila-Orangun." *History of Religions* 17(1):1–28.

Scott, Rebecca J. 1985. *Slave Emancipation in Cuba: The Transition to Free Labor, 1860–1899.* Princeton: Princeton University Press.

Snelgrave, William. 1734. *A New Account of Some Parts of the Guinea and the Slave Trade.* London: John James and Paul Knapton.

Verger, Pierre. 1957. *Notes sur le culte des orişa et vodun.* Dakar: IFAN.

Walker, Sheila S. 1990. "Everday and Esoteric Reality in the Afro-Brazilian Candomblé." *History of Religions* 30(2):103–28.

MIGUEL "WILLIE" RAMOS

AFRO-CUBAN ORISHA WORSHIP

For more than three centuries, approximately ten to twelve million Africans were transported to the shores of the New World (Knight 1970; Uya 1989). As human commodities, the Africans were shipped off to new lands where they received brutal, inhuman treatment and the inescapable sentence of suffering under the yoke of another man who claimed superiority based on "religious salvation," skin color, and the preposterous notion of race. The major part of this human cargo was imported from the western shores of the African continent, particularly West and Central Africa, two areas largely exploited by traders dealing in human beings.

THE ARRIVAL OF THE YORUBA

In the initial stages of the trade, the demand for slaves on the island of Cuba was minimal. Yet, at the turn of the nineteenth century, especially after the Haitian Revolution, Cuba became the leader in the production of sugarcane in the New World. This shift from minor cattle ranching and tobacco farming to the "sugar revolution" transformed the course of Cuban history, for the change in production required an extremely large labor force, and as a result the presence of African slaves on Cuban plantations increased tremendously (Knight 1970; Uya 1989; Castellanos and Castellanos 1988).

It has been estimated that the total number of Africans transported to Cuba ranged somewhere from 750,000 to more than one million (ibid.). The exact numbers are still subject to debate, principally

52

because of the impoverished system of record keeping employed by the traders. Consequently, accurate figures for the different tribes and ethnic groups transported to Cuba during the duration of the trade are difficult to establish. Based on the survival of many cultural elements of different African groups in Cuba, one can safely say that the Yoruba people were present in substantial numbers, especially during the latter part of the trade (see Castellanos and Castellanos 1988:vol. 1:43). A great number of the slave ships that arrived in Cuba were loaded in Benin (formerly Dahomey), a country located southwest of Ile-Ife in present-day Nigeria (see Buxton, in Sandoval 1975), the city recognized by the Yoruba as the cradle of civilization.

Along with their devastation and corporal captivity, the Yoruba transplanted their culture to Cuban shores, contributing not only their sweat, blood, and lives (literally), but also many aspects of their culture including their religious beliefs and practices, their major endowment to the embryonic cultural institutions of the island after the European colonization.

The Yoruba were an urban people, favored by the plantation owners because of their "docile and industrious"[1] character, possibly two reasons for which many were employed in domestic services. This afforded a greater degree of access and contact with the "master" class, an important factor in the retention and transmission of Yoruba culture. As a result, many female slaves would nurture and rear white children. In these respects, the socialization of white children by the slaves serves as one of the vessels for the transmission and later assimilation of the two cultures.

Among the Yoruba, various subgroups were present: the Egbado, Ijebu, Ketu, Ekiti, Ife, Ilesha (called Yesa in Cuba), Egba, and, especially during the latter years, the Oyos. Also, from neighboring Dahomey (today the Republic of Benin) to the west of present-day Nigeria, arrived the Ewe-Fon (collectively called Arara), Sabalu, Mahi, Agicon, and the Cuevano (Sandoval 1975).

The Yoruba slaves came from the southwestern portion of present-day Nigeria. Yorubaland covers about 70,000 square kilometers. Toward the south, it meets the Gulf of Benin and is adjacent to Dahomey, where large numbers of Yoruba and their descendants can also be found. Yorubaland extends approximately 300 kilometers from the Guinea Coast inward, meeting the Niger River about halfway through its course.

Yoruba territory is 1,600 feet above sea level, with a gradual increase in elevation as one moves north. It is an area of savannahs and includes some of the great forests of equatorial Africa. The coastal areas are low and marshy. The language is of the Kwa family of languages, belonging to the Niger-Congo branch of the great Congo-Kordofanian language family (Bascom 1969c).

Yoruba influence in West Africa was great, especially in the time of the Oyo empire, which was a period of political and cultural greatness. Nonetheless, they were

considerably debilitated by the incessant wars with neighboring, non-Yoruba tribes, a major influence in their deterioration. During the eighteenth century, the Yoruba began to decline, mainly because of constant territorial wars with Dahomey. The Fulani, a subgroup from the north of Africa, took advantage of this state of confusion to penetrate into Yoruba territory (see Johnson 1921). The Yoruba collapse coincided with an increase in the demand for the importation of slaves in certain parts of the New World, particularly in those areas where sugar was the major crop.

In Cuba, the Yoruba are known as Lucumi or Locumi. The origins of the term *Lucumi* are still obscure, and a number of conflicting opinions exist regarding this issue. In the early literature, references are made to the Kingdom of Oulkoumi or Ulkumi. Early scholars make use of the terms Ulkami, Ulkumi, or Alkamy to refer to the Yoruba (see, e.g., O. Dapper and J. Barbot, in Awoniyi 1981:365). Awoniyi (1981:104) attributes this term to the customary usage of *oloku mi* ("my fellow tribesman") commonly employed as a salutation when two members of the same tribe meet.

Although other African tribes have left their legacies,[2] Yoruba influence in Cuba as well as in Brazil, Trinidad, and other areas of the New World was very strong. Today we encounter Yoruba vestiges in the music, art, folklore, and culinary styles of Cuba. However, the greatest of the Yoruba legacies to the island is undoubtedly the religious complex which survives to this day. The coming together of two traditions, two distinct religious systems and cultures, united through the influence of destiny, gave birth to the Afro-Cuban Orisha tradition.[3]

THE CULTURAL ENCOUNTER

Christianization and conquest occurred simultaneously in the New World. Prior to departure for the New World, or shortly after their arrival, the slaves were introduced to Christianity by force, through the ritual of baptism (Laviña 1989:46). Whether or not they were taught the doctrines of Christianity mattered little. Justification for slavery was juxtaposed with the "generosity" of the Europeans, for not only were they "saving souls," they were helping the Africans to achieve "liberation from barbarism . . . and the acquisition of the category of 'human'" (ibid.).

The Spanish crown and the Roman Catholic Church placed little emphasis on educating the slaves in the doctrines of Christianity (ibid.:47). So long as they had ensured the safety of the "pagan's" soul, everything else was of little importance. So ironically, for the crown and the church, the enslavement of the body mattered not, as long as the soul was guaranteed a safe passage into the Christian heaven (Laviña 1989; Bastide 1978a, b).

In spite of its deficiencies and errors, the presence of Catholicism played an important role in the retention and transmittal of Yoruba religion in the New World. When Olodumare,[4] the Supreme Being in Yoruba belief, created the earth and all

53

things therein, he also created the orishas, the minor divinities that would serve as intermediaries between heaven and earth. Each orisha is related to one or more aspects of nature and earthly existence. The orishas are divine in their own right, believed to be not only representatives of the Supreme Being, but also manifestations of Olodumare's omnipresence and omnipotence. Their aid is sought at all major crossroads, and especially in times of distress, infirmity, and disorientation.

The orishas are also extremely humanlike in their character, an important aspect of the deity that allows for a closer association between the devotee and the object of worship. Every orisha has specific dominions, places of habitat, offerings, taboos, colors employed in their vestments and paraphernalia, and ritual emblems. Shango, the virile and hot-tempered orisha patron of thunder and lightning, receives offerings at the foot of a royal palm (*Roystonea regia* [H.B.K.] O. F. Cook) or silk-cotton tree (*Ceiba pentandra*, L.). Shango forbids lies and deception, receives sacrifices of rams, turtles, and roosters; enjoys bananas, mamey apples, and okra stew with corn meal porridge; dresses in red and white, wears beads of the same colors, and dances brandishing a double-bladed ax.

On the other hand, Roman Catholicism bears a very close resemblance to Yoruba religion, especially the popular practices of rural (or medieval) Catholicism,[5] the "cult" of the saints, very prevalent in Spain and Portugal (Bastide 1978a,b). This belief system employs a pattern of worship in which homage and devotion toward a particular saint obscure that given to the church and its strict principle of monotheism. Adherents acknowledge and worship the Supreme Being in accordance with Catholic dogma: the Holy Trinity composed of the Father, the Son, and the Holy Spirit, three essences in one being. Unlike orthodox Roman Catholics, adherents of rural Catholicism believe that the Catholic saints, like the orishas, have control over certain natural phenomena and spheres of human life.

Special powers and roles are attributed to the saints, allowing them to intercede with the Supreme Being on behalf of a devotee. Every saint has a particular day of the year set aside for his or her celebration or worship, and is also thought to have particular preferences and aversions.

A devotee can petition special favors from the patron saint by promising to execute certain deeds, processions, or wear particular garments associated with the saint. But the devotee can also "punish" a saint that refuses to concede favors. An example of this, still very prevalent in most of Latin America, is the custom of placing St. Anthony's statue upside-down, under running water, when a lonely female is searching for a husband or lover.

Therefore, it is not difficult to see how Yoruba religion and rural Catholicism share common elements that would facilitate the assimilation and understanding of one by the devotee of the other. A popular analogy, often called "syncretism," was

the eventual result. Although they were not fully versed in the doctrine and practice of Catholicism, through the encounter with the popular beliefs of the master class, devotees juxtaposed the African orisha with the Catholic saint.

There is much debate today over the actual level or degree of syncretism between Catholicism and African religions in the New World. Whether syncretism was a fusion of the two concepts or simply a mechanism of camouflage continues to be an ardent subject (cf. Houk 1992). Most Afro-Cuban devotees make a point of distinguishing the differences between one religion and the other, but nevertheless, for nearly every Yoruba orisha, there is a correlation in the Catholic pantheon. It would be futile to negate the extreme importance of the presence of Catholicism as an influential factor in the process of adaptation for the Africans. It would be just as futile to pretend that this encounter has not taken its toll on elements of Yoruba religion that as a result may have been modified or diluted. Yet, had Catholicism not been the dominant religious form, I speculate that African religions in the New World would not have survived intact.[6]

Regardless of whether the two religions fused, or the African religion simply hid behind a "veil" of Catholicism, in the mind of the adherent, the similarities between the two religions were too many to go unnoticed. The correlative process not only facilitated understanding of Yoruba religion for the Europeans but also served to ensure its survival. It must be emphasized that devotees make clear and definite distinctions between the orisha and the saint, and the Yoruba practices are, as a rule, separated from the Catholic ones. Nevertheless, Yoruba theology is at times replaced or obscured by the dominant Catholic dogma, particularly in the case of converts to Orisha worship who were originally Catholic.

As in the days of slavery, many Orisha priests require that their disciples be baptized Catholics. This custom is apparently losing force today among religious descendants of the Cuban diaspora, yet in Cuba it still prevails. Slavery obliterated or obscured many Yoruba rituals which were not necessary or possible in the new social setting. Yoruba rituals were replaced by Catholic rituals that served similar functions. This is understandable when coupled with the fact that those who did not adhere to the Catholic rituals as dictated by society were the victims of ridicule and persecution. So with the passage of time, Yoruba ceremonies that relate to birth, marriage, passage into adulthood, and many other aspects of life in Yorubaland were displaced by the dominant norms of Cuban society.

Regardless of the displacement process, Yoruba customs survive and continue to be transmitted through the oracles and their myths. In the Ifa, Dilogun, and Obo oracles[7] employed by Afro-Cuban Orisha worshipers, one returns to Yorubaland in all its regalia and glory through the *patakis* or myths narrated by the diviners in consultation. As with all cultural encounters, the *patakis* also go through a process of

adaptation and reinterpretation, but closer scrutiny of the oracular corpus will reveal the richness and variety of Yoruba culture contained within them.

THE ORISHAS

The deities worshiped in Yoruba traditional religion and its offspring in the New World are collectively referred to as orishas. The deities that make up the Yoruba pantheon are innumerable (see, e.g., Epega 1931), and although many survived the transatlantic voyage, not all the orishas worshiped in Yorubaland are known in the New World. In certain areas particular orishas appear to be more popular than others. Other orishas were retained in one country and lost in another: knowledge of Logun Ede, for example, was virtually lost in Cuba where the orisha is known as Laro; on the other hand, Ifa and the initiation into its priesthood survive intact in Cuba, while it is only currently finding its way back to Brazil.

As with any transplanted culture, adaptation and transformation are inevitable. Many orishas acquired new domains and attributes in the New World. Yemoja, patron orisha of the Ogun River, after crossing the Atlantic, divides rulership over the ocean with her husband, Olokun. Oshun in Yorubaland rules over the river that bears her name, yet in Cuba Ochún becomes the patron deity of all rivers. Oshosi in the New World is not only the god of the hunt, but also the patron of fugitive slaves and, by extension, of all those who flee from injustice.

The orishas are humanlike in their characteristics, as well as in their preferences and aversions. Every orisha has its own town of origin, its own personality, a particular archetypal behavior often emulated by its devotees, and a series of observances and taboos that must be adhered to by all. Additionally, practically every orisha is related to an aspect of nature, as well as certain details or components of the human condition. Most important, the orisha is not only a representative of the Supreme Being, but also a manifestation of his wisdom and supremacy.

According to E. Bolaji Idowu (1962:61), the term *orisha* is a corruption of *orishe*, a name originally used in certain parts of Yorubaland to refer to Olodumare. Idowu's translation of the term *orishe* is as follows: *ori*—head source; the soul or guardian entity that resides in the head; *she*—to originate, begin; to derive or spring from. The name *orishe* would then be an ellipsis of *ibiti ori ti she*—the origin or source of *ori*: Olodumare himself. Idowu notes that the name *Orisha* is applied to Olodumare in certain parts of Yorubaland, emphasizing that Olodumare is "indisputably not one among the divinities" (ibid.:60) but the source of the *orishas*. *Orisha*, then, is an adulteration of *orishe*, therefore confirming the belief that the Yoruba orishas are manifestations of the Supreme Being (ibid.:61).

Olodumare is present in each and every one of his creations. Elemi—Owner of the (life-giving) breath—alludes to the deity's personal imparting of the breath from

which life emanates into the bodies created by Obatala. Obatala molds and creates the human body, but only Olodumare can give it life. Olodumare is therefore present in every creature that breathes.

Furthermore, Eleda—Owner of the head—is an appellative for the Creator that is also employed interchangeably with the Yoruba *eri* or *ori* to refer to an individual's "head." This not only alludes to the exalted position of the head in Yoruba traditions; it also implies the divine presence of the deity in each of his creations. It is precisely because of these considerations that worshipers are offended by the claims of studies that refer to Olodumare as a "distant, remote, or inaccessible deity." Olodumare not only takes an active role in his creation, but he is a palpitant and living entity that communes with his creation through the orishas and the ancestors. Olodumare is omnipresent and participates in the daily affairs of human existence through his divine presence in the bodies of human beings, for all humans must breathe.

The Supreme Being is also called Olorun—Owner of the sky (or Owner of the sun, depending on the position of the accent)—and, among Afro-Cubans, Olofin—Owner of the heavenly palace. Although few rituals in the worship system are directly performed in his honor, Olodumare permeates each and every aspect of worship through his representation in the orishas. At the onset of any ritual, devotees salute Olodumare, calling to the deity by all of his appellations and flattering praises before saluting the ancestors and the orishas. No matter how powerful an orisha is believed to be, its power is always dependent on the will of Olodumare, for if "Olodumare does not will it, it cannot be."

Before birth, Olodumare allows his subjects to select the type of life they wish to endure on earth. Each individual is allowed to choose his or her *ori*, a Yoruba concept that relates to destiny. The *ori* of a human being is a personal entity, a guiding force, and, similar to the Catholic concept of the "guardian angel," the *ori* accompanies the devotee throughout the earthly cycle. Unlike the Catholic belief, however, *ori* is physically present in the head of the devotee and not just a guiding spirit. The chosen destiny is forgotten once the individual is born. On earth, this person will live out that which was chosen in *orun*, although care must be taken that the negative entities[8] that live among humans do not provoke events or occurrences that can alter the individual's existence. Only through the intervention of these entities will the chosen destiny deviate from its path.

The orishas also have power to alter a person's destiny or, depending on the devotee's behavior, intercede in the life cycle to improve the individual's lot on earth. This is brought about in accord with the person's behavior and *iwa* (character). Through the oracles, devotees are warned about forthcoming events in their lives

57

that may be avoided either with particular behaviors or a propitiatory ritual. Failure to heed the warning of the deities could provoke Elegba to "play" with the individual. By causing havoc or placing obstacles in the person's path, Elegba attempts to bring about the desired performance in the devotee. Sometimes people are so stubborn that not only do they not comply with the guidance of the oracles, but they refuse to acknowledge or accept Elegba's timely warnings. The consequences may be catastrophic.

58

The orishas also have the prerogative of punishing human beings for improper behavior. Human beings are required to be proper and righteous, as is everything that emanates from Olodumare, yet they are not required to be perfect. Possessing virtues and flaws, some people may allow their defects to permeate their life. Warnings will be issued, which, if not heeded, will result in the first "pinch" from an orisha trying to spare his or her child from calamity. The orishas, in their parental role, always tend to treat a devotee as a mother would her child. At times this may involve indifference or a period of inattentiveness in hopes that the person will acknowledge and rectify the behavior.

When all warnings and/or punishments fail, as a last resort, the orisha can eliminate its tutelage altogether and allow *iku* (death) to attack the person. The orisha cannot occasion death, for Olodumare will never willingly destroy what he creates, nor does he permit the orishas to do so. Only when all else fails will he allow the orisha to withdraw its protection from an individual so that negative forces can attack a person.

If a person dies before the destined time, whether as the result of punishment or the work of malignant forces, the individual will not be able to return to heaven until the time stipulated in the chosen destiny is up. This person will roam the earth as an *iwi* or *iwin*, lurking in desolate places. The *iwi* delight in scaring people and causing havoc. These are the spirits that evil magicians sometimes use to inflict harm on others.

Upon returning to heaven, Olodumare will judge the individual's earthly behavior. The righteous individual will be allowed to go to *orun rere* (the good heaven), where he or she will enjoy an afterlife full of the rewards Olodumare reserves for the righteous. From *orun rere*, the *araorun* (citizen of heaven) can intervene on behalf of descendants, and when he or she so desires, request to return to the world of the living and live among loved ones and their offspring.

Orun buruku (the bad heaven) awaits those whose earthly behavior was not in accordance with Olodumare's dictates. Here the individual will reside in total desperation, for all types of punishment and torment await. Intervention on behalf of descendants is impossible, and reincarnation is out of the question. But Olodumare is merciful. Once the punishment has served its purpose, the individual will be al-

lowed to return to the world of the living, although as a lower being (an insect or an animal). Progression on the evolutionary ladder up to the category of human being will depend on the original behavior for which the person was first reprimanded.

ASHE: THE DIVINE FORCE

In accordance with the Yoruba creation myth, everything that emanated from, or came into contact with the deity, whether in Yorubaland or elsewhere, was imparted the ineffable power of *ashe*. In western terms, there is no equivalent for this concept. It is similar, though, to the Polynesian idea of *mana* and the Oriental *chi*. *Ashe* is the animating force that moves both earth and cosmos. It can be found in a plant, an animal, a stone, a body of water, a hill, the heavens, the stars. But *ashe* is also present in human beings, and can be manifested through bodily actions, but is especially active in words (*afud'ashe*). When a priest speaks to the orishas, *ashe* is at work, for the words he employs are loaded with religious and magical meaning, imploring particular actions from the deities and their[4] attention to problems of the daily cycle. *Ashe* also allows for the effectiveness of the diviner's predictions. It is believed that when a diviner speaks to a client, the orishas are speaking through him.

All humans are born with *ashe*, although the degree of this power varies in accordance with the individual's chosen destiny. Through the initiation rituals, devotees of the orishas are further endowed with this ineffable force. *Ashe* (in the form of a mixture of herbs and other things) is placed on the head of the initiate, transforming the individual from a "normal" human being into the equivalent status of "mediator" for the orishas and Olodumare among human beings. This not only affords status but also allows the priest to mediate with the orishas on behalf of a client.

Through divination, the priest or priestess can employ *ashe* to tap into the source or origin of human conflicts, suffering, and earthly afflictions. Once the source is identified, through *ebo* or sacrifice, the priest helps the client to tap into the *ashe* contained within other elements, and employs this power to bring about an immediate solution to the client's problems. Sacrifice in Yoruba religion could mean any one of a series of purification rituals: food offerings, propitiation, prayers, bathing with herbs, cleaning the body with particular herbs, or animal sacrifices. The Yoruba emphasis on the "here and now," and their obsession with life and the world of the living, are marked by the importance placed on *ashe* and *ebo*.

Ebo eje (blood sacrifice) entails the offering of an animal to a deity in exchange for the orisha's protection or involvement in the affairs of the living. Worshipers consider the sacrifice of an animal as the most intimate contact between the spheres of the sacred and the profane. It is a communion, the establishment of a bond between worshiper and deity that serves as a medium of exchange.

After the animal is sacrificed, the meat is cleaned and prepared for consumption. Certain parts, such as the heart, lungs, kidneys, and other internal organs,

along with the head, feet, and, in the case of a fowl, the tips of the wings, are cooked for the orisha. These offerings, also called *ashe*, are cooked in accordance with the specific tastes of the orisha to whom it will be offered[9] and placed before the receptacle containing the sacred implements that represent the deity. The rest of the animal is cooked for human consumption, and, as in the case of initiation ceremonies, is communally eaten by worshipers in a ritual meal on the following day.

The belief that *ashe* is contained within everything that exists justifies the existence of this transcendental force in other cultures and religious beliefs, for Olodumare is not the exclusive domain of the Yoruba. He made his presence known to all human beings, regardless of "race" and skin color. This explains why Yoruba descendants in the New World were not only receptive to Christianity and Catholicism, but also to other African beliefs, Kardecian spiritualism, and the indigenous practices that prevailed throughout the Americas. In the New World, the Yoruba and their descendants find *ashe* in the holy water and candles of the Europeans, the magical practices of the Bantus and Abakuas, the Vodun of the Ewe-Fon and Rada, possession by "spiritual guides," and the maize and tobacco of the indigenous populations.

A devotee of the orishas can feel equally at home in a Catholic or Protestant[10] church, a Kardecian spiritual séance, or in a Haitian or Dominican Vodun ceremony. This all-encompassing nature, coupled with its facility to adapt to any setting, is a strong feature of Orisha worship, as has been demonstrated in the many New World settings where Yoruba religion survives and continues to thrive.

THE PANTHEON Most of the Yoruba deities worshiped in the New World are the same in Brazil, Cuba, and Trinidad. Adaptational and regional differences exist, as well as phonetic and grammatical variations in the spelling of the names in accordance with the dominant language in each country. The sound of the Yoruba *s*, pronounced *sh* as in the English "shoe," does not exist in Spanish. The same holds true for Brazilian Portuguese. In Cuba, this sound is replaced by the stronger *ch* sound, as in the English "choice," while in Brazil the *x* serves this purpose. So the Yoruba Oshun is written and pronounced Ochun by Afro-Cubans, and Oxun among Afro-Brazilians. Wherever possible, I have tried to maintain the standard Yoruba pronunciation, although not necessarily the proper and accentuated Yoruba spelling, while placing in parentheses alternative spellings of the orisha's name.

The following table lists the principal orishas worshiped by Afro-Cuban devotees, as well as their Catholic counterparts, their roles in the pantheon, and the ritual instruments and colors used to identify them. The deities are listed in the hierarchical order employed in the worship system.

60

THE AFRO-CUBAN PANTHEON

ORISHA	CATHOLIC SYNCRETISM	DOMAIN	RITUAL INSTRUMENT	RITUAL COLORS
Elegba	Holy Child of Atocha	crossroads	*garabato*[1]	red, black, and white
Ogun	St. Peter	iron/war	cudgel/machete	black, green, and red
Oshosi (Ochosi)	St. Norbert	hunting	bow and arrow	dark blue and amber
Osayin (Osain)	St. Sylvester	healing/traditional medicine	beaded gourd	no preference
Erinle (Inle)	St. Raphael	fishing/healing	fishing rod	turquoise, green, and coral
Orishaoko	St. Isidore	agriculture	plow	turquoise and mauve
Babaluaye	St. Lazarus	smallpox and epidemics	*ja* (broom of palm fibers)	brown, black, and red
Ibeji (Ibeyi)	Sts. Cosmas and Damian	twin births	none	white and red (sometimes blue)
Dada	Our Lady of the Rosary	unborn children	calabash adorned with beads and cowries	red and white
Bayani (Abañale)	St. Raymond Nonato	same as Dada	none	red and white
Iroko	Immaculate Conception	silk-cotton tree	beaded cane	green and turquoise
Aganju (Agallu)	St. Christopher	volcano	double-edged ax	brown and opal
Shango (Chango)	St. Barbara[2]	thunder/fire	double-edged ax[3]	red and white
Obatala	Our Lady of Mercy	purity	*iruke* (horse tail)	white
Oduduwa	St. Manuel	death	coffer[4]	white and opal
Oba	St. Catherine	river	coffer and key	brown, amber, and coral
Yewa	Our Lady of Montserrat	cemetery	beaded horse tail	mauve and crimson
Oya	St. Theresa[5]	tempests/marketplace	beaded horse tail and machete	brown, red, or burgundy[6]
Yemoja (Yemaya)	Our Lady of Regla	ocean and all waters	fan adorned with peacock feathers	blue and opal or crystal
Olokun	none	ocean	none	dark blue, red, coral, and green
Nana Buruku	Our Lady of Mt. Carmel	lagoon	wooden knife	black and mauve
Oshun (Ochun)	Our Lady of Charity	river	brass fan	amber, yellow, and coral
Orunmila	St. Francis of Assisi	divination	divining chain and tray	yellow and green

[1] A hooklike instrument used in cutting grass or sugarcane, usually made of wood from the guava tree. Depending on the creativity of the devotee, the *garabato* may be painted, or adorned with beads and cowries.

[2] Although in Matanzas and other areas of the island, this could vary. It is interesting to note that Chinese immigrants to Cuba compared Shango with their god of fortune, Kwan Kung.

[3] Aganju's ax is similar to Shango's, yet differs in that Aganju's has double edges on the upper and lower portions of the ax, with a central handle by which it is held.

[4] This is undoubtedly a Cuban adaptation or improvisation for the covered calabash used in Yorubaland.

[5] In Matanzas and areas outside of Havana, Oya is syncretized with Our Lady of Candlemas.

[6] Oya also favors multicolored prints.

ELEGBA (ELEGGUA)

Elegba, the god of the crossroads, represents the ever-watchful eyes of Olodumare on *aiye* (the earth). Elegba tests humankind's faith and devotion to Olodumare. Elegba is the messenger that links humankind with Olodumare, the orishas, and the egungun (ancestors). Afro-Cubans understand his irascible nature as childlike, and his tests of faith as if these were the mischievous pranks of a child.

Elegba is present when human beings choose their destiny before birth. He knows the type of life the individual will live, along with all the events that will occur, both jovial and dismal, and can place obstacles and rewards in the individual's path. But Elegba never punishes unjustly. When he does, he must have due reason, and obtain Olodumare's permission beforehand, for he cannot interfere in human life capriciously.

The juxtaposition of orishas and saints has brought about the erroneous and arrogant equation of Elegba with the Judeo-Christian Satan among many New World orisha devotees.[11] It is important to distinguish that Elegba's nature is not intrinsically evil. Elegba uses his manipulative power to test people, but he also compensates for good behavior. Elegba is not the evil Satan whose sole purpose is to separate human beings from their Creator. Elegba's role is to seek and ensure absolute devotion to Olodumare and the orishas.

OGUN

Ogun is the god of iron and war. He is the patron orisha of blacksmiths, yet in our modern era, Ogun's patronage is also extended to chauffeurs, pilots, astronauts, policemen, and all whose profession brings them into contact with metal. It is also Ogun who guides the surgeon's scalpel. Consequently, before submitting to surgery, Ogun's aid is enlisted. Furthermore, Ogun is also a hunting deity, patron of hunters. Because of the facility with which he manages the cudgel, Ogun is able to cut through the densest of forests, thereby considered a path "maker" or "opener." Ogun opened the path for all the orishas on their descent from heaven. It is Ogun who lends his *obe* (knife) to the *ashogun* or priests who perform sacrifices.

OSHOSI (OCHOSI)

Oshosi is the god of the hunt, patron of hunters. Oshosi is endowed with the ability to hunt any animal (or foe), regardless of distance. Yet he depends on his brother Ogun to clear the path through the bushes in order to reach his prey. Oshosi is also the avenger of injustice. Piercing the guilty with his arrows, it is Oshosi who allows the criminal to be punished and the innocent to be set free. For this reason, Oshosi is propitiated when one faces an undeserved battle in court.

OSAYIN (OSAIN)

Osayin represents flora and fauna. He knows the secret of the *ashe* contained within all of Olodumare's creations and its use in providing the remedies for the maladies that afflict human beings. Worshipers consider Osayin a magician, shaman, and

healer, simultaneously. Without Osayin, the worship of the other orishas would be impossible, for it is he who provides the sacred herbs for the preparation of the *omiero*, a sacred infusion of herbs employed in the consecration of the orishas and the initiation into the priesthood.

Osayin is a horrendous but powerful man. His head is disproportionate to the size of his body. He has only one leg and one arm, a single eye, an enormous ear through which he hears absolutely nothing, and a very tiny ear through which he can hear a pin drop halfway across the world. He hops along through the forest, and works closely with Aroni and Aja (Aya), two companion orishas that help him with his daily chores.

ERINLE (INLE)

Erinle is the patron orisha of fishermen. Oshosi hunts on dry land; Erinle hunts in the water. Because of his syncretism with the Archangel Raphael, he is often called the "divine doctor." Together with Abatan (orisha of the marshland) and Otin (a minor orisha, also related to Yemoja), Erinle administers the cure while Abatan and Otin supervise the patient.

ORISHAOKO (OCHAOCO, ORICHA OKO)

Orishaoko is the god of agriculture. In compliance with a pact he made with Olodumare, Iku (death personified), and *aiye* (his father, brother, and sister, respectively), he nourishes human beings with the fruits of his labor. In turn, humans must eventually repay him with their worship and, upon death, repay his brother and sister for their cooperation in the process. His aid is also sought in cases of sterility or impotence for Orishaoko can inseminate any barren field. He shares his agricultural duties with his brother Korinkoto, who ensures the germination and rooting of his seeds.

BABALUAYE

Babaluaye,[12] the wrath of Olodumare, has control over smallpox and, by extension, of all skin sores and diseases. He is highly respected and feared; devotees implore his aid at the slightest onset of disease, but especially in times of epidemic. Among the Yoruba, Shoponno, as he is sometimes called, is dreaded, and his devotees seek to placate his wrath. Although Afro-Cubans also fear his rage, their worship centers around the procurement of health and remedies for the afflictions of life.

When epidemics spread out of control, some devotees offer an *agban*, a cleansing ritual that employs beans, tubers, fruits, meats, and all types of food. These items are put on plates surrounding a basket that contains an open piece of jute cloth. Devotees take handfuls of the food, grip it tightly in their hands, and run their closed fists over their body, starting at the feet, working their way up to the head. These items are then thrown into the basket. Symbolically, this ritual expels sickness from the body.

IBEJI (BEYI, MEYI)

The Ibeji are the patron orishas of twins. According to the myth, the first twins were children of Oshun and Shango, and were fostered by Yemoja. Because of their childish and mischievous nature, no obstacle is so great that their influence cannot overcome it. One myth about their cunning nature describes how they were able to deceive evil, thereby forcing it to spare their lives. They are small but powerful. Feasts for the Ibeji include such things as the distribution of candies and sweets to children, and may also include a piñata, obviously a New World adaptation.

The Ibeji pantheon consists of seven different orishas. The original Ibeji, Taiwo and Kahinde, followed by Idowu (Ideu), Araba (Alaba), Oronia, and Olori, all under the auspices and guidance of Aina, who is revered as the "mother"[13] of the Ibeji.

DADA AND BAYANI (ABAÑALE)

Dada and Bayani are elder siblings of Shango. Dada, his elder brother,[14] and Bayani, Shango's older sister and Dada's complement, represent Shango's crown. Together they afford the thunder god with the righteousness and serenity necessary to be a suitable and decorous ruler. Dada is Shango's adviser, while Bayani soothes his temper. Dada is also the god of unborn children. Children born with curly hair or a crownlike formation on the head are sacred to him.

IROKO (IROCO)

Iroko, the orisha of abundance and fecundity, is worshiped at the foot of the *araba* or silk-cotton tree, the sacred meeting place of all the orishas. Once when Olodumare was offended by human behavior, he withdrew to a distant place in the heavens. As a consequence of his withdrawal, drought visited the earth. During the drought, Iroko accumulated the last water that remained on earth within the roots of the *araba*. Every species that walked the planet gathered at its roots to quench its thirst. The *ceiba*, as it is called in Spanish, was the only tree whose branches reached high enough into the heavens to beseech Olodumare's mercy. After convincing Olodumare to forgive his creation, Iroko was credited with saving the world from annihilation.

Similar to Maya myths (see Schele and Freidel 1990), Afro-Cubans believe that Iroko and the *ceiba* tree are endowed with mysterious energy that separates the realms of the living and the dead.

AGANJU (AGGALLU)

Aganju is the explosive but renovating force contained within the earth's core that flows when a volcano erupts. Aganju is also the orisha of the desert and barren terrains. Like the Roman Atlas, Afro-Cubans concur that this orisha sustains the earth in its place. Some worshipers revere Aganju as Shango's father, yet others consider him Shango's elder brother. The syncretism with St. Christopher has also extended to Aganju the role of protecting travelers and navigators, ensuring their safe arrival at their chosen destination.

SHANGO (CHANGO)

Possibly the most popular orisha of the Afro-Cuban and New World traditions, Shango is the god of lightning and thunder and, along with Ogun, also a war god. He avenges evil, deplores deceit, and combats and punishes those who offend Olodumare's divine principles. There are many myths that relate accounts of his multiple romantic encounters and tell of his virile, seductive manner. Because of this, Shango's priests are generally boastful and at times attempt to emulate the behavior of their patron divinity. Shango created the ritual of initiation into the priesthood, and, in honor of this, his mortar serves as the seat where an *iyawo* (wife) of the orisha (novice) goes through the rite of initiation.

65

There are several orishas related to Shango's worship. Aina, the "mother" of the Ibeji, patron of fire and of children born entangled in the umbilical cord, serves as the magic element that allows Shango to spew fire from his mouth when he punishes the wicked. Oge (Ogue), ex-slave of Oya which she gives to Shango after violating one of his taboos, is the orisha of the pathways. Oge is represented by a pair of bull horns and helps Shango to find his way in battle. Ibokun, his military adviser, designs his war strategies.

OBATALA

Obatala is the god of creation, and of purity, suggested by his ritual use of white. His name means "the king of the white cloth." He molds human bodies from clay. Priests equate Obatala with Jesus Christ, conceptualizing him as the son of Olodumare and his direct earthly representative. Obatala is also considered the father of all the orishas, making him the most revered of all the deities, and the only orisha able to placate the wrath of all of them. All the deities must acquiesce before him and acknowledge his superiority and wisdom. Regardless of the tutelar deity of the priest or priestess, Obatala is the "owner" of all heads, and all humankind are his children.

Obatala has many "roads": different aspects or manifestations, avatars in the Hindu sense, in which the characteristics and attributes of the orisha vary tremendously. These range from a belligerent and bellicose warrior, Ajaguna, to a feeble, absent-minded old man, Oshalufon, who relies on a cane or staff for walking. Obalufon introduced the vocal chords, and thereby taught humans the art of speaking. Baba Asho shares with Obalufon the art of weaving and clothing humankind. Baba fururu and Alamorere are the sculptors of the human body. Yeku yeku represents the aging process and, along with Orolu, the wisdom acquired with age.

Although his masculine aspects dominate, certain "roads" are considered female manifestations of the deity (e.g., Oshanla, Eru Aye, Obanla). The syncretism of Obatala with Our Lady of Mercy can be said to be a "generic" veil of the major attributes encompassed by the deity. This is emphasized by the fact that each "road" is also equated with a particular Catholic saint: Ajaguna is syncretized with St. Se-

bastian; Oshaogiyan (Oshagriñan) is syncretized with St. Joseph; Oshanla is syncretized with St. Anne.

Obatala also counts on the assistance of various orishas: Oke, the god of the mountain, represents immortality; Ogan serves as Ajaguna's war general, along with Obon and Oboni; Ogidai (Agidai) helps him in controlling the spread of epidemics.

ODUDUWA (ODUA, ODDUA)

Among Afro-Cubans, Oduduwa, the progenitor of the Yoruba race, is the supreme orisha, above or equal to Obatala, sometimes considered Olodumare's direct presence among his creation. He answers to no one but Olodumare. He is recognized as the "king of the dead" and is believed to induce the decomposition of the human body after death. Initiations into the worship of this orisha seldom occur, but he may be consecrated for priests of other orishas when the need for his protection arises, either as indicated by the oracles or because of failing health.

Boromu and Borosia are two orishas that are closely connected to Oduduwa; the former is related to ailments of the body, and the latter to afflictions of the head.

OBA

Oba is the patron divinity of matrimony, Shango's original and "legitimate"[15] wife. She represents true and unconditional love, which she demonstrates when, in order to preserve her failing relationship with Shango, she falls prey to the vengeful deceit of her co-wife, Oshun. As instructed by Oshun, Oba cuts off her ear[16] and makes okra stew with it for Shango, in the belief that by so doing she would finally attain Shango's love. The thunder god became infuriated, resulting in Oba's departure from the palace. Oba, feeling hurt and useless, takes her life by jumping into a river, and is eventually deified and worshiped as an orisha. The river bears her name.

Oba is also related to death. Another version of this myth says that when Oba departed from the palace she went to live with Yewa in the cemetery. She notifies Iku when an individual's allotted time on earth has expired. Iku then takes over the transition process from life to death.

YEWA (LLEGUA)

Yewa is an orisha intrinsically connected to death. Yewa was Olofin's favored daughter or, as frequently described by priests, the "most beautiful flower in Olofin's garden," for whom sexual intercourse was proscribed. Nonetheless, Yewa falls prey to Shango's seduction, violating her taboo. When the offense was discovered, she prescribed her own punishment, choosing to withdraw to the cemetery and live in seclusion among the dead, where no living man could ever set eyes upon her again. Together with Oduduwa, Yewa regulates the decomposition of the human corpse.

Yewa is a very chaste and secluded deity. Yewa forbids sexual promiscuity, condemns polygamy, and the sexual conduct of her devotees must be discreet. She rec-

ognizes only one husband for her daughters, and it is not uncommon to find daughters of Yewa who have never married nor had sexual intercourse.

OYA (OLLA)

Oya, the fierce Amazonlike deity of the winds and tempests, third wife of Shango, is well known for her belligerent nature. It is Oya who always precedes Shango's arrival, for she is represented by the lightning rod which she gave as a present to her husband. Oya is believed to lead Shango's forces into battle, opening the way for the ensuing raid, after which Shango will then enter the battleground. When in battle (or enraged), Oya takes on a masculine personality; she grows a beard, converts her skirt into a pair of trousers, mounts her horse, and rides away with Shango to serve justice. Afro-Cuban priests sometimes affectionately call her *obini toto, olo shokoto mesan* (the fearful woman, owner of nine pairs of trousers). As related by the Ifa myth for the *odu* Osa Ogunda (see Castillo 1976), Oyá is as powerful as the buffalo or bush cow whose hide she employs as a disguise when she withdraws from the world.

Oya plays a role in the death cycle. Olodumare gave Oya the right to accompany the soul on its journey to *orun* (heaven). She clears the path of the righteous, ensuring his or her return to the place from which all things emanate. In funeral rites, Oya's *iruke* (whisk) is employed to symbolically cleanse the cadaver of earthly impurities.

Despite all her hypernormal characteristics, Oya can be as seductive, charming, and beautiful as Oshun. It was her elegance and beauty that attracted Shango's interest when he stole her heart from his brother Ogun.

YEMOJA (YEMAYA, YEMALLA)

In Yorubaland Yemoja is principally associated with the Ogun River, but in the New World she is the mother of all waters and receives offerings at the seashore. All the riches of the ocean are at her disposal, and when she believes her children are deserving, she rewards their good deeds with countless blessings. Yemoja controls the reproductive organs and their function, as well as the gestation process. She fills the womb of the infertile woman and regulates the production of milk in a woman's breasts. Yemoja is the mother of many of the major orishas. One myth says she gave birth to seventeen orishas, including Elegba, Ogun, Oshosi, Shango, Oya, and Oshun. Because of this important role, Yemoja is considered a very maternal, understanding, and loving deity who consoles her children in times of woe.

Yemoja's character is often compared to the ocean. She can be as calm as the most serene body of water, yet suddenly she can be as devastating as a tidal wave. Some of Yemoja's "roads" emphasize her versatility. Yemoja Asesu is very relaxed and carefree. Asesu spends her time counting the feathers of her mascot, the duck. If she loses count, she will start all over again. Her children are taught the virtue of

patience. Yemoja Ogunte or Okute, on the other hand, is as fierce as Oya. She is the wife of Ogun, and brandishes the cutlass as well as, or better than, her husband. Mojelewu, the Yemoja whose breasts are so large that she can nurture the whole world, is also represented by the eddy, and can be just as revolutionary. As in the case of Obatala, Yemoja's roads are also equated with various Catholic saints.

OLOKUN (OLOCUN)

Olokun is the Yoruba god of the ocean, the West African Poseidon. According to one myth, he considered himself so powerful that he challenged Olodumare to compete for the dominion of the earth. Olokun eventually lost and was condemned to live in the deepest part of the ocean. Two roads of Yemoja, Asesu and Ashaba, were assigned to assist him, along with Eshu Ayanki, the Elegba that brings Olokun's messages to the surface. The tidal wave is an indicator of his power, and when he encounters Oya, hurricanes frequent the world.

Olokun has various wives, among them the two roads of Yemoja already mentioned, along with Olosa, the goddess of the lagoons, and Ajeshaluga, the goddess of wealth. Aina, the "mother" of the Ibeji, is the daughter of Olokun and Ajeshaluga. Olokun has no priesthood among Afro-Cubans, nor does he possess any devotee, but he is consecrated and propitiated. His "scions" are initiated under the tutelage of Yemoja, and "receive" (have the attributes of the orisha consecrated) Olokun.

In Yorubaland as well as in Cuba, Olokun is considered male by some devotees and female by others. I have also heard some people describe Olokun as an androgynous orisha. A proverb of the Dilogun odu Irosun states that "No one knows what is at the bottom of the ocean." Priests attribute to this proverb the confusion surrounding Olokun's gender, emphasizing furthermore that the issue of gender is irrelevant when compared to Olokun's extensive power.

NANA BURUKU (NANA BURUCU)

Nana Buruku is the owner of sweet water. It is Nana who gives the river to Oshun. Nana is also Babaluaye's wife, whom she marries after expulsion to Dahomey. Some priests consider Nana Buruku to be a road of Obatala. Nana is more revered in Dahomey, where the Fon consider her the mother of Mawu-Lisa, the Fon equivalent of the Supreme Being. Since Olodumare in Yoruba belief cannot possibly emanate from any entity, for he is the source of all life, it is possible that the correlation with Obatala came about as a misunderstanding of the exalted position given Nana among the Fon.

Upon the descent from heaven, after Ogun cleared the path for the orishas' entrance into life, all the deities paid tribute to the god of iron. Access to Ife would have been impossible, for the path was covered with dense brush. Nana refused to pay tribute to Ogun because she did not consider it fitting that a woman of her standing would have to bow before such "brute" force. Ever since, Nana refuses to

acknowledge Ogun's power, prohibiting the use of metal for her sacrifices. Therefore, Nana's sacrifices are performed with a wooden or glass knife.

OSHUN (OCHUN)

Oshun is the owner of the river, a role she predominantly acquires in Cuba, for although a river deity in Yorubaland (patron of the river that bears her name), the Yoruba do not associate Oshun with all rivers. Oshun is better known for her alluring and sensual nature. Past scholars have equated Oshun with the Greek Aphrodite or the Roman Venus. Honey, a delicacy that she receives from Orishaoko's bees, is her lure. With it, even Olodumare has succumbed to her whims. Oshun can be the most capricious of all the orishas. Although she is the youngest of all the deities, Oshun employs her sensuality and capriciousness to achieve whatever she desires.

In spite of her apparent hedonistic nature, Oshun represents the suffering of womankind, reputed to defend her daughters from the abuse of *man*kind, often attacking men where it hurts most! Oshun laughs when she is annoyed, and cries when she is content. Her honey can be delightfully sweet, but at the slightest offense she can convert it into an extremely bitter purge. In a similar fashion, she rewards the righteous by "sweetening" their lives, and punishes the evil by making every aspect of their existence as bitter as she can.

Oshun controls the flow of blood in the human body. She chastises those who break the divine laws or incur her displeasure by attacking the circulatory system, the blood, or the heart. Oshun has been known to "sweeten" the bloodstream of many an offender.

ORUNMILA (ORUNLA, ORULA)

Orunmila is the god of divination, master of the Ifa oracle that is sometimes confused with the deity. Both names are used interchangeably by the priest to relate to the orisha. Orunmila's name means "only heaven knows those that will be saved," and it alludes to this orisha's presence when an individual chooses his or her destiny before birth.[17] For this reason, only Olodumare, Orunmila, and Elegba can guide an individual that has somehow deviated from his chosen destiny. This guidance is provided by the oracles.

Orunmila does not possess his priests, the *babalawo* (father of the secrets). Initiation into his priesthood is reserved for men. According to an Ifa myth, the worship of Orunmila and the initiation into the mysteries of Ifa were once female endeavors. Orishanla, a female road of Obatala, failed to heed the advice of Orunmila and initiated her two sons. As had been foretold, the children of Orishanla surpassed the women in their ability to memorize the *patakis* and rituals, resulting in the usurpation of the status by men and the proscription of the cult for women.

Afro-Cuban devotees also employ two other oracles that are offsprings of Ifa. Owo merindilogun, or simply Dilogun, employs sixteen cowries (*C. monneta* L. or

69

C. annulus L.). The diviner removes the convex portion of the shell with a file, so that when the cowries are cast in divination, either the natural mouth or the "open" side shows. After a series of invocations and prayers, the diviner casts the cowries on a straw mat, and counts the position of the natural mouths facing upwards. There are seventeen possible combinations, although sixteen prevail. The combinations, as in Ifa, are called *odus*.

Obi divination employs four pieces of coconut which are cast on the ground. As with the other oracles, invocations and prayers precede divination. When the coconut segments are cast, they are read in accordance with the position in which they fall (i.e., concave or convex; white or brown side up). There are five possible combinations, but the diviner also takes into consideration the position in which they fall and the pattern they form on the ground (an "L" shape, or a "T" shape may be interpreted in different manners by different diviners).

Both Dilogun and Obi are more popular than Ifa, although the latter is the "maximum" authority. As derivations of Ifa, these younger oracles have certain limits imposed on them. When a diviner encounters a problem in Dilogun or Obi divination, a *babalawo* or Ifa priest may have to be consulted. These oracles are popular because, as opposed to Ifa, they can be employed by all worshipers, both male and female.

THE PRIESTHOOD

The *babalawo* is the highest category in the priesthood. As said before, initiation into Ifa is limited to men; women cannot become Ifa priestesses.[18] A *babalawo* can be an initiate of another orisha before going through initiation into Ifa. These are called *oluwo* (owner of secrets), while the *awo* (secret) is the Ifa priest who never undertook initiation into any other orisha before Ifa. In the Afro-Cuban tradition, the *babalawo* can initiate priests only into the cult of Orunmila and Ifa. He cannot initiate the children of other orishas.

Following the *babalawo* in the hierarchical ladder are the priests and priestesses, referred to collectively as *olosha* (owners of orisha).[19] The priestess is called *iyalosha* (mother of the orisha); the priest, *babalosha* (father of the orisha).[20] It is the *olosha* who initiates other adherents into the worship of their tutelar orisha. They become the "spiritual" mothers or fathers of their disciples, and status is inferred by the number of people an *olosha* initiates into the priesthood, as well as through the acquisition of certain orishas which are considered as marks of status and respect (e.g., Oduduwa, Yewa, Osayin).

Among the *oloshas*, the position of *oriate* is sought by many. Although historically it has been a position dominated by men, women can also aspire to become *oriate*. The *oriate* is the officiating priest and master of ceremonies of the initiation rituals. Regardless of the individual's years in practice, at an initiation the *oriate* is

considered the *oba* (king), and his word is law. It is the responsibility of this priest that the ritual be carried out in utmost detail and to perfection, in accordance with the established rites handed down from generation to generation. The *oriate* also interprets the oracle on the third day of the initiation, the *ita* ceremony,[21] in which all the *orishas* the novice receives communicate with the person through the *dilogun* or cowries consecrated for the new *olosha*.

The novice is called *iyawo* (wife of the orisha). Initiation is considered a "marriage" between Eleda and *ori*, and the person's tutelar orisha. The ensuing relationship is one of mutual cooperation. The tutelar deity of the *iyawo* is identified by the oracles, principally Ifa or Dilogun. An individual cannot choose the orisha he or she would like to worship: the orishas choose their "children." It is believed that the priest is the offspring of the union between Eleda, *ori*, and the tutelar deity. Consequently, the orisha/devotee relationship is that of parent and child. A devotee is not only the worshiper but primarily the spiritual *omo* or child of the deity under which he or she is initiated.

The *iyawo* is a "newborn" child. This child must go through a series of steps to acquire "maturity" in the hierarchical scheme of the priesthood. For one year and seven days from the date of the initiation, the individual will observe a very restrictive dress and behavioral code. The *iyawo* must dress in white, wear a white hat or headscarf, refrain from liquor, dancing, and places where large numbers of people congregate, with the exception of religious ceremonies and celebrations. The *iyawo* is required to learn the different characteristics of the orishas acquired at initiation, as well as other ritual details related to initiations and other ceremonies.

At the end of the year, the *iyawo* celebrates the anniversary with a feast. The particulars of this feast may involve ritual drumming, and an elaborate array of fruits and sweets arranged before an altar or *trono* (throne) in which all the orishas are decorously displayed. The feast is open for all who wish to attend, both ecclesiastical and secular. This anniversary marks the rite of passage into the position of *olosha*. From there, the long and absorbing learning process begins, guided by the accumulated intergenerational knowledge of the older and more experienced worshipers.

The learning process of an Orisha priest is a very complex matter. Not only must the individual know how to deal with different elements of the world of the divinities, but the *olosha* must also learn how to deal with the idiosyncrasies and expectations of the living. The *olosha* is expected to guide others, and is called upon to intervene through divination and rituals on behalf of his or her godchildren.[22] This is a process unto itself, and requires not only religious knowledge but a high degree of patience and understanding if the individual is to succeed in the religious community.

The people who frequent the home of an *olosha* for guidance are distinguished according to their affiliation with the household. The *aleyo* are those for whom the oracle has recommended certain consecrations, such as the imposition of the *elekes* or beads, or have "received" an orisha with the priest. Once they have undergone these rituals, the *aleyo* is considered part of the orisha family, and enters the religious lineage of the initiating *olosha*.

This individual is no longer a stranger to the house, for he or she is now a "spiritual" child of the *olosha* and has consequently acquired a religious family in which the other members of the house are brothers, sisters, grandparents, and so on, according to their relationship with the *olosha*. The afflictions of the individual are now the interest of the collective group, and a network of mutual help is born through which support is offered and exchanged.

There are people who will consult an *olosha* sporadically, without necessarily becoming affiliated with the house. These are the *iworo* (visitors). These people simply employ the aid of the *olosha* and the deities at specific periods of crisis without necessarily having to become an adherent of the religion.

Afro-Cuban Orisha worship is a complicated religious practice that requires the full devotion of the individual. The *olosha* must learn to play a multiplicity of roles, sometimes simultaneously. This individual is not only responsible for him or herself and the welfare of the immediate family, but also for the well-being of a multitude of people that compose the vast and extended religious family.

Unlike other religions, Orisha worship becomes an intrinsic part of daily living. It is not only a religion; it is a way of life. The *olosha*'s *ita* is unique: a personal communication between the deity and the devotee, in which the individual is given the prescriptions and proscriptions that will amount to a full and proper life. These are individual and personal revelations that are forecast for the individual, and not theological and impersonal doctrines for the collective.

There are no churches, for the devotee's shrine is in the home. The home becomes the church, the temple, and the sanctuary. Each *olosha* has his own personal orishas consecrated especially for the individual. These deities are given to the priest or priestess, and reside in the individual's home as one more "member" of the dwelling. The orishas are not alienated from the worshiper; they are not in a distant structure to which the individual goes to pray on a weekly basis. The deities become palpable, personal entities that are active elements and participants in daily affairs. They share the devotee's joys and sorrows, comforts and aggravations, creating a bond that is born from personal devotion and dedication, from the devotee to the orisha and vice versa.

Although many may feel a calling, few are truly "chosen." It is these few who, in the short period of one lifetime, attempt to deposit a grain of sand in the vast ocean that represents human existence. And these few people, coupled with the experience they acquire with the years, continue to transmit this knowledge to all subsequent generations. A ritual chant for the ancestors expresses this sentiment: *alagba-lagba ofe n'soro* (the elders have seen and spoken).

NOTES

1. Blassingame 1977:319, reprinting depositions that appeared in the *Anti-Slavery Reporter*, ser. 3, vol. 2, October 2, 1854, pp. 234–39.

2. In addition to the Yoruba, other groups also preserved aspects of their culture. The Efik (known in Cuba as Abakua), the Ewe-Fon, and many subgroups from the Congo, especially the Bantu, also retained their magico-religious practices. The Abakua secret society, known in Cuba as the ñañigos, is the Efik legacy. The Ewe-Fon preserved their religious practices, known in Cuba as Regla Arara. Palo Mayombe/Kimbisa comes from the various Congo groups. See Cabrera 1975.

3. I decline to use the term *Santería* because of its pejorative connotations. In this chapter I refer to the religion as Afro-Cuban Orisha worship or Orisha tradition. I use *Orisha* when referring to the religion, and lowercase orisha to refer to the deity. When I describe aspects of the religion as Afro-Cuban, I extend this classification to all practices of this tradition, which are no longer limited to Cuba and Cubans. As a result of the Cuban Revolution, there are now Afro-Cuban priests in the United States, Canada, the Dominican Republic, Puerto Rico, Panama, Venezuela, Colombia, Spain, France, and other countries where Cubans have migrated.

4. Also called Olorun (Owner of the heavens) and Olofin (Owner of the heavenly palace).

5. For which *Santería* was an opprobrious and demeaning label; see Ortiz 1965.

6. In today's totalitarian Cuba, the Afro-Cuban religions have been the major influence in the survival of Catholicism. Adherents go to the churches to worship the Virgin of Regla (Virgin of Charity), while simultaneously venerating Yemoja and Oshun at home. In these respects, we can say that the score is even.

7. For further reading on the Ifa oracle in Yorubaland, see Bascom 1969b; on Dilogun, see Bascom 1980; on Obi, see Epega 1931. For reading on the Cuban adaptation of these oracles, on Ifa, see Castillo 1976 and Bascom 1952; on Dilogun, see Cabrera 1980 and Bascom 1952, 1980; on Obi, see Ramos 1982a.

8. Witches, sorcerers, and the personified representations of *iku* (death); *arun* (sickness); *ofo* (loss); *eyo* (tragedy), and so forth.

9. Each orisha has specific details that are strictly observed in preparation for offerings and meals. Obatala forbids the use of salt and spices in his foods. Elegba, Ogun, Shango, Babaluaye, and the other fiery orishas delight in spicy foods. Oshun's foods are served in accordance with her refined nature.

10. As is the case in Trinidad where Yoruba religion merges with the beliefs of the Spiritual Baptists (Houk 1992).

11. Although this correlation does not apply for Cuba, in Trinidad and Brazil Eshu-Elegba is compared to Satan.

12. Babaluaye is syncretized with the biblical Lazarus widely venerated throughout Latin America, and not the canonized Lazarus. Although not recognized as a saint by the church, in popular Catholicism he is considered one.

13. She is considered the "mother" of the Ibeji because Aina is the eldest member of the seven orishas in the Ibeji pantheon.

14. In one myth, Dada is depicted as Shango's elder sister who raised him when his father, Obatala, enraged by an incestuous relationship between his elder son Ogun and his mother Yemoja, swore to kill any child born from Yemoja's womb henceforth.

15. The emphasis on the legitimacy of Oba's marriage to Shango and her role in the pantheon as the patron divinity of matrimony possibly attempts to account for polygamy, practiced by the Yoruba yet shunned by Christian mores. This may also account for the many amorous anecdotes attributed to Shango, since Oya and Oshun are also considered wives of the thunder god.

16. Oshun is reputed to be Shango's favorite wife. In the myth, Oba asks for Oshun's help. Oshun tells her that she has won Shango's unconditional love by feeding him a small piece of her ear in okra stew. Oba figures that if Oshun gained her status with a small piece, she could topple that position by feeding Shango her whole ear.

17. Besides Olodumare and Orunmila, the only other orisha present is Elegba. Orunmila and Elegba are intrinsically related to the three divinatory systems employed in Yoruba religion.

18. Recently an Obatala priestess, originally initiated into the Afro-Cuban system, was initiated into the cult by a Yoruba *babalawo*. According to sources, the initiation took place in New York City during the late 1980s.

19. The word *orisha* is frequently abbreviated to *osha* or *ocha*.

20. "Mother" and "father" are used figuratively, for although they do not physically give birth to the orishas themselves, these priests "give birth" to, or create, the orishas worshiped by an individual.

21. His function as "reader," or interpreter of *ita*, has given birth to the term *italero* (he who reads *ita*), a merger of Yoruba and Spanish terms.

22. The *oloshas* are called *madrina* or *padrino*, godmother or godfather. Their followers are their *ahijados*, or godchildren, obviously as a result of the Catholic influence.

REFERENCES

Abraham, R. C. 1946. *Dictionary of Modern Yoruba*. London: Hodder and Stoughton Educational.

Angarica, Nicolas V. n.d. *Manual del Orihate-Religión Lucumi*. Havana.

Awoniyi, Timothy. 1981. *The Word Yoruba*. Nigeria.

Bascom, William. 1952. "Two Forms of Afro-Cuban Divination." In *Acculturation in the Americas*, vol. 2, gen. ed. Sol Tax. Chicago: University of Chicago Press

———. 1969a. "Yoruba Concepts of the Soul. In *Men and Culture*, ed. A.F.C. Wallace. Berkeley: University of California Press.

———. 1969b. *Ifa Divination: Communication between Gods and Men in West Africa*. Bloomington: Indiana University Press.

———. 1969c. *The Yoruba of Southwestern Nigeria*. New York: Holt, Rinehart and Winston.

———. 1972. *Shango in the New World*. Austin: African and Afro-American Research Institute, University of Texas at Austin.

———. 1980. *Sixteen Cowries: Yoruba Divination from Africa to the New World*. Bloomington: Indiana University Press.

Bastide, Roger. 1978a. *The African Religions of Brazil*. Baltimore: Johns Hopkins University Press.

———. 1978b. *O Candomble Da Bahia: Rita Nago*. São Paulo: Instituto Nacional Do Livro.

Blassingame, John W. 1977. *Slave Testimony: Two Centuries of Letters, Speeches, Interviews, and Autobiographies*. Baton Rouge: Louisiana University Press.

Cabrera, Lydia. 1970. *Anago: Vocabulario Lucumi*. Miami: Universal.

———. 1975. *El Monte*. Miami: Universal.

———. 1980. *Koeko Iyawo: Aprende Novicia—Pequeño tratado de Regla Lucumi*. Miami: Universal.

Castellanos, Jorge, and Isabel Castellanos. 1988. *Cultura afrocubana 1 (El Negro en Cuba, 1492–1844)*. Miami: Ediciones Universal.

Castillo, Jose M. 1976. *Ifa en tierra de Ifa*. Miami.

Epega, D. Onadele. 1931. *The Mystery of Yoruba Gods*. Ode Remo, Nigeria: Imole Oluwa Institute.

Houk III, James Titus. 1992. *The Orisha Religion in Trinidad: A Study of Culture Process and Transformation*. Ph.D. dissertation. Tulane University.

Idowu, E. Bolaji. 1962. *Olodumare: God in Yoruba Belief*. London: Longmans.

Johnson, Samuel. 1921. *The History of the Yorubas*. London: Routledge and Kegan Paul.

Knight, Franklin W. 1970. *Slave Society in Cuba during the Nineteenth Century*. Madison: University of Wisconsin Press.

Lachatañeré, Rómulo. 1939. "El sistema religioso de los Lucumís y otras influencias africanas en Cuba. In *Estudios afrocubanos* 3:28–90.

Laviña, Javier. 1989. *Doctrina para Negros: Explicación de la Doctrina Cristiana acomodada a la capacidad de los Negros Bozales*. Barcelona: Sendai Ediciones.

Ortiz, Fernando. 1952–55. *Los instrumentos de la musica afrocubana*, 5 vols. Havana: Ministerio de Educación.

———. 1965. *La Africania de la musica folklorica de Cuba*. Santa Clara, Cuba: Universidad de Las Villas.

———. 1973. *Hampa Afrocubana: Los Negros Brujos*. Miami: Universal.

Palmer, Colin. 1992. "The Cruelest Commerce." *National Geographic* 182(3):63.

Ramos, Arthur. 1980. *The Negro in Brazil*. Philadelphia: Porcupine Press.

Ramos, Miguel W. 1982a. *Dida Obi: Adivinación a Través del Coco*. Carolina, Puerto Rico.

———. 1982b. *Oro . . . Egungun: Las Honras de Egungun*. Carolina, Puerto Rico.

Sandoval, Mercedes C. 1975. *La religión afrocubana*. Madrid: Playor.

Schele, Linda, and David Freidel. 1990. *A Forest of Kings: The Untold Story of the Ancient Maya*. New York: Quill William Morrow & Co.

Simpson, George E. 1978. *Black Religions in the New World*. New York. Columbia University Press.

———. 1980. *Religious Cults of the Caribbean: Trinidad, Jamaica and Haiti*. Puerto Rico: Institute of Caribbean Studies, University of Puerto Rico.

75

Uya, Okon Edet. 1989. *Historia de la esclavitud negra en las Americas y el Caribe*. Argentina: Editorial Claridad.

Verger, Pierre. 1957. *Notes sur le culte des Orisa et Vodun*. Dakar: L'Institut Français d'Afrique Noire.

Warner-Lewis, Maureen. 1991. *Guinea's Other Suns*. Dover, Mass.: The Majority Press.

DAVID H. BROWN

TOWARD AN ETHNOAESTHETICS OF SANTERÍA RITUAL ARTS
THE PRACTICE OF ALTAR-MAKING AND GIFT EXCHANGE

Priests of the religion popularly called La Santería or La Regla de Ocha,[1] for perhaps two centuries in Cuba and more than fifty years in the United States, have assembled shrines for the *orichas*.[2] The *orichas*, a pantheon of deities brought to Cuba by enslaved Yoruba in the nineteenth century, are experienced by devotees as loving, protective, but demanding sacred powers. The Afro-Cuban imagination reconstituted the iconography of these splendid royal presences—originally the mythological founders, kings, queens, and warriors of great West African kingdoms—by combining Yoruba traditions of bead- and clothwork and local models of baroque adornment appropriated from the Cuban colonial church, state, and rising bourgeoisie in the nineteenth century. *Orichas* formally "dressed" for periodic and calendrical ritual celebrations are saluted as they occupy temporary festival altars called *tronos* ("thrones"), assemblages of cloth, ceramics, and beadwork, which in the United States today are constructed almost entirely of mass-marketplace materials and purchases.

The following discussions explore the "experience-near" (Geertz 1983b)[3] aesthetic and religious concerns of two New York priestesses (*iyalochas*) of La Regla de Ocha. In addition to the involved and expensive ritual work they engage in daily, they devote significant amounts of time, concern, and money to making "beautiful" cloth and beaded objects in order to present formally their *orichas* in annual and periodic celebrations. Close consideration of their creative artistic practice reveals a special, active, and generative role for art object making in their religious lives, which may be obscured by some of the

interpretive assumptions and emphases commonly applied to ritual arts in a field that has drawn from art history and anthropology.

Regarding the priestesses' artwork in "wholly intra-aesthetic" (Geertz 1983a), formal terms clearly has its limits, as the objects participate in a socio-ritual process. Classing their art making and objects with other media and actions in the "ritual system," along continua of affective form (aesthetics), meaning, instrumentality, and social function is a useful heuristic exercise, yet may obscure, as much as reveal, subtle dimensions of the priestesses' art-making intentionality. Particularly, questions about the relation of art and ritual as systems of phenomena—what aesthetic categories they occupy, what they "mean," and how they function—produce different kinds of answers than questions about the emergent experience and feelings of specific historical agents.[4]

As a set of hypotheses, which build on the conclusions of recent studies in Africa and the African Diaspora, it is suggested that (1) while clearly related to more technical "ritual" work, the priestesses' production of artful altar objects, and visually striking altar presentation itself, participates in a distinctive, emotionally charged cycle of ongoing, gift-exchange relationships with the *orichas* that is central to their personal, religious, and social lives; (2) art making is a strategy for "pleasing the *orichas*" aesthetically on marked, semi-public occasions,[5] which brings returns and transforms realities; (3) although initiated as *oricha* priestesses in prior, decisive ritual passages, their artistic production generates and creates in important ways what are emergent and imaginative, ongoing relationships with the *orichas*. In short, there is a kind of "surplus" of meaning and sense or feeling which is unaccounted for by the usual questions we ask about form, meaning, and function. Alternatively, one might say there may be an absence of conventionally expected kinds of meaning.

Theoretically and methodologically speaking, an emphasis upon everyday, emergent artistic practice limits our ability to depend wholly upon such static structuralist abstractions, generalizing contexts, or totalizing subtexts as "belief system," "ritual system," "iconographic tradition," "the Yoruba," "Santería," "cultural code," and so on, which render human agents relatively "transparent" in their actions and expressions and which cannot account for the fluidity of change, what scholars have called "traditionalizing," in local settings.[6] Throne making (and altar making more generally) is an additive, emergent process of exchanges, usefully seen as a diachronic and very specifically historical problem. We have become quite content, for example, to interpret, gloss, decode, or situate objects, for conceptually and discursively based meanings, and in relation to contexts and structures that are taken for granted or taken to be unproblematic. How those contexts and structures may have been created or reproduced (micro)historically in the very process of the objects' making and circulation, by agents whose performance and work transform

them and their world, is obscured. In particular, I want to suggest that the priest-esses' art making instantiates cosmological and socio-ritual structures and relationships, as opposed to merely "reflecting" or "expressing" prior abstract structures or relationships seen as more "fundamental" than the practices themselves.

AESTHETICS, INSTRUMEN-TALITY, AND MEANING IN YORUBA-ATLANTIC RITUAL ARTS

How should one locate clothwork and beadwork objects in Afro-Cuban Santería, objects that priests evaluate as "beautiful," in relation to other "ritual objects" in the same religion specifically, and the Yoruba-Atlantic tradition[7] in general? Are they distinct from the efficacious, technical media of initiation and sacrifice (ebó) that ritually consecrate orichas and solve problems in the Yoruba-derived ritual pattern (Awolalu 1979; Bascom 1950)? May they be discussed profitably in terms used to characterize, for example, the effect of Yoruba sculptural arts? It is relatively easy to see "stones, herbs, and blood," defined by William Bascom as the "focus of Cuban Santería" (1950) (along with water, palm nuts, cowrie shells, and so on), as generative and efficacious in the sacred terms of the religion. They embody and provide directly the aché (enabling power) of nature (la naturaleza), without which one cannot start or accomplish anything.[8] Washed and fed with fresh herbal infusions (osains) and animal blood, respectively, stones and shells are invigorated with aché and form the envesseled core "secrets" of the Yoruba-Atlantic shrine (Bascom 1950; Thompson 1983; Brown 1989, 1993; Matory 1994).[9]

79

Clothwork and the thick, multistrand bead sashes called collares de mazo (see below), because of their decoratively elaborated aspect, appear somewhat more gratuitous, or at least "optional" and dispensable, objects of art. First, they are not formally "consecrated" with herbal infusions and blood. Second, not "secrets" at all, they are intended for semi-public display. Third, moreover, in most Cuban impoverished settings they have been scarce or nonexistent; the religion survives without them.[10] One could indeed imagine a kind of minimalist practice that admitted of very few—and very mildly elaborated at that—iconographic objects for the gods, as in many Yoruba shrines (see Matory 1994:156, 163).[11] At the same time, even Yoruba—and several other kinds of Santería—ritual artworks in wood, terracotta, and metal are washed and fed with blood and food in order to invigorate them with ashé.[12] In short, many ritual media are consecrated ritually and restricted visually, although for those initiated priests who handle them, they may be (minimally) aesthetically marked. Much Yoruba ritual art is, in fact, consecrated in this way. Yet the beaded and cloth objects are nonconsecrated, heavily marked aesthetically, and subject to public and extended visual contemplation and evaluation.

Scholars have discussed ritual arts in the Yoruba-Atlantic tradition along several dimensions, explaining their ritual/cosmological role on a continuum with other ritual media in terms of affective form (aesthetics), instrumentality, and mean-

ing. If it is accepted, for example, that "the Yoruba assess everything aesthetically— from the taste of a yam to the qualities of a dye, to the dress and deportment of a woman or a man" (Thompson 1983:5), ritual art objects may be seen as similar to other aesthetically marked objects, words, actions, dispositions, and experiences in the culture. Indigenous systems or grids of classification depend significantly on aesthetic qualities as well as latent symbolic meanings (Levi-Strauss 1966), and Yoruba and Afro-Cuban religions have been regarded in such terms (e.g., Marks 1987). From another angle, instrumentality, in concert with aesthetic form, initiates a second continuum. Linked with the idea of the ritual "praise" utterance, arts have been dubbed "visual praise poems" (Thompson's term),[13] implying that art participates in the ritual process in not only "honoring" the deities but also calling them into presence and action. Special and appropriate objects potentially can "incarnate . . . àshe" or the ritual power of efficacy (Thompson 1983:5–7; Drewal 1989; Abiọdun 1994). Thompson (1983:7), Henry Drewal et al. (1989), Margaret Drewal (1989), and Robert Plant Armstrong (1981) specifically connect artwork and aesthetics to ritual and cosmology through the concept of "invocation."[14] For all of them, in the religious context, art objects both embody presence-as-spirit (i.e., ashé), as containers of a sort, and simultaneously are the media of invocation—like offerings of praise and sacrifice (Drewal et al. 1989:26). Spiritual presence is invoked in and through them for purposes of ritual passages and problem solving.

Apart from such practical efficacy, and consistent with Armstrong's notion of "affecting presence," Abiọdun suggests that it is the presence of ashé (which Abiọdun characterizes as an "affective" presence) that distinguishes an ordinary "attractive artifact" from one that makes "an appreciable religio-aesthetic impact." A sculpture and imaginably any other work such as a beaded crown or splendid cloth gown that embody ashé, have efficacy in their ability to "trigger . . . an emotional response in the audience," presumably with life-changing potential (Abiọdun 1994:74, 78). In this formulation, an object can manifest ashé by being recognized as having certain aesthetic qualities, not necessarily by being formally consecrated with ritual media. Indeed, according to Armstrong, objects not directly involved in the "invocation" process may nevertheless enrich the affective power of composite assemblages like shrines, by the addition merely of their aesthetic virtue or "excellence"—like figurated houseposts (Armstrong 1981) and, imaginably, like the flywhisks and elaborate cloth that accompany a king's consecrated beaded crown as auxiliary statements about his power and prerogative (see Thompson 1970). Thompson, Lawal, and others, moreover, find that in their exceptional formal aesthetic qualities art objects manifest and project moral principles and ideals at the heart of the culture ("character" and "coolness"), as well as the divine principle of ashé. They inspire awe and reverence, model ideal behavior and attitudes, and so on

(Thompson 1983; Lawal 1974). Humanistic Yoruba shrine sculptures, according to Drewal et al., "locate" the worshiper relative to the divine, as they "provide images of devotion and represent the empowerment by the god of those who kneel and present offerings and sacrifices" (Drewal et al. 1989:26). One implication, an idea this study heartily embraces, is that the sculptures in fact face and mirror worshipers in the shrine as affective, mimetic "models of/models for" (Geertz 1973b:93) appropriate, bodily, devotional dispositions or attitudes.

Finally, art objects may be classed and approached together with other ritual objects in the dimension of their referential "meaning." Victor Turner's symbolic anthropology (e.g., 1967), Clifford Geertz's interpretive anthropology (1973a), and Erwin Panofsky's iconography/iconology (1955) have, explicitly or implicitly, shaped approaches to and assumptions about meaning in African and African Diaspora arts. Aesthetically exceptional, wholly utilitarian, mundane, and natural objects may be addressed for their symbolic meanings. They are read, decoded, deciphered, or interpreted like texts for latent meanings that have their basis in prior, external, or more fundamental grounds—particularly social structure, "culture," or a subsystem like "religion," and inscribed master texts like the Bible. Turner approaches objects, as well as gestures, words, and so on, as "symbols" or clusters of them. Symbols, the "smallest unit[s] of ritual" (1967:19), are to be interpreted emically and etically for three levels of meaning in relation to the social field of action.[15] For Geertz (1973a), culture is a "semiotic . . . concept" ("webs of meaning"), cultural analysis is an "interpretive one in search of meaning" (p. 5), and ritual is regarded necessarily as instrumental but as a hermeneutic "window" on the society for the ethnographic observer and a self-reflexive mode for the participant (see Bell 1992).[16] Panofsky's three-tiered method consists in (1) situating objects/icons/motifs in a form history (*pre-iconographical description*); (2) identifying the meanings of the forms in textual "images, stories, and allegories," that is, "types" (*iconographical* analysis); and (3) interpreting the forms, as "cultural symptoms," to reveal the "symbolical values" or "attitudes" of a "nation, period, class, religious or philosophic persuasion" (*iconological interpretation*) (1955:26–41).

Something like Panofsky's three-tiered method was taken up by pioneers of Yoruba ritual arts such as Joan Wescott (1962) and Robert Farris Thompson in Africa and the Diaspora (e.g., 1983). After these powerful models we have learned to gloss or contextualize objects by marshaling myths and praise poems from published accounts and/or the lips of informants.[17] For Wescott, "myths and songs give the best clues to [the meaning of] cult symbols and sculptured forms" beyond, and despite, even, the commentary of informants. For the ultimate domain of meaning is "beyond the conscious level within the culture itself." The investigator would "link . . . a statement in myth with . . . [its] visual parallel or iconographic referent

in the sculpture" (1962:336–37). So, for example, from an itemizing of Eshu-Elegba's iconographic formal elements (Panofsky's first tier), Wescott moves to the parallel or identification of sculptural forms and selected myths/praise song themes (Panofsky's second tier), and culminates with the eliciting of abstract cultural meanings, in which elements of Eshu-Elegba sculpture are seen to refer to "commerce," "aggression," "destruction," "vanity," and so on, that is, their "iconological significance" (p. 349) as in Panofsky's third tier.[18] If Panofsky's method and Wescott's deployment of it are illuminating, they produce somewhat static results, however. Thompson's iconography/iconology, on the other hand, is somewhat more consonant with Victor Turner's emphasis upon symbols as "force[s] in a field of social action" (1967:44). Thompson addresses the dynamic role of objects in "motion," that is, the relation of "icon and act" (1974) in the "danced faiths" (1966) of the black Atlantic world.

82

KINDS OF MEANING

If we are interested in meaning, how does one balance so-called "deeper" or higher-order cultural or archetypal meanings on the one hand (e.g., Barnes 1989) with locally and individually specific, even idiosyncratic, meanings on the other hand?[19] How are general and paradigmatic cultural "core principles" reconciled with the emergent and positioned meanings of individuals and local groups? How does the kind of meaning relevant to the explanation of *systems of phenomena* correlate with the meaning of *individual experience*? With information from intensive work with a single diviner, Oṣitola, for example, the Drewals were able to elicit the meaning, function, and aesthetics of a particular Ifá divining board and shrine, revealed in relation to his specific history and practice, and which Margaret Drewal has demonstrated to be emergent and improvisatory (M. Drewal and H. Drewal 1983; Drewal 1992). (Of course, given the historical collecting context of African art, ethnoaesthetic consideration of a single creative individual, as here and in Thompson's early work with the potter Abatan [1969], has not always been possible.) The writers caution that "because interpretations in matters involving supernatural forces can be personal, and because there are regional variations of practice, generalizations about Yoruba religious beliefs and practices are risky. The practice of Yoruba religion is dynamic, not rigidly prescribed" (p. 25). On the other hand, these and other writers do identify and generalize "core principles" or paradigms, such as the Yoruba concept of the head (orí) (Drewal et al. 1989:26), the cosmic principles of orun and aye (p. 14), and such moral or ethnophilosophical principles as "character" (iwa) and "coolness" (itutu) (Thompson 1983:9–16), which manifest themselves in artworks.

Part of the answer lies in the balance of what used to be called emic and etic emphases on the part of the observer—alternatively local and global, particularizing

and totalizing, or derived and imposed positionalities. The important question, Turner (1967:26) asks, is "meaning for whom?" Depending upon our focus, we can represent "Santería" as a synchronic ritual and iconographic system of Yoruba origin whose structural categories transcend, but will predict the behavior of, any particular practitioner. Or we can focus on the world of a practitioner or small group of them (e.g., a "house"). Our assumptions about structure, system, and meaning, and the weight we give to the structure and constraint of "tradition"—in this case the relative determinacy of African origins—will affect how much of a role the practitioners' authority and specific intentionalities will have in the representation of what they do.[20] Turner, as opposed to earlier researchers who chose to discount everything but the conscious statements of informants (i.e., to reject any "uncomprehended symbol"), chose to build a method on an etic as well as emic perspective. Yet for him, only the observer's "objective" position could elicit the "total meaning," that is, the polysemic and contradictory meanings of single symbols across various contexts that more narrowly positioned participants could not see (1967:26).

The psychoanalytic paradigm permits Panofsky and Wescott to explore the "unconscious" links between objects and meanings, beyond or despite the explanations of informants/creators. In relation to the problem of tradition in conditions of diaspora, how much emphasis should an indigenous core cultural principle like the Bakongo "four moments of the sun" have in any local site of interpretation, where its presence may not specifically be acknowledged by agents but interpreted from its form? For example, the principle first brilliantly elicited in Africa (Thompson and Cornet 1981) is often transposed to the interpretation of Afro-Brazilian, Afro-Cuban, and Haitian religious signs (Thompson 1983), African-American self-taught artists (Intar Gallery 1989), and African-American crafts and studio arts (Thompson 1989; Wahlman 1986). These interpretive postures shoulder the researcher with serious responsibility as a privileged representer of a group.[21] On the other hand, particularistic fidelity to one group or individual in a more complex field may overlook crucial differences in competence between "laymen" and "specialists" (Turner 1967:51). Or it may lead to the ethnographer's capture by particular interests in a field of inter- or intracultural politics. A certain global posture is almost demanded of the observer in order to represent competing truth claims which have, at one time or another, turned ethnographic and historical reporting into a kind of propaganda in local, regional, and diasporic cultural politics (Apter 1992; Wafer 1991).[22]

The ethnoaesthetic argument of Price and Price (1980) suggests that the question is less one of applying a particular approach to the problem of meaning than allowing the categories of informants to produce an appropriate approach for the observer. The Prices critiqued the general applicability of iconographic and symbolic

approaches in demonstrating that Suriname Maroons do not correlate objects and designs with abstract reference systems of meaning. Particular designs do not "mean," for example, "fertility" or "love," just the kinds of abstract or archetypal meanings Wescott interpreted in Elegba sculpture or Sandra Barnes elicited as the "deepest meanings" of the iron god Ogún (1989). "Meanings" for Maroons were far more mundane and concrete. Cryptic designs turned out to be marks of ownership; an object "means" to Maroons in terms of who gave or received it on what occasion, who may use it in what context. Thus "meaning" is lodged in the dynamic circulation and intensive aesthetic evaluation of objects that proceed within networks of social relationships of exchange. In short, an ethnoaesthetic focus *in this case* excludes an iconographic or symbolic approach—Maroons do not think in terms of "iconographic meaning"—and, in a sense, produces the concept of *"social meaning"* instead (Price and Price 1980:ch.7; emphasis added). Ultimately, however, do the connotations of the term "social *meaning*" itself undercut a possibly stronger sense of how Maroon art "permeates" Maroon life (Price and Price 1980:35) as wholly "embodied" and "embodying"?[23]

Two questions remain about meaning. How dependent is one's approach upon discursively based conceptual or semantic meanings and how are objects and actions, if at all, to be seen in relation to what we are used to calling contexts, structures, and systems of reference? The "interpretive" posture often assumes that objects, actions, the identities of the actors, the religion they practice, and the culture they belong to, are all thoroughly representable or mediatable in discourse as systematic objects of knowledge, and mediatable to an audience through the anthropologist-translator. Catherine Bell (1992) explains that "the interpretive project" assumes that the "text" (e.g., object or rite) "is autonomous and unified on the one hand, and that its latent meaning is fully accessible to a close reading of its manifest form on the other." As it "encodes something . . . the assumed existence of such a 'something,' the latent meaning of the act . . . devalues the action itself, making it a second stage representation of prior [abstract] values" (p. 45)—or more "fundamental" grounds, reference systems, or structures such as "culture" and "society" (p. 37). Panofsky's iconology, for example, specifically refers to the work of art as a "symptom of something else," that is, unconscious "symbolical values" (Panofsky 1955:31).

While Panofsky's iconography/iconology remains virtually committed to text-bound discursive or semantic meaning, both Turner's symbolic approach and Geertz's interpretive approach attempt to contain nondiscursive, noncognitive, affective sense on the one hand and discursive meaning on the other hand—in an enterprise that Bell's critique nevertheless reveals as internally contradictory.[24] Robert Plant Armstrong (1971, 1981), taking an extreme position, removes aesthetic ob-

PLATE 1.

Birthday throne for the Obatalá-Ayáguna by Melba Carillo, Manhattan, October 9, 1987. *Paños, collares de mazo* by Melba. Overall throne design by Ramón Esquivél. From the left: Changó, San Lázaro (his sacred broom is visible), Obatalá-Ayáguna and Obatalá-Ochanlá (up high); Yemayá-Achabá (below); Ibeyi and Guerreros (below); Ochosi (leopard cover); Ochún. Center U-shaped mat is for *Moforibale*, at whose head is the basket for tributes and the shakers and bells for salutation. White birthday cake with red trim and "tower" of meringue are for Obatalá. Photo: David H. Brown.

PLATE 2.

Detail of plate 1. Yemayá with *mazo* and oars, with layered *paños*; Ibeyi twin dolls; Eleguas with *mazos* and hooked *garabato* staff (front center); Ogún with *mazos* and beaded machete. Photo: David H. Brown.

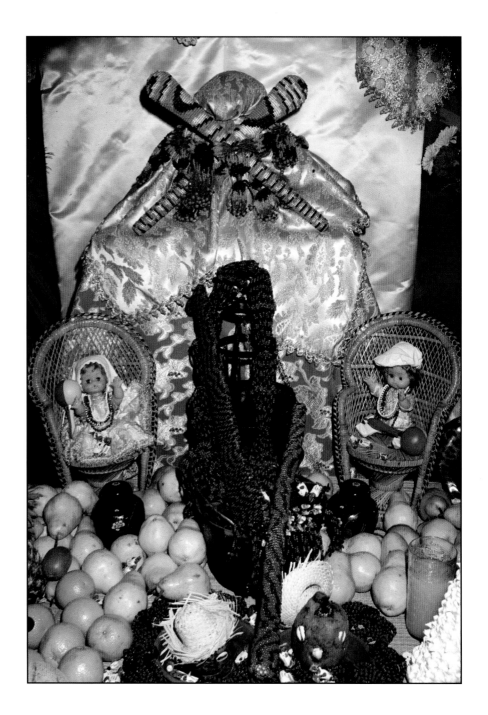

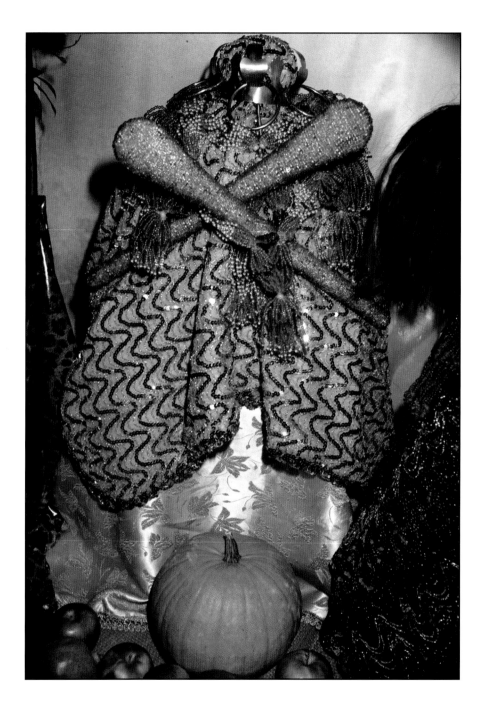

PLATE 3.

Detail of plate 1. Ochún with brass crown, beaded oars, and *mazos*. Note "rock candy" *glorias* and layering of *paños*. Ochún receives a pumpkin which she uses to heal. Oyá's *paño* of "nine colors" is partly visible. Photo: David H. Brown.

PLATE 4.

Detail. Layered *paño* made by Josie García for Yemayá-Achabá, with sheer aquamarine paisley fabric in front and dark silver brocade beneath, along with *mazo* made by Melba Carillo. Iron chain of Ogún's tools belongs to this "warrior" Yemayá because she takes the strength of the strong Ogún. Note decorative *gloria* and "coral" beads. Photo: David H. Brown.

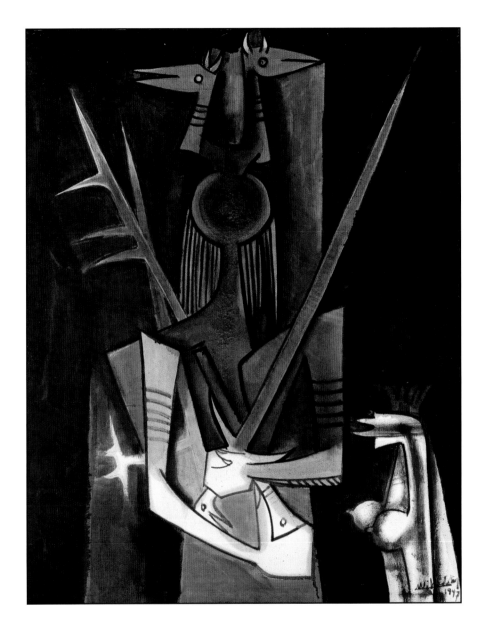

PLATE 5.

Wifredo Lam, *The Warrior (Le Guerrier)*. 1947. Oil on canvas. 106.0 × 84.1 cm (41¾ × 33⅛ in.). Courtesy of the Estate of Wifredo Lam and Galerie Lelong, New York.

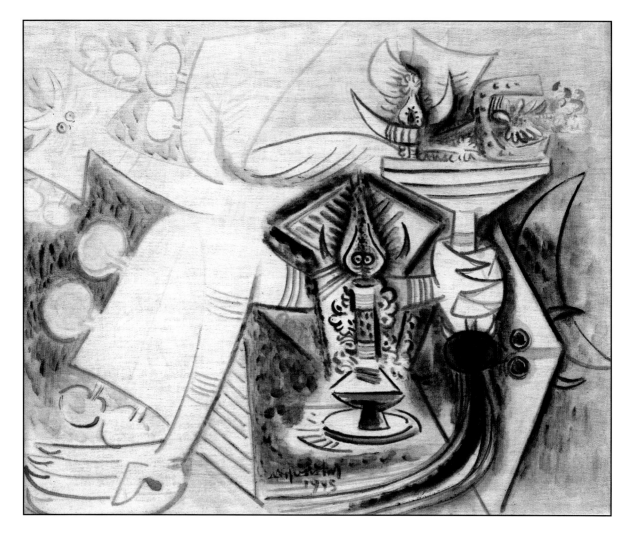

PLATE 6.

Wifredo Lam, *The Night
Lamp* (*La Lámpara*).
1945. Oil on canvas.
59.4 × 72.4 cm (23⅜ ×
28½ in.). Private collec-
tion. Courtesy Sotheby's,
New York.

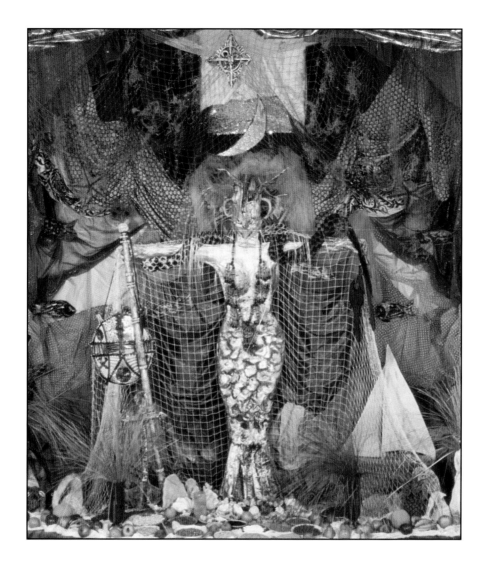

PLATE 8.

Juan Boza, *Oyancile*. 1982. 127.0 × 91.4 cm (50 × 36 in.). Acrylic on canvas. Courtesy of Ricardo Viera.

PLATE 9.

Juan Boza, *Sese-Edibo*. 1984. 127.0 × 91.4 cm (50 × 40 in.). Mixed media on canvas. Courtesy of Ricardo Viera.

PLATE 10.

Ana Mendieta, *Silueta Works in Iowa.* 1976–78. 50.8 × 34.3 cm (20 × 13½ in.). Courtesy of the Estate of Ana Mendieta and Galerie Lelong, New York.

PLATE 11.

Ana Mendieta, *Silueta Works in Iowa.* 1976–78. 50.8 × 34.3 cm (20 × 13½ in.). Courtesy of the Estate of Ana Mendieta and Galerie Lelong, New York.

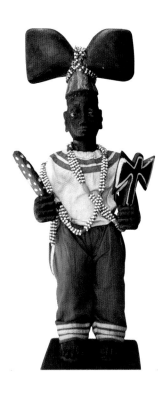

PLATE 12.

Changó—Dios del trueno, el rayo, la lluvia. Collection of Casa de las Américas. Fernando Ortiz Collection, Havana, Cuba. Photo: Arturo Lindsay.

PLATE 13.

Angel Suarez-Rosado, *Babalú-Aye.* 1991. Multimedia installation. Courtesy of the artist.

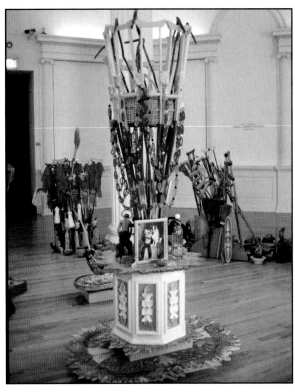

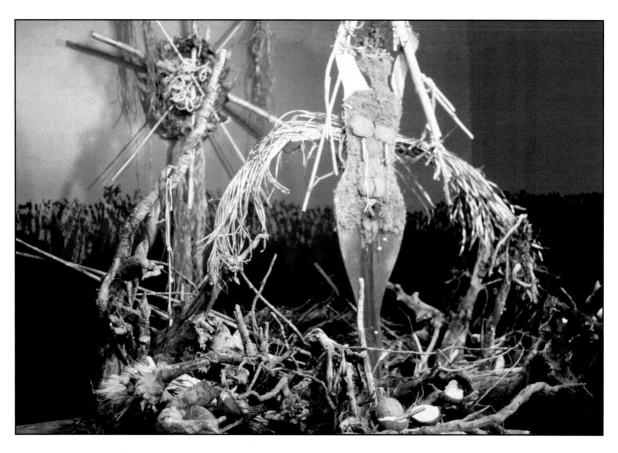

PLATE 14.

Raquelín Mendieta,

Raices y Memorias. 1993.

Multimedia installation.

2.4 × 4.9 × 4.0 m

(8 × 16 × 13 ft.).

Courtesy of the artist.

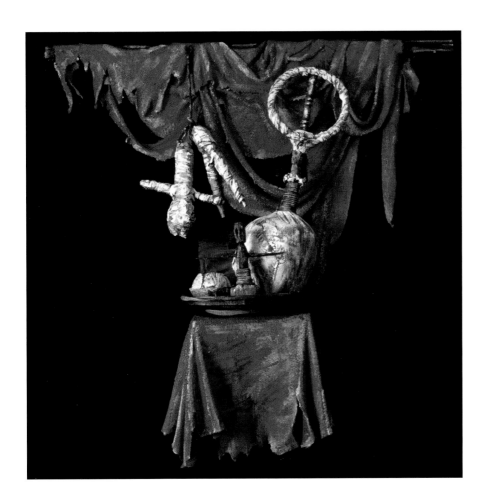

PLATE 15.

Osvaldo Mesa, *Fetish Bowl*. 1993. Multimedia installation. 139.7 × 160.0 × 45.7 cm (55 × 63 × 18 in.). Courtesy of the artist.

PLATE 16.

Elaine Soto, *Osanyín— Share*. 1990. Mixed-media painting. 40.6 × 50.8 cm (16 × 20 in.). Photo: Sarah Lewis; courtesy of the artist.

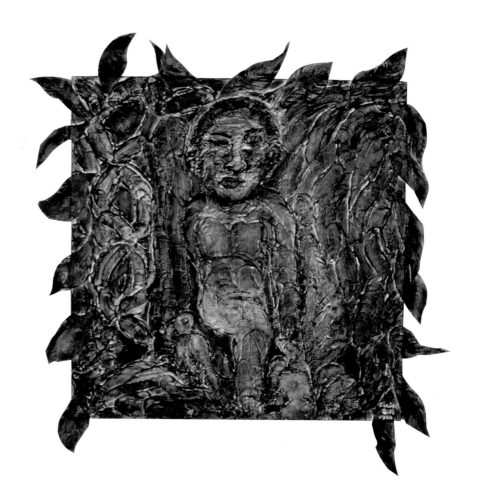

PLATE 17.

Rene Chamizo, *Obatala*.
1994. Wall installation
of woven reeds.
127.0 × 254.0 × 76.2 cm
(50 × 100 × 30 in.).
Courtesy of the artist.

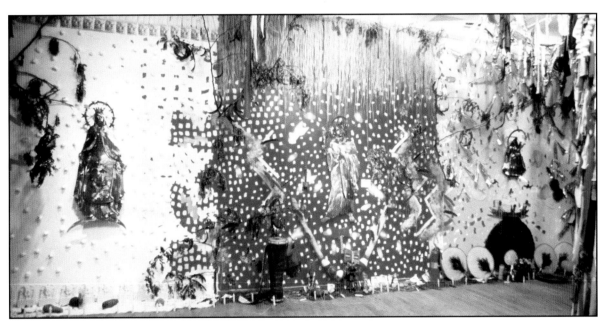

PLATE 18.

Jorge Luis Rodriguez and
Charles Abramson,
*ORISHA/SANTOS: An
Artistic Interpretation of
the Seven African Powers*,
detail. 1985. Multimedia
installation. Courtesy of
the artist.

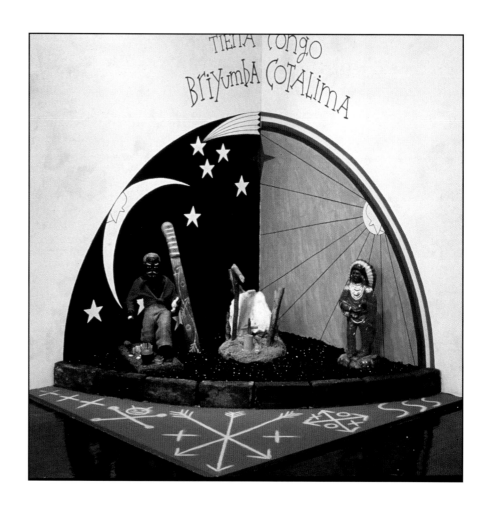

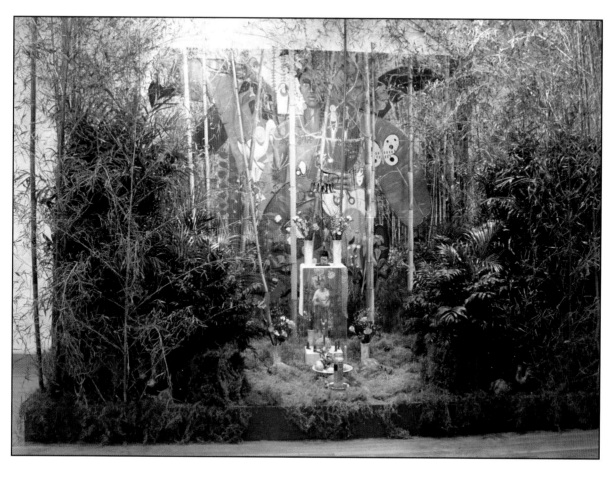

PLATE 20.

Arturo Lindsay, *Homenaje a Osanyín*. 1991. Multi-media installation with music and scent. 457.2 × 609.6 × 439.4 cm (180 × 240 × 173 in.).

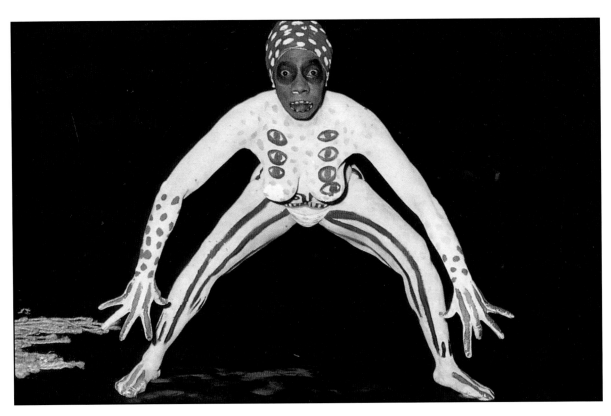

PLATE 21.

Manuel Mendive,

Dancer with body paint

during an interdisciplinary

performance. 1988.

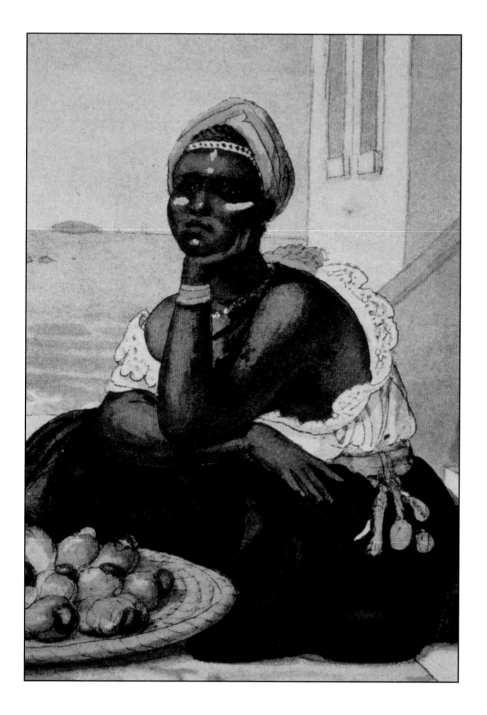

PLATE 22.

Balangandans, silver and gold pendants worn by Afro-Brazilians since at least the early 19th century. Detail from a painting by Jean Baptiste Debret done in Brazil in the 1820s. Photo: Henry J. Drewal.

PLATE 23.

The artist Mimito with a crown (*adê*) and staff (*opaxorô*) associated with one of the aspects of Oxalá. Photo: Henry J. Drewal.

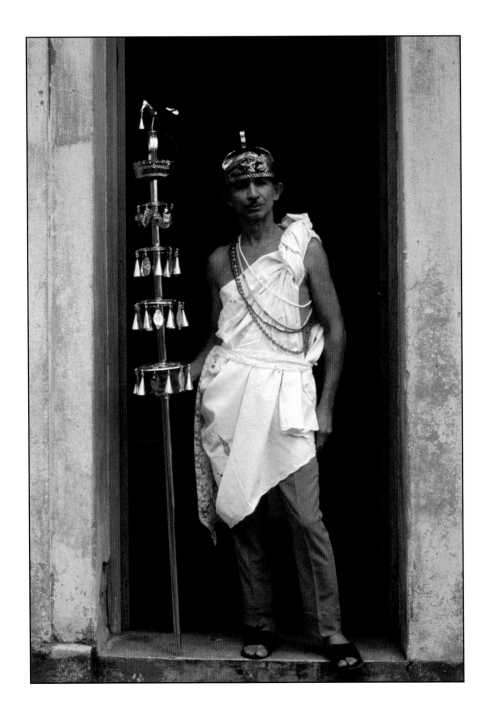

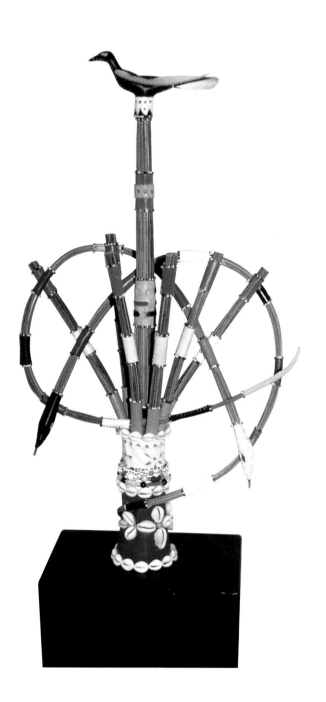

PLATE 24.

A sculpture by
Deoscoredes M. dos
Santos fuses references
to several *orixás*—ser-
pents symbolic of
Oxumare swirl around the
central shaft while a
majestic bird floats above.
Photo: Henry J. Drewal.

PLATE 25.

A large, shallow wooden bowl known as *gamela* is an important and recurrent motif in Terciliano's 1993 painting of a Candomblé ceremony where it is a primary receptacle for offerings of the gods. Photo: Henry J. Drewal.

PLATE 26.

The color red and hard-
edged, double-bladed
forms in this work by
Rubem Valentim signal
the ax of Xangô. Photo:
Henry J. Drewal.

PLATE 27.

Lines in Maria Adair's work may be inspired by West African strip-woven cloth (*pano da costa*) imported to and made in Brazil since the 18th century. Photo: Henry J. Drewal.

jects entirely from the domain of cognitive meaning, emphasizing affect. Objects and performances, understood as "affecting things and events," are "purposefully concerned with potency, emotion, values, and states of being or experience—all, in a clear sense, *powers*" which are concrete and irreducible (Armstrong 1971:3–4, quoted in Davis 1983:238). For him, the objects do not "refer" to or "represent" anything else; they "*are* whatever they are" because the experience of them is affective and immediate.[25] At the same time, the objects would seem to resist static contextualization in synchronic frameworks. Objects circulate in an "ambient of time," diachronically, as they are additively or "syndetically" applied by agents in the performance or "work" of invoking affecting presence (Armstrong 1981:5).

One of the most sustained revisionist approaches to problems of structure and discursive, conceptual, or semantic meaning is found in theories of practice (e.g., Bourdieu 1977) and the phenomenology of experience (see Jackson 1989). Michael Jackson rejects the "decoding [of] . . . ritual activities" as if they stood for prior "symbolically coherent structure[s]," abstract "semantic truths," and "unconscious concerns," or were functionally related to a priori social structure. Relying on the concept of "embodied knowledge," learned through patterns of bodily use, he suggests that actions and objects "often make sense without being intentional in the linguistic sense: as communicating, codifying, symbolizing, signifying thoughts or things that lie outside or anterior to speech" (Jackson 1989:123–27).[26] Michael Mason, a student of Jackson, for example, demonstrates how a religious principle, "the head rules the body," while discursively articulatable as a proverb in other domains, does not require the mediation of words or explanation for it to be practically embodied by a neophyte during initiation in Santería (Mason 1994).

Practice theory thus suggests that synchronic structures of "meaning," "society," "tradition," "rules," "cosmology," and "myth" exist only as reified abstractions outside of embodied irreducible instances of quotidian experience, which are to be regarded diachronically. Kris Hardin (1993), whose theory of practice does emphasize the reflection of creative agents,[27] suggests that action "instantiates" structure—or, more precisely, "structural properties"—which are perceived as "redundant" across multiple domains of experience and, in turn, are reproduced by individuals. There is no single fundamental ground that determines or is reflected by actions and objects. Indebted in part to the practice theory of Anthony Giddens, Hardin insists that "Structural properties are 'temporally present only in their instantiation, in the constituting moments of social systems.' They are never present in identical forms over time but are always in the process of becoming through human action. In this way 'social structures are both constituted *by* human agency, and yet at the same time are the very *medium* of this constitution'" (Hardin 1993:12–13). Equally important for my purposes, Hardin suggests that *aesthetic* experience—in

production and evaluation—lies at the heart of practice. Individuals try to advance their emergent interests and goals on the basis of knowledge that their acts and creations will be judged for their (aesthetic) appropriateness and fitness in the public domain. Their acts and creations succeed and are legitimated, or fail and are rejected, based upon group evaluation—the criteria being their resonance but also their creative response to the structural properties that are perceived across domains. Hardin demonstrates—and this point is also made strongly by John Miller Chernoff (1979)—that there is a huge social, economic, spiritual, and personal investment in music, dance, and artistic performance. The "success" or "failure" of such events is determined by the level of "sweetness" it produces in the "hearts" or "stomachs" of the participants. Dance performance aesthetics, for example, concretize, and provide an arena for, many inchoate feelings, ambitions, and interests, to be realized there. It is, for example, an arena to display wealth and status and to constitute and validate social allegiances. Dance ties people together in networks of reciprocal obligations that exist as "kinship structure" only abstractly outside of concrete actions and performances (see Hardin 1993).[28]

Hardin's theory is useful to my work in regarding priestess-artists as active, imaginative, and reflective agents who instantiate ritual, cultural, and social structures in their practice. They are not wholly "transparent" bearers of culture, whose actions and objects merely illustrate more abstract cultural rules or "core principles" or simply follow from socio-ritual relationships constituted more fundamentally "somewhere else." Yet they are shaped by perceived rules, norms, and traditions. Artwork and evaluation, particularly in the public presentation of highly aesthetically marked displays, are central to the way the priestesses generate and structure their relationships with the *orichas* within the set of practice that is called Santería.

To my mind, the point in an ethnoaesthetic investigation is neither to eschew symbolic and iconographic methods nor apply them indiscriminately, but to ask whether particular subjects produce and respond to objects in ways that could be called "iconographical." In the case of Santería priestesses, evidence suggests they do think about and respond to objects "iconographically." But it is left for us to specify how this operates. Is their practice rigidly systematic and rule-bound or ad hoc and practical? do they reference a body of inscribed texts, oral knowledge, or abstract concepts? and how rigorously so? What degree of specificity and precision is evident in the makers' distinctions between categories and qualities of objects? Do they mediate, and if so, how, their aesthetic production with discursive explanations? Finally, the question is not going to be "iconographic meaning *or* social meaning." The experience-near concerns of the priestesses also suggest the appropriateness of Price's concept of "social meaning" as regards the character of the exchanges that proceed between priestesses and *orichas*.

Finally, with respect to the issue of "tradition" and "change," a treatment of more global "structural change" would require more data than I have at my disposal at this point. My limited concern here, with respect to change, is that in an ethno-aesthetic investigation, one must focus upon what constitutes significant change in relation to the makers' practical experience, in the framework of their local significant group(s). Yet this experience of change would ideally, in a more global perspective, be located within local, regional, national, and/or international histories. In representing the art production of two New York priestesses who are ritually related, I am reluctant, at this point, to generalize or distinguish their practice as fully as I would like, within a larger field, which evidence suggests has many variations, competing values, and divergent traditions (see Brown 1989:ch. 3, 4, 7). Only continued research by myself and others, that has a specific and local perspective, can one day provide the basis for a broader view.[29] Yet the most important question that guides this investigation is a revised version of an initial question: building on the heuristic value of questions about the relation of (systems of) art and aesthetics to ritual and cosmology in the Yoruba-Atlantic tradition (along continua of affective form, meaning, instrumentality), I want to ask, what is the role of art and aesthetics in the particular practice of two New York priestesses?

87

THE PRIESTESSES AS ARTISTS: CAPSULE BIOGRAPHIES

Melba Carillo and Josefina García are two New York priestesses (*iyalochas*) who specialize in clothwork for the *orichas*' celebratory thrones. Melba Carillo is also a talented maker of beaded shrine objects and dance wands. Born in Marianao, Havana, Cuba in 1941, she came permanently to the United States in 1950. She became involved with Santería in New York in the late 1950s. During the 1960s and 1970s she worked at and managed various anti-poverty programs and training organizations as well as performed hospital work. She was initiated as a priestess of Obatalá in 1974, the same year she lost her job with a training consultant firm that moved out of the city. She has been extremely active in Ocha (synonym for Santería) since 1980, having initiated a score of godchildren into the religion. She has been instrumental in administrating a temple of *santeros* and *babaláwos* in New Jersey, a house exclusively dedicated to work in Ocha and Ifá.[30]

Given economic necessity, Melba began producing *oricha* beadwork on a small scale in 1974, the year she lost her job and also the year in which, as a vulnerable new *iyawó* (initiate), she had a falling out with her Santería godfather of initiation, leaving her for a time without ritual family support. Regaining social and ritual connections and support within the religion after 1978 with a group of *babaláwos*, and in 1980 with two newly arrived Mariel *santeros*, Adolfo Fernández—whom she took on as a new "representative" godfather—and Ramón Esquivél, her Ocha activity increased dramatically through the 1980s. She initiated fourteen priests between 1980 and 1988, second-godparented (as *oyubona*) at least ten others, and

"gave" scores of auxiliary *orichas* to a wide range of individuals. Carillo, Fernández, Esquivél, and their respective godchildren worked together as a group, along with the temple's main *babaláwos*, supporting each other's initiations of new priests. Their ritual kinship connections between these three "houses" grew as they each second-godparented (*oyubonear*) many of the others' initiations of new godchildren. Melba's own growing stable of personal *orichas* and those of her godchildren, as well as the visibility of her work to an expanding community as it appeared on thrones honoring these *orichas*, increased the demand for her bead- and clothwork. She continues producing *oricha* objects in her spare time, beyond the ritual work ("working the *santo*") she performs in regular initiations (making and giving *orichas* to godchildren). She has lived in Manhattan, in the west fifties, for more than twenty years.

Josefina García (Josie), born in Ponce, Puerto Rico in 1924, came to New York in 1944. A long-time resident of the Bronx, she was a social worker until she retired in 1986 at age sixty-two. Since then she has lived on a pension. Initiated by Melba at age fifty-nine in 1981—quite late in her life—as a priestess of Ochún, she "worked the *santo*" within the collective group that operated out of the New Jersey temple, specializing as a ritual cook, and initiated her first godchild in 1987. Since she and Melba went their separate ways in 1989, and with the deaths of Fernández in 1990 and Esquivél in 1993, she has kept her own *oricha* practice relatively private and limited, having initiated very few godchildren.

The ritual and aesthetic experience Melba and Josie gained in their work with Esquivél, Fernández, and the *babaláwos* during the 1980s included throne building (see Brown 1993). They depended upon and learned much from the brilliant throne artist Esquivél, who had studied interior design in Havana. Esquivél headed the construction of thrones for the group's drummings and initiations that took place in the temple and their own birthday celebrations (*cumpleaños*, the annual event around the anniversary of initiation) in their respective homes. In this context, Josie developed her talent for clothwork objects, including ritual covers (*bandeles*) in 1983 for the temple's sacred *batá* drums and a number of shrine attributes primarily for her own *orichas*. Melba became a skilled artist of beadwork *oricha* attributes, as well as clothwork, which came to adorn the altars and thrones of Esquivél, Fernández, the temple's *babaláwos*, and the circle of godchildren.

THE OBJECTS AS OBSERVED IN USE: A PROCESSUAL DESCRIPTION

As special altars of *oricha*-celebration, *thrones* constitute a site for supplicants to approach, salute, praise, communicate with, and make offerings (*ebó*) and tributes (*derechos*) to the *orichas*. Thrones are temporary installations, whose scale often requires reallocation of domestic space, and whose duration as an assemblage is coextensive with particular ritual periods and passages. These include events that have

private and semi-public phases, in which the community is invited into the "sacred room" (*cuarto sagrado* or *igbodún*) to greet formally presented *orichas*.

During an initiation ceremony (*asiento*), in which the *aché* or spiritual power of an *oricha* is "crowned" or "seated" on the head, priests and priestesses are said to "make" (*hacer*) a primary *oricha* who will be their "guardian angel" (*angel de guardia*) and "receive" (*recibir*) usually three to four other *oricha* companions. These *orichas* together, in Melba's words, form the "original group" of the *asiento*—in addition to the "warriors" (*guerreros*) Elegguá, Ogún, Ochosi, and Osun (not to be confused with Ochún), received prior to the initiation. The guardian angel is regarded as the priest's "father" (*padre*) if it is male or "mother" (*madre*) if it is female. Then, in most houses, a second *oricha* of the opposite gender is selected through divination in the *Itá* ceremony, two days following the *asiento*, to be a second parent. The *orichas* are presented to the initiate in lidded vessels called *soperas* ("soup tureens"), as well as in wood and metal containers, depending upon the characteristics of the deity.

The cloth of the enclosure, given observations of thrones between 1983 and 1993, characteristically radiates the identifying colors of the *oricha* of honor, the *oricha* that is the focus of the particular *ceremonia* ("ceremony"), a set of colors found most basically in the *orichas*' traditional beadwork, reconstituted from Yoruba models (see all figures). Thrones constructed for the *asiento* characteristically combine a canopy/background in colors belonging to the initiate's guardian angel, with bright square blazons of cloth, called *paños* (alt. *pañuelos*), representing the constellation of the three or four additional protectors. The *paños* punctuate the canopy and background in artistically gathered or pinned configurations.

Initiates consecrated on the first day of initiation (the *asiento*), as they sit upon a sacred mortar-stool (*pilón* or *odó*), are then installed within the throne's precinct and spend that night and the succeeding five nights living "under" its canopied protective domain. On the semi-public second or "middle" day of the initiation, the initiate is dressed in the royal finery of the guardian *oricha* to which he or she has been initiated and is publicly presented, under the throne's canopy, to the community. The garments of this event are called *ropa de santo* ("clothes of the saint") or *traje del medio* ("suit of the middle day"), and include an elaborate tunic with pants for male *orichas* or a floor-length gown for female *orichas*.[31] Included is a pasteboard crown which, along with the suit itself, is encrusted with iconographic *oricha* attributes. Some houses regard the middle day as a formal "coronation," which they liken to the coronation of a Yoruba king (see Brown 1993).

The initiate additionally carries a handheld implement, a dance wand—often painted or heavily decorated with beads and cowrie shells—that the particular *oricha* "uses": for Changó a red-and-white double thunder-ax, a fan for the riverine

goddesses Yemayá and Ochún, a hooked staff for the trickster Elegguá, a flywhisk for Oyá of the wind, a machete for the warrior and blacksmith Ogún, a bow-and-arrow for the hunter Ochosi.

Finally, the initiate will wear as many as five heavy, multistrand beaded sashes, called *collares de mazo*, saddled diagonally across the body like bandoliers in two directions, forming an "X." The *ropa de santo* and dance wands, the *collares de mazo*, and a set of lidded ceramic and wood vessels containing the *orichas*' "secrets" the initiate receives in the initiation all feature the appropriate colors and iconography characteristic of each *oricha* in question. Like the *soperas*, the dance wands and *mazos* become part of the *orichas*' permanent home shrine (*canastillero/cuarto de santo*), and their *ropa de santo* and throne-cloth is stored carefully in drawers, closets, or trunks.

While the throne of the initiation serves to present publicly and protect the newly crowned *iyawó*, the throne of the "birthday" (*cumpleaños*) presents formally, as a dramatic array, all of the priest's *orichas* themselves, which have remained in their *soperas* and confined in their permanent shrine during the year. The annual *oricha*'s birthday is the anniversary of a priest's initiation—the very date on which his or her "crown" was born. The throne stands for seven days, recalling the original seven-day initiation period. This throne includes the "original group" of *orichas* and any additional protectors received subsequent to the initiation, called *ad-dimú-orichas*. The intention of the birthday is to present the *orichas* formally in the individual priest's house in order that they receive respectful tributes and salutations and insure their priests' tranquil, healthy passage into the new year. Elevated on pedestals, the *orichas* residing in their *soperas* are covered artfully with their dazzling *paños*, topped with metal crowns (where appropriate) and their beaded dance wands, and draped with their *collares de mazo* (see pls. 1–4 and figs. 4.1, 4.3, 4.4). Thrones for birthdays and "drum-

90

FIGURE 4.2.

Drumming throne for Ochún made of "leaves," New Jersey, September 12, 1987. Ochún's covered vessel is at center, surrounded by *paños* representing Yemayá (L), Oyá (R), and Obatalá and Changó (above). Photo: David H. Brown.

FIGURE 4.3.

Birthday throne for the Ochún of Josefina García, Bronx, New York, May 16, 1987. *Paños* by J. García; *mazos* by Melba Carillo. Throne designed by J. García. From the left: Changó, Oyá, Agayú, Ibeyi, Ochún, Obatalá (above), Ibeyi, Yemayá, Olokun, San Lázaro. Photo: David H. Brown.

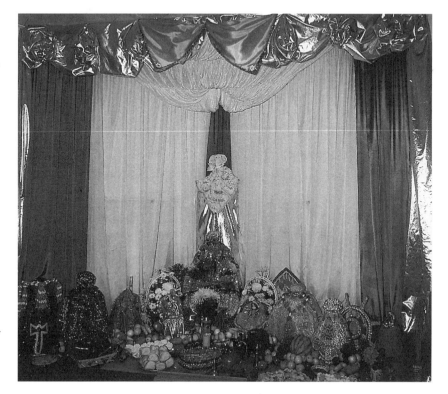

FIGURE 4.4.

Detail of figure 4.3. San Lázaro with burlap *paño* with flower motif, beaded *ajá* (broom dance wand), Afrá (the Arará Eleguá that accompanies San Lázaro), and the Osun staff that accompanies this San Lázaro. Photo: David H. Brown. All rights reserved.

mings" (periodic drumming celebrations to *orichas*: fig. 4.2) find a sumptuous cornucopia of colorful fruit and sweets called a *plaza* spread out on straw mats (*estera*). An array of metal bells and painted or beaded shakers lies near the center on the mat for rhythmic salutations to particular *orichas*. A covered calabash awaits monetary tributes in sums numerically appropriate to the *orichas*' oracular numbers (see pl. 1).

THRONES IN DIACHRONIC PERSPECTIVE: SPIRITUAL BIOGRAPHY, QUOTIDIAN ARTISTIC PRODUCTION, AND RITUAL OCCASION

Each time Josie and Melba assemble thrones for their birthday celebrations, new additions and surprising improvisations combine with time-honored arrangements. The beauty, splendor, and freshness of the throne mark the specialness of the occasion and the gratitude they desire to show the *orichas*. For them, an important factor in the success of each annual presentation is the appearance on the throne of bright new *oricha* objects that they have lovingly made. Yet such new objects that they produce themselves during the year take up their place on the throne next to special gifts from godchildren and favored standard pieces stored on altars and in closets and trunks. Most important, for active priestesses like Melba Carillo, the stable of her *orichas* has grown dramatically since her initiation with the receiving

of *addimú-orichas*. The throne thus embodies an emergent spiritual and personal biography, in which the objects themselves, prepared and given by ritual elders, colleagues, friends, or godchildren, have their own histories and "biographies" (Kopytoff 1986). In short, the throne becomes both the focus of a cyclical ritual process—a sacred life cycle—and the aesthetic and emotional focus for the production and exchange of objects.

In addition to the larger annual sacred cycle, the birthday event with its throne must also be seen for its diachronic, processual dimension, involving formal modification over time. The throne is the fulcrum of a series of actions as well as "produces actions." It might be seen as an example of what Victor Turner calls a "dominant symbol": "symbols . . . produce action, and dominant symbols [like shrines] tend to become focuses in interaction. Groups mobilize around them, worship before them, perform other symbolic activities near them, and add other symbolic objects to them" (Turner 1967:22). Mounted for a set ritual period of seven days, in an additive/subtractive manner it ebbs and flows with the "syndetic" (Armstrong 1981:ch. 1) accretion and distribution of objects, over the course of the first day and the remainder of the week. If it is meant to be seen and contemplated in a moment, it is too complex to take in all at once. If the eye can move through hierarchical paces, it also must rove to and fro, in and out, to comprehend its richness. A single photograph of it at any moment will be partial.

The calendrical ritual cycle shapes the intensity of their home production of cloth and objects for the *orichas*. Yet the work, energy, increased mobility, and emotional concern of the priestess-artists in relation to the needs of the *orichas* and ritual kin is what gives the "calendar" its affective and spiritual rhythm. During the year Melba Carillo is more constantly working on *paños* and beadwork as she not only produces them for her *orichas* but also for those of others—her "business." Yet, just as her personal work is driven by the goal of producing objects for her annual *cumpleaños* (October 9th), the demand for her work by others is also driven by the ritual events others have planned, particularly birthdays.

Melba normally spends the morning shopping and visiting godchildren—those she has initiated or "represents" as a *madrina*—returns at 2:00 p.m. to cook for her mother who lives upstairs, and then sits on her plastic-covered living room sofa before the television, working over a low coffee table, from overflowing bags and boxes of cloth and beads. Finished commission work, looking very much like king's riches, piles up on the other sofa. When she takes on work on short notice by clients who "wanted it yesterday," she will begin working at 10:00 a.m. until midnight, breaking for several hours in the afternoon and early evening. This occurs on top of preparations for the several initiations of godchildren she conducts each year, which require months of advance work. The pressure is really on during the month prior to

93

her October 9th birthday. As Josie's creations are more exclusively personal, the intensity of her work is focused on the several months before her May 6th *cumpleaños*. At the end of February she begins to decide what she will need for her birthday. "The end of February I start to make an inventory of the things I'm going to do, what I'm going to buy, even the food that I'm going to cook, I plan ahead of time. Because it's a lot of work, and if you leave everything for the last minute, then you get crazy and you get tired." [32]

94

Decisions about what objects to make anew, what objects to replace, and which *orichas* will receive the new objects are not arbitrary. Within, and sometimes despite, time and financial constraints, the decisions are influenced by the importance of each *oricha* in the personal ritual history of the priestesses and by evaluations about the aesthetic quality and condition of their extant objects. Certain objects are replaced because they are deemed "old" (some get dirty or damaged) or no longer interesting. It also may depend upon what "promises" (*promesas*) or elements of offerings (*ebó*) the priestess has outstanding with particular *orichas*, including those *orichas* of other priests to whom one will need to deliver a birthday gift. *Ebó*, as developed below, often include iconographic objects that the *oricha* needs to "work" with, and that the priests are instructed to buy or make.

For many priests and priestesses, it takes years to acquire objects for their entire stable of *orichas*, if in fact they are financially able and aesthetically inclined to do so. Following the original initiation period, especially as the first *cumpleaños* approaches (the end of their initiation "year of white" as an *iyawó*), and/or later as they can put away a little money, priests begin to make or commission *paños* and *mazos* for their *orichas*. These objects usually are not made in preparation for (prior to) the initiation but afterwards, as the specific identities ("paths") of key *orichas* are identified in most houses only in the *Itá* divination ceremony (on the third day of initiation). The *mazos* that the *iyawó* wear on the "middle day" and the *paños* that appear on the initiation throne often belong to the initiating godparent and may be of generalized *oricha* colors, not the specific colors of the "paths" to be determined later in the *Itá*. The *mazos* and *paños* made or commissioned later are individualized to the specific color combinations and iconographic requirements of the newly made *orichas*' paths, particularly in the cases of Obatalá, Yemayá, and Ochún. [33] In time, according to something of an ethic Melba disseminates to her godchildren, each of the *orichas* should, as economic means allow, find themselves respectfully and beautifully outfitted, complete with *paños, collares de mazo*, and other appropriate attributes (fans, flywhisks, implements, and so on).

All other things being equal—finances, time, special obligations—both priestesses tend to prioritize the *orichas* in their original group as candidates for the most intensive aesthetic attention, over and above the various *addimú-orichas* they have

received. Within that group, they are most concerned to lavish attention on their "father" and "mother"—"my parents" (*mis padres*). For Josie these are Obatalá-Ayáguna and Ochún-Anggalé, respectively, and for Melba Obatalá-Ayáguna and Yemayá-Achabá respectively. At the same time, Changó holds a particularly powerful place in the upper rungs of their imagination and ritual concern.[34] Thus both of their Changós have a comparatively large number of *paños* that they have made for him. In 1987, when Melba began to consider replacing the substandard *mazos* she had made for her original group when she was an *iyawó*, only her Obatalá and her Changó received new ones (see pl. 1 and fig. 4.1). If in 1987 Melba's Obatalá and Changó received new *mazos*—intricate objects that may require more than ten thousand beads and intensive labor to produce—her Yemayá and Ochún nevertheless received pairs of stunningly beaded oars (*remos*; see pls. 2, 3), while Oyá received a carved and figurated tourist flywhisk, purchased from an African importer, which she then modified by encircling its middle with Oyá's particular bead colors. This year, Melba is struggling within her work schedule to produce new *mazos* for the remaining members of her original group, the three females Yemayá (her mother), Ochún, and Oyá, in that order of priority. Josie, having lavished much attention on her Ochún and Changó, has determined that her father Obatalá will receive a new *paño* this year. Also Josie's Yemayá will receive this year a reworked ship's wheel, an actual wood wheel which previously was covered in dark blue satin and encrusted in cowrie shells. The previous incarnation was "old." She had used it for many years, the threads had loosened, cowries and braid had fallen off, and thus it was time for a new one.

For Melba, the *mazos* that are being replaced were made by her at a time when she lacked the necessary skills to make them properly and beautifully. Having worked *mazos* for twenty years now, she evaluates the old ones as "awful," "ghastly," and "embarrassing" in her conception of how her *orichas* should be presented on her birthday. Indeed, in the past, when she could not bear dressing them in the early *mazos*, she borrowed ones she had made for her son's *orichas*, an almost equally embarrassing compromise in her ethic—although it is quite common within *oricha* houses that *mazos* are shared when priests have not commissioned their own. Even though as an *iyawó* she thought the old ones looked "gorgeous," her "experience" provided new criteria of evaluation as well as a new sense of possibility. The new *mazos* are "more fancy"—richer in variation of color, texture, and bead size, and heavier in weight.[35]

Their production of new objects is also shaped by an ethic of originality and novelty, which is tied to an awareness of the impressiveness and power of display at *oricha* events. For the *orichas* to "look their best" they should not have to wear the same old thing year after year. And it is hoped that visitors are impressed and revi-

95

talized by new and fresh displays. At the same time, objects that "came out" extremely well and that, through their particular qualities, so beautifully and appropriately outfit an *oricha*, are proudly used again and again, like a classic suit. These two principles of an emergent personal tradition dynamically combine staid preference and novelty. The two may come into conflict as other voices—those of godchildren who participate in the construction of their godmothers' birthday thrones—introduce their own opinions.

An additional factor in change and traditionalizing is that certain time-honored fabrics and colors cease to be available in the marketplace and thus appear to take on more value. For example, Melba's favorite *paño* for Changó is a "wine"-colored velvet with an elegant floral embroidery in silver metallic thread, although she made at least four other relatively newer, fiery red *paños* that have been "lying in the closet" for three or four years (see fig. 4.1). In general terms, for Changó darker wine-colored reds lie on one end of a continuum of appropriate or correct variations on a theme, whose other pole includes fiery bright reds. The wine she likes is no longer sold, and the others were made with the brighter reds that, according to her, now dominate in stores.

> MC: I prefer wine. I'll put red on [Changó] but I prefer the wine color. In fact, he's got four [other *paños*] that he's never worn. . . . I prefer this [more] than the [others] . . . like my goddaughter was telling me this year, "you know you better stop putting this one on and put something else, you have so many of them over here."
>
> I says, "yeah I know but [I like] that particular [color]. . . ." Because I never found another one in that color.
>
> DB: What's special about the wine?
>
> MC: I happen to like the wine color for Changó more than bright brassy red. It's my choice. You know.[36]

Here an old *paño* rather than a new one carries marked value, perhaps especially because its cloth is no longer available. Wearing the wine *paño* is simply how her Changó will "look his best." This is what she likes and prefers, and it is presumably what he likes and prefers.

FORMAL AESTHETIC CONCERNS, PRACTICE, AND THE PROBLEM OF SYMBOLISM

In the experience-near and quite humanized Santería religious idiom, each *oricha* "owns" aspects of the natural world, including flora, fauna, fruits, foods, natural formations of the landscape and climate, human attitudes and emotions, as well as colors and icons. If these elements may be seen, as in the more abstract classifying grids known to symbolic anthropology and semiotics as signs or symbols with signified meanings (e.g., Douglas 1978), they may also be appreciated in the practi-

cal and vernacular sense of what each *oricha* "prefers" aesthetically. Appropriateness of reference may be mapped symbolically, or appropriateness may be seen as a matter of subjective aesthetic preference and practical meaning (the *orichas* being taken as aesthetically interested "subjects" also).[37]

In the evaluation and selection of materials for, and the fabrication of, objects for the *orichas*, color and number (*oricha* oracular numerology) serve as basic iconographic patterns for creativity and improvisation. Each *oricha* identifies itself with a specific color or counterpointed set of colors and is also associated with a specific number. The numbers appear to derive from the mathematical positions (*letras* or *odu*) certain *orichas* dominate within the oracular system of *Diloggún*, the cowrie shell system of divination, in which the "mouths" of sixteen shells cast upon a mat fall "up" or "down" (see Bascom 1980, 1952; Elizondo n.d; Angarica n.d). Most *orichas* turn up in several different oracular positions, and some *orichas* share numbers, such as Agayú and Oyá (9), Yemayá and Ochosi (7). The number characterizing each *oricha* in all but a few cases also designates the number of "roads" (*caminos*), or distinct manifestations the *oricha* possesses. Ochún, dominating the *odu* Oché (5 cowries up), has five different roads. Yemayá, dominating the *odu* Oddí (7 cowries up), has seven roads. On the other hand, Changó, who dominates both Obara (6) and Ellilachebora (12), is unitary and does not have distinct roads in the way most others do, although he is seen to have different facets.

Both dimensions, color and oracular number (or multiples thereof), are central to what may be seen as a practical mnemonic scheme embodied in *oricha* beadwork. As bead necklaces are most often the first aesthetically important, consecrated *oricha* objects people receive, wear around their necks, and take care of, their color schemes are experience-near, concrete sources of further mimetic reproduction, that is, a copying and elaborating into other media. The "receiving of the necklaces" (*collares*)—usually four to six consecrated (washed and fed) single-bead strands—marks the advent of a godchild-godparent relationship in the ritual kinship system and the *orichas*' protection of the wearer. Such beadwork for the archdivinity of purity, Obatalá, is predominantly white, punctuated by red, purple, green, clear, or "coral," depending upon the particular road in question. That of Eleguá is black and red, of Ogún green and black, of Changó red and white, that of Oyá brown (with variations), that of Yemayá blue and white or clear, that of Ochún yellow and amber or clear. The last two also receive punctuations of other color depending upon their roads (see Brown 1989:ch. 3; Brandon 1983; Murphy 1988).[38]

In her making of *collares de mazo*, the "fanciness" and decorative embellishment of Melba's pieces emerge through elaborations on the *orichas*' colors and numbers (or multiples thereof).[39] For example, novel textural, optical, and iconographic effects occur through the selection and variation of larger fastening beads,

97

called *glorias*, that punctuate the basic multiple strands (see Brown 1989:400–401, 508–13; 1993:47–48). When making other objects, such as *paños*, "their colors" are a formal starting point for creativity, elaboration, and improvisation. Thus the understanding, as she expresses it, that "I could use my imagination as far as adorning them, as long as I had the right colors."[40]

What the "right colors" are is a relatively fuzzy category. The right colors are learned practically in the house among elders and godchildren and in the urban consumer marketplace, with the experience of seeing, selecting, and handling beads and cloth. In the beadwork for basic consecrated necklaces, the colors—usually the industry size 6 "seed" beads—are relatively more standardized across any sample of practitioners, given the color/value limits of their industrial production, while for the large *mazos* priests may radically vary and punctuate the bunched strands of no. 6 beads with the virtually infinite variety of larger fastening beads (*glorias*) available in the urban marketplace. For clothwork, along the same lines, there will be much more variation in color, pattern, texture, and so on, although, of course, industrial decisions determine the range of materials (see below). In Melba's clothwork, she "associates" cloth color with the basic colors of the *orichas'* bead necklaces and *mazos* and has a sense of what variations work for her and will be acceptable to the *orichas* and others. The darker wine-red, as her personal preference or choice, is the way she wants to dress and present her Changó that feels the best and most appropriate or correct, even though, at other moments, it felt appropriate enough to make four *paños* in other brighter reds. For her these reds, from wine to fire, are pleasing and also efficacious in her own practice. That is the point at which particular constructions of cosmological and aesthetic rightness or appropriateness come together. At the same time, "right" can also cease to be wine if it disappears irrevocably from the stores.

How to approach the logic at work in the assignment of color and number and the evaluation of the "rightness" of particular colors, may usefully be discussed, at some level, in terms of iconographic and symbolic reference systems.[41] Yet, if a systematic, discursively mediated, and relatively transparent set of symbolic or iconic[42] relations of sign and meaning have any importance to practitioners—whereby color and number are keyed to knowledge of *oricha* attributes and divination texts—they nevertheless share the field with a more pragmatic and "mute" diacritics in which color marks the differences between *orichas* or instantiates local and personal traditions. Depending upon the priest, the approach to color and number is relatively more or less discursive and more or less practical. Some priests will respond to questions about the symbolic meaning or referent of some colors. For example, many will say that blue and white or clear "represent" Yemayá's seawater and ocean spume respectively and together the externally oscillating power of the sea (Angarica

n.d.); yellow, amber, and clear represent Ochún's "sweet things," including sweet (fresh) river water, honey, and gold, as well as the "vicissitudes of life" (Angarica n.d.); white represents Obatalá's "purity." This is quite characteristic.

Babaláwo Luís Castillo, upon being asked the "meaning" of Orunmila's yellow and green, replied that green "represents healing" (i.e., herbalism) and yellow "sickness" and "death."[43] In some cases, even, the color's iconic reference substitutes in discourse for the name of the color itself. For example, clear colorless beads are sometimes called *agua* ("water").[44] Yet these cases do not necessarily and consistently add up to a systematic set of transparent referents, meanings, or universally verifiable semantic truths. The semi-translucent white beads for some roads of Yemayá are called *jabón* ("soap"), possibly because they recall foamy or opaque waters, or possibly only because they recall the dull sheen of soap and not for any other reason.[45] Other colors and the reasons why particular *orichas* have them are answerable only by reference to practice.

Melba Carillo's *addimú-oricha* Obba wears yellow and white beads for no other reason than "that's the way I received it." Alternatively one often hears: "that's the way my house does it." My investigator's questions, attempting to press or nuance the issue of Obatalá colors received from Melba Carillo an uncomplicated, insistent, factual statement: "*These are their colors*." She continued:

> There are some Obatalás that are white with a purple bead, which is [Obámoro].
> There are ones that are green, you know, it depends, and Ayáguna's happens to be
> red. Ochaquiriñán is coral, Obanlá is white, Ochanlá is white, Yecú Yecú is white.
> There are a lot that are completely white, and there are a lot that take different colors, so you have to associate the *pañuelos* with their colors. At least I do that. Some
> of the people will just put it all white and then put the *mazo* in the certain color.[46]

For Melba, the "right colors" have significance because they are "theirs"—the *orichas*'. These colors belong to them, are to be seen with them, and are what they "use." That quite direct, mundane, and instrumental sense does not necessarily require further explanation in conceptual terms. The practice of "associat[ing] the *pañuelos* with their colors"—something like a mimetic reproduction of, and improvisation upon, bead colors across domains—suggests itself as a creative activity that can bypass extensive discursive mediation (see Jackson 1989:127). It is possible to see beadwork, clothwork, and other created *oricha* objects as an associated/associatable, mimetic or indexical series, without the assumption that conceptual blueprints or extended abstract reflection upon "meanings" intervene in their production. Some practitioners "associate" more concretely, and others reflect more abstractly. Josie and Melba engage their work at both levels. Finally, although locat-

99

able in terms of general classificatory outlines, that is, referenceable to *orichas*' attributes and *oricha* roads, the particular colors Melba chooses in her clothwork have personal, even ineffable, significance. The wine *paño* and its contrast with newer red ones may resist an investigator's probe for symbolic meaning in relation to a mythological or ritual system or set of abstract rules. It is also a tricky exercise to attempt to justify the variation based upon African origin alone.[47] Melba's preference is one of the practical ways—"on the hither side of discourse" (Bourdieu 1977:2)—that she instantiates her Changó, with whom she has an ongoing relationship.

Even in cases in which the meanings or referents of colors are defined systematically, such as in Nicolás Angarica's meticulous practitioner manual, the articulated meanings do not reduce transparently to abstract signifieds. He does relate white to the spotless purity of Obatalá, blue to the eternally oscillating power of Yemayá's oceans, red to the principle of "action," and yellow to the "vicissitudes of life" (Angarica n.d.:72–73). Yet his overarching point is that the colors invoke, embody, and emanate the spiritual presence of the *orichas* and the ancestors, and are associated concretely with objects and substances of ritual use and healing. The colors are bound up in, and indivisible from, processes. In the larger frame, for him the colors "symbolize the splendor of our religion," something perceived less as a semantically based meaning than as a kind of ineffable grace that impresses itself boldly upon experience.

My point is not to deny issues of competence within tradition such that certain members learn, master, and articulate better and more correctly than others a body of transmitted knowledge. There is clearly an elegance and coherence in the complex interrelation of the religion's many levels; and most practitioners place a high value on "knowledge" (*conocimiento*) and the capacity (*capacidad*) to carry out "well-made" (*bien hecho*) ceremonies. Yet this "knowledge" and "capacity" exist less as a monolithic grid or structure of rules that *everyone* carries in their head than as knowledge practically learned and transmitted, which varies from person to person, house to house, generation to generation, depending on practical need. This is what Pierre Bourdieu meant by "practical mastery" as opposed to the more totalizing concept of a systematic "symbolic mastery" (Bourdieu 1977:19). Michael Mason suggests that, within Santería, erudition and *conocimiento* in fact represent only one value center or basis for priestly authority and charisma; the "good heart" (*buen corazon*) is another, often competing basis in an arena in which authority is negotiated.[48] The ability to articulate the "meaning" of a particular color or number to the investigator's satisfaction may at times be a function of the latter's discourse—a field variable hard to control for—within which the informant is being encouraged to participate.

Neither do I want to deny the very important distinction between "laymen"

and "specialists" (Turner 1967:51), or that there are shared criteria of correctness within and between houses. More learned diviners (*italeros*) and *obá* (masters of ceremonies) memorize huge quantities of information more or less systematically and usually rationalize what they do explicitly in terms of the system of divination lore called *odú*. Within the Ocha religion, there has been a movement, particularly among male diviners, to codify and systematize belief and practice—to make practitioners more aware (*conciente*) and less "manual" (more cerebral and less "practical") in their work (e.g., Pichardo 1984:76–79). *Libretas* ("notebooks") or manuals (*manuales*), virtually all of them written by such diviners, have mediated practice with textualization—the result being that for many the religion has become more explainable, representable, and articulatable in discourse. Yet it may be more useful to see the manuals as positioned reform strategies in the rationalization of practices than to privilege these texts as "windows" on the "ritual system." [49] For that would be to plant a mirror of the investigator's desire for transparency, comprehensiveness, and discursive logic in the unruly garden of diverse practices.

101

ETHNO-SHOPPING: [50] CREATIVITY, TRADITIONAL-IZING, EMERGENCE, AND THE MASS MARKETPLACE

In exploring the aesthetics of handmade and modified objects, and throne assemblages composed of them, whose source materials are mostly mass produced, the emergent criteria and standards of search and selection based on "color" and "number," and the nature of those choices within the limits and possibilities of the consumer experience, are important considerations. The investigator's more or less systematic and totalizing knowledge of *oricha* iconography and symbolism can serve heuristic purposes in field research, can predict the general outlines of artistic results, and delineate continuities in the "tradition" of object making considered as a paradigm. However, the aesthetic experience of the maker, for example, why colors are chosen for how they *feel* rather than for what they reference iconographically or "mean," and the measure of what is significant change in the artistic practice of particular priestesses and houses, must be uncovered by closer attention to the personal, the private, and often the nondiscursive. That ineffable sense of "feeling" represents a kind of "surplus" over and above what can be accounted for in iconographic or symbolic investigations.

In the United States, *oricha* thrones and objects are assembled with materials mostly purchased in a variety of urban consumer outlets, including the huge cloth and bead markets of Manhattan's garment district, and the retail specialty phenomenon known as the *botánica*.[51] Both Melba and Josie make specific shopping trips to the garment district for cloth and beads, or to the *botánica* for other materials, with their own *orichas*' needs in mind, or, in the case of Melba, for the commissions she has outstanding. They are sophisticated consumers aware of cloth types and the possibilities and limits that certain kinds of weave, texture, weight, flexibility, and rela-

tive translucency offer. Both are responsive to price structure and quality. They always look for and jump at bargains but never skimp, within their means, of course, where the *orichas* are concerned.

Both go shopping with "the colors in mind," informed of the outlines of appropriate *oricha* iconography, armed with a sense of personal preference, and motivated to buy the "best" they can afford. Beyond that they are open to the surprises that the overwhelming variety of the garment district offers. Josie, who often draws out on paper her design ideas beforehand, explains, "when you go in there you have the frame of mind already of what you want. You say, 'Obatalá is white, I'm going to buy the best white material that I find and I'm able, that I can afford,' you know." [52] One day Melba was dazzled by a roll of sinuously sequined cloth, a length of which she bought just before 1985 to make a treasured *paño* for her Ochún. It was the peculiar quality of the color that struck her, but not at that moment the fact that it also had a wavy pattern that I have associated with water. "No, no, I just don't go by that" [the wavy pattern], she said. "Just the color, you know. Cause it was gold gold; it was so *goldy*, you know, and you associate Ochún with all that, so" (see pl. 3). Ochún owns "anything that's yellow," she explains, of which gold is taken to be a subset; but in this case a particular affective quality of fabric touched her. It was an issue of more than merely "color," but a certain richness and intensity that moved her. [53]

If "color" is one consideration of selection, more subtle figurings of *oricha* qualities and iconography have caught her eye and heart and drawn her purchase. Melba encountered a certain bead whose special quality was not only apparent in Ochún's color but appeared to manifest her characteristic sweetness as well: "They were plastic, but they looked like a piece of rock candy. . . . They look like a piece of rock candy, only in honey, and they look so nice." [54] These large chunky fastening beads became a central motif in a *mazo* she made for her son's Ochún, but which she has used on her own birthday throne since 1985 (see pl. 3). On another occasion she encountered a fabric that not only bore the colors of Changó but also embodied something of his iconography, the thunder-ax, as she extrapolated it from the industrial design. It wasn't exactly a thunder-ax but "it resembled one." Unfortunately, she could not at that time afford it.

> I saw a beaded one for Changó that I . . . *oh!* . . . I just couldn't believe it because the pattern on it was so beaded that it actually—you know when you actually looked at it—it looked like little axes all over. And it was just so beautiful. It wasn't really axes, but you know it just felt in a way that it resembled, and it was so beautiful. [55]

Likewise, the garment district made available to her cloth in blue and white for Yemayá, purple for San Lázaro, green and gold for Orunmila, brown for Agayú, sequins in Oyá's "nine colors." The last does not actually have nine, but its spectrum is allowed to act as "nine colors"—presumably because it "resembles." A bolt of cloth iconographically appropriate to Ochosi, the hunter, and which she could afford, appeared on her 1987 birthday throne: a shiny metallic fabric photographically printed with the image of leopard skin (see pl. 1).

If the cloth and their colors are meaningful in terms of an "iconography" that can be discursively explained and represented as part of a "system," they must also be considered for their "aesthetic force" or surplus in the makers' changing experience. While one investigator's iconographic lens may desire to focus on the formal and semantic bases of the icons, another may want to find a way of valorizing the *enthusiasm* of her responses and incorporating them into an affective account of religious practice. The fabrics were chosen because they were "so beautiful" and the "best." They struck affective chords. They were aesthetically appropriate to the makers' practical *sense* at the same time that they were cosmologically appropriate. Or, alternatively put, they instantiated "structural properties" of cosmology in and through the maker's emergent, personal sense of aesthetic appropriateness.

Now, if the creative process of "selection"—of what the priestess-consumers "have in mind"—is shaped by prior familiarity with an iconographic repertoire and time-honored personal preferences, it is constantly open to improvisation in the thick of the often emotionally charged shopping experience. Melba explained: "I work with whatever I find. When I go down there and I like something, I picture it in my mind and I buy it." She arrives in the garment district with general ideas of what she wants:

> But if I get there and I see something that I think would go pretty with whatever I'm going to make, I'd buy it.
>
> DB: When you go to the store you have certain ideas. . . .
>
> MC: . . . of what I want, yeah, but if I get there and I see something that I think would go pretty with whatever I'm going to make, I'd buy it.
>
> DB: So you could go there with an idea but . . .
>
> MC: . . . then change my mind.[56]

Given that the variety of designs is not really infinite, but in fact determined by what companies produce and stores choose to represent to the consumer, at least something of the "look" of the thrones is shaped by industrial decisions in a dialectic with individual decision. In whatever terms the tradition of a priest, their house, or their ritual line is cast, not the least of its aesthetic features—the very surfaces of

the throne itself—may be modified through mass production and display and the response of the "educated consumer" in the store, while window-shopping on the street, or in taking a tip from a fellow *santera* of a particular sale.[57]

Preferences and expectations established in particular houses are ones that emerge from an ongoing process of improvisation and "traditionalizing" (Handler and Linnekin 1984; Kirshenblatt-Gimblett 1983). Outcomes are subject to incremental change over time. They can be established and legitimated in the *madrina*'s or *padrino*'s deployment of a particular form and its acceptance by godchildren and others (see, e.g., Flores 1990, 1994).[58] This makes aesthetic outcomes partly a question of "performance," in the sense of the "responsibility" an agent takes in relation to the expectations of an "audience" that evaluates the performers' competence for the *way* it is carried out (see Bauman 1975, 1989). Outcomes are "successful" to the extent that they are effectively and affectively appropriate to a particular group—in Chernoff and Hardin's sense, the occasion is made "sweet" by what a maker holds out in dynamic relation to "tradition." The provisional/speculative outcome (attempts to) instantiate certain properties, or pushes creatively the boundaries of those properties, and is judged as "appropriate," successful, and effective as it resonates with what else the participants know and have felt and experienced about the *orichas* in various domains.

A form may, however, be overturned and changed by the contingencies of external forces, not the intentional choice of the maker-agent/community. Here enter as factors corporate decision making and the "invisible hand" of market operation. Here also enters our consideration of the precise, experience-near calibration of what constitutes iconographic "change" for the makers. For example, in commenting on two kinds of beads essential to making *mazos* for her Yemayá-Achabá and those for some of her godchildren—dark blue beads in a particular shade and size and larger round "coral" beads—Melba lamented the disappearance of certain colors, sizes, and weights. With respect to the first and last, color and weight, plastic is partly to blame; it has pushed much ceramic and glass out of the marketplace:

> There are a lot of different blues, you see that blue that's there? [light blue bead called *azul celesta* or *azul aqua*, pls. 2 and 4]; I can no longer get it. [And] [t]he dark blue [*azul prusia*]. It's very difficult to match colors from long ago to colors that you have now. There's no comparison, you know. And the bead is so small [now].
>
> DB: And the little round balls at the end?
>
> MC: Those are coral [*corál*]. That no longer comes like that, those are little round coral colors. Now it comes in a more orangy color and not that round, like a regular bead. But this doesn't come no more. I've had godchildren tell me "why

are the [new] ones for Yemayá so . . . ?"

And I tell them, "honey, well that doesn't exist any more, what do you want me to do?" But people don't want to change. Believe me, I used to make a *mazo* with fifteen strings that it was so heavy that you couldn't even lift it. Because the bead was so big.[59]

In this case Melba had made new *mazos* for godchildren who could not reconcile what they received from her with what they had become accustomed to seeing around their *madrina*'s own Yemayá vessel. *Mazos* made "heavy" with large glass and ceramic fastening beads are to be seen less and less in priests' homes these days and are virtually nonexistent in *botánicas* in Miami and New York.

Thus certain possibilities of throne work are both liberated and limited by the consumer experience and socioeconomic pressure in the marketplace in the United States—which includes factors of availability, variety, and the need to economize. How "liberating" it is also produces ambivalence: there exists such a bewildering abundance of stores that sell cloth in the garment district that "you could go bananas," according to Melba. At the same time, if product display generates desire and enthusiasm, and credit cards expand the possibility of realization, they also produce frustration and loss. "There is a particular store that I no longer go in there because everything starts like $20 and up. So I don't want to *suffer*, so I don't go in there." The beaded cloth for Changó which was so desirable and appropriate for him caught her eye, "but it happened to be $75 a yard and I just didn't have it. You understand. Now if I had a credit card with me, I would have gone ahead without the blink of an eye."[60] Both women desire thrilling expensive fabrics and will jump at bargains, but will compromise on quality when finances are thin.[61] Thus what goes on the throne can, at some level, be affected by what is "on sale." In Cuba today, of course, such possibilities are radically circumscribed by and limited to what has been saved, borrowed, or brought from abroad.

Change occurs incrementally, in pragmatic ways, over time, in complex arenas of performance and aesthetic evaluation, but also in an emotional economy linked to the consumer economy, where mood, desire, and loss are not the least of the factors. It is thus difficult to delineate synchronic models or "styles" that we imagine as wholly stable other than in general ways. While enduring iconographic patterns shape choices, the emergent nature of their work and experience defy simple rule-making.

MAKING PAÑOS Thrones employ a basic dominant form: an installation of colorful cloth creating a canopy overhead, a curtain backdrop behind, and symmetrically parted and tied-back curtains in front. The enclosure, hung, draped, and stapled in large plain

swatches, is constructed of relatively more or less expensive cloth, depending on the means of the house. Of all the throne-cloth purchased in the garment district, it is that destined for *paños* which is usually the most expensive and is given the most labor-intensive attention. This is the cloth that the *orichas* themselves "wear," are "dressed" in. Draped over their *soperas*, the *paños*' elaborateness, density, and dazzling shine call attention to the powerful secrets within.[62]

Josie and Melba's *paños* begin with the purchase of cloth cut from 45-inch industry rolls. They normally purchase 45-inch lengths in order to make squares. The preferred choices observed in the houses of Melba Carillo, Josie García, and Ramón Esquivél ranged from the thick and heavy to the delicately thin and sheer: from velvet, taffeta, and satin to silk and chiffon (crepe). The cloths most often used for *paños* feature floral surface embroidery in gold or silver metallic thread, or what the massive industry calls the "metallic print" of a surface design. Also highly favored, as mentioned, are densely metallic-sequined fabrics and, in some cases, lamé. Each has its affective value and produces certain visual effects. A chief desired effect is that the fabric and/or its designs "will shine" (*brillar*).[63] Metallic embroidery or print may swirl dramatically on backgrounds which themselves are luminous satin, silk, or taffeta (pl. 2) or on darker backgrounds of velvet that have an elegant deep sheen. The desired feeling and appeal is "luxury,"[64] a word Melba uses often to describe the sensibility.

The selection and purchase of cloth squares is the first stage in designing more complex objects whose effect is heightened through layering and the adding of dramatic borders. Cloth selected to be the "front" of the *paño* is always given a "back" or "lining" by both women. The backing makes thinner fabrics "look a little thicker";[65] as such, the *paños* drape more smoothly, heavily, and elegantly over the ceramic tureens beneath them. The lining principle also opens up the possibility of creating layered and visual effects between back and front. Josie is proud of her expressive work with open, sheer metallic-print or surface-embroidered chiffon or crepe, layered over luminous and even sparkling backgrounds which themselves have metallic designs or consist of solid sparkling lamé. The "special material" that she purchased for her Obatalá is layered over a lining of silver lamé "because that material [the front has] little holes, with the embroidery, so you could see from the bottom. You could see that it shines from the bottom."[66] The *paño* for her Yemayá, of sheer silk fabric but in light blue, has an embroidered paisley surface design with which "you give the illusion that it is the wave of the sea." The lining is a darker blue with sparkling silver embroidery. It "shines and everything and have like gold stuff; I put that as the lining and facing the front, where everybody will see it, you know. I put the side that shines, so you will see the shine of that material through the

crepe, because that chiffon is transparent, you could see the other side."[67] Such is an instance in which, within the appropriate colors, Josie has not only improvised a striking decorative effect of richness through layering (as in the Obatalá *paño*) but has also recreated iconically the watery domain of Yemayá. The light blue paisley resembles swirling water, and the translucent front over the rich dark blue background evoke together the surface and depths of the sea.

Hand-hemmed and sewn-together backs and fronts then receive decorative borders selected with an eye toward complementing the embroidered or printed surfaces and colors. Bright borders add dramatic contrast to darker backgrounds, and colored sequin borders contrast with lighter luminous surfaces. The garment district offers dozens of stores specializing exclusively in these "trimmings," which include silver and gold braid, and sequins in all colors, in varying widths and complexity of design (pls. 1-3 and fig. 4.4). Their effect is the heightening of density and decorativeness, like flourishes of dripping jewelry if they are silver or gold. They multiply the effect of brilliance and richness as they catch and throw the light, sometimes bouncing points of light off adjacent walls. At the same time, color sequin borders extend or complete the counterpointed *oricha* color patterns, as in the thick, sinuous, red-sequined border for Obatalá-Ayáguna's heavy synthetic silver *paño* in plate 2. This Obatalá, a youthful "warrior," takes some of the hot Changó's red into his archetypal pure white.

107

Finally, Josie and Melba have experimented with further elaboration of their layered and bordered *paños* with multimedia iconographic appliquéd patterns. The designs are informed by familiarity with *oricha* iconography and, apparently, images from *apatakí*, legends or "histories" about the *orichas*, derived from the two Cuban Lucumí systems of divination (see Bascom 1952; Ecun 1989). Yet it is also apparent that the resulting objects, in turn, become concrete reference points for the remembering and telling of stories, especially at birthday time when newcomers engage in discussions with the priestesses (see below). The objects instantiate a personal, intimate, selective, and affective construction of *orichas'* qualities as much as they "express" prior "themes."

Josie's Changó's blazing red-sequined *paño* features appliquéd double thunder-axes (*oché*) and thunder-rattles (*acheré*) outlined in white sequin trimming (fig. 4.3 left side). On the blue taffeta *paño* for her Olokun—deity of profound mysteries of the deep (see Angarica n.d.:16)—she sewed four configurations of fourteen cowrie shells that form anchors at the four edges and then a constellation of cowries in the middle to form, as she explains, a "crown," when the *paño* is centered, draped, and tied over the elevated *sopera*. The crown, a touch of royalty and grandeur, was also conceived with multiples of Olokun's number (7) in mind.[68]

Jumping ahead to how *paños* already made are combined improvisationally for effect, Melba explains her layering of two *paños* for Yemayá—one over the ceramic *sopera* and one over the pedestal that supports it—as a juxtaposition appropriate to the watery qualities of her mother's road: Achabá. For Melba, Achabá's colors, as "associated" with the bead pattern, are "light" blue (*azul claro*) accompanied by "water" (*agua*), a darker opaque blue (*azul oscuro* or *prusia*), and an orangey "coral" (*corál*). Thus, in her selection and arrangement of the *paños* in 1987, resonating with the beadwork, "I combined dark and light on her because she sits in *el muelle* [the wharves] where the wave breaks, so you know, when the wave breaks, it breaks into many different colors [shades]. So for her *mazo* and her oars, I combine light with *agua* and with dark blue" (pl. 2). The "coral" is also as a manifestation of this upper level of the sea where waves break on reefs.[69]

Those more straightforward representations of color and number are enriched with subtle, private, and pragmatic figurings of *oricha* qualities. Josie constructed the *paño* for her Oyá at the outset with an extra measure of cloth—a one-and-a-half-yard rectangle (45″ × 54″) rather than a 45-inch square, not only because Oyá's *sopera* is "a little wider [than the others but also because] I want to show like a woman, like a heavy woman, you know; so when I make with a yard and a half it looks wider and it gives the impression of a warrior that is right there, like '*I'm ready!*' Um hunh, that's the impression that [I want]."[70] Oyá may or may not be a "heavy woman" to all priests and priestesses. Oyá has been imagined in myriad forms (see Gleason 1987). That is the way Josie instantiates her Oyá.

In one of the most complex cases, the *paños* Josie made for "my beautiful *viejo*" ("old man," i.e., San Lázaro/Babalú-Ayé), an *oricha* she received in 1987 from Melba Carillo, began with burlap cloth bordered in purple and silver braid and backed with thick purple satin (see fig. 4.4). Burlap—or hennequin—and purple figure the dual royal-ecclesiastical and humble (penitential) aspects, respectively, of St. Lazarus.[71] She constructed a "flower" of five concentric pleated strips of shiny satin trimming, bordered with gold braid, as the *paño*'s central appliquéd motif. The flower reproduces the pattern of five alternating bead colors first encountered on the broomlike dance wand (*ajá*) she received along with his terracotta vessel. The five colors define the secret of this particular road San Lázaro, who is of the Arará (Dahomean-Cuban) line. She was told by the *babaláwo* who fabricated this San Lázaro for her that the five colors are tied to "five secrets" given to "this special Asojuano" (a praise name for San Lázaro) by five *orichas*, respectively, with whom he had ritually "contracted":

[The *babaláwo*] said to me: "*cinco misterios un contrato que el tiene con eso cinco*" [five secrets, (from) a contract that he had with those five (*orichas*)]. *En-*

tonces, I made the top, the trimming, to match that with the five colors. The design on the *paño* to match the *ajá*. Like a circle, but I made them real tight and made pleats to make them look wider, and I used the five colors.[72]

While the *paños'* elements and representations would immediately conform to most informed visitors' general expectations—their knowledge about *oricha* characteristics—others remain more restricted, for example, the esoteric *apataki* segment communicated to her by the *babaláwo*. The choice of a flower motif to articulate the "five colors" appears to be purely whimsical and decorative, without symbolic or iconic meaning.[73]

As a response to an open-ended question to talk about this presentation, her narrative reveals the presence of iconographic interpretations and extrapolations, which she made in relation to ambiguities in the *babaláwo's* explanations. The *babaláwo* did not reveal to her exactly which five *orichas* contracted with this San Lázaro. "He didn't explain that to me but I figure out: it have yellow and green: that must be Orula and Ochún; and it have black and red: that must be Changó and Eleguá; and it have blue, which is Yemayá. Then they have a contract with that [Asojuano]."[74] What the five bead colors represent collectively first emerges orally in dialogue with the *babaláwo* and then is amplified and refined through her inconographic interpretations, associations which she then works out concretely in and through the selection and piecing of cloth. One might confirm or document these iconographic references with conventional myths that appear in private or published texts, or as told by diviners. Yet if the *paño* has an iconographic meaning that is rooted in myth parallels, the object also embodies an ineffable "surplus" of significance, force, or "presence" as it registers her experiences of "her beautiful old man": the momentous occasion of receiving him, her loving personal interaction with him over time, the emotional and aesthetic investment in making this *paño* as a gift to appear on her birthday throne.

AN AESTHETICS OF PLACEMENT: PAÑOS AND THE BIRTHDAY THRONE

Fundamental to an aesthetic that emerges through assemblage is the arrangement of objects in a temporary spatial installation form. The throne form has a strong paradigmatic dimension in its hierarchicalization of the *orichas* and its spatial/scale relationship to human bodies that go to the floor before it to salute the *orichas*. It also, as discussed above, has strong diachronic and processual dimensions.

This section develops the idea, along both the paradigmatic axis and diachronic axis, that the creative work of throne assemblage and organization is a practice of instantiating cosmology, where aesthetic appropriateness and cosmological correctness are difficult to separate. No doubt there exist shared ideas of cosmology in the form of the Santería hierarchical pantheon of deities and their relationships. There

are to be found generally shared and enduring paradigms—what one might identify as the "tradition"—among practitioners for arranging the *orichas* on the throne. On the other hand, there are patterns that are particular only to one's own house, in the form of private recurrent patterns, unpredictable motivations, and oracular inspirations that lead to new and novel arrangements, which may be seen one time only and never again. If priests and priestesses rely on repeated formulas that have worked for them in the past, inspirations "come to" them as they stand before an empty corner of the room with cloth in their hands. The creative process, a diachronic issue also, is nothing if not heavily improvisatory, sometimes proceeding through several false starts and provisional arrangements before a final result is acceptable. An explanation given to a researcher that seems principled may be contradicted the next year when different choices are made. In short, if the throne can be appreciated as a paradigmatic arrangement, especially one that is designed to impress visually during a specific moment, its diachronic dimension can also be appreciated as the throne's planning and production are enmeshed in the lived relationship a priestess nurtures with the *orichas*.

For the birthday throne, *paños* are employed to cover the *orichas' soperas*, elevated on pedestals (milk crates, boxes, tables, bureaus), to drape the pedestals themselves, and to adorn the throne's canopy. The throne's canopy, curtains, and backdrop are erected first, in a space that is often a point of negotiation between *oricha* and priest (see below). Then the *soperas* are arranged on pedestals according to rank. In Melba Carillo's house, *orichas* "made" and "received" in the initiation (the "original group") are grouped together centrally, while additional *addimú-orichas* "received" later are usually added to the extremes of a frontally facing lateral array. In her house, Obatalá—the arch-*oricha* known as the "owner of all heads"—is always ascendant, followed in vertical register, a step lower, by the priest's guardian angel (if it is not already Obatalá), followed by the "second parent." Eleguá, the *orichas'* messenger and mediator, always goes front and center on the floor. This scheme of placement instantiates cosmology and a set of values of authority on two levels—the relative authority of the *orichas* themselves, and the authority of the *madrina* to ensure the *orichas'* proper presentation as a matter of respect. Godchildren may be rebuked for their throne-work, if upon inspection by their *madrina*, Obatalá is "not high enough." Melba explains:

> The five originals [or] the six originals go by order. Obatalá always goes highest. Obatalá has to go highest, even if he's not your head, but your head has to go high, then everybody else has to go lower than your head. Let's say with [Fulana], Obatalá goes the highest, then comes Changó, which is her father, then her mother in front—Obba. [With me] it would be Obatalá [guardian angel], then Yemayá

["mother"]. Eleguá always goes first. . . . Eleguá always goes in front, because he's the first one that you give *cocos* to [divine to]. He is on the floor always.[75]

Aesthetic calibrations of height, space, and position embody authority, order, and *oricha* vocation. To repeat, Obatalá is the Owner of all Heads and thus highest, and Eleguá is a kind of foot messenger and intermediary—he belongs front and center on the mat.

Over each *oricha*'s arranged *paño*, the *oricha*'s *mazo* is doubled to encircle the top of the now-covered *sopera*, or else it is draped sash-style. The nine-pointed copper crown of Oyá and the five-pointed brass crown of Ochún[76] are then placed atop the *mazo*, their dangling attributes radiating out from the center (see, e.g., pl. 3).[77] In order "to make it beautiful," the top of the *paño* is often carefully coaxed up through the crown, or pinched and tied if there is no crown, to form a puffy navel or head which Josie likens to a "bun" (pls. 2–3 and figs. 4.1–2).[78] Finally the appropriate beaded or painted staffs, dance wands, or other attributes owned by the *oricha* are placed on top, slipped through the *mazo*, or nestled nearby against a wall. The result poses the finely dressed *orichas* as a glorious assembled theatrical cast at a curtain call or, more precisely, like royalty sitting in state.

As shown, Josie García and Melba Carillo intentionally figure in cloth and throne arrangements aspects of the conventionalized *oricha* legends called *apataki* as well as a more personal sense of their relationships with particular *orichas*. Both dimensions may develop out of transmitted oracular information which comes from *itá* (the results of divination readings), from dreams, which are also prophetic in nature, from informal conversations, and from personal, private contemplation. García, as I have reported elsewhere, fashioned the overarching canopy or *techo* ("roof") of her 1986 birthday throne as a running river's surface as seen from below, for she understands her particular road of Ochún (Anggalé) as having "lived in a river in a cave" (Brown 1993:52), something she learned in her *itá* and has elaborated since as a throne motif.

In placing the *orichas*' vessels under the throne's canopy, the two priestesses, although ritually related, employ divergent patterns that evoke cycles of myths but that are also personally appropriate. Melba consistently separates Changó on the one hand from Oyá and Ochún on the other—two women who competed for his attention—by the interposition of Yemayá, the mother of all of them, whose favorite child is Changó (see Brown 1989:416–17). Oyá and Yemayá are understood to be "enemies" and are separated in mythology and ritual practice.[79] Melba apparently prefers not to antagonize her own tutelary *oricha* Yemayá by placing Oyá, or another lover, together with Changó. Thus Yemayá always goes in the center and Changó sits to her right. Oyá and Ochún sit opposite, off to Yemayá's left (pl. 1). On

111

the other hand, Josie, a priestess of Ochún, likes to place Changó and Oyá together because they are "lovers." She applies a different solution to the conflict: she keeps Yemayá at a distance to shield her sensitivities. She explained: "Oh, Oyá and Changó, that's a love!" Yet she cautions that "you never have Oyá next to Yemayá because of Changó. Yemayá loves him so much, she's jealous of Oyá." [80] Ochún, as Josie's mother, sits centrally. In some ways, Josie's particular Ochún, called Aggalé, apparently remains unimplicated in these tense affairs because she is an old Ochún who carries on an intimate relationship with the diviner-*oricha* Orunmila (Orula). Thus Ochún appears on the throne with Orunmila's beadwork incorporated into her own and Orunmila's divining equipment placed on and around her *sopera*. Oyá and Changó occupy one extreme and Yemayá the other (fig. 4.3). Such divergent arrangements have as much to do with the different versions in the cycle of mythological texts as they do with Josie's and Melba's intimate experience of the likes and dislikes—preferences—of the personalities that are the *orichas*.

Many of the foregoing, somewhat conventionalized mythic segments, as emblematized in cloth, are widely known. Yet some *apataki* become more important than others to practitioners, given the identity of their particular *oricha* roads (as seen above). At the same time, even more personalized narratives of their relationship with the *orichas* take shape in divination readings (regular *registros* and more momentous, periodic *itá*), as the practitioners' particular *caminos* ("roads") are revealed to them. These are embellished over time in the practitioner's imagination. They are worked out concretely in throne arrangements where aesthetic force is as important as discursive explanation.

In terms similar to the aesthetic "rules" Melba articulated above, Josie acknowledges the ascendance of Obatalá in general (as the "owner of all heads") and as her "father" in particular as she places him "high" upon the throne. At the same time she carries on a very special relationship with Changó, who is her special "secret," as she describes him. Regardless of the location of Changó's *paño*-covered vessel upon the throne's mat, she doubly represents him in the form of another red *paño*, shaped like a thunder-ax, high, front and center, above everything else (fig. 4.3):

> I heard from the eldest people that you put on top [a *paño*] from where you were born. . . . See everybody have Obatalá on top [already], no matter what saint you have, but the *paño* behind [above] him [also] that will say, "I was born from him." Usually when you make the *trono*, right in the middle they take a *paño* and put it very nice all the way up. In this case, I don't put that because I put in front my Changó. [81]

In other words, she is adhering to the convention of her house in putting the *sopera* of Obatalá highest. Yet she is revising what she takes to be another convention, encountered in the houses of other respected elders, about additionally representing with a high *paño* the *oricha* from whom one is "born." As she was "born from" Obatalá, the fulfillment of the latter convention would mean the placement high of another white *paño* for Obatalá.[82] (Presumably Ochún, her mother, is already represented by the dominant yellow cloth of the throne itself.) However, instead she places high the additional red *paño* for Changó. Josie recognizes and receives responses from observers that are aesthetic and interpretive, respectively, but also relativizes them with her unique experience of Changó:

> That's my strength [the Changó *paño*]. Well a lot of people they . . . tell you, they say, "that looks nice in there." Like my *madrina*, she say, "that is the justice man," but in the back of my mind I say "he's the one who gives me everything so I will have him high." And see nobody asks me [laughs]—this is the first time that I'm talking about my secret; nobody asked me that. But that's one of the things: he's the man who gives me everything, so, he's my provider.[83]

Josie acknowledges here two responses to her work, which the statement inscribes with its deictic or indexical markers (a pointing "that") as a phenomenology of viewing. One response is aesthetically evaluative ("that looks nice in there"). We imagine Josie and visitors standing together before the throne, fruit spread out before their feet, looking up at the *paño* and perhaps pointing. The second is interpretive, symbolic, or iconographic—what someone knows about Changó: "that is the justice man." The red cloth thunder ax refers to Changó's role as protector, defender, and solver of problems.

Yet how she qualifies the observers' positions with "but in the back of my mind" suggests, first, a distinction between more public and private dimensions of her work. The throne is there for all to see, but personal secrets remain. Second, suggested is a logic distinct from the iconographic and the aesthetically evaluative, which resists a static discursive decoding and dynamizes her *work* (in the Armstrong sense)[84] within her lived relationship with Changó. "He is the one who gives me everything so I will have him high." "High" instantiates concretely his importance and strength and her gratitude and respect. It is not merely that "high" "means"— "sends messages" of—those things whose metaphysical ground is somewhere else. In the throne they are demonstrated in a heightened moment, her birthday. They are embodied, impressed upon her and all comers in relation to their own bodily height and physical position. Josie had to climb a ladder to place the *paño* high, and the group, dwarfed by the throne, has to look up and point at it.

Most important, the concrete logic of her aesthetic work is that it is integral to her ongoing exchange relationship with Changó, one that proceeds in an "ambient of time," diachronically, as much as it represents an abstract value expressed in space (synchronically).[85] "He *gives* me everything *so*"—it follows—"I *will have* him high." She is participating in and completing a series of exchanges—responding to Changó—*in and through* her aesthetic work. If the throne follows from her extant relationship with Changó and her other *orichas*, it also renews, regenerates, and propels that relationship. The work can participate in this way because it is iconographically and cosmologically appropriate—it employs the "right colors" and icons which "are theirs"; because it is aesthetically appropriate, that is, "beautiful" and the "best"; and because it is given and presented at the appropriate time, the *orichas'* birthday.

The *paños* and throne arrangements in space may be taken to be the women's particular mode of "telling stories." Yet if the objects themselves may be "explained" inwards by the makers, the explanations do not "substitute" for the displays and pieces themselves, which, in Ysamur Flores' terms, "speak without a voice" (Flores 1990, 1994). Indeed, the utterances: Oyá—"*Big Woman*" // Ochún—"*Angalé [that] lived in a cave*" // San Lázaro—"*My Beautiful Old Man*" // "*Changó and Oyá, that's a love*" // Changó: "*That's the Justice Man*" // *Changó . . . will fight all your wars*" (see below), may be seen as personalized emblems or vernacular praise-epithets[86] that are additively or "syndetically" applied (Armstrong 1981:ch.1). They pile up right here rather than remain "somewhere else" as prior grounds of meaning. In this revised sense they are like the praise-poem/myth "parallels" employed by Wescott and Thompson, but are emblematic equivalents, not higher-order explanations of the objects, which themselves are emblematic. To repeat, the objects do not necessarily "refer" transparently to "myth," to texts, or even to imaginably more fundamental "story-telling contexts." "They are whatever they are" (Armstrong 1981:5) and resonate in an associative series, something like Hardin's instantiations of "structural properties" which may be perceived as redundant across domains (story-telling, divination, ritual practice, life situations, art objects) (see Mason 1993).[87]

Finally, the aesthetic force and "presence" of the emblematic utterances and *paños* can be as important as any signified meaning. If Josie's statement, "That's my strength," as she points to the large and looming red *paño* in the shape of a thunder ax, can refer to ("mean") the strength qualities of Changó, it is clear that the *paño* *is*—embodies—his strength-made-hers. In Armstrong's terms, something of Changó is *im*-mediately, affectively, "in presence" (Armstrong 1981)—in the *paño* she made and in their *relationship* ("my strength") which the *paño* cements.

ORACULAR UTTERANCES AND THRONE DESIGN

The reported experience of priests and priestesses suggests that the *orichas* partici- pate in throne construction as aesthetically interested agents. The ethnoaesthetic cat- egories illuminated in this investigation should therefore include the *orichas* as cre- ative subjects and their own intentions with respect to the production of throne artwork. They regularly express directly or indirectly how they are to be presented for birthdays and drummings. Specifically, *santeros* report the influence of dreams, divination, and speech by *orichas* possessing priests, as factors in throne construc- tion. Such oracular modes may provide detailed visual plans for visual representa- tion. And the *orichas* are seen to respond with satisfaction when priests do right by them. Josie relates that when she enters a store to purchase cloth, "the same *orichas*, the same spirits that you have . . . guide you to what you really want. Like some- times you don't really go looking for that and you see that and you go, 'oh this is for Ochun.'"[88] The idea of spiritual inspiration, and more specifically the religion's id- iom of *aché* (enabling power), encourage a revision of the notions such as "personal choice" and individual artistic agency. In their ritual and aesthetic work, people are felt to have an *aché* for certain kinds of "talent." Ramón Esquivél was said to have an *aché* for throne building; Josie might be said to have an *aché* for making *paños*, and Melba for *mazos* and *paños*. And their aesthetic pleasure and responses in rela- tion to beautiful and appropriate throne work should also not be seen as "wholly intra-aesthetic." They are at one with the mutual and negotiated interests of priests, *orichas*, and members of the house.

115

DREAMS

Melba Carillo constructed her Obatalá's birthday throne for many years in the nar- row second bedroom of the apartment she shared with her son. Beginning in 1984 she began to have recurrent dreams of a magnificent and expansive birthday throne for Obatalá constructed in her own bedroom, the master bedroom of the apartment. The dreams gave the throne a generous horseshoe- or U-shape which seemed to defy the physical limits of the room itself. She knew Obatalá was voicing his desire that she enthrone him there (as much as it was also her own desire to please him) but re- sisted installing the throne in the master bedroom in 1984, 1985, and 1986 because of the trouble involved in moving the large bed and displacing herself onto the sofa for a week while the throne stood. In the terms of their more or less explicit dialogue and negotiation, the possibility of offering Obatalá a more luxurious venue for his birthday throne was tied to the possibility that someday he would provide Melba with a larger house, in which the saints would have their own permanent room, and could each year be assured that a large spreading throne would be built for them. For Obatalá's fourteenth birthday in October 1987, after more suggestive dreams, she decided to try the master bedroom. On the eve of her birthday, just as she and her godchildren, under Ramón Esquivél's supervision, had finished the work, she

began hearing the hearty, warm laugh of a man obviously overwhelmed with pleasure. She tried to locate its source, but none of the other priests in the house had been laughing. It was Obatalá, happy that his wishes had been fulfilled. "I knew it was Obatalá laughing, he was showing his pleasure, that he finally got that room."[89] The appropriateness of the dream's realization in the birthday throne was further confirmed by the arrival of a woman visitor the next day, another priestess who had seen the very same throne in her own dream of the previous night. A final confirmation came for Melba when the throne's drapes, tenuously stapled for seven days to the inhospitable, rock-hard apartment walls, virtually fell into her hands when it was time to dismantle the throne. In other words, Obatalá had allowed a technically impossible feat for the week-long period in order that the throne be realized for him.[90] Two years later her son was married and moved out. A new house was not provided, but the *orichas* now have their own room.

The 1987 birthday throne centrally elevated Melba's two Obatalás over, and situated the rest of her *orichas* around, a series of floor mats in a U-shaped pattern (pl. 1). The sea of arranged fruits and sweets—the *plaza*—bordered a central mat at whose head rested her Eleguás. Also at that end of the mat rest the bells and shakers (*maracas*) used to ritually salute the *orichas*, the basket (*jícara*) for depositing monetary tributes (*derechos*), and the candle to be lighted after the *orichas*, through divination with the coconuts (*obi*), state their satisfaction at the spread they have before them. The open central mat, perpendicular to the throne's array, is laid out specifically for priests to "throw themselves to the floor" (*moforibale*) to salute the *orichas*.

While the throne materialized the U-shape from the dream, it could not feasibly realize the dream's more lavish details. The dream had specified not only a set of materials preferred by Obatalá (silver); it also specified the heavenward ladder that is iconographically appropriate to this *oricha* who bridges sky and earth, whose steps manifest the oracular number of Obatalá in the cowrie divination system (8). Not merely a visual attribute in the dream, the ladder was an architectural element tied to ritual performance. It provided a dramatic mode of bodily salutation. As impressive as it was, Melba felt financially unable to realize the whole design.

There were eight steps leading up to Obatalá, and on the first [top] there were the *maracas* and the candle. On the second [from top] there was the money. The eighth step was down to the floor. People could walk up, or throw themselves right on the steps so their head would just touch him [Obatalá]. The ladder was all silver, pure silver. I heard myself saying in the dream to Obatalá, "I haven't got the money for a silver ladder, the best I can do is foil."

Nevertheless, later in our interview Melba added, "if I hit the lotto, that's the first thing I would do . . . [get those steps]."[91] Short of a lotto prize, foil would stand for silver in the dream's negotiations.

Here a dream, which is taken to be the active intervention of the agency of an *oricha*, is integral to the creative process of throne making. Melba's throne work was an aesthetic performance that articulated concretely and negotiated a set of desires and interests, embodying dramatically a moment in an emergent life joined to Obatalá. The throne was not merely a function or result of some more basic or prior priestly relationship with Obatalá—which she "made" ritually in her initiation. It was in the very dreaming, desiring, the throne work, and its responses, that the relationship was experienced, (re)made, affirmed, and propelled, in a heightened, semi-public moment. The throne's aesthetic work moved priestess and *oricha* from one place to another, if no more than to a place of increased potential.

117

THRONE DESIGN AND
FORMAL EBÓ

If dreams inspire the creation of throne art and may be interpreted to express the designs of *orichas* and priests, formal divination and immediate possession speech do also, but within the context of specific ritual work the *oricha* plans to execute. The content and structure of thrones can emerge at the culmination of divination readings as ingredients the *orichas* "mark" (*marcar*) as part of *ebó* ("sacrifices"/offerings) in order to resolve the issues raised in the reading.

Oracular instructions can vary from the very simple and minimal to the complex and expensive. They may involve no more than lighting a candle or taking an herbal bath. A reading can instruct the client to place an iconographic or art object, such as a beaded flywhisk, or a utilitarian tool, such as a machete or gun, on or in the *oricha*'s vessel. It can require heavy obligations such as giving the *oricha* a drumming (*un tambor*). The latter can run into the thousands of dollars and usually involves building a throne, hiring drummers, and often contracting a priest to "dance the *oricha*"—that is, to become possessed by the *oricha* of honor in order to perform ritual work—which necessitates that a new ritual *oricha* costume (*ropa de santo*) be commissioned for the event. In the case of the call for a drumming, most often the reading or speaking *oricha* will simply indicate that a priest must "play for" this or that deity. It follows, customarily, that a throne be built for the event. The throne is creatively improvised from the conventional aesthetic attributes understood to be appropriate to the *oricha* in question. For example, a drumming throne for Ochún will generally employ yellow and/or gold cloth for the canopy and curtains; it will elevate Ochún centrally and have her covered with a *paño* and so on. Other *orichas* may be represented with *paños*, but their *soperas* probably will usually not be present. Yet readings may provide detailed information that often inexplicably revises aesthetic expectations.

In a 1987 case in New Jersey, during a divination reading (*itá*) that accompanied an Ochún priestess's receiving of a set of powers associated with Ogún called "the knife" (*pinaldo* or *cuchillo*), the cowrie shells were interpreted to call for a very specific and idiosyncratic set of guidelines in the construction of the throne. The woman was instructed by the reading to "play for Ochún." Yet the group of participants was quite surprised when the *letra* (divination result) of the woman's reading also dictated that the throne—as opposed to what is normally done for Ochún—consist of "leaves," like one built for Eleguá, Ogún, and Ochosi, the "Warriors" who live in the forest (fig. 4.2). As Melba explains, using a Changó example, if the *orichas* want a drumming, "we play for them. We'll make the throne red and white [if it is Changó]. Now if he specifically says 'this is how I want it' then we'll make it the way he says he wants it."[92] The plan for the Ochún throne was kept a closely guarded secret, and there was much speculation within the group about how "surprised," if not confused, people were going to be about such an unusual throne. In other words, divination generated a novel aesthetic configuration that would not immediately conform to certain shared iconographic conventions for Ochún, although it would be appropriate in terms of the divination *letra* known by the immediate in-group. Specific to this *letra*, such a throne of leaves for Ochún might never be repeated.

In another 1987 case, the Changó of Adolfo Fernandez dictated through divination first, and then later in person as he possessed Fernandez, that a drumming be given to heal the leading *babaláwo* in the community to which Melba, Josie, Fernandez, and Esquivél belonged. The *babaláwo* was recovering from a near-fatal internal illness, having had surgery in July 1987. At that time, a "dark *egun*" had been seen lurking about and raised the suspicion that it had been sent out of jealousy by someone from a rival group in order to take advantage of the *babaláwo*'s weakened condition.[93] A *tambor* to Changó with a massive throne was given on September 24, 1987. During that event Changó came down and dramatically cleaned the *babaláwo* and his group, employing fruit from the throne.

Because of this *ebó*'s dictated requirements—a huge amount of fruit and prepared foods and sweets proportional to the extent of the cleansing that needed to be done—it had to extend the entire length of a fifteen-foot wall. Moreover, Changó demanded that the throne was to include not only the Changó vessel of the *babaláwo* but also that of the priest (Changó's "son," Fernandez) whose Changó would come down to perform the cleansing of the group. The throne maker, Ramón Esquivél, devised a novel form of display built around the dual presentation of the two Changós.

Beyond the formal aesthetic requirements entailed by the oracular information remains an issue of instrumentality and meaning. Fruit and "sweets" are usually

purchased in order to provide the *orichas* with a respectable and generous *plaza*. At the end of the event—a birthday or drumming—the fruit and sweets, understood generally to have been "blessed," are given away to, and eaten by, all the participants, including those who put on the event. In this case, however, the in-group responsible for the drumming specifically intended the *plaza* and flowers to be an *ebó* for cleansing the *babaláwo* and themselves, whose meaning and function was specific to the problem and solution at hand. They could not eat the fruit because it was "cleaning" them. The visitors from outside this group would act as vehicles to take away malignant influences from the house but would not themselves be tainted or harmed by what the fruit and food carried.[94] An outside visitor and observer could appreciate the throne aesthetically, salute it, receive its blessings, but never be made aware of this specific level of ritual process.

Thus, in the cases of the 1987 Ochún and Changó thrones, unless the particular circumstances of the divination *letra* and *ebó* were explained to a visitor—and this is rare because the ritual goals of the house can be quite private—aspects of the thrones' appearance would remain anomalies with respect to certain shared aesthetic conventions or traditions within Santería for representing the *orichas*. Divination can be a generative force where aesthetics is concerned, but often in ways that cannot be predicted in advance, and which, in practice, defy a priori iconographic rules we often desire to uncover in our investigations.

THE ROLE OF AESTHETICS IN EXCHANGE AND THE TRANSFORMATIVE WORK OF ART MAKING

The final sections treat more explicitly the thesis that object making and responses to it be seen as aesthetically marked, practical strategies of empowerment, advancement, and securing life's social and spiritual goods, within a community of emergent relationships. Those strategies are effected in and through object making and aesthetic evaluation as much as they are "reflected" by them. Consistent with Hardin's argument about the relation of aesthetic production and evaluation to action, change, and structure, such a process proceeds as one lavishes one's own *orichas* with beautiful and appropriate aesthetic objects, evaluates aesthetically others' dressed *orichas* when they are enthroned, and, by extension, evaluates other priests' character, status, and authority as they are embodied in and through their relative commitment to aesthetic elaboration. I hesitate to generalize my findings at this point beyond the houses studied and evidence available in several recent publications; thus I regard these points as hypotheses for development in future work. Yet they appear consistent with the findings of Karin Barber (1981), Mikelle Smith Omari (1984), and Ysamur Flores (1990, 1994) in Africa and the Diaspora, and resonate with work on religious arts in other fields of art history (see Melion 1990, 1992, 1994).[95] Omari writes astutely of a similar pattern among Candomblé practitioners in Salvador Bahia:

> Purchasing liturgical vestments and implements involves great expense, and many initiates borrow large sums which they try to repay in installments (à prestaçao). This financial outlay is partly justified by the appreciation of the spectators and initiates who scrutinize and discuss each costume and performance. The Orixá of Oxunlade, an initiate of Oxum and visiting *iyálorixá* from Brasilia, elicited much enthusiastic commentary with her lavish costumes which included an unusual transparent gold-colored skirt draped into scallops with tiny gold and pink flowers. Oxunlade gained a great deal of recognition and prestige, and the beauty of the dance and costume of her Oxum were discussed for weeks after the event; no one knew that the expense left her without funds for a month. She believed that her efforts to please her Orixá aesthetically would result in spiritual benefits which would more than compensate her for the hardship. (Omari 1984:27–28)

Omari intends that the Afro-Brazilian Candomblé's aesthetic practices be understood against the West African background, wherein the Yoruba employ "art and objects of aesthetic value" as "suitable offerings to the gods." The Portuguese verb *festejar* ("to fete")—in which the *orixás* are celebrated—"implies 'do something big or extraordinary for someone or something elevated.'" Thus, she concludes, "the Orixá can be manipulated by aesthetic display" where "large public festivals (*xire*) are collective tributes to the Orixá with the expectation of public benefit" and where "ritual objects and attire are seen as individual offerings" (Omari 1984:28). Omari's sense indeed resonates with Karin Barber's observations among the Yoruba:

> Each devotee concentrates on her own òrìṣà and tries to enhance its glory through her attentions. This involves not only making offerings and chanting oriki, but also spending money as lavishly as possible on their day to give the feast. In return, the òrìṣà is asked to give blessings and protection. . . . Personal magnificence enhances reputation: it is the outward sign of greatness, and is described in images of riches, sumptuous garments, beads, beauty, elegance, graceful dancing, and so on. . . . [The devotee's] concern is . . . to elevate and enhance her own [òrìṣà] so that it will be able to bless and protect her. . . . It is the devotees who spend conspicuously to increase the prestige of their òrìṣà. Indeed, the devotee seems here to be combining the roles of supporter and Big Man. He adulates his òrìṣà and by doing so increases his own stature. (Barber 1981:735–37)

Neither Omari nor Barber is compelled to distinguish between technically "ritual" acts (*ebó*), which bring life's goods, and aesthetic productions and evaluations, which are, indeed, also understood to bring benefits such as blessing, protection, and enhancement of reputation and stature. Candomblé priestesses triumph among their peers and "manipulate" the *orixas* through aesthetically impressing the former and "pleasing" the latter. As in the Hardin and Chernoff framework, aesthetic dis-

play, precisely and simultaneously as it engenders powerful alliances with deities, functions as a token of power in a charged, emergent social arena. It is difficult to limit the circulation of enabling power (*aché*) to narrowly technical "ritual" acts, as it seems to infuse the multiple dimensions and domains of priestly practice. Moreover, in both the Omari and Barber cases the value of the objects and results is informed and legitimized by the monetary terms of the marketplace, in dollars and cents, resisting more romanticized views of a hermetic sacred sphere untouched by the "outside world."

In the case of the 1987 throne for Changó, the architectural massiveness of the throne was technically necessary to accommodate the huge *plaza* of dozens of boxes of fruit and scores of dishes dedicated to cleaning a large group of people. There Changó had intended the *ebó* not only to heal the *babaláwo*-leader but also to "bring them [the group] together," where tensions and problems caused by an opposing group might otherwise have divided them. At the same time much of their excitement and enthusiasm in the planning stages, in numerous discussions between July and the September 24th event, centered around aesthetic concerns: how big, lavish, and stunning the throne would be; and they imagined novel ways to represent, for example, Changó's red and white castle and brickwork. It was apparent from listening to those discussions that the beauty, magnificence, and sheer impressiveness of the throne was going to contribute to their triumph over the opposing forces who would encounter the throne. It is somewhat difficult here to separate the issue of aesthetic force from their group interests, their loving feelings toward the indefatigable defender Changó, who, through the efficacy of the *ebó*/drumming, would protect them, unify them, and solve their problems. The case suggests to me that, although the technical ritual work of Changó's *ebó* was crucial in accomplishing the goals of the event, the aesthetic discussions, the collective aesthetic work in making the event come off, and the satisfaction they felt with the result—the throne—helped renew and realign the group, (re)generate their relationships among themselves and with Changó, as well as triumph over enemies.

As suggested, the aesthetic work that Melba and Josie produce may be seen as special, ongoing gift exchanges[96] with *orichas*. Gifts of *paños* and beadwork are presented at moments that are heavily aesthetically marked. For birthdays and drummings, private homes become community centers and the *orichas* are presented formally and publicly. On such occasions, the *orichas* are to be presented "at their best," and their splendor—as they sit dressed in the highly worked gifts Josie and Melba have given them—is aesthetically evaluated by visitors, often vocally and in detail. Consistent with Omari's findings, the objects produced by the two priestesses are thought of precisely as gifts to "please" the *orichas*, involving personal sacrifices in their many hours of work and reprioritizations of household budgets, the out-

come of which brings them well-being and even money in return.

Priests', *orichas*', and visitors' aesthetic evaluations of the objects and throne presentations include assessments of quality, originality, iconographic appropriateness, and apparent wealth value—considered in relation to the earnest, loving "work" that went into them. All of these factors are subsumed laconically by the evaluative term "beautiful." For Melba, such an event "is the accomplishment of all my work, nights without sleeping, and it looks so beautiful" (see below). Josie explains:

> It makes it beautiful when you put all your heart [in it] to do the designs, you
> know, and you try your best to please them, you know, she [Ochún] will love this.
> Like on the [throne] I tried to make the waves [of the river out of cloth] and all that,
> so in my eyes it is beautiful because I'm trying to do all the things that she likes, you
> know. And then when people come, they will see, sometimes they don't always look
> so much at the material but the work that you put in it, "*look!*" [they say].

Here Josie is referring to her 1986 birthday throne in which she shaped a vast piece of honey-colored cloth into a spreading butterfly, whose wings doubly recreated the lapping concentric waves at the river's banks (Brown 1993:52–53). The design was beautiful because it so appropriately and creatively improvised on some of Ochún's iconographic motifs—butterflies, river water, and "honey"—and because of its affective impact. It is "beautiful" because of the material and design but also because of what is felt: the work, attention, and love that the pieces embody. They truly have her "heart" in them, which is something a priestess of Ochún, the *oricha* of love and sweet things, should know about. Ochún's sweetness moves mountains. Indeed, Josie included the large expanse of "honey"-colored cloth in this throne specifically to sweeten a year that had been a little "sour."[97]

Such effects are made possible by the spending of money. But their spending is guided by the principle that nothing is too good for their *orichas*: "it's not a question of cost. If it's for them I don't care," explains Melba.[98] Josie's "special material" for her Obatalá was "very expensive," even at the sale price of $132 a yard, down from $140. The store is known to her as selling "very expensive materials," a store that she believes serves "people that [are], not rich, but you know that could afford it that could go and buy materials."[99] Clearly Obatalá's clothes should be purchased in such a store. The embroidered material she chose, she was convinced, "[would] look very nice because . . . not only [is it] expensive but the material per se, says "I'm the best."[100] By extension, when displayed on the birthday throne, it should say "I'm the best" to visitors. Melba invests in the presentation of her own *orichas*—her spiritual parents—with the same vigor that she invests in the presentation of *orichas* she "makes," that is, the initiations she conducts. It is as important to her to put on

a beautiful display for the *orichas* of her godchildren at their initiations as for her own birthdays. In the case of a particularly beloved godchild who was to be initiated as a priestess of Oyá, Melba went further than her own godfather did for her 1974 initiation. For the 1985 Oyá initiation:

> I went all out, made a big, beautiful throne. It's the accomplishment of all my work, nights without sleeping, and it looks so beautiful. It's a once in a lifetime thing to look back on. Mine [my own initiation] wasn't like any of the ones I've done [to others]. I try to make it something beautiful. I go out and pick everything outstanding. Forever it is going to sit there. [After I made the Oyá, the *babaláwo*] said, "Melba, if you hadn't laid out the money, it wouldn't have been as beautiful as it was." [101]

The centerpieces of the "middle-day" public portion of that event were the *iyawó*'s *ropa de santo* (consecration dress) and the lavish throne of eggplant-colored velvet that cost more than $90 a yard. Discussion and accolades followed the initiation; the throne's beauty was the result of her refusal to compromise financially for the sake of Oyá. "Going all out" aesthetically produces powerful memories of the event and a beautiful *santo* that will "forever" (the life of the priest) grace the shrine of the practitioner's house.

Melba is quite conscious of the interest *santeros* have in the impressiveness and originality of throne work, and she is known for her work in cloth and beads: "there are a lot of people who come to your house just to see what you've done." Likewise, Josie hopes that her creations will be impressive visually. Yet for both of them visual impressiveness is not "intra-aesthetic" but from the start embedded in the logic of religious practice. Josie's birthday throne provides the opportunity for her to "teach" visitors about the *orichas*. Some are impressed enough that they want to "copy" her designs, but it takes time to master the terms of technique, content, and quality, which Josie evaluates in her friend/student:

> You know when Teresa came, she wanted to copy my designs. She asked me if it was ok that she copied the design from my *paños* for her brother. To me it was an honor . . . She says, "they're beautiful, I have been to a lot of [houses] but I have never seen anything like this." She tries. She did the anchor with the Yemayá but the material was not the same so it didn't look that good and she didn't make it with the shells.
>
> The design, they ask you, "what is this and what is that?" And then they could relate to the *orichas*, they can relate. They say, "oh this is from Yemayá. . . . that's the anchor"; or from Changó . . . they ask, "what's the bat?" And [I answer], "with that bat he will fight all your wars." So you are teaching them. . . . The little bit that

I know I teach them: "this is what she [the *oricha*] likes this is how it is" and like she [Teresa] was so impressed that she came and I show her my *paños* and she try her best to copy them.[102]

Here the question-and-answer process of teaching, prompted precisely by elements of the throne's visual display, encompasses iconographic, implicitly instrumental, and affective dimensions. In Josie's practical pedagogy, the visitor/student learns about the *orichas* through the association of concrete iconographic elements with their respective *oricha* owners. Through the objects they learn the role the *orichas*—in this case Changó—play as effective allies who use the appropriate objects and icons to execute their (instrumental) work ("with that bat he will fight all your wars"); and they learn how to please them with what they like or prefer aesthetically. Objects of appropriate iconography and demonstrable mastery, which please the *orichas*, contribute to the building of relationships and well-being. The three dimensions are inseparable.

For Josie, not only her objects but also her active role as teacher please the *orichas*. The knowledge gained is not an intellectual or aesthetic exercise but on a continuum with becoming a devotee.

Because this way I'm not only doing them a favor, I'm pleasing my gods. You know you're spreading the belief. And you know you make people think. And pleasing them by spreading the belief and getting people closer to them.[103]

At least as explained by Josie, her work is one model and vehicle for the *orichas* to gain and strengthen their relationships with (potential) devotees. The phrase "closer to them" (*acercarse*) is used specifically in the Santería and Spiritist idioms to refer to spiritual influence: *orichas* and spirits "fall in love with your head" and may begin to make demands, or make things happen to you if you ignore them.[104] The practical, if not symbolic, mastery of aesthetic forms the *orichas* like is achieved as one copies and learns, and comes to be a strategy for pleasing one's own *orichas*, in turn, in a way that has proved to be successful already in the work of someone like Josie or Melba.

For Melba and Josie, making *paños* and beadwork for their annual *orichas*' birthdays is an act that demonstrates ongoing commitment, gratitude, and love toward the *orichas*. Aesthetic beauty deeply embodies those values, which are at the heart of the efficacy of the exchanges. The first implicit principle in Josie's and Melba's explanations of annual aesthetically marked gift exchanges is that the gifts are presented as reciprocation for what the *oricha* has already given them during the

year. That is, at this stage, the *orichas* are taken to be the primary givers or movers in the mutually developing relationship. And, at this stage, the priestess's gifts are reciprocations that embody gratitude. Josie explains, "Yes, you know, I say, 'it's once a year I dress them. Let us dress them nicely because all year they're helping me, they're giving me health, they help me to take care of my family.'"[105]

A second implicit principle is that these exchanges are, and should be, free of self-interest (*interés*). For Melba, her relationship with the *orichas* is about love. In fact, as Melba explains, the *orichas* don't really ask for "fancy things," but this is a particularly human way of wanting to do something for them—even though what is reciprocated by humans in gratitude can only be small by contrast.

> I believe that the *orichas* are love. They don't ask for us to do all that for them, you know. They don't ask for fancy things or anything like that. They just ask for love, and our beliefs. But I guess we do that because we want to give them something special, for all the things they do for us. At least I do. I don't know about the rest. But I guess, you know, I've heard the same answer from several of my friends; they feel the same way I do. That we think that it's such a little thing that we're doing, while they give them [us] so much, that we're doing so little, you know, that if we could do much more we would.[106]

"Doing something special" for them entails, for Josie and Melba, an aesthetically marked "birthday party" in which the *orichas* are dressed "nicely" (Josie) and made "pretty with *mazos* and this and that" (Melba).

While Josie agrees that these birthday gifts are demonstrations of gratitude for what the *orichas* have already provided during the year, for her the gifts do not terminate a cycle but produce, in turn, further benefits. The *orichas*, upon receipt of such gifts, feel compelled to reward her anew for her efforts. For Josie, her large purchases of expensive cloth for the *orichas* are

> worth it . . . You get a satisfaction when you buy the best that you could and you please your *oricha*. It's not only a satisfaction, it's a relief that you did everything O.K. and you have peace of mind. That's the way I feel. . . . When I do everything alright, when I go to buy for the saints, and you say, "may I ask, how much is a yard of that," and you say, "three dollars," I don't argue because its for the saints, I pay that. And I think they see that I made sacrifices. . . . so they reimburse me, they give me health, they give me the way to get the money [back]—sometimes I hit a number—I go to the bingo and I hit the jackpot. They always help me out. So really, I'm spending what they give me. . . . I put [out] my money, but when I go to the bingo and I make a jackpot $200, that's more money that I have to spend,

you know. And sometimes I get it afterward. They always repay you. Always repay you. Yes, they're very proud. They don't want you to give them something for nothing. Yes.[107]

Josie links explicitly the production of aesthetically marked and evaluated objects and the receiving of life's goods. Here not ritual sacrifice but financial "sacrifices" not only make possible a beautiful display, but also the rewards of health and economic advancement, both of which are also petitioned in other "ritual" activity. The terms of the giving and receiving of birthday gifts include aesthetic evaluation, which centers around the maker's "satisfaction" and the *orichas*' "pleasure." At the same time, this aesthetic evaluation is connected explicitly to terms of appropriateness and efficacy that might characterize other ritual exchanges and life outcomes: the display's success is tied to "doing everything alright," as if her performance as a whole—the buying, the presenting, her motives—is being judged by the *orichas*. "Peace of mind" is secured because the whole process of buying, making, and presenting came off well. The *orichas see* her magnanimity and sacrifices—not skimping or haggling crassly in her purchases for them—*so* they reimburse her money and give her health.

From the experience-near point of view, the very money she spent is returned afterwards—often with a bonus—through games of chance whose positive outcomes the *orichas* effect. Or else money arrives in advance precisely in order that she treat them in the style to which they are accustomed. If not money, they provide indirect agents whose gifts make possible a successful celebration for them. On the day of the birthday, Josie reports, godchildren show up with dishes of food and sweets, cake and fruit, flowers, and so on. "They [the *orichas*] make it possible for you to give them a good birthday. Yes they do."[108] In a stunningly humanistic characterization of the *orichas*' disposition regarding their exchange relationships with humans, she refers to them as "proud." That is, they are like people of integrity one can count on who, conscientiously, always repay their debts. They are uncomfortable if they don't reciprocate. At the same time, they locate their relationships with humans outside the domain of self-interested exchange. Selflessness with no anticipation of return brings rewards.

The knowledge that rewards come from aesthetic work, in the face of the principle of disinterested exchange, almost requires that one state a kind of rule against self-interest, which carries the threat of punishment if transgressed.

But [the gifts] have to come from your heart, that you really do it because you love them. . . . But the thing is, you don't do it as part of your thinking that you are going to get it back, you know. You do it because it's from your heart, that you want

to give the best. Like it's my mother, so I want the best for my mother. If you have in mind that they're going to give you back, don't do it, because then they get up-set. You're selfish now. They read your mind and they read your heart. Yes they do. "Love me, really love me. Sacrifice for me and you will never regret it." This is the key to this, love and respect. If you love and respect your *orichas* you have no problem.[109]

Selfishness and *interés*, and presumably any other less than respectable behavior or motives, are repaid with "problems."[110]

127

AESTHETIC EVALUATION AND SOCIAL CRITICISM

Aesthetic evaluation of *oricha* display embodies social criticism, at least as it is in ev-idence in the house of one priestess, Melba Carillo. Clearly, cyclical movements of celebration, in which aesthetic display is publicly foregrounded and evaluated, are heavily invested with values and expectations, whose fulfillment or failure is deeply demonstrative of character, religious commitment, and respect.[111]

The principle of *oricha* benevolence as primary and deserving of gratitude, at least for Melba's house, forms the basis of a righteous posture of social criticism. People have money, health, and well-being *"because ocha gave it to them."* The *orichas* certainly do not expect what cannot be provided—as in the case of very im-poverished priests. Apparently, when one *does* have, one *should* give. And the form that the giving has come to take is encountered in luxury items one gains the means to acquire when one comes into money.

Melba relates a case in which she could almost not contain herself upon wit-nessing the neglect and ingratitude of one wealthy priest toward his *orichas*. The *orichas* had made him wealthy, and yet twelve birthdays had gone by since his initi-ation and he had not provided them with a single *collar de mazo*. Finally he com-missioned Melba to make just one *mazo* for his Ochún, but this was regarded by her as parsimonious. It was a token gift, and in truth he was a "tightwad" (*agarrado*).

> You see so many people that have so much money and that the *santo* has given them so much and they really don't spend a penny on their birthday on their saints [lowered voice of lament]. You know they will buy just any old thing and put it there. I happen to know a guy who just, whose 12 years in Ocha, and he just told me the other day to make a *mazo* for his Ochún, and I looked at him, and his wife says "why don't you make one for every one of them, you can surely afford it." I mean he owns his own home, cars and everything; I mean, he lives very well, and *ocha* has done all that for him, and yet that this man doesn't spend. "Maybe one a year [he said]; I decided it's time to do it, maybe one a year."[112]

She wanted to ask him outright, "well they give you so much and why don't you give

them something in return?" But she chose indirection. "I looked at him, you know, and I think the expression on my face told him a lot." She allowed in our conversations that "maybe he gives them in other ways. You know, but as far as making them pretty with *mazos* and this and that, he doesn't. So perhaps they are perfectly happy because he does other things for them, you understand?" Her concession invokes implicitly the logic that different individuals have an *aché* for different kinds of *oricha*-related activity. This man may manifest his *aché* along a different axis, perhaps as a diviner or a master singer. Yet at least within Melba's house, the once-a-year party remains heavily invested with visual/aesthetic expectations. Notwithstanding what else he might do, the man's refusal to spend money to "make them beautiful, you know, [to] go out of [his] way to make them look nice" for their one party a year apparently leaves his character and commitment in doubt and he remains open to criticism.

Yet Melba does not level her criticism indiscriminately where the relative elaborateness of birthday throne presentation is concerned, "because I don't [always] know the person, how much they can spend or how much they have, and sometimes it's just enough for them to put them [the *orichas*] out there, do you understand?, and give *coco* [divine to them], and pay for somebody to come and [give] their head rogation [cleansing in preparation for the birthday]." This is something the *orichas* "understand." Her criticism is directed at selfishness and ingratitude, which become evident in the discrepancy between how one treats oneself and how one celebrates one's *orichas* with the available means. In fact, so profoundly important are Melba's birthday presentations to her that she has often sacrificed beyond her means.

> What I criticize is people that *can* do it and have the money to do it and they don't do it. You know. And when they do it they do something so reduced that they can really spend $100s of dollars in it and they don't. And I know others that can. And how many times did I put my rent money into it? I didn't think twice: "don't worry about it." You know, so it makes you sad, that not everybody feels the same way about it.[113]

If such an ethic defines her efforts to create ever more beautiful throne presentations, she also knows that there may be times when she cannot put on an elaborate display for them. This year, for example, as she is caring for a *babaláwo* with a terminal illness, she did not construct a throne at all but merely presented her *orichas* on their permanent shelves. She will receive the head rogation, prepare food, and host a house full of people, and the *orichas* will be "given *cocos*" (divined to), salutes, and tributes, yet she will not spend the time to mount an elaborate throne

because she does not "want to be caught celebrating."[114] The presence of guests alone might signal celebration, but this year will be more subdued because of his ill health. Thus is her sense of "celebrating" so synonymous with making an elaborate throne. Throne making is not obligatory, as much other ritual work might be. Yet it is key to the sense of semi-public *oricha* celebration, built upon months of work, enthusiasm, creativity, and life hopes. This year the *orichas* will understand. There is always next year.

CONCLUSION In emphasizing questions about the particular aesthetic and religious experience of two New York Santería priestesses who make *oricha* objects, rather than questions about systems and relations of religious and aesthetic phenomena, I bracketed some of my more generalizing findings about the meaning, function, affective values, social role, and history of Afro-Cuban religious altars and objects (see Brown 1989, 1993).[115] In focusing almost exclusively on the feelings and particular responses of the two women, I open up a space for consideration of their private, personal, and mundane feelings and doings that can get lost or trivialized in discussions of the "ritual system" and the cultural, mythic, and more general or typological ritual meanings of its iconography. Clearly their art making does not define exhaustively their role as priestesses, for they spend much of their time "working *santo*" in the round of initiations and *ebó* and caring for family and ritual kin. Yet their great investment of time, energy, emotion, and aesthetic concern in making cloth and beaded gifts for the *orichas* begs consideration as an activity related to but distinct from "ritual work."

Close consideration of their making of nonconsecrated objects permits an evaluation and critique of approaches to "ritual arts"—along continua of meaning, affect, instrumentality. Clothwork and *mazo* beadwork may be grouped with other ritual media/ritual arts. Yet ethnoaesthetic investigation of the priestesses' practice elicits resistances to certain assumptions about the transparency of objects and agents in relation to religious systems, particularly where discursive meanings are assumed to wholly mediate practice and explanation. I suggest, for example, that if *oricha* color and number provide patterns for the elaboration of *paños* and *mazos*, that the "associative" or mimetic process of creativity could bypass the systematic mediation of semantic meanings. Where explanations, interpretations, and teachings about objects are in evidence, the verbal utterances may also be taken to be emblematic and immediate—like praise-epithets—rather than privileged reflections or references to some abstract system or other context. Moreover, while the idea of contexts and systems has a certain heuristic value, it is difficult to "contextualize" or "decode" a given set of objects statically in relation to practices that are variant,

personal, novel, and improvised. That is not to deny ideas of sharedness and competence. Yet the point is that the diachronic and emergent dimension of practice renders synchronic models and interpretive expectations problematic. If structures shape practice, structures are also reproduced, recreated, and revised by practice. Priestesses, drawing on practical knowledge and divine inspiration, within the practical limits of their urban worlds, negotiate, structure, create the conditions of their relations with the *orichas*, as much as they are shaped by those conditions. With Hardin I agree that aesthetics plays there an important role.

130

Their art objects may be understood in all of the ways ritual arts of the Yoruba-Atlantic/African-Diaspora tradition have been written about. Indeed, the priestesses do make and respond to objects in iconographic ways, they do evaluate objects aesthetically for their formal beauty, and the objects may be seen as linked to and derivative of the ritual instrumentalities that emerge in divination and the marking of *ebó*—whose many media are also aesthetically marked and classified. At the same time, their devotion to object making around annual and periodic, highly aesthetically marked public *oricha* events reveals something of an independent dynamic and intentionality where the nonconsecrated objects are concerned. There remains a kind of "surplus" of sense and meaning after the dimensions of iconography, aesthetic form, and instrumentality are considered. Clearly, as in the Candomblé, any event depends on the ritually created and maintained efficacy of *aché* throughout the year. Yet the priestesses' intentions and efforts to please the *orichas* aesthetically, where their object making embodies their love, interests, desires, expectations, and authority, and turns on intimate gift exchanges, deserves attention as an important dynamic that shapes the "success" of, and is not merely derivative or epiphenomenal to, those events. To the extent that their object making affirms, as well as elaborates upon, their relationships with the *orichas*—indeed instantiates their *orichas* in subtle, manifold, personal ways—it may be seen to generate aspects of the "ritual system" that are otherwise taken for granted as a stable context.

NOTES

This article is dedicated to Melba Carillo, Josefina García, Michael Atwood Mason, and Ocan Oñi. Michael's consistent encouragement, his active participation in my thinking through the ideas and material presented here, and his critical reading of several drafts made the outcome possible. Thanks are also due my colleagues Gay Robins, Elisha Renne, and Debra Spitulnik, and my History of Art 779 "Ritual Arts" graduate students, particularly Cynthia Liesenfield, for reading and commenting upon manuscript versions of this article. Thanks are also due to Jane Rehl for proofreading.

1. I use the terms Santería and Ocha interchangeably to refer to the Afro-Cuban Lucumí religion of Yoruba origin. While some priests object to the term *Santería* (e.g., Ernesto Pichardo of Miami and Ysamur Flores of Los Angeles) because it was applied by the Spanish and does not recognize the Yoruba nomenclature, it is commonly used by the priests in the

houses under study. Thus I will continue to use it here.

2. In *oricha* and other terms, such as Ocha, *aché*, and Ochún, I preserve the Spanish orthography (*ch*), which reflects the pronunciation of the Cuban practitioners I worked with for this study—especially since I am attempting to advance an ethnoaesthetic approach. At the same time, this orthography is also encountered in most Spanish language ethnography and Afro-Cuban practitioners' manuals. The terms alternatively appear as *orisha*, *ashé*, Oshún, and so on, where writers use the *sh* of English orthography, as found in the literature on the Yoruba, as well as in the growing literature by and about American practitioners of the Yoruba religion. A movement is afoot also among conscientious Spanish-speaking priests who are writing about their religion to switch to the English orthography. I might choose to switch to the English orthography if I were discussing in depth and quoting multiple constituencies in order to maintain consistency in the text.

3. I choose to use the concept of "experience-near" (Geertz 1983b) in order to underscore that in this study I am concerned mainly with the personal experience, perspective, and opinions of the two New York priestesses, as consistent with an ethnoaesthetic approach, that is, one that emphasizes the aesthetic categories of the subjects. The ethnoscientific terms "emic" and "etic" have been used in the past to refer to the cultural positions of subject and observer. There are several places in this chapter where I do use these terms, as when I am discussing the work of Victor Turner. Now, as my friend and colleague Andrew Apter tells me, these have been replaced with "local and global," "particularizing and totalizing," and "derived and imposed" positionalities—which I also use in several cases below. The recent critical revisions of ethnographic authority would seem to undermine the assumptions behind the ethnoscientific distinction between the experience of the "informant" and the objective analytical stance of the observer, as the fieldwork experience and its ironies challenge and overflow such Cartesian boundaries and distinctions as subject and object (Jackson 1989). One might challenge Geertz's distinction of "experience-near" and "experience-distant" on the grounds that the blurring of the boundaries of identity constructions and the global interdependence of human beings in the postmodern setting make such distinctions in "experience" a very problematic thing, as Jackson's and Clifford's writings also suggest. However, I still consider it legitimate to choose to emphasize the experience-near concerns of the two priestesses out of interest in their artistic decision making and opinions, without having to qualify what may be an artificial construction—that is, their "world"—and my own positioned stance as an observer. I save that for another venue.

4. I am grateful to Michael Atwood Mason for spelling out this distinction so clearly to me (personal communication, October 5, 1994).

5. "Pleasing the *orichas*" with art objects is a phrase my informants have used. "Pleasing the *orichas* aesthetically" is close enough to the spirit and letter of Mikelle Smith Omari's notion—which I use to corroborate my own observations—that I cite her. She says that a Candomblé priestess "believed that her efforts to please her Orixá aesthetically would result in spiritual benefits which would more than compensate her for the hardship [of spending money on a costume]" (Omari 1984:28).

6. "Local" is Geertz's concept (1983a:97); "traditionalizing" vs. "tradition" in the old sense derives from Kirshenblatt-Gimblett 1983; Handler and Linnekin 1984.

7. The "Yoruba-Atlantic tradition" has been charted by Thompson's work (1983). J. Lorand Matory speaks of the "'Yoruba-Atlantic' complex" (Matory 1994:225). Both refer to

the transmission of Yoruba religion through the slave trade to Cuba, Brazil, Haiti, Trinidad, etc., and the flourishing of Yoruba-based practices there.

8. *Santeros* speak of *la vida de la vida*: life comes from life, not from nothing. The *aché* of blood provides that, as well as the *aché* "drawn from" or "tapped from" (Mason and Edwards 1985:3) plants, water, and so on.

9. As generative media, the shells "speak" and command and the stones "have life . . . can walk and grow, and . . . have children" (Bascom 1950:65).

10. Lavish beaded and cloth objects fill the vitrines of Havana's ethnographic museums as mementos of the wealthier houses of past eras.

11. Many Yoruba shrines are just that: minimalist assemblages of several ritual pots containing "secrets" or water, perhaps a sculpture or two, a simple dance wand, and the possession gown of the priestess.

12. In Santería, as in Candomblé, there are metal staffs (*osun*), wood representational sculptures and images (*aworán*), and decorative clay vessels that are washed and consecrated with blood.

13. Thompson has used the term "visual praise poems" to characterize ritual arts in lectures and discussions that I have attended since 1982.

14. For Margaret Drewal (1989), Yoruba art, ritual media, words, song, music, performance gestures first "evoke" a deity's "dynamic qualities" and in doing so "invoke" and ultimately "materialize" the presence of the deity, the most dramatic form of which is spirit possession. For Drewal et al. (1989), artistic compositions, the carvings on an Ifa divination tray, are "a formal means of organizing diverse powers, not only to acknowledge their autonomy but, more importantly to marshal and bring them into the phenomenal world. The significance of segmented composition in Yoruba art can be appreciated if one understands that art and ritual are integral to each other.

"The design of Ifa sacred art forms both expresses the presence of a host of cosmic forces and recalls valuable precedents from the mythic past. Ifa divination trays, *opon*, by their composition, articulate a cosmos of competing, autonomous forces. The etymology of the term *opon* means to flatter, and the tray, through the artistry of its embellishments, is meant to praise the momentous work of diviners as they seek to disclose the forces active in a situation. The tray's iconography is often documented in myth, which preserves the lessons of the past. More importantly, the arrangement of motifs of an object, together with efficacious invocations and actions enacted in its presence, not only acknowledge supernatural forces and events, but bring them into the present world from the other and the past for the benefit of devout Yoruba" (1989:17). The tray's form organizes and orients synchronically and diachronically the process of divination—conceptually, affectively, and instrumentally, embodies a local history whose figures (diviner ancestors) it helps in calling, and models in microcosm the Yoruba cosmos.

15. Turner's three levels of meaning are: (1) exegetical meaning, which is the indigenous interpretation of ritual symbols by informants—laymen and specialists; (2) operational meaning: the equation of its meaning with its use, i.e., observing what practitioners do with it, especially as related to social use; (3) positional meaning: the polysemy of single symbols across different action-field contexts; this meaning derives from the symbol's relationship to other symbols in a totality (see Turner 1967:50–51). The first derives from the informant, the second two from the observer's fieldwork.

16. For example, the Balinese Cockfight is "a story [the Balinese] tell themselves about themselves" (p. 448).

17. To be fair to the context of the quote, this method was to be conducted with due caution, given the "element of the arbitrary" in linking the visual and the textual and the "subjectivity" of the interpreter, a caution that Panofsky delivered himself (1955:32).

18. Likewise, in Thompson's groundbreaking writing (e.g., 1983), the form history of a complex Candomblé iron sculpture for Ogún is then seen to be "paralleled" by a myth of the relation of the brothers Ogún and Oshosi (p. 57). The deepest meaning is "the ambivalent civilizing force of iron" (p. 52), which Sandra Barnes (1989) has articulated as Ogún's "creative/destructive" archetypal power. For objects of the river goddess Oshún, Thompson (1983) begins with (1) a discussion of the history of forms (round brass fans), moves to (2) elicitation of "myths [that] explain the meaning of the roundness of the fans" as they recall drops of water, round protective dwellings, and the archetypal act of cooling through fanning, i.e., assuagement (p. 73); (3) ultimately, the fans refer to the deep cultural value of "coolness."

19. Emphasis on unconscious meanings (a psychoanalytic paradigm), the quasi-literary interpretation and referencing of myth/praise "texts" (iconographic/interpretive paradigm), and the structuralist reliance on an ideal, agentless, abstract subject (see Eagleton 1983), inscribes a more general cultural framework of meaning that we imagine individual actors to somehow carry around in their heads. Victor Turner insists that the informant's exegesis represents only the first level among three—where the anthropologist's etic and objective perspective permits the revelation of the polysemic and contradictory meanings of a single symbol across various action-field contexts which the individually and subjectively positioned actors cannot see (1967:ch. 1–2).

20. See James Clifford's various discussions on ethnographic authority, representation, and the politics of fieldwork (1988b).

21. The politics of representation in ethnography is a subject too vast to cover here. Its ins and outs have been treated in depth by Clifford 1988a.

22. Apter (1992:ch.1) demonstrates that Samuel Johnson's *The History of the Yorubas* (1921) was shaped by Oyo Yoruba origin myths in a field in which Oyo claims to primacy were part of its strategy against the rival ancient Ifẹ. Wafer (1991:57) suggests that the "traditional" Candomblés in Bahia used ethnographers as adjuncts to legitimize their claims about the purity of its African rituals as against the "syncretic" Candomblés.

23. In other words, does the "social meaning" of art still depend upon the idea that art refers somewhere else for its meaning, that is, to an anterior and more fundamental social ground? That the "structural properties" of the "social" can be instantiated in and through or embodied by art production and evaluative responses is what I would call a stronger sense of how art "permeates" life. The idea of "social meaning" in Price and Price 1980 seems to depend upon the distinctions earlier advanced by Mintz and Price together (1976) wherein "culture" is articulated through analytically anterior social "institutions."

24. Geertz (1973b) shows ritual to synthesize, in the experience of the participant, the sensory, aesthetic, noncognitive element of "ethos" and the more cognitive, ideological element of "world view"—dualisms also visible in Turner's "sensory pole" and "ideological pole" of ritual symbols. Turner (1967) exegetes objects and actions for their "meaning," but at the same time insists that the symbols are nothing less than "force[s] in a field of social action" (p. 44). "Ritual symbols" are not objects of cognition, a mere set of referents to known

phenomena" (p. 298). And he explicitly critiques "the framework of structuralist theory and cultural anthropology" for "treat[ing] ritual symbols as timeless entities" (p. 44). Catherine Bell (1992) suggests that the very need for qualifications around, and the attempted synthesis of, the *a priori* division of the cognitive and affective, "world view" and "ethos," are a function of dualistic thinking in the West (i.e., "thought" vs. "action"; the mind-body split) that produces contradictions in the concept of ritual, embodied in the distinction between "belief" and "rite," "myth" and "ritual," "ritual" and other social phenomena, and in the "practice of ritual theory" that constructs "ritual" as the object of the subject-observer's analysis and interpretation.

25. Armstrong writes: "Such things are not, at base, symbols of something else (a symbol being something that has arbitrary form and is held by convention to 'stand for' something else); they *are* whatever they are" (Armstrong 1981:5), and elsewhere in his text, they are "not *mimetic* of things in the world . . . they *are* things in the world" (Armstrong 1981:34).

26. In his own early work, Jackson admits: "the quest for semantic truths also explained my inability to participate in the spirit of the performances and why I spent my time asking people to tell me what was going on, what it all meant, as if the painted bodies and mimetic dances were only the insipid remnants of what had perhaps once been a symbolically coherent structure of myths and masks" (Jackson 1989:127).

27. Hardin's formulation emphasizes the perceptions, interests, and subjectivity of agents, as opposed to Bourdieu's more objectivizing emphasis on human beings as social facts who embody and reproduce the habitus. Bourdieu (1971:3–4) shuns phenomenology in order to avoid a naive subjectivism, and the privileging of the experience of agents is problematic for him. I thank Michael Mason for this distinction. Hardin draws predominantly on the social theory of Anthony Giddens and Gregory Bateson, and the theory of agency of Ivan Karp. Michael Jackson, as opposed to Bourdieu, is centrally interested in the experience of the agents. He uses Bourdieu's construction of the habitus to discuss embodied knowledge, relying on Bourdieu's objectivism as a kind of check to counter a "naive subjectivism" in his "phenomenological approach to bodily praxis" (1989:124).

28. In one of Hardin's examples, a patriarch succeeds in his harvest next season not only because formally he occupies a place of authority in the kinship system (a determinate or fundamental ground) but also because he was present to dance in an appropriate way at his nephew's initiation ceremony. Obligations and alliances are instantiated, regenerated, and possibly changed, in and through aesthetically marked performance of his social ties.

29. The real problem today is that there are already numerous works that presume to define and generalize about the Santería "ritual system" where research on the ethnographic diversity of practices is wholly lacking (e.g., Murphy 1988).

30. In practitioner parlance "[La Regla de] Ocha" refers to the group of male and female initiated priests that serve the *orichas*, some of whom are *oriaté* or *obá*—cowrie diviners and masters of ceremonies. "[La Regla de] Ifá" refers to the group of male diviners whose patron deity is Orunmila, interpreter of the Ifá oracle—they use palm nuts in concert with a divining tray (*tablero de Ifá*) and a divining chain (*ekuele*). Practitioners say *santero* to refer to the former and *babaláwo* to refer to the latter.

31. Female initiates of male *orichas* wear tunics and pants; female initiates of female *orichas* wear gowns; male initiates of male *orichas* wear knicker-type pants; male initiates of female *orichas* wear long pants.

134

32. Interview with Josefina García, by David H. Brown, March 10, 1994, Bronx, New York.

33. Obatalá has sixteen different paths or roads; Yemayá has seven; Ochún has five. The colors of each basic archetype—called their "normal" colors—are white, blue and white or clear, yellow or amber, respectively. Each road or path is then distinguished by additional shades and punctuating colors. For example, while the archetype Obatalá takes white beads for purity and calmness, Obatalá-Ayáguna, a warrior who has some characteristics of the hot Changó, takes some of Changó's red beads. At the same time, the basic counterpointed colors may vary by road. Yemayás that live deeper in the sea take darker blue beads, while those that live close to the surface take lighter beads, some punctuated by red, others by "coral"; some use clear colorless beads with blue, others opaque white.

34. In general, Changó is very important and popular to many priests as the loyal, indefatigable defender (see, e.g., Gleason 1992). One important reason Changó is particularly important to Josie and Melba is that their father, Obatalá-Ayáguna, is understood to be very "close to" Changó. Ayáguna is a manifestation of Obatalá who is a young warrior seen to be very close to, if not an alternate form of, Changó. Ayáguna takes one of Changó's hot red beads into his immaculate whiteness, and Changó balances his hot red with Obatalá's cooling white beads. Interview with Melba Carillo, August 7, 1987; see also Brown 1989:436. More particularly, for Josie, similarly, even though she knows she is supposed to treat her parents Ochún and Obatalá specially, "Changó" is her "secret," "the one that helps me out with everything." From interviews of March 10, 1994.

35. Quoted phrases and words are Melba's language here, interviews of March 1994.

36. Interview with Melba Carillo, March 10, 1994.

37. John Mason's remarkable book, *Food for the Gods*, a taxonomy of ritual media and sacrificial food recipes, is also implicitly a taxonomy of *oricha* aesthetic preference. The idea that *oricha* "preference" can be understood in aesthetic terms emerged in my conversations with Michael Atwood Mason, spring 1994. The river *oricha* Ochún prefers yellow cloth and *ochinchín*, a dish prepared with shrimp and greens that may grow near inland fresh water (Mason and Edwards 1981; see also Miralda and Mason 1985). Yemayá prefers male sheep (*carnero*) and will not eat goat, while Oyá will eat only goat. This difference marks radical divergences in their respective tastes and orientations. Oyá refused to listen to her mother Yemayá's order that she desist from trying to destroy the marriage of Changó and Obá. Their eternal separation, and the eternal close bond of Yemayá and her prized son Changó, as of that moment, is embodied ritually in their "eating" separately different animals: Changó and Yemayá "eat together" male sheep (*carnero*), while Oyá eats female goat (*chiva*) apart. See Pérez 1986:103–4. Reinforcing the idea of aesthetic preference in this case, singer Emilio Barreto explained to me in 1987 that Yemayá "doesn't like the smell of goat," the preferred animal of Oyá. The strong and fierce warrior and ironworker Ogún prefers his iron objects not be washed in water—as is done with other *orichas*—because he "does not like to get a bath"; he prefers to be washed in fiery rum (*aguardiente*), given his strong character as a blacksmith and denizen of the forest. Interview with Josefina García, March 10, 1994.

38. Some houses give four necklaces: Obatalá, Yemayá, Ochún, Changó—leaving out Eleguá, whose necklace is apparently received when one is initiated. Most houses give the five necklaces. Houses like Melba Carillo's usually give five, but if it is known that the *oricha* to whom the godchild will be initiated (all except Changó and Yemayá) requires the presence of

Oyá, then Oyá's necklace will also be given. Additionally, if it is a *babaláwo* house, then one has already received the necklace of the *babaláwo*'s patron Orula. Finally, in Cuba, because of lack of beads and impoverishment, godparents are giving just one necklace at a time—usually the one who is determined to "own" the godchild's head.

39. It should remain clear that the *collares*—the single-strand consecrated necklaces—are distinct from the *collares de mazo*, complex multistrand sashes that are unconsecrated.

40. Interview with Melba Carillo of March 10, 1994.

41. If thinking iconographically in a systematic way has anything to do with the way the Yoruba of West Africa rationalized their religious pantheon, it may also be that in the New World such thinking was cultivated through experience with the Catholic saints, wherein each has its particular legends, attributes, functional domain, and calendrical celebration. Wholly apart from the debate about whether or not Africans and their descendants "believe" in the saints, it is clear that they "learned their attributes, and worked out a series of parallelisms linking Christian figures and powers to the forces of their ancient deities" (Thompson 1983:17; see also Herskovits 1966; Ortiz 1973 [1906]; Bastide 1978; Brandon 1993; Murphy 1988). In other words, as the structure or armature of the Catholic calendar was used strategically to reorganize *oricha* celebrations annually, perhaps also was the idea of a mnemonically rationalized and iconographically elaborated system of representation also used to reconstitute and teach the identity of the African deities, which twentieth-century practitioners' manuals have facilitated in their theologizing, systematizing, and hierarchalizing of the *oricha* pantheon (e.g., Angarica n.d.; Elizondo n.d.).

42. The meanings of "symbolic" and "iconic" here refer to the Peircean system in which the former is an arbitrary sign and the latter is one that bears some organic connection to its referent, or resembles its referent.

43. Interview with Luis Castillo, fall 1987.

44. The bead pattern for a female road of Obatalá, Ochanlá, is called "white with water." Melba says: "they called it water—*agua*—in Spanish that clear bead is called *agua, una cuenta de agua*. . . . For her *mazo*, some people will make her *collar* [necklace] the same way too or you can make it all white, but if you're going to make it white with water you can't make it all water, you have to make it white with water." Interview with Melba Carillo, March 10, 1994.

45. It might be stretching it to suggest it is because soap goes with water.

46. Interview with Melba Carillo, March 10, 1994.

47. For example, I have heard scholarly observers suggest that the shades of red for Changó on the wine or rusty-red end of the spectrum have their origin among the Oyo Yoruba.

48. Conversations with Michael Atwood Mason, spring 1994.

49. The manuals themselves are an unruly lot. There are public and private manuals. Many disagree, and many plagiarize from others. See Angarica n.d.; Elizondo n.d. Some are sworn by as the "real thing" by some, and held in contempt by others.

50. "Ethno-shopping" is a term I have coined to describe culturally specific creative uses of the marketplace of mass-produced goods. I was inspired by Bernardo Belasco's study of "ethno-marketing"—particular features of local changing economies—among the Yoruba of southwestern Nigeria (Belasco 1980).

51. *Botánicas* are specialty stores, most often located in Latin barrios, that import and

distribute an extraordinary spectrum of goods for the *orichas*, Palo Monte (Kongo-Cuban), and Spiritist worship—from tropical plants and dried exotic animals to the full line of ritual objects for the deities (see Brown 1989:app. 2). Some objects are purchased and used as is, like the ceramic lidded *soperas* available in *botánicas* and the many "Chinese" outlets of mass-produced decorative gifts. Priests have referred to these stores as "Chinese" because of their owners—who may be of diverse Asian backgrounds. Others are purchased and modified, such as the wood tourist machetes and flywhisks which come to be encrusted in cowries and beads. The *orichas' herramientas*—their metal iconographic implements that go inside and on top of their *soperas*, including crowns and bracelets of brass (Ochún), tin or silver (Yemayá and Obatalá), copper (Oyá); iron implements for Ogún and Ochosi—and the lathe-turned wood mortar-pedestals (*pilón*) and vessels (*batea*) for Changó, are often produced by artisans with technical expertise for sale to *botánicas*, where they are resold to priests. As the entrepreneurial mass marketplace would have it, presently a large California company called International Products produces and distributes a range of such objects which *botánicas* select from a catalogue (personal communication with Dan Owen, employee of The Magic Square Botanica in Atlanta, March 1994); at the same time many *botánicas* themselves, such as Original Products of the Bronx and Shangó's Warehouse (Almacenes Shangó) of Manhattan, import and distribute internationally. *Botánicas* also stock the elaborate beadwork dance wands and *collares de mazo*, which many priests produce at home for their own *orichas* and on a commission basis for others—including the *botánicas*. *Ropa de santo*, the often highly worked and elaborate consecration outfits and the immaculate white garments for the initiate's first year, are privately commissioned out to trained seamstresses who produce to order. In New York, the extraordinary commercial wholesale and retail outlets of the garment district provide beads (mid-30s between 7th and 6th Avenues) and cloth (8th Avenue between 36th–40th Streets, and those streets between 8th and 7th Avenues).

52. Interview with Josefina García, March 10, 1994.

53. Interview with Melba Carillo, March 10, 1994.

54. Interview with Melba Carillo, March 10, 1994.

55. Interview with Melba Carillo, March 10, 1994.

56. Interview with Melba Carillo, March 10, 1994.

57. Indeed, I purchased a selection of cloth from a store on 38th Street run by Indians, on a tip from Melba that they had given her a sale price of $5.00 a yard. She told me to tell them that I was a friend of hers.

58. Flores describes how he, as a priest, introduced a novel style of consecration outfit for Yemayá which represented an issue of his competence in relation to how he would be evaluated by visitors in the community (Flores 1990).

59. Interview with Melba Carillo, March 10, 1994.

60. Interview with Melba Carillo, March 10, 1994.

61. For Melba, "thick satin," for example, which is "real nice" and normally retails for $4.98 a yard, has a sheen and quality of substance that is desired, but unless it is on sale, Melba purchases a thinner satin "lining" ($1–$2 per yard). At a closeout she managed to get a quantity of the thick satin for $2.98 (see pl. 1), which appeared on her grand 1987 birthday throne (its red background).

62. See my discussion about the dazzling public exterior and secret interior of *paño* and *sopera*, respectively, as inspired by Gleason (1987:102), in Brown 1993:53.

63. *Brillo*, as well as *luminoso*, are adjectives regularly used by priests to describe desirable *paño* and throne fabrics.

64. "A throne is luxury." Interview with Melba Carillo, March 20, 1987.

65. Interview with Melba Carillo, March 10, 1994.

66. Interview with Josefina García, March 10, 1994.

67. Interview with Josefina García, March 10, 1994.

68. The tradition of appliquéing sequins (or beads) and cowries to cloth is found also in the *bandeles*, special *paños* which cover the three hourglass-shaped sacred drums called *batá*. Josie produced a set of these for New Jersey's Templo Bonifacio Valdés after its *babaláwos* consecrated a set of drums in 1982. Older examples from Cuba may be seen in Thompson 1993:171–72, pls. 188, 189, and 191.

69. Interview with Melba Carillo, March 10, 1994.

70. Interview with Josefina García, March 10, 1994.

71. The burlap is a New World transformation of the Yoruba deity Babalú-Ayé's raffia and other fibrous materials of the earth, like the palm-fiber bundle which comprises the broomlike beaded dance wand he carries. On the purple iconography and the raffia/straw component see Thompson 1993:218–28. Purple comes from the robes of San Lázaro Obispo (bishop), whose famous church (El Rincón) is located outside of Havana in Santiago de las Vegas, as well as the popular chromolithographs of the beggar San Lázaro. Morton Marks shows the transformation of raffia into burlap in Cuba, the latter coming from the *sacos de yute*—jute sacks—used in shipping agricultural products in Cuba (Marks 1987:235–38).

72. Interview with Josefina García, March 10, 1994. The *ajá* itself was made by a *botánica* owner in Brooklyn. Melba Carillo produces them also. The palm-fibers, purchaseable in *botánicas*, are bound with tape at one end; that end is then covered in burlap, wrapped in beads, and then decorated with cowrie shells.

73. The flower may be consistent with the fact that the "five secrets" were probably herbal, but it is more simply a decorative motif. Several years ago, thinking in terms of associated iconic references, I would have insisted that the "flower" recalled strongly the circular skin ulcers of San Lázaro.

74. Interview with Josefina García, March 10, 1994.

75. Interview with Melba Carillo, August 7, 1987. Oricha Oko also must always be on the floor because he is the earth; San Lázaro, as Obaluaye among the Yoruba, is also connected with the earth (Thompson 1983:61–68); the *guerreros* accompany Eleguá who is "small" and low to the ground; yet if one has "made" Elegúa, Ogún, or Ochosí, they will usually be seen elevated on the large stone used as the seat under the *trono del asiento*.

76. Oyá and Ochún are the only two *orichas* that receive metalwork crowns; the reason for this is apparently that they are the two, sometimes competing, wives and queens of Changó. There are, however, examples of silver crowns for Yemayá in Cuban ethnographic collections (the Fernando Ortiz Collection of the Casa de Africa in Havana). The program of brass (Ochún), copper (Oyá), and silver (Yemayá) crowns for these three female *orichas* appears to be identical to that found in the Brazilian Candomblé (see Carybé 1980).

77. Oyá's crown bears nine tools of Ogún's forge, in copper, while Ochún's has five brass connected oars or bracelets.

78. "To make it beautiful" and "bun" from interviews with Josefina García, May 21, 1988.

79. See note 37.

80. Interview with Josefina García, May 16, 1986.

81. Interview with Josefina García, March 10, 1994.

82. I observed a case of this in Cuba (December 1994), in which an elder priestess, Isabel Castellín Domínguez (Ocha Ilé, "Chola") of Barrio Obrero in Havana, explained to me that on her throne for Ochún and San Lázaro on the occasion of a drumming for them, she felt obliged to place high in the middle a *paño* for her "father" Obatalá, so that he would not get *bravo* ("angry") at her for disrespecting his authority. Perhaps some practitioners would disagree with this convention. Although the sharedness of tradition does interest me, it doesn't really matter in this context whether any other practitioner thinks this is correct or incorrect, although it would be interesting as a contrasted version. The question is what Josie understands and how she acts on it.

83. Interview with Josefina García, March 10, 1994.

84. For Armstrong, aesthetic form is integral to a dynamic "art of invocation." In cultural performance (e.g., ritual), mere "items" or things become *works* in an "ambient of time," which come to have "affecting presence," "estativity," or subjectivity, and thus combine the categories of things and "person."

85. See Bourdieu 1977:1–2 and Armstrong 1981:11 for the discussion in which he refers to the work of ritual arts as occurring in an "ambient of time."

86. I say "vernacular praise-epithets" because they are personal praises in Spanish that appear similar in spirit and form to the praise-names in Yoruba-Cuban (Lucumí) used in more formal ritual or the Yoruba praises (*òrìkì*) that Karin Barber has written about. See Barber 1990 and 1991, as well as J. Mason 1992 for the kinds of praises found in Afro-Cuban *oricha* songs.

87. Michael Mason (1993) shows how a proverb related to a divination *odu* in which Ochún dominates, "the blood that runs in the veins," indexes numerous life and ritual domains.

88. Interview with Josefina García, March 10, 1994.

89. Interview with Melba Carillo, October 9, 1987.

90. Interviews with Melba Carillo, fall 1987, fall 1988.

91. Interview with Melba Carillo, November 14, 1987.

92. Interview with Melba Carillo, March 10, 1994.

93. It was explained to me that the *egun* had not caused the illness, but "when people find out that you are sick, they start doing their thing—they can take advantage of your weakness and send something that will finish you off."

94. I do not know whether or not the fruit eaten by those visitors with bad intentions was intended to affect them in any way.

95. I owe the notion of religious commitment as embodied (or figured) "in and through" aesthetic work to my colleague Walter Melion. In his study of Northern Renaissance reproductive engraving, he demonstrates, in terms of the period, how reproductive engravers like Hendrick Goltzius "convert[ed] pictorial manner . . . into the currency of exemplary Christian service" (Melion 1994). In other words, their images were not merely "about" religious themes in the transparent sense of representation. The extraordinary dexterity and aesthetic virtuosity of their making "figured" or embodied piety and religious commitment, a conception which problematizes a purely iconological approach to the images' textual "meanings."

The virtue of the images—or the culturally recognized virtue of that virtuosity—constituted for the artists a currency or token in the ideological and practical arena of Christian service, power, and patronage, as the images were produced often as gifts for aristocratic patrons. The artists never chose to enter into actual Christian service, but that it operated thusly as service is "thematized" in their work (see Melion 1990, 1992, 1994).

96. The scope of this study does not permit a fuller discussion of the concept of "gift exchange" other than to state simply that it is a system of gift and countergift. I agree with Bourdieu that it is best seen as a practice which proceeds in time (diachronically), whose outcomes cannot always be predicted in advance. That is, the "system" of exchange may be mapped as a synchronic model only at risk of imagining it as "reversible," that is, that every gift is automatically matched by a countergift, wherein the time lag, issues of honor, and power relations precisely around the time lag are salient, and where giving can "misfire" or fail (see Bourdieu 1977:3–8). For other important discussions of gift exchange, especially where it encounters the commodity—which would be important to take into account in a more developed discussion of throne objects and mass culture—see Appadurai (ed.) 1986 and Weiner 1992.

97. Interview with Josefina García, May 18, 1987.

98. Interview with Melba Carillo, March 10, 1994.

99. Interview with Josefina García, March 10, 1994.

100. Quotes from interview with Josefina García, March 10, 1994.

101. Interview with Melba Carillo, March 20, 1987.

102. Interview with Melba Carillo, March 10, 1994.

103. Quotes from interview with Josefina García, March 10, 1994. The "bat" is a baseball bat that has become an attribute of Changó. In Josie's case, she appliquéd the white outlined image of a bat onto Changó's sequined *paño*.

104. Interview with Idalberto Cardenas, July 25, 1987. As an example, *santeros* were impressed that I, as a researcher was attending *oricha* occasions with such dedication, and said that I would get "closer" to them in this way. On the other hand, they were concerned that things could start happening to me because I was "seeing more than most people usually see" and therefore they would get "jealous." At a certain point it would be inevitable for me to be initiated.

105. Interview with Josefina García, March 10, 1994.

106. Interview with Melba Carillo, March 10, 1994.

107. Interview with Josefina García, March 10, 1994.

108. Interview with Josefina García, March 10, 1994.

109. Interview with Josefina García, March 10, 1994.

110. Josie's and Melba's insistence that the gift exchanges be disinterested might be taken as an ideal model or set of rules that one ought to follow. In practice, it is more likely, evidence suggests, that exchanges proceed on a continuum from interested to disinterested. They may be characterized by negotiations, enticements, and anticipations of return. At the same time, such ideal rules and the ethic behind them are what enable practitioners from time to time strategically to level social criticism and distance their religion and their own practice from identified opponents or the commercialism of the marketplace. Because of the complexity of these issues, from an analytical standpoint I am not prepared to characterize all exchanges of aesthetic objects as either completely disinterested or as interested vehicles of "manipulation," which Omari reported as common in Brazilian Candomblé. The resort to idealized or official explanations of exchange resonates with Bourdieu's notion that the prac-

tice of gift exchange, *in order* to operate, depends upon an ideology of disinterested exchange, for that is precisely what makes it different from "swapping" or payment for services rendered (Bourdieu 1977:2–9). Disinterested relations with the *orichas* are often seen in contrast to market relations. This idea has formed the basis of a somewhat romanticized view of the religion as a form of resistance against the capitalist marketplace (Gregory 1986). Nevertheless, within the universe of Afro-Cuban religions, and the culturally recognized contrasts between them, Santería is also seen in contrast to the kind of mercenary exchange that takes place in the Afro-Cuban religion called Palo Monte, in which the services of spirits of the dead are *contracted* and paid for. Different relations of giving characterize different dimensions of Afro-Cuban religious practice. Neither can one generalize the ideal or official rule across the Diaspora and the Atlantic. The atmosphere of Candomblé religious practice that Wafer (1991) investigates in Brazil is saturated with interested exchanges between *orixas* and priests, and between priests and their godchildren. Karin Barber (1981) insists that explicit, mutually interested exchanges between *orisha* and priest are normal in the perspective and practice of Yoruba religion in Nigeria. Yet outcries against the commercialization of the Afro-Cuban religions are increasingly common today. In Cuba, for example, my own godmother, approached with the proposition that she initiate foreigners for the government's growing "religious tourism" industry, responded angrily and righteously, "my stones [sacred objects] will never be used by the government!"

111. One can only think of the set of feelings and social sanction around the characteristically Cuban notions of *malagradecido* ("ungrateful") and *falta de respeto* ("lack of respect").

112. Interview with Melba Carillo, March 10, 1994.

113. Interview with Melba Carillo, March 10, 1994.

114. Personal communication with Melba Carillo, October 1, 1994.

115. Elsewhere I have written (Brown 1989, 1993), more in kind with the literature I reviewed in the introduction, that *oricha* objects identify and distinguish iconographically the deities in the pantheon; that semiotically, cloth and beadwork "mark" or "frame" the active presence and influence of *orichas* in periods of ritual performance and spirit possession; that the throne is a dialogic and interactive space for bodily and communicative practice. Following Judith Gleason (1987:102), I have written that the dazzling surfaces of cloth and beadwork that cover the *orichas'* vessels heighten the dramatic tension between what can be seen and what is concealed and "secret"; that cloth protects from negative spiritual influences vulnerable new initiates in their thrones, while beadwork is used as a lasso to ensnare and claim new followers. Finally, among other things, I have suggested that the splendor of cloth and beadwork sends messages of the *orichas'* wealth, power, and authority, inscribes the values of a sacred cosmology or landscape, and that the *bricolage* of altar assembly condenses a cultural history of royalty and resistance.

REFERENCES

Abiọdun, Rowland. 1994. "Understanding Yoruba Art and Aesthetics: The Concept of *àṣẹ*. *African Arts* 27 (July):68–78, 102.

Angarica, Nicolas Valentin. n.d. *Manual de Orihate: Religión Lucumí*. Havana: n.p. 336 pp.

Appadurai, Arjun, ed. 1986. *The Social Life of Things: Commodities in Cultural Perspective*. Cambridge, Mass.: Cambridge University Press.

Apter, Andrew. 1992. *Black Critics and Kings: The Hermeneutics of Power in Yoruba Society*. Chicago: University of Chicago Press.

Armstrong, Robert Plant. 1971. *The Affecting Presence: An Essay in Humanistic Anthropology*. Urbana: University of Illinois Press.

———. 1981. *The Powers of Presence: Consciousness, Myth, and Affecting Presence*. Philadelphia: University of Pennsylvania Press.

Awolalu, J. Omosade. 1979. *Yoruba Beliefs and Sacrificial Rites*. London: Longman.

Barber, Karin. 1981. "How Man Makes God in West Africa." *Africa* 5(3):724–44.

———. 1990. "Oriki, Women and the Proliferation and Merging of Oriṣa." *Africa* 60(3):313–37.

———. 1991. *I could speak until tomorrow: Oríkì, Women, and the Past in a Yoruba Town*. The International African Library. Washington, D.C.: Smithsonian Institution Press.

Barnes, Sandra. 1989. "The Many Faces of Ogun." In *Africa's Ogun: Old World and New*, ed. Sandra Barnes. African Systems of Thought. Bloomington: Indiana University Press, pp. 1–28.

Bascom, William. 1950. "The Focus of the Cuban Santeria." *Southwestern Journal of Anthropology* 6(1):64–68.

———. 1952. "Two Forms of Afro-Cuban Divination." In *Acculturation in the Americas*, gen. ed. Sol Tax, 3 vols. Proceedings and Selected Papers of the XXIX International Congress of Americanists, vol. 2. Chicago: University of Chicago Press.

———. 1980. *Sixteen Cowries: Yoruba Divination from Africa to the New World*. Bloomington: Indiana University Press.

Bastide, Roger. 1978. *The African Religions of Brazil: Toward a Sociology of the Interpenetration of Civilizations*, trans. Helen Sebba. Johns Hopkins Studies in Atlantic History and Culture. Baltimore: Johns Hopkins University Press.

Bauman, Richard, 1975. "Verbal Art as Performance." *American Anthropologist* 77 (June):290–311.

———. 1989. "Performance." In *The International Encyclopedia of Communications*, vol. 3. New York-Oxford: Oxford University Press and The Annenberg School of Communications, University of Pennsylvania, pp. 262–66.

Belasco, Bernardo I. 1980. *The Entrepreneur as Culture-Hero: Preadaptations in Nigerian Economic Development*. Praeger Special Studies. New York: Praeger.

Bell, Catherine. 1992. *Ritual Practice, Ritual Theory*. New York: Oxford University Press.

Bourdieu, Pierre. 1977. *Outline of a Theory of Practice*, trans. Richard Nice. Cambridge Studies in Social Anthropology, vol. 16. Cambridge: Cambridge University Press.

———. 1984. *Distinction: A Social Critique of the Judgment of Taste*, trans. Richard Nice. Cambridge, Mass.: Harvard University Press.

Brandon, George E. 1983. *"The Dead Sell Memories": An Anthropological Study of Santería in New York City*. Ph.D. dissertation, Rutgers University.

———. 1993. *Santería from Africa to the New World: The Dead Sell Memories*. Blacks in the Diaspora. Bloomington: Indiana University Press.

Brown, David. 1989. *Garden in the Machine: Afro-Cuban Sacred Art and Performance in Urban New Jersey and New York*. Ph.D. dissertation, Yale University.

Brown, David H. 1993. "Thrones of the Orichas: Afro-Cuban Altars." *African Arts* 26(4):44–59, 85–87.

Carybé. 1980. *Iconografía dos Deuses Africanos no Candomblé da Bahia.* Salvador, Bahia, Brazil: Fundação Cultural Do E. Da Bahia, Instituto Nacional Do Livro Universidade Federal Da Bahia.

Chernoff, John Miller. 1979. *African Rhythm and African Sensibility: Aesthetics and Social Action in African Musical Idioms.* Chicago-London: University of Chicago Press.

Clifford, James. 1988a. "On Ethnographic Authority." In *The Predicament of Culture: Twentieth Century Ethnography, Literature and Art.* Cambridge, Mass.: Harvard University Press, pp. 21–54.

———. 1988b. *The Predicament of Culture: Twentieth Century Ethnography, Literature and Art.* Cambridge, Mass.: Harvard University Press.

Davis, Gerald. 1983. "Afro-American Coil Basketry in Charleston, South Carolina: Affective Characteristics of an Artistic Craft in a Social Context." In *Afro-American Folk Art and Crafts*, ed. Ferris William. Jackson, Mississippi-London: University Press of Mississippi, pp. 235–58.

Douglas, Mary. 1978 [1969]. *Purity and Danger: An Analysis of Concepts of Pollution and Taboo.* London: Routledge and Kegan Paul.

Drewal, Henry J., John Pemberton III, and Rowland Abiọdun. 1989. *Yoruba: Nine Centuries of African Art and Thought.* New York: Center for African Art and Harry N. Abrams.

Drewal, Margaret. 1989. "Dancing for Ogun in Yorubaland and Brazil." In *Africa's Ogun: Old World and New*, ed. Sandra Barnes. African Systems of Thought. Bloomington: Indiana University Press, pp. 199–234.

———. 1992. *Yoruba Ritual: Performers, Play, Agency.* Bloomington: Indiana University Press.

Drewal, Margaret T., and Henry J. Drewal. 1983. "An Ifa Diviner's Shrine in Ijebuland." *African Arts* 16 (February):61–67, 99–100.

Eagleton, Terry. 1983. *Literary Theory: An Introduction.* Minneapolis: University of Minnesota Press.

Ecun, Oba. 1989. *Ita: Mythology of the Yoruba Religion.* Miami: n.p.

Elizondo, Carlos. n.d. *Manual de la religion Lucumi.* New Jersey: n.p.

Flores-Peña, Ysamur. 1990. " 'Fit for a Queen': Analysis of a Consecration Outfit in the Cult of Yemayá." *Folklore Forum* 1(2):47–56.

Flores-Peña, Ysamur, and Roberta J. Evanchuck. 1994. *Speaking without a Voice: Santería Garments and Altars.* Jackson: University of Mississippi Press.

Geertz, Clifford. 1973a. *The Interpretation of Cultures: Selected Essays.* New York: Basic Books.

———. 1973b. "Religion as a Cultural System." In *The Interpretation of Cultures: Selected Essays.* New York: Basic Books, pp. 87–125.

———. 1983a [1976]. "Art as a Cultural System." In *Local Knowledge: Further Essays in Interpretive Anthropology*, by Clifford Geertz. New York: Basic Books, pp. 93–122.

———. 1983b. " 'From the Native's Point of View': On the Nature of Anthropological Understanding," by Clifford Geertz. In *Local Knowledge: Further Essays in Interpretive Anthropology.* New York: Basic Books, pp. 55–70.

Gleason, Judith. 1987. *Oya: In Praise of the Goddess.* Boston, Mass.: Shambhala.

———. 1992. *The King Does Not Lie: Initiation of a Shango Priest.* Film.

Gregory, Stephen. 1986. *Santería in New York City: A Study in Cultural Resistance.* Ph.D.

143

dissertation, The New School for Social Research.

Handler, Richard, and Jocelyn Linnekin. 1984. "Tradition, Genuine or Spurious." *Journal of American Folklore* 97(385):273–90.

Hardin, Kris L. 1993. *The Aesthetics of Action: Continuity and Change in a West African Town*. Smithsonian Series in Ethnographic Inquiry. Washington-London: Smithsonian Institution Press.

Herskovits, Melville J. 1966. "African Gods and Catholic Saints in New World Negro Belief." In *The New World Negro: Selected Papers in Afroamerican Studies*, ed. Francis S. Herskovits. Bloomington: Indiana University Press, pp. 321–29.

Intar Gallery. 1989. *Another Face of the Diamond: Pathways through the Black Atlantic South*, exhibition catalogue, curator Judith McWillie; project director Inverna Lockpez. New York: Intar Latin American Gallery.

Jackson, Michael. 1989. *Paths toward a Clearing: Radical Empiricism and Ethnographic Inquiry*. Bloomington-Indianapolis: Indiana University Press.

Johnson, Samuel. 1921. *The History of the Yorubas*. Lagos: C.M.S. Bookshops.

Kirshenblatt-Gimblett, Barbara. 1983. "The Future of Folklore Studies in America: The Urban Frontier." *Folklore Forum* 16 (Winter):185–234.

Kopytoff, Igor. 1986. "The Cultural Biography of Things: Commoditization as Process." In *The Social Life of Things: Commodities in Cultural Perspective*. Cambridge, Mass.: Cambridge University Press, pp. 64–94.

Lawal, Babatunde. 1974. "Some Aspects of Yoruba Aesthetics." *British Journal of Aesthetics* 14 (Summer):239–49.

Levi-Strauss, Claude. 1966. *The Savage Mind*. Chicago: University of Chicago Press.

Marks, Morton. 1987. "Exploring *El Monte*: Ethnobotany and the Afro-Cuban Science of the Concrete." In *En Torno a Lydia Cabrera (Cincuentenario de 'Cuentos Negros de Cuba', 1936–1986)*, ed. Isabel Castellanos and Josefina Inclán. Miami: Ediciones Universal, pp. 227–44.

Mason, John. 1992. *Orin Òrìṣà: Songs for Selected Heads*. Brooklyn, N.Y.: Yoruba Theological Archministry.

Mason, John, and Gary Edwards. 1981. *Onjẹ fun Orisa (Food for the Gods)*. New York: Yoruba Theological Archministry.

———. 1985. *Black Gods: Orisa Studies in the New World*. Brooklyn, N.Y.: Yoruba Theological Archministry.

Mason, Michael Atwood. 1993. "*The Blood That Runs in the Veins*: The Creation of Identity and a Client's Experience of Cuban-American Dilogún Divination." *The Drama Review* 37 (Summer):119–30.

———. 1994. "'*I Bow My Head to the Ground*': The Creation of Bodily Experience in a Cuban-American *Santería* Initiation." *Journal of American Folklore* 106 (423–424): 1–17.

Matory, J. Lorand. 1994. *Sex and the Empire That Is No More: Gender and the Politics of Metaphor in Oyo Yoruba Religion*. Minneapolis-London: University of Minnesota Press.

Melion, Walter. 1990. "Hendrick Goltzius's Project of Reproductive Engraving." *Art History* 13 (December):458–87.

———. 1992. "Piety and Pictorial Manner in Hendrick Goltzius's Early Life of the Virgin."

In *Hendrick Goltzius and the Classical Tradition*, exhibition catalogue, ed. G. Har-
court. Los Angeles: Fisher Gallery and University of Southern California Press,
pp. 44–51.

———. 1994. "Hendrick Goltzius and the Thematics of Exemplary Christian Service." Un-
published Conference Paper Presented at the Annual College Art Association Confer-
ence, New York City.

Mintz, Sidney W., and Richard Price. 1976. *An Anthropological Approach to the Afro-
American Past: A Caribbean Perspective*. Philadelphia: Institute for the Study of Human
Issues (ISHI).

Miralda, Antonio, and John Mason. 1985. *Santa Comida/Holy Food*, exhibition catalogue,
in collaboration with John Mason. New York: El Museo del Barrio.

Murphy, Joseph. 1988. *Santería: An African Religion in America*. Boston: Beacon Press.

Omari, Mikelle Smith. 1984. *From the Inside to the Outside: The Art and Ritual of the
Bahian Candomblé*. The Monograph Series of the Museum of Cultural History 24. Los
Angeles: University of California Press.

Ortiz, Fernando. 1973 [1906]. *Los negros brujos: Apuntes para un estudio de etnología
criminal*. Miami: Ediciones Universal.

Panofsky, Erwin. 1955. *Meaning in the Visual Arts*. Garden City, N.Y.: Doubleday/Anchor.

Pérez, Cecilio (Oba Ecun). 1986. *Ita: Mitología de la religión "Yoruba."* N.p.: Gráficas
Maravillas.

Pichardo, Ernesto. 1984. *Oduduwa/Obatala*, co-author Lourdes Nieto. Miami: St. Babalu
Aye, Church of the Lukumi; printed by Rex Press.

Price, Sally, and Richard Price. 1980. *Afro-American Arts of the Suriname Rain Forest*. Los
Angeles: Museum of Cultural History/University of California Press.

Thompson, Robert Farris. 1966. "An Aesthetic of the Cool: West African Dance." *African
Forum* 2 (Fall):85–101.

———. 1969. "Abatan: A Master Potter of the Egbado Yoruba." In *Tradition and Creativity
in Tribal Art*, ed. Daniel Biebuyck. Berkeley-Los Angeles: University of California Press,
pp. 120–82.

———. 1970. "The Sign of the Divine King: An Essay on Yoruba Bead-Embroidered
Crowns with Veil and Bird Decorations." *African Arts* 3(3):8–17, 74–80.

———. 1974. *African Art in Motion: Icon and Act*, exhibition catalogue, National Gallery
of Art, Washington, D.C. Los Angeles: University of California Press.

———. 1983. *Flash of the Spirit: African and Afro-American Art and Philosophy*. New
York: Random House.

———. 1989. "The Song That Named the Land: The Visionary Presence of African-Ameri-
can Art." In *Black Art, Ancestral Legacy: The African Impulse in African-American
Art*, exhibition catalogue, curator Alvia Wardlaw, ed. Robert V. Rozelle, Alvia Ward-
law, and Maureen A. McKenna. Dallas: Dallas Museum of Art, pp. 97–135.

———. 1993. *Face of the Gods: Art and Altars of Africa and the African-Americas*, exhibi-
tion catalogue. New York: Museum of African Art.

Thompson, Robert Farris, and Joseph Cornet. 1981. *The Four Moments of the Sun: Kongo
Art in Two Worlds*, exhibition catalogue. Washington, D.C.: National Gallery of Art.

Turner, Victor W. 1967. *The Forest of Symbols: Aspects of Ndembu Ritual*. Ithaca-London:
Cornell University Press.

Wafer, Jim. 1991. *The Taste of Blood: Spirit Possession in the Brazilian Candomblé.* Philadelphia: University of Pennsylvania Press.

Wahlman, Maude Southwell. 1986. "African Symbolism in Afro-American Quilts." *African Arts* 20 (November):68–76.

Weiner, Annette B. 1992. *Inalienable Possessions: The Pardox of Keeping-while-giving.* Berkeley-Los Angeles-Oxford: University of California Press.

Wescott, Joan. 1962. "The Sculpture and Myths of Eshu-Elegba, the Yoruba Trickster." *Africa* 33(4):336–54.

PART

TWO

SANTERÍA AESTHETICS IN THE VISUAL ARTS

JULIA P. HERZBERG

REREADING LAM

Wifredo Lam (1902–82) participated in two major twentieth-century aesthetic movements that contributed to redefining art and life. One of these was international Surrealism, and the other was the *négritude* movement in Cuba. The two movements overlapped and intersected throughout the decade of the 1940s, the years in which Lam was repatriated to Cuba during World War II. During the war years many Surrealists found exile in the New World. André Breton, the father of Surrealism, lived in New York, as did Max Ernst, Marcel Duchamp, André Masson, Matta, Gordon Onslow-Ford, Kurt Seligmann, and Yves Tanguy. Pierre Mabille, the Surrealist writer, was in Haiti, Benjamin Péret and Remedio Varos were in Mexico, and the Paris avant-garde dealer Pierre Loeb was in Cuba. Breton was at the center, organizing diverse activities that kept the group spiritually united even though they were separated geographically. Lam was very much a part of this group that kept each other informed through letters and visits,[1] collaborated on new literary and art magazines,[2] and participated in each other's exhibitions, sometimes from afar.[3]

It was in the Americas during the years in exile when the Surrealists, who had long appreciated the cultural contexts of the so-called "primitive" peoples, had the opportunity to experience non-European cultures at first hand.[4] From a Surrealist-Ethnographic viewpoint, nonwestern peoples were viewed as living in perpetual communion with the essence of things,[5] and therefore their art and myths "provided an antidote for the rational, the beautiful, and the normal of the West."[6] At the same time that Surrealism encouraged colonial peoples to take pride in their own heritages, it also propagated the notion that

the "primitive" was the carrier of the "marvelous"—that mysterious, liberating, imaginative element thought to be inherent in nonwestern peoples. Breton and Mabille, who were the first Europeans in exile to write on Lam, brought this Surrealist ideology to bear on the western-trained Afro-Cuban artist. Although Breton's introductory words on Lam are those that have been recited most often in the critical literature, it was Mabille's 1944 essay titled "La manigua" (a Spanish translation from French "La jungle") that acknowledged the depth of Lam's black Cuban ties and claimed him as the artist par excellence for returning to his native sources for images grounded in "myth" and "magic." [7]

Breton's call for the creation of a modern myth was an objective very much at the heart of artistic exploration in New York during much of the 1940s. While many New York artists such as Adolph Gottlieb, Jackson Pollock, Barnett Newman, and Clifford Still, to mention a few, adopted Surrealist vocabularies and invented private symbols in an attempt to express a generalized or universalized myth, Lam used specific symbolism originating in the sacred and profane beliefs of the African heritage in Cuba.[8] Both groups, however, were responding to current interests in both anthropology and literature as well as the visual and performing arts for a broad range of subject matter. Lam seized this development in the evolution of Surrealism, as did the Martinican poet Aimé Césaire, to examine his own heritage. In that sense Lam looked within his own culture for iconographic sources in contradistinction to the European Surrealists and the emerging New York School artists who were excavating subjects from outside their own Anglo-European ambients. Although Lam, who exhibited at the Pierre Matisse Gallery in New York from 1942 to 1950, made a significant name for himself in international Surrealist circles, he would in later years claim an even larger territory for himself and for his people by reclaiming the African element in Cuban culture. It would take a few generations of rereading Lam before scholars, critics, and artists would recognize the significance of his reappropriations.

Lam's evolving style of the 1940s merges aspects of Surrealism and Cubism with Africanizing images. His visual world is replete with motifs whose meaning can be explained within an Afro-Cuban world view. With great imagination, the artist redefined the visual language of the traditional genres of figure(s) in landscape, landscape, portraiture, and still life.[9] In an extensive and inventive series executed throughout the 1940s, portraits of single and multiple figures are depicted with their anatomical parts rearranged and their sexual organs interchanged, resulting in a jolt to normal visual expectations.[10] In confirming an understanding of the relationship between aesthetics and creative freedom according to Surrealist theory, Lam's work seems to subvert traditional subjects by redefining the empirical world in terms of the spiritual world. While the Surrealists held that the spiritual world was part of the

unconscious, to the Afro-Cuban, the spiritual world was part of everyday reality. Lam, whose early religious upbringing was steeped in Santería, brought this Afro-Cuban world view to center stage in his work.[11]

Deity with Foliage of 1942 (fig. 5.1) is characteristic of the many inventive hybrid figures combining human and animal traits from the early Havana period. The female gender is suggested by the breasts, the male by the phallus and testicles, and the animal species by the pointed ears and tail. The hybrid is configured in a Cubist space in which the anatomical parts are depicted from multiple viewpoints. By overlapping delicately drawn lines and washes of paint, one figure metamorphoses into another in typical Surrealist fashion. The second figure's presence is clarified by adding fragments of a second head to the central one in the fashion of the additive imagery found in collective drawings made by Lam and other Surrealist artists in Europe.[12] The multiple-headed image of the deity is one of several mask-faces used, among other things, as a device for joining male and female genders and the human and animal species. The equine features such as the muzzle, mane, ears, and tail transform an otherwise naturalistic human figure into a hybrid with horse features. The resulting image is often referred to as a horse-woman or *femme-cheval*. Lam's use of equine motifs, while reminiscent of Picasso's bovine and horse imagery, is more specific to Afro-Cuban ceremonies, and in particular to the phenomenon known as spiritual possession. During a celebration known as a *bembé*, for example, an exchange of life-force (*ashé*) takes place between the devotee and his or her orisha/deity. When spiritual union occurs, the devotee, who is referred to as the "horse," becomes the vehicle through which the orisha expresses itself. Thus the image of the "horse," used by the artist to reconfigure the human figure, symbolizes the spiritual materialization of the divinity. Lam's new iconography reflects an Afro-Cuban world view in which the human, animal, and plant kingdoms are united. This world view was one the artist had known since childhood.[13]

In the late 1940s Lam again redefined the human figure. In works such as *Personnage* of 1947 (fig. 5.2) and *The Warrior* of 1947 (pl. 5), the bird-head motif is prominently featured. Although the birds are depicted in a generalized manner in both works, it is probable that they are vultures, which are the divine messengers of Olofi, the supreme deity who is present in every orisha. A Santería devotee believes that Olofi (also called Olodumare) lives in every human's head. The Yoruba word *eleda* expresses the concept that an orisha/deity lives in a devotee's head.[14]

The theme of the figure in landscape provided Lam with new possibilities for expressing sacred and profane beliefs according to the Afro-Cuban world view. In such works as *The Noise* of 1942 (*Le Bruit*, also titled *The Murmur*) and *The Jungle* of 1943 (fig. 5.3), among others, the interconnectedness between orisha and nature is signified by the hybrids whose forms echo the surrounding vegetation, for exam-

152

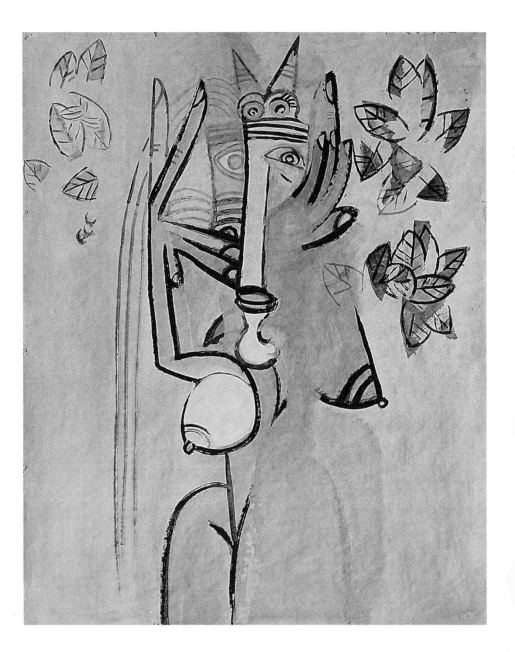

ple, the legs conflate with the sugarcane stalks and the breasts with the papaya fruit from the paw-paw tree. In a gesture reminiscent of listening, *The Noise* signals the mysteries of nature. Believing in the sacredness of mother earth, commonly referred to as the *monte*, Santería devotees think of it as both a physical place and a spiritual realm where prayer and offerings are made.[15]

The orishas were born in the *monte*; some continue to inhabit its natural elements; others bestow their blessing in the form of *ashé* (divine force or power).

FIGURE 5.2.

Wifredo Lam, *Personnage*. 1947. Oil on canvas. 109.5 × 91.4 cm (43 ⅛ × 36 in.). Santa Barbara Museum of Art, Gift of Wright S. Ludington.

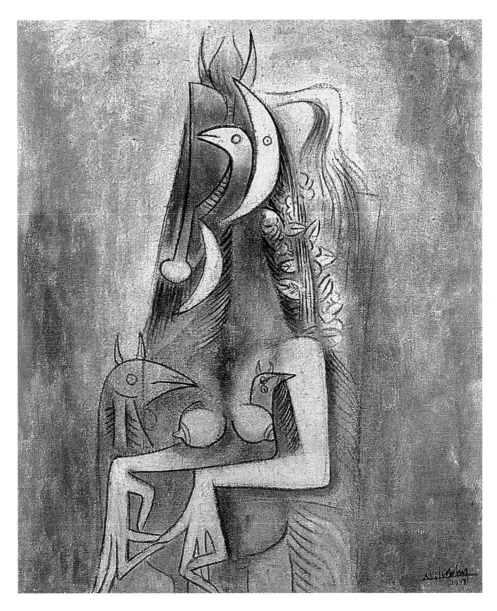

Priests and devotees alike propitiate plants or herbs before cutting them for medicinal or ritual use. It seems likely that the scissor motif, noted in the hand of the fourth figure on the right in *The Jungle*, is intended as a reference to the actual act of cutting the plants and herbs for medicinal or ritual purposes. Two figures who are holding plants in their outstretched palms in the same painting are, in all probability, offering these to the orishas. The hybrid figures-cum-sugarcane stalks in the painting appear monumental, occupying the height and breadth of the pictorial space. The dense, flora-filled background pushes the hybrid forms forward, crowding the fore-

FIGURE 5.3.

Wifredo Lam, *The Jungle*. 1943. Gouache on paper mounted on canvas. 239.4 × 229.9 cm (94¼ × 90½ in.). The Museum of Modern Art, New York. Inter-American Fund.

ground and creating spatial tension. This tension is heightened by the upward pull of the vertical forms. Further oppositions are achieved by the depiction of enlarged feet, hands, and boldly configured masks which contrast with the delicate, thin forms of the sugarcane stalks-cum-limbs. A sense of dynamism results from the push forward and the pull upward, which, together with the thumping of the large feet, create the sensation of the forms moving in different directions over the ground. The group, amalgams of human, plant, and animal forms, dances slowly and rhythmically to honor and celebrate those spiritual, life-giving forces found in all aspects of nature.

The anthropomorphic nature of Afro-Cuban orishas is a principal theme in any number of Lam's works in the 1940s. Two deities most often depicted are Elegguá

FIGURE 5.4.

Wifredo Lam, *The Green Morning* (*La mañana verde*). 1943. Oil on paper mounted on canvas. 186.7 × 123.8 cm (73½ × 48¾ in.). Private collection. Courtesy Christie's, New York.

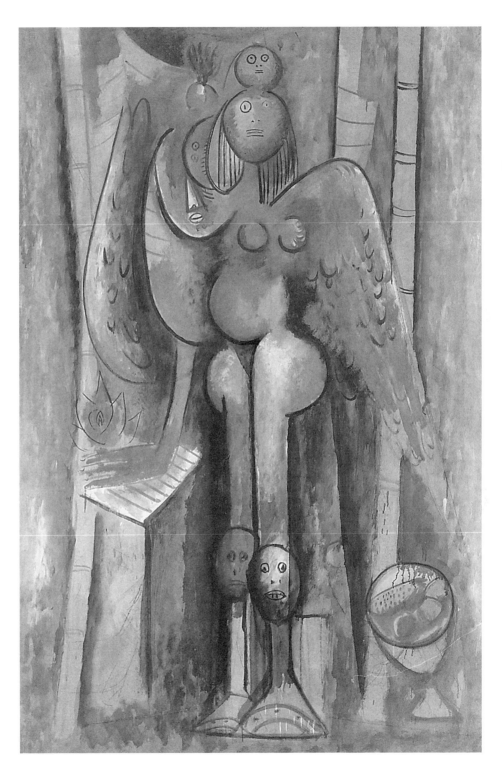

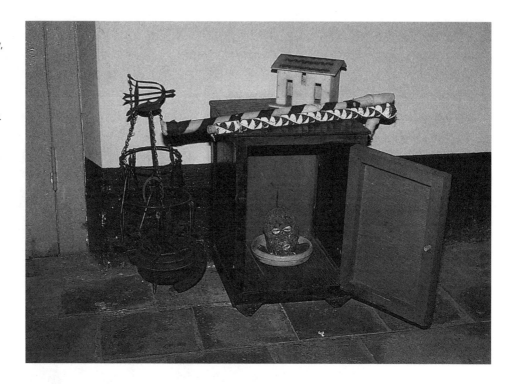

and Ogún, both of whom retained their primacy from the African to the Cuban con-
text.[16] *The Green Morning* of 1943 (fig. 5.4) is one splendid example. In the center
of the composition, the voluptuous figure with several heads and huge bird wings
has limbs echoing the contours of the sugarcane stalks, feet shaped like horseshoes,
and round heads for kneecaps. Elegguá, the guardian of one's paths, is signified by
the little round head surmounting the central head of the winged figure. Among
Elegguá's many avocations, he predicts, prevents, and allows for the vicissitudes of
life.[17] His role as protector is represented by a small votive image commonly placed
in a receptacle by the entrance of Cuban homes.[18] These images are made of clay, ce-
ment, or stone, with eyes and mouths that are either painted or composed of cowrie
shells (fig. 5.5). Other manifestations of the spirit world are portrayed in *The Green
Morning* in the form of little heads with ringed-toothed mouths. Their ominous ap-
pearance is intended to evoke evil which looms large in the *monte*.[19] As an adult
Lam remembered being afraid of the Chicherekú, the three-toothed gnomes who
haunted the houses, and the *guijes*, who lived near the river in the artist's hometown
of Sagua la Grande.[20] Lam seemed to delight in retelling these stories to friends at
various times in his life.

In this painting, Ogún, the god of iron and war and protector of the *monte*, is
symbolized by the horseshoe motif. In popular Santería practice, devotees of Ogún

FIGURE 5.6.

Wifredo Lam,
Malembo. 1943. Oil
on canvas. 153.0 ×
126.4 cm (60¼ ×
49¾ in.). Private collec-
tion. Courtesy Pierre
Matisse Foundation.

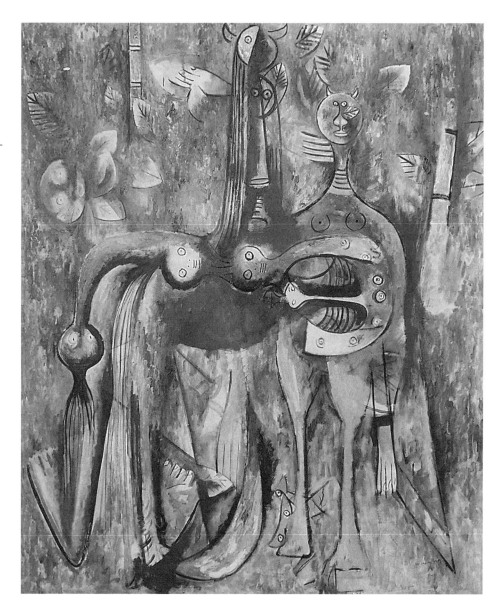

symbolize the deity's presence by leaving metal objects, such as a necklace or a chain
with an arrow, a yoke, pike, ax, machete, hammer, and a key, together with food of-
ferings at the foot of the silk-cotton tree (*ceiba*).[21] Lam, who was never interested in
straightforward narrations of magico-religious practices, however, depicted sugar-
cane stalks rather than a *ceiba* and placed a food offering near them.

Ogún's presence is equally commanding in *Malembo* (fig. 5.6), another signa-
ture work of 1943. When Lam's close friend Lydia Cabrera first saw the painting,
she was reminded of evil or a magic spell, or *malembo* as it is known in the Cuban
Congo language.[22] The painting was one of several works from the early 1940s that

FIGURE 5.7.

Wifredo Lam, *Anamu*.
1942. Oil on canvas.
122.6 × 147.3 cm
(48¼ × 58 in.). Mu-
seum of Contemporary
Art, Chicago, Gift of
Joseph and Jory
Shapiro.

158

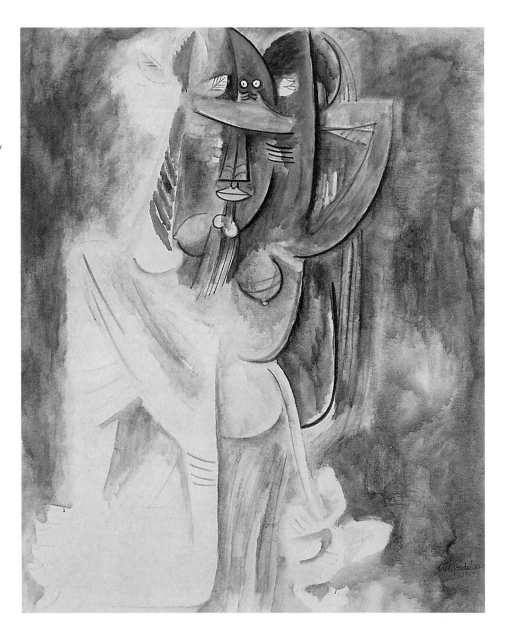

Cabrera titled.[23] *Anamu* (fig. 5.7), from the same period, is a work in which the title
also connotes ritualistic practices in Santería. In Afro-Cuban folk practice, many
people put two leaves of *anamu* in the soles of their shoes to ward off evil.[24] Perhaps
it was no coincidence that when *Malembo* was shown at the Pierre Matisse Gallery
in New York in 1944, it was hung next to *Anamu*.

Lam chose the Greek mythic title *Hermes* for a 1944 painting. If the artist had
continued his usual practice of assigning Afro-Cuban titles, he might have chosen

FIGURE 5.8.

Wifredo Lam, *Hermes*.
1944. Oil on canvas.
154.9 × 125.7 cm (61
× 49½ in.). Private col-
lection. Courtesy Pierre
Matisse Foundation.

Elegguá, the messenger god in Yoruba. It seems that Lam selected a Greek title out
of a sense of communal spirit with a group of New York artists who were also as-
signing mythic titles to their work.[25] Although the central figure in *Hermes* (fig. 5.8)
is not specifically identifiable, the various iconographic motifs suggest that the figure
is Elegguá. The round head at the top of the figure, as well as the many little round
heads that fill the pictorial space, are attributes identified with that deity. Most of the
Elegguá images in this painting have horns, a syncretistic element that originates

FIGURE 5.9.

Wifredo Lam, *The Eternal Present*. 1945. Mixed media on jute. 215.9 × 196.8 cm (85 × 77½ in.). Museum of Art, Rhode Island School of Design, Providence.

from the Christian identification of Elegguá with evil or the devil. Directly below the central head, Lam inserted gourds which are also associated with that orisha. The depiction of a goat in the lower right suggests an offering.[26] The feathers allude to an important sacrificial rite known as *acobijarse* or *acobijamiento* which, literally translated, means "to cover oneself." When a feathered animal has been sacrificed to the deity, feathers are then plucked and used to cover the orisha who is represented by *otan* (holy stones). The devotee feels that through the act of covering the orisha, he or she is also covered, that is, protected from harm.[27]

The Eternal Present of 1945 (fig. 5.9), another ambitious multifigural composi-

tion, illustrates a change in Lam's stylistic evolution in which the hybrids have a sculptural quality, and their forms no longer conflate with the surrounding vegetation. The iconography suggests the presence of four warrior deities.[28] From the left, the first figure, Oshún, orisha of the river and fresh water, is noted by her sensuality;[29] the second, Elegguá, the first deity summoned when the ceremony begins, is represented by both the little round head and the votive image; the third, Ogún, is symbolized by the knife which, when used in ritual sacrifice, is guided by the orisha's power; and the fourth, Ochosí, the orisha of the hunt and the mysteries of the forest, is symbolized by the lance.

From the time of Lam's return to Cuba, the artist was fascinated by the dense, lush, natural wildlife of his country. He painted in his light-filled garden which was full of plantains, paw-paw trees, sugarcane, palm trees, avocados, and sweet potatoes, making it a microcosm of the island's natural tropical splendor. That vegetation reappeared in his work in a recognizable but not realistic style. In the mid-1940s Lam did an extensive series of landscape paintings in which the artist captured the island's tropical light. In these works, nature's forms are charged with supernatural forces, with the result that the palm fronds are reshaped into triangles and diamonds with staring eyes, little horns, papaya fruit breasts, and a variety of other metamorphosed forms originating in human, animal, and plant species. The diamond-shaped leaf noted in such works as *The Birds* of 1944 and *The Song of the Forest* of 1946, to name just two, refers to a similar geometrical shape employed by the Abakuá, an important religious confraternity in Cuba.[30] It is worth noting that there was a great deal of interest in the Abakuá among artists, intellectuals, and writers at this time. Lam, who did an untitled painting of the masked devil figure playing a drum, was one of several Cuban artists who portrayed the Abakuá in their works.[31] The artist went to Abakuá, or Ñañigo, ceremonies at different times with his friends, the writer Alejo Carpentier, and his dealer Pierre Loeb.[32] Masked devils, or *diablitos*, as they were known, wore brightly colored costumes and peaked headdresses. When they appeared in public on certain religious holidays, they attracted a great deal of public attention even among those who were not Abakuá.

Sur les traces (fig. 5.10) is a beautiful painting from a small group of black-and-white landscape paintings of 1945. The iconography is of particular interest, in part because it contains specific references to Catholicism and Santería. In the upper right, Lam portrays several objects including a cross. The altarlike image is painted with barely visible brush strokes, making its identification somewhat elusive. Although the central image cannot be fully identified, fragments of Changó's thunder ax, eggs, scepter, and candle are among the numerous motifs that are readable. Just to the left of the middle of the composition is a candle motif with a base in the shape of a staff. Its significance is enigmatic, but the fragment of the staff could be a refer-

FIGURE 5.10.

Wifredo Lam, *Sur les traces*. 1945. Oil on canvas. 154.9 × 125.7 cm (61 × 49 ½ in.). Mr. and Mrs. Melvin W. Knyper, Aspen, Colorado.

162

ence to the *osun*, the medicine staff belonging to the orisha Osain, who is the god of medicine and protector of the *monte*.

In relationship to portraiture, landscape, and figures in landscapes, Lam made few still lifes. Two exceptional examples of this theme are *The Night Lamp* of 1945 (pl. 6) and *Secret Rites* of 1950. The imagery in the earlier work contains camou-

FIGURE 5.11.

Wifredo Lam, *The Grenadine-Colored Curtain* (*Le rideau grenade*). 1944. Oil on paper mounted on canvas. 113.0 × 81.9 cm (44½ × 32¼ in.). Private collection. Courtesy Christie's, New York.

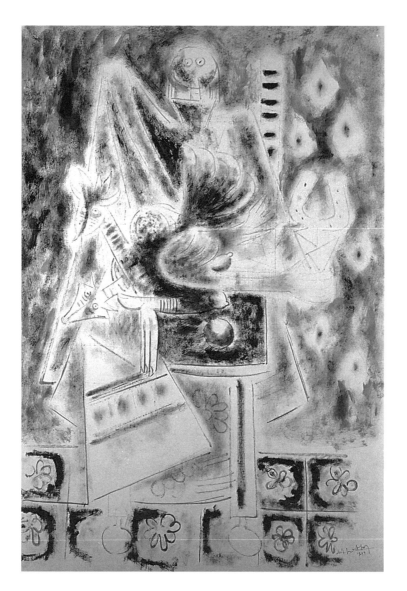

flaged references to the orishas and the ceremonies held in their honor. The night light, from which the title originates and that appears at the center of the composition, is given principally as an offering to Oshún, Elegguá, and Changó. Night lights (*lámparas*) are made from hollowed-out pumpkins or coconuts to which oil is added; wicks are then floated in the oil. These offerings are made for the purpose of asking the deities to open a path, to provide guidance, or to bring about a change. In this work the anthropomorphic figure in the upper left is identifiable as Changó, the deity of thunder, by the ax that forms his head. Another attribute of the deity is the banana leaf found below the head. There is also a small altar which is held by two

hands. On the top of the altar are the horseshoe symbol of Ogún and two bull horns that symbolize Oyá, the orisha that accompanies Changó.[33]

The still life genre takes another turn in two similar works, *Altar for Yemayá* and *The Grenadine-Colored Curtain* (fig. 5.11), both of 1944. At least on one level, these works deal with the theme of propitiation. In *The Grenadine-Colored Curtain* we can identify a kid goat, fruit, and perhaps rooster feathers. *Altar for Yemayá* depicts a table outdoors with an array of barely discernible elements on it. All the images converge in a way that prevents too literal a description of each element. The small votive image of the omnipresent Elegguá, however, is clearly readable. The subject of the altar presented as a still life illustrates Lam's inclination to utilize a traditional genre in untraditional ways. Common in Cuba during Lam's time, home altars were made indoors or outdoors (in one's yard) to honor one's orisha/saint.[34] Their transcendental importance is attested to by their continued presence throughout the United States and in Latin American communities whose members are influenced by both African and Catholic beliefs and traditions. Domestic altars connect and mediate between the terrestrial and celestial, the material and the spiritual, the personal and communal aspects of everyday life.[35] Lam chose the format of a time-honored genre into which he inserted local source material to extend the modernist dialogue. While the artist's stylistic language was based on those contemporary idioms that were experimental at the time, his ideology was different. He asserted a personal and collective identity through form and subjects inherent in a Santería world view.

When Lam returned to Cuba at the end of 1941, a small group of Cuban intellectuals was actively exploring Afro-Cuban history, folklore, literature, music, and dance. The effects of the Afro-Cuban literary movement (1928–38) were still in the air. Anthropological studies by Fernando Ortiz and his student Romulo Lachantañerie were under way. Ortiz was a founding member of the Sociedad de Estudios Afrocubanos (Society of Afro-Cuban Studies), a prestigious institution comprised of men and women of biracial backgrounds. The society published a scholarly journal (1937–40) in which a range of subjects on black culture in Cuba, the Caribbean (Haiti and Puerto Rico), and South America (Uruguay) appeared. Ortiz had written such articles as "El fenómeno social de la transculturación y su importancia in Cuba" (1940); and Lachantañerie had already published *¡Oh, mio Yemayá!*, the article "Nota histórica sobre los lucumis," and *Manual de santería: el sístema de cultos "lucumis"* (1942). Lam became connected to the circle of Cuban intellectuals through the folklorist and ethnographer Lydia Cabrera and the writer Alejo Carpentier.[36] The three Cubans were of the same generation and had all spent many years in Europe, where they were affected by the European interest in African art. In the early 1940s Cabrera was involved in a ten-year field study of Cuba's black folk

legends and oral history which was published as *El monte* (1954); Carpentier was working on *La música en Cuba*,[37] a scholarly account of music from the colonial period to the modern published in 1946.

The first body of criticism on Lam by Cuban writers emphasized his Surrealist connections and Afro-Cuban content. Cabrera was Lam's first compatriot to write about the artist in a leading Havana newspaper in the spring of 1943.[38] Her main objective was to introduce the then unknown Lam to a new readership. Without discussing the themes or imagery in the artist's work, she said that Lam's Asian and African lineage was expressed in his art, adding that "his work was not 'exotic' or 'vulgar' in the commonly understood meaning of the words—for Lam was a trained artist whose work was not to be confused with commercial art." Evidently Cabrera wanted to distinguish between the fine art of a talented painter and the commercial street-trade kitsch that coopted Africanizing subjects. In Cabrera's second article, she elaborated on the Afro-Cuban content in Lam's work: "The ancient ancestral black deities . . . appeared tangible to him in Cuba . . . where they are expressed . . . in each corner of the landscape, in each tree-divinity, in each fabulous leaf of his garden in Buen Retiro."[39] A few months after Cabrera's article appeared, Carpentier wrote an essay that is still highly regarded by Lam scholars. The Latin American writer defined the artist's iconography as one that blends the human, the animal, and the vegetal. In order to establish the historical significance of Lam's imagery, Carpentier suggested that the artist was "animating a world of primitive myths with something that was ecumenically Antillean—myths that belonged not only to the soil of Cuba, but to the larger chain of islands."[40] Carpentier saw Lam as an especially [Pan-] American—not a European—artist. This view of Lam has had resounding echoes in the art and discussion of contemporary Latin American and Latino artists in the United States as well as other artists in this country who seek ways to express their national and cultural heritages in their art.

Although Lam found enormous support for his visual investigations of Afro-Cubanism, in a myriad of ways, in the friendships of Cabrera and Carpentier, it was very difficult for the artist who went against the grain when he drew upon subjects from Afro-Cubanism. Not only was white Cuban society uninterested in and/or dismissive of black Cuban culture, but it was also uninterested in modern art, especially that done by contemporary Cuban artists.[41]

The critical position toward Lam has changed over the decades. The Surrealist allure for the marvelous and the exotic has lost much of its currency. From a contemporary vantage point, Lam has become a paradigm for something more than a contributor to European Modernism. He is viewed by many as having "opened the path" for artists of multicultural backgrounds who aim to express their cultural identities in their work. It is the new generation of artists, critics, and art historians

that have emerged in the late 1970s and early 1980s who, while acknowledging Lam's historical position in Modernism, also celebrate his role in reclaiming a racial and national identity at a time when Afro-Cubanness was barely audible in his own country, much less central to discourse in western art.

1. Pierre Mabille visited Lam and Helena Holzer (Lam's companion and second wife) each time he passed through Cuba on his way to Mexico where he visited Benjamin Péret, Remedio Varos, Wolfgang Paalen, and Alice Rahon. Péret and Varos also visited Lam and Helena Holzer in Cuba. Lam stayed in Haiti four months (December 1945 to April 1946) at the invitation of Mabille who was at that time the French cultural attaché. There he saw Breton who was also invited to Haiti in early 1946. For an excellent synthesis of these activities, see Juan Manuel Bonet, "By Way of Introduction," in *El Surrealismo entre el viejo y nuevo mundo* (Las Palmas de Gran Canaria: Cabildo Insular de Gran Canaria, Centro Atlántico de Arte Moderno, 1989), 15–23.

2. For discussion of Lam's participation in literary and art magazines such as *VVV, View, Hémispheres* in New York and *Gaceta del Caribe, Origenes: Revista de Arte y Literatura* in Havana and the Surrealists' interest in the Antilles as this interest was written about in New York publications, see Julia P. Herzberg, "Wifredo Lam: The Development of a Style and World View. The Havana Years, 1941–1951," in *Wifredo Lam and His Contemporaries* (New York: The Studio Museum in Harlem, 1992), 31–51.

3. Breton organized "First Papers of Surrealism," the first and only group exhibition of the Surrealists during their exile in New York (October to November 1942). The exhibition, held at the Whitelaw Reid Mansion, was sponsored by the Coordinating Council of French Relief Societies. It included a roster of famous European artists such as Duchamp, Chagall, Ernst, Giacometti, and Masson, lesser-known young New York artists such as Motherwell and Baziotes, and the Latin Americans Frida Kahlo, Lam, and Matta. Duchamp installed the work; Breton discussed myths in the catalogue. See William Rubin, *Dada and Surrealist Art* (New York: H. N. Abrams, 1969). For Lam's participation in national and international exhibitions during the 1940s, see "Chronology," in *Wifredo Lam and His Contemporaries*, 343–44, 470.

4. Breton and Masson collaborated on *Martinique charmeuse de serpents*, a book inspired by Caribbean nature and mythology. Péret and Mabille were inspired by the culture of the Antilles. On different occasions, Breton traveled to Arizona and New Mexico to visit the Hopi and Zuni and to Haiti to see Voodoo ceremonies. Ernst, together with Dorothea Tanning, was deeply immersed in American Indian culture. For a further discussion concerning the interests of Paalen, Seligmann, Onslow-Ford, and others in nonwestern cultures, particularly in Mexico and the United States, see Martica Sawain, "Ethnographic Surrealism and Indigenous America," in *El Surrealismo*, 81–87.

5. Marcel Nadeau, *History of Surrealism* (New York: Macmillan, 1965), 340.

6. James Clifford, "On Ethnographic Surrealism," *Comparative Studies in Society and History* 23 (January 1981):546.

7. André Breton wrote a brief essay in a catalogue brochure for Lam's first exhibition at the Pierre Matisse Gallery in the fall of 1942. Pierre Mabille's essay was published as "La jungle," in *Tropiques* 12 (January 1945); reprinted in *Tropiques* 2 (Feb. 1943–Sept. 1945)

(Paris, 1978), 173–87. For a critical overview of the writings on Lam in the 1940s, see Herzberg in *Wifredo Lam and His Contemporaries*, 31–51.

8. Rothko and Gottlieb, with the assistance of Barnett Newman, set forth their ideological program in a letter (December 1943) they sent to the *New York Times*. Therein the artists stated that painting had to be timeless and tragic and that myth was the only valid subject matter. Lowery Stokes Sims addresses the questions of myth and primitivism in her catalogue essay "Myths and Primitivism: The Work of Wifredo Lam in the Context of the New York School and the School of Paris, 1942–1952," in *Wifredo Lam and His Contemporaries*, 71–88.

9. In the literature on Lam's art to this point, his body of work produced in the 1940s has not been seen as belonging to traditional categories.

10. Lam also executed straightforward depictions of the human figure during the early Havana years. In such instances the model was Helena Holzer.

11. The artist was the son of an Afro-Spanish mother and a Chinese father. He received his spiritual guidance from Mantonica Wilson, a Changó priestess in Santería.

12. While awaiting passage out of war-torn Europe in 1941–42, Lam and a group of artists and writers, including André Breton, Jacqueline Lamba, Oscar Dominguez, Max Ernst, Jacques Hérold, André Masson, Benjamin Péret, and Victor Bauner, among others, met regularly at the villa Air-Bel in Marseilles. To distract themselves from the worsening conditions, André Breton organized a variety of parlor games which included collective drawings intended to emphasize the role of chance and improvisation.

13. Helena H. Benitéz, Lam's second wife, said that the two of them often spoke about this world view which holds that plants and animals and the deity have a soul, a vital force (conversation with the author, February 7, 1990).

14. For discussion of *eleda*, see Raúl Canizares, *Walking with the Night: The Afro-Cuban World of Santería* (Rochester, Vt.: Destiny Books, 1993), 54, 55.

15. Known as the bush in Africa, the *monte* or *manigua* describes an untilled area that is sacred in the traditional rural life of the Afro-Cuban. However, in industrialized society, the *monte* or *manigua* can be a riverbank in a city or even the backyard of a Santería devotee. Although the Spanish words *jungla* (jungle) and *selva* (forest) are also used to describe the physical aspects of a natural forest area, they do not connote a sacred terrain. See Lydia Cabrera, *El monte* (Miami: Colección del Chichereku, 1975), 67, 68.

16. For a comparison of both Elegbara in Africa and Elegguá in Cuba and Ogún in Africa and Cuba, see Mercedes Cros Sandoval, *La religión afrocubana* (Madrid: Plaza Mayor, 1975), 195–96, 233–37.

17. Ibid., 166. For a similar discussion of Elegguá, see Janheinz Jahn, *Muntu: The New African Culture*, trans. Marjorie Green (New York: Grove Press, 1961), 64.

18. Although as an adult, Lam did not practice any formal religion—including Santería or Catholicism—the artist did observe the custom of placing an Elegguá near the door of his home in Cuba (conversation with Helena H. Benitéz, February 7, 1990).

19. Oral tradition is full of stories of evil spirits. Such accounts are written about by Lydia Cabrera, *Porqué . . . Cuentos negros de Cuba* (Havana, 1948; repr. Madrid: Ramos, 1972), 36, 37.

20. Michel Leiris, *Wifredo Lam* (Paris: Fratelli Fabbri, 1970), 6.

21. Cros Sandoval, *La religión afrocubana*, 241.

22. Conversation with the author, May 5, 1984. For references to *malembo*, see Cabrera, *El monte*, 17, 325, 499.

23. Conversation with Helena H. Benitéz, February 7, 1990.

24. *Anamu* is a wild plant that grows throughout Cuba and Puerto Rico and is used extensively for ritualistic and medicinal purposes. The plant is described in Cabrera, *El monte*, 322–24.

25. For example, Adolph Gottlieb chose such titles as *Hands of Oedipus*, and Jackson Pollock, *Pasiphaë* and *Guardian of the Secret*.

26. Sacrifices are made to the deities for especially prescribed reasons, including as a gesture of propitiation to ward off evil or to prevent illness or negative elements of a punitive nature. Animal sacrifices are eaten in a communal meal as a celebration between the divinity and the devotee.

27. I am very grateful to Miguel W. Ramos, who has shared with me his expertise concerning Santería rituals and beliefs, thereby adding greatly to my understanding of them.

28. The identification of the warrior deities in this work is the author's. Lam made relatively few comments and left scant records in this regard.

29. For an informative and sensitive discussion of the sensual and sexual aspects of Oshun's nature, see Beatriz Morales, "Afro-Cuban Religious Transformations: Lucumi Religion and the Tradition of Spirit Belief," doctoral dissertation (City University of New York, 1990), 54.

30. The secret society of the Abakuá or the Nañigos, as they became popularly known, was founded in Cuba in the second half of the nineteenth century by people of southern Nigerian origins. One of the important books on this group is Lydia Cabrera, *La sociedad secreta Abakuá* (Miami: Colección del Chichereku, 1970).

31. Giulio V. Blanc has provided a very good account of this figure in Cuban art from the nineteenth century to its more recent appearance in the work of such Cuban modernists as Amelia Peláez, Victor Mañuel, Mario Carreño, and Luis Martínez-Pedro. See Giulio V. Blanc, "Cuban Modernism: The Search for a National Ethos," in *Wifredo Lam and His Contemporaries*, 53–69.

32. For a fuller account of Lam's interest in the Abakuá and his adoption of their emblems in a host of works from the Havana years, see Herzberg's essay in *Wifredo Lam and His Contemporaries*.

33. The author thanks Miguel W. Ramos for his discussions concerning the ritualistic use of night lamps which were very useful in order for me to assign iconographic attributions to the deities.

34. Cros Sandoval, *La religión afrocubana*, 55.

35. For discussion of altars in the works of contemporary Chicano artists, see Tomás Ibarro-Frausto, *Ceremony of Memory* (New York: INTAR Gallery, 1989).

36. Lam briefly met Carpentier in Spain sometime in the 1930s when the artist lived there. Their close friendship developed after Lam moved back to Havana in 1941.

37. By the time Carpentier returned to Havana from Paris in 1939, he was a well-known journalist and critic of the arts. Toward the end of the 1940s Carpentier began to be recognized as an important literary writer.

38. Lydia Cabrera, "Wifredo Lam," *Diario de la Marina*, May 17, 1943.

39. Ibid., January 30, 1944.

40. Carpentier, "Reflexiones acerca de la pintura de Wilfredo Lam," *Gaceta del Caribe* (July 1944), repr. in *Alcance a la Revista de la Biblioteca Nacional José Marti* 3 (1989):99.

41. See Alfred H. Barr, Jr., "Modern Cuban Painters," *Museum of Modern Art Bulletin* 11 (April 1, 1944):7; see also Lydia Cabrera, "Wifredo Lam," *Diario de la Marina*, May 17, 1943.

JUAN BOZA
TRAVAILS OF AN ARTIST-PRIEST, 1941—1991
EDITED BY RANDALL MORRIS AND JULIE EDWARDS

JUAN BOZA: EXCERPTS FROM THE ARTIST'S FINAL STATEMENT, JANUARY 1991

TRANS. R. VIERA, ED. R. MORRIS

I was born in the colonial city of Camagüey, Cuba, the flattest area of the entire island. It has many houses with clay or flagstone floors and enormous windows covered by beautifully and distinctively designed gratings. The streets are made of cobblestones. It is the city with the most Catholic churches on the island. It is called the city of the church and the *tinajones* (water jars). Since it is so flat there are many problems with water, so the people keep various clay *tinajones* in their back-yards to collect water for everyday use.

Camagüey has many magico-religious legends inherited from its ancestors. By casual observation many people would not perceive the city's underlying rituals, its relationship with the supernatural, the cosmic laws of cause and effect with their direct connections to terrestrial life. Much is secret and concealed. It involves so much more concentration to really perceive it.

During my childhood I learned to understand many of the different cultural influences in Cuba. My interpretations of these philosophies and a background of the old combined with new, more universal influences are the fundamentals of my aesthetics. In addition, my identity synthesizes all of this to make intellectual order.

172

In a spontaneous and flowing way, I have selected images from my unconscious that sometimes appear to be part of my daily existence . . . autobiographical images from memories. The patrimony of my religion through the language of Yoruba, the Congo, and Carabali are united and incarnated through different rituals. The bilingualism, compounded by existential secretiveness, is inevitably called upon at the time of sacred creation. The human eye is capable of collecting messages, both reachable and obscure, that are products of the spiritual. . . .

On the first days of January my aunt, the *santera mayor*, the *oní-yemayá*, and I used to visit her godfather, an old Lucumí Echu-migua. He was small in stature, but very large in knowledge about all the teachings passed on generation to generation by word of mouth and intimate demonstration. Since it was the beginning of a new year, the visit took three days of spiritual development and purification. New members of the religion were also initiated. We learned to dance the different rituals and how to sing the different songs of the orishas of the Yoruba-Lucumí pantheon. We also did this to Palo Mayombe and to the Iremes of the secret society of Abakuá.

I had wanted to paint and draw from the time I was nine or ten years old. During my adolescence I had many realistic and unrealistic fantasies. At the same time my parents were making plans for my life without considering what I wanted to be. During these adolescent years I made an oil painting (my first work using this technique) of a neighbor who was loved and respected by many people. This painting, done in shades of blue, was a crucial point in my career. I took this painting to an exhibition in the city which showed other recognized painters, and I won a scholarship from the mayor of Camagüey to study at San Alejandro in Havana. Many who wanted to become career painters aspired to this. It was a turning point in my life when I realized what I really wanted to do and saw the path open up for me.

In 1962 I enrolled in the School of National Art in Cubanacan. This was the new art university in Cuba in the 1960s when there were new generations of Marxists moving into power. During this time, my work was influenced by major Latin American artists like Wifredo Lam and Roberto Matta. Lam was born in Cuba but lived most of his life in Europe, especially in Paris. He was in touch with African influences, but he looked at them from a European point of view. These African influences are found blended together in Cuban culture, which is a mixture of the different styles of the Caribbean, Spain, and Africa.

In 1971, without being given any concrete reasons, I was prohibited from working as, or even existing as, an artist. I was forced to look deep inside and hold onto almost nothing in order to endure this difficult time.

Although I stopped working as an artist, my spiritual communion and culture never ceased to exist. It was a phase in my life during which I overcame all my internal contradictions and restructured myself. My strong will enabled me to develop a

new personality as a defense against a hostile and uncertain environment. My life changed in all possible forms, and I learned to live in a more spiritual world. I kept working toward a level where I could live without getting into trouble. This was the only way I could consider exile. This was very difficult, but thanks to faith and spirit, after a long decade of nonexistence, a miracle happened in my life. I was able to leave Cuba in 1980, leaving behind all the people to whom I owe what I am today. Nevertheless I did bring with me all my memories and heritage. All my ancestors traveled with me across the waters, and with their help I became another Juan Boza, in search of my spiritual self. Difficult experiences make us more trusting and aesthetically sensitive. In my case, striving for positive change, trying to excel, trying to have a more humanistic definition of the world, maintaining a passion for life, and leaving behind all the bad memories, helped me to be determined and focused and to put all my thoughts in order. In a subliminal way I went back to my origins. After months of work the result was an encounter with the flow of the gods of the New World.

173

JUAN BOZA: REINVENTING HIMSELF

BY RICARDO VIERA

My exodus via Mariel was an unbelievable journey; the ocean, the waves in the middle of the night, made the end seem near. New York was a tremendous shock; I was not happy with my work. I had to rebuild Juan Boza from scratch, and find my own expression.[1]

The last time I had the opportunity to see and interact with Juan Boza was in January 1991 while in Chicago for the *Cuba-USA: The First Generation* premiere exhibition at the Museum of Contemporary Art. Boza expressed a strong desire to go back to Cuba to see his elderly parents. Because of their advanced age, he was concerned that this would be his last chance to visit them. From our numerous conversations, I sensed a mysterious, compelling, and underlying emotion existing within his obsession to go back to the island, but I could not unravel it because of his usual vibrant energy and self-assurance.

Less than two months later, on March 5, 1991, I received a call from a mutual friend and colleague, Ileana Fuentes, who gave me the unexpected and unfortunate news of Boza's death. He had begun to feel ill a few weeks prior to the evening of March 4, but kept relatively quiet about it. When the pain became unbearable, he rushed to Brooklyn Hospital for help. He collapsed in the emergency room while filling out forms and died the following night from massive kidney failure.

The ordeal seemed unreal and left many questions unanswered. Ileana had been notified by Boza's friend, Pedro R. Monge-Raulfs, who was listed on the hospital registration forms as his contact person in case of emergency. When Monge was reached by Brooklyn Hospital, he discovered that Boza's personal belongings were

lost. To his dismay, he realized he had no legal authority to claim the body because he was not the next-of-kin. No known last will or testament had been made. No one had access to Boza's apartment/studio. Ultimately, the Borough of Brooklyn took possession of all his belongings including his artwork. The burial ceremonial rituals, a custom of the Yoruba religion, were problematic because there was no access to Boza's altar. If that was not enough, no funds were available to take Juan Boza to a dignified final resting place.

Immediately, fellow artists, collectors, and friends formed an action working committee to demonstrate their profound love and respect for the man. "Together we buried him; together we mourn him. At St. Michael's Cemetery in Astoria, the body of Juan Boza rests in peace with nature. His soul, in harmony with his beliefs, has gone to the orishas. His spirit remains with all of us."[2]

Questions still remain unanswered. Legal steps and logistical complications are pending. Unfortunately, the most important matter, the recognition that the man and his work earned and deserved, is almost forgotten. Four years have passed, and the work is still in storage with no immediate solution in sight. A committee, composed of representatives of museum professionals who knew and understand the importance of Boza's work, is unofficially acting as his estate. This committee continues to fight political bureaucracy and other complications, as well as time itself. At times, the feeling of helplessness is prevalent. Attempts have been high, but hurdles are higher. The committee's objectives are to maintain the integrity of Boza's goals as an artist and to attain recognition for his pioneering efforts.

Juan Boza came to the United States during the Mariel ordeal in 1980. For Boza, this was a liberating experience, a miracle of sorts. By 1982, Boza was transformed. Before the New York transformation, his work was, as he called it himself, "science fiction" (fig. 6.1). It was totally contrary to his new direction, where freedom of expression and a painterly attitude had a spiritual foundation from which he created tableaus of magnetic environments. These were based on oral ancestral tradition and on his life experiences with Afro-Cuban Santería, not only as an artist but also as a Santería priest.

The influence of Cuban Santería in contemporary Latino art is prevalent in the creative work of individual artists expressing or recreating several aspects of their rich religious and cultural heritage. This syncretic religion was developed from a combination of Yoruba and Catholic elements. These influences are also evident, as Robert Farris Thompson has noted, "through powers of creative transformation." In other words, artworks suggest traces of Afro-Latino cultural traditions that could reveal ways of seeing and perceiving, either consciously or unconsciously.

Juan Boza left an impressive body of work consisting of drawings, prints, paintings, and photographic documentation of his altar installations. His work broke

FIGURE 6.1.

Juan Boza, *Espación transparente* (series). 1975–76. 50.8 × 45.7 cm (20 × 18 in.). Color lithograph, printed in Cuba. Courtesy of Ricardo Viera.

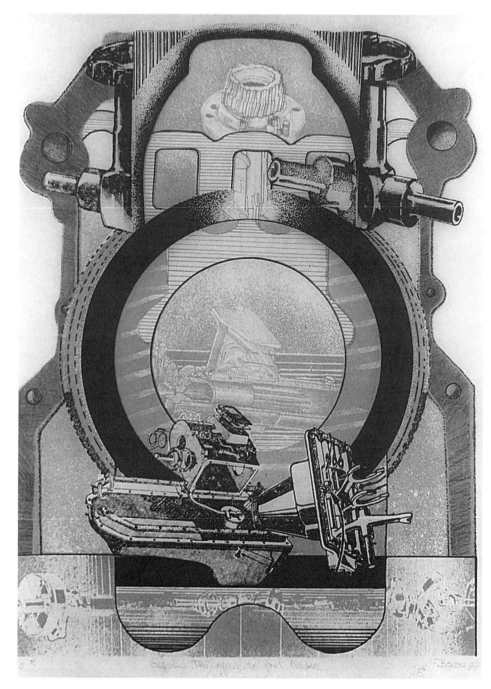

new ground in Afro-Caribbean religious iconography, not only from a historical point of view but from a very unique and strong aesthetic foundation, rarely acknowledged by the art world establishment. "The role of tradition and belief, of memory, family, and history in art is a touching subject today for a variety of valid political and theoretical reasons," asserted Lucy Lippard in *Mixed Blessings: New Art in a Multicultural America* (1990).

Boza's interpretation of the Afro-Cuban/Yoruba cosmos contains his own mystical and sensitive vocabulary. This vocabulary encompasses his childhood experiences as well as his mature artistic discourse and wisdom as an ordained Santería priest. "Super-realities, juxtapositions, real characters and fantasy—all of these Yoruba-Lucumbí, Palo Mayombe, and the Abakuá traditions compose the fundamental principles which reign over the creation of the exuberance of the great power of these sacred entities." [3]

The powers and energies of these earth forces through the orishas provide the inspiration and foundation of his work. Each orisha has power over certain forces. "It encompasses the idea of magic, the intangibles, and reaching the 'astral,' it mixes rites and revelations through contacts with the familiar ancestors who passed on to a better life." [4]

Afro-Cuban Santería is a religious system known for its inherited richness, symbolism, and rituals. "Like orisha worship in Nigeria, Santería is noted for its flexibility and lack of dogmatism, changes take place as they are needed or as they occur. Deities change character, adopt new traits, blend traits with those of the Catholic saints with which they are identified." [5]

The religious ceremonies encompass a ritual of songs and dance accompanied by sacred drums and other musical instruments as well as a rich variety of ritual paraphernalia and objects. They are used in numerous rites including celebrating initiation, birth, marriage, and burial. In short, the religion is a way of life, a cultural ideology. Because of the Yoruba divination system called Ifa, the level of performance and theatrical elements can easily be related to the established art terms: total environment, total art form.

Through the centuries, the theological and sociological phenomenon of Santería has been distilled and oppressed but not extinguished, to the point where individual freedom within has created its own visual language as well as an autonomy of creed and interpretation. This freedom, exemplified by artist-priest Juan Boza, has given the Latino artist and audience a fertile ground in which to develop and pursue a visual idiom of their own without being measured by European art history canons.

The unique aspect of Santería art is that, although the imagery and artistic concepts for installations are based on traditional iconography, the artist, especially in the case of Boza, does not hesitate to interpret the subject matter freely. There are

ritual prescriptions that must be followed. Details are dictated by the code or recognizable symbols and objects assigned to each orisha, such as color, food, and environmental settings. In essence, everything comes from nature and goes back to nature.

Usually misinterpreted, and controversial in some circles, is the decorative aspect, the "prettiness" that is often perceived by outsiders as "kitsch": store-bought items such as china, tureens, plastic flowers, and other decorative gadgets. Another element is the conscious taste for "primitivism" that opposes "prettiness" in relation to the ancestral tradition and uses objects such as handcrafted bowls and other utensils specially made for Santería.[6]

Boza orchestrated his installations as a theatrical performance of sorts with a very serious ceremonial intent. Each material element was carefully selected in order to reflect and represent a broad constituency, including multicultural idiosyncrasies, in particular those related to the orishas. He dealt with the obvious: everyday objects and familiar varieties of so-called fancy fabrics such as taffeta, tulle, metallic, and organza, as well as feathers, beads, and other altered or natural organic materials. Juxtapositions and contradictions of materials dictate not only the inventory and invention of certain textures and feelings, but a nonfamiliar aesthetic to some art history-minded people. Issues of inclusion, representation, and quality of religious ideology open doors not only to intellectual dialogues, but to visual acceptance where particular aesthetics are taken for granted. Therefore, this art form cannot be dismissed or judged separately because of its decorative qualities.

In the 1989 installation *The Sound of Waters*, Boza presents Olokun. "One of the many reincarnations of Yemayá, the Yoruba Lucumí, recognized as the mother of creation. She lives in a very particular marine environment, the sea itself covering the biggest part of the entire earth. . . . The mistress of the sea, she symbolizes death and life. She is better known as the universal mother of children of fishermen. . . . According to the Afro-Cuban tradition, Olokun represents the life of the planet earth"[7] (pl. 7). This well-balanced and attractive marine environment, although a busy composition, is made from an assortment of materials such as blue fabrics adorned with glitters and other metallic and nonmetallic textures that help the piece transcend its mere sculptural reality. The resourcefulness and single vision of Boza, in making this installation effective, are quite sensitive and inspirational. The structural materials vary from cellophane to garbage bags in order to suggest the illusion of water. By adding a myriad of manmade and organic objects, he created an underwater tableau that becomes alive and mesmerizing.

The two-dimensional works of Juan Boza—prints, drawings, and paintings (fig. 6.2, pls. 8, 9) have two main sources of inspiration: elements from symbols of the Cuban Abakuá (Leopard) secret society, and from *pataki* (narratives and leg-

FIGURE 6.2.

Juan Boza, *Eleguá*.
1986. 48.3 × 68.6 cm
(19 × 27 in.). Silk-
screen. Courtesy of
Ricardo Viera.

178

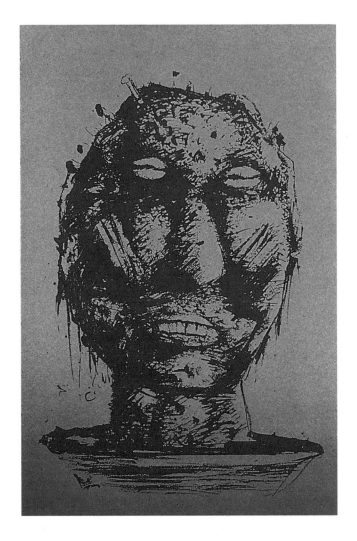

ends) or specific orisha portraits and interpretations. These works are a continuum of his installations. Although the mediums are quite different, the altars and the two-dimensional works share the same spirit, pictorial approach, and conceptual framework. They are confrontational and quite compelling, with a decorative edge, especially when the work is symbolic rather than narrative. This aspect balances the message Boza is trying to convey in each individual image.

Boza's work calls for further study. The influence of Santería in contemporary Latino art and, in essence, American art at large has given organized religion and individuals the freedom and autonomy to create their own visual language and interpretation that genuinely touches others.

JUAN BOZA:
INTERVIEW WITH
RICARDO VIERA

(ED. R. MORRIS)

The following 1986 interview contains significant excerpts from an in-depth conversation I had with Juan Boza for the Rutgers University *Outside Cuba/Fuera de Cuba* exhibition and book.[8] I was extremely fortunate to be a friend of this simple and kind human being. He was a powerful and spiritual man who was not afraid, with the help of his orishas, to reinvent himself over and over again.

V: Tell us about your beginnings as an artist.

B: I was born in Camagüey, Cuba. I painted from when I was ten years old. I was seventeen years old when the revolution came. In 1959 I received my first scholarship from Camagüey's mayor. There was an exhibition of artists called *Artistas del patio*, and the mayor saw my work and liked it so much that he gave me a scholarship to study at San Alejandro from 1960 to 1962. Meanwhile I was still participating in exhibitions outside school. This means that I had an academic life, but at the same time I kept painting at home.

I was influenced in the very beginning by Cuban professors such as Carlos Enrique and Wifredo Lam, who was the professor I first discovered when I started. Later, in 1962, they opened the Escuela Nacional de Arte, in Cubanacan, where I received another scholarship. By this time I was leaving behind Lam's influence on my work. I then met another painter called Matta who influenced my work a lot. While I was still a student, Matta used to travel to Cuba often and saw my work and liked my style very much.

In 1964 there was a student strike due to political reasons, and I was thrown out of school in Cubanacan. In 1965 I was basically on the streets, but I never stopped painting because I had always considered myself to be an artist. Learning and receiving an education was very important to me, but with my discipline and motivation I started to learn on my own.

I can say that 1964 was the period when I became a professional artist. I had already been in two different schools and was attending the school of graphics in Havana, where I studied lithography. That same year I was selected to be a member of La Union de Escritores y Artistas, and that is when my professional career began.

V: Were there repercussions to your career from being thrown out of school in Cubanacan?

B: No, because that happened in Cubanacan, and this new "school" was for professional artists and they had accepted me as a member. So the political issue did not affect me.

In 1967 I won the Casa de las Americas award, which was fundamentally a

Latin American award given mainly to artists that lived in Paris or other parts of Europe. Only a few Cuban artists have ever won this award, so out of luck or coincidence I sent in my work, the jury happened to like it, and I won. This even forced the people that had thrown me out of school to accept me as an artist.

I continued my professional career until 1967 when I started to work as a designer in the Coliseo Nacional de Cultura, which was what I did for a living in Cuba.

In 1970 there was an exhibition in El Palacio de Bellas Artes in Cuba, where many young artists exhibited things that were not normally accepted, such as erotic art or abstract, more daring, and contemporary work.

V: Would you say that these were to some extent copies of international artists' work?

B: I would not say exactly copies.

V: Influences then?

B: These were artists that wanted to keep up with what was going on outside of Cuba since they were able to obtain magazines about different foreign arts.

V: Were you already a member of La Union de Artistas?

B: Yes, I was already a member of La Union de Escritores y Artistas and was considered to be one of the young painters. I still have the newspaper clippings.

Going a little bit back, in 1967 I had my first personal exhibit at the Havana Gallery. I was a designer, but at the same time, between 1970 and 1971, I was basically an official painter because I was going to represent Cuba in Paris. Nevertheless, I was never given the chance to travel outside of Cuba, not even to socialist countries. I will never forget that I was supposed to go to Paris as a young artist and had to stay home with my ten-meter-long painting. This happened because of the creation of the Congreso de Educación y Cultura, which closed many doors to most of the young artists in Cuba. This organization started to fire actors, musicians, dancers, and painters. I was one of them. All of a sudden, without having done anything wrong, I was thrown out on the streets. I had no one outside of Cuba, but I always used to say to myself that I was going to leave.

V: You were thinking of leaving in 1970?

B: To be honest with you, I think that desire existed inside every person. I had so many opportunities to go abroad. For example, one time I was supposed to go to England, and I never knew what happened. Everything was ready, and after that they never said anything else. It was like that in many other situations. The only

thing I was able to do was to send my work to different countries, places like Tokyo, Norway, and Italy. Cuba participated in a lot of artistic events, but would only send the artwork and not the artist. The worst part was that they had to send someone with the artwork, so they sent really bad painters from State Security or a simple politician who knew nothing about art. All those things made me feel that I couldn't take it anymore. One has a certain dignity as a human being, and there is only so much one can take.

V: You lived through a transition. You supported yourself, you survived, you painted, and you worked.

B: Well, spiritually speaking I had an awful time and experience.

V: But as far as your work and maintenance as an artist went?

B: I continued to paint, but I have to tell you that as an artist I felt as if I was dead, especially mentally. I used to tell myself that I would never make it intellectually as an artist because of the circumstances I lived in.

V: What kind of artwork did you do back then?

B: At that point in Cuba my work could have been described as "science fiction," which has nothing to do with what I am doing now. In fact it is the opposite of what I am currently doing. What I am doing now is what I started to work on at the very beginning of my career in Cuba but that I could not develop. During those early years I painted and restored religious images in order to survive. That is what I used to do.

V: Let's talk about when you arrived in the United States. What happened?

B: One of the first things that happened was the impact or the uncertainty of not knowing if I was going to be Juan Boza again. When I arrived in the United States, I still worked with "science fiction," but I did not like it, it did not make me feel good. I had very bad experiences during this transition.

V: Was that work published in a magazine?

B: Yes. That was what I used to do in Cuba. As paintings I liked them, but I needed something more. So I started looking at all the exhibits I could possibly see. I had to work and do something to support myself, but at the same time I needed to find a message in my work. Without knowing when or how, I started drawing little pictures, and came up with what I used to do in Cuba during the 1960s. They were pictures with a Cuban theme, especially an Afro-Cuban theme.

V: When the revolution started, Santería began to vanish. Nevertheless, Santería, especially the Afro-Cuban themes, has been an influence on you since you were a child. Can you elaborate on this a little?

B: Certainly. I was born in a town near the plaza of Bedolla that was very famous for its carnivals. I lived integrated into that way of life, but I always wanted to study and make something of my life. The only thing that people did around me was to play the *tambor* all day long. I remember I used to go to bed listening to them playing and woke up in the morning still hearing them playing. It got to the point where I started to hate them, because I was not realizing that it was all a part of my life and my culture.

Even at my house, my mother used to have images of Santa Barbara and San Lázaro. Meanwhile, I liked to listen to classical music. My brothers used to say that it was music for the dead, and turn the radio off. Apparently there was a conflict between the environment where I was born and my ideas.

V: In other words, you are saying that you were born in an environment where you were totally different from the very beginning. You were very curious and interested in anything that involved an element of art.

B: Yes, but without noticing it, all these influences were inside of me. The painting that I made in 1960, when I received a scholarship to study at San Alejandro, was a painting of Santería. It was called *La Lucumiguera*, who was a woman that used to live next to my house in Camagüey. She used to have Santería gatherings at her house and wanted me to become a part of it and to make me a priest or *santero*. She used to tell me that I was the son of Ogún. This woman looked like a slave. She was extremely dark, with beautiful facial features. I will never forget her because when I was a boy I used to eat all the food and candies she offered to the statue of Ogún. Since I was a little boy, I did not know what it meant, so I just ate everything without her noticing it until she caught me one day.

I have always thought that painters should reflect their lives, culture, and idiosyncrasies through their work, and without noticing it I started to do this. Because regardless of who I am now, that is where I come from. Believing this I started looking for visual information about Santería back in Cuba, but could not find anything that exactly resembled what I used to see in Cuba when I was a little boy.

V: I want you to make a synthesis of your life after you were made a *santero,* right after you were completely integrated into the religion. You were still an artist, and you said that the separation of your faith and the aesthetic did not exist because to a certain extent your life was a miracle. You told me that the circumstances back in

Cuba were so difficult that you even thought about committing suicide if you were not able to leave. So you survived through faith, but at the same time you were trained as an artist.

B: What I wanted to tell you is a very curious thing that happened to me. I had made a human-scale doll for an exhibit long before I was initiated into the religion and became a *santero*. You know how *santeros* have many different dolls in their houses. I found a used wedding dress and painted it, and exhibited it two or three different times. During the ceremony when I became a *santero*, one person, whom I did not even know, said that the ceremony could not proceed because there was a spirit of a woman wearing a wedding dress that was claiming something. So he asked me if I had a doll in my house. At this point I did not even remember about the doll. Then I remembered and told him that in fact I did have a doll at my house dressed in a wedding gown, but that it was not a Santería doll, it was for an exhibition. Anyway, we had to build an altar for this doll because it was a spirit within my domain. I had made that doll two years before and did not know that it was going to be a part of my religious life. We made the altar, otherwise the ceremony could not proceed. Nobody at the ceremony knew about me or about the existence of this doll. Now, when these people look at my paintings, they see something more than just the paintings and treat them as if there were saints inside of them. I do not know to what extent this is real.

183

V: Well, there is a point where it really does not matter. There is so much to explore, and interpret through these things.

B: Yes, but not many people have touched this theme. You know how in Cuba people used to say that Lam, whom I respect greatly, was the Afro-Cuban artist. Well, when I came here I realized that what he used to do in reality was African art and not Afro-Cuban art. Lam's coloration had nothing to do with Cuba. What he made were those really dark African sculptures.

V: You have to remember that, due to influences and the environment, Lam interpreted things in a universal way. Nowadays you have the opportunity to look at things in two different perspectives. He knew what was going on, but he did it in such a way that he could penetrate a universal way of thinking using himself. Many other modernists used African art this way.

B: Yes, but Afro-Cuban art has nothing to do with that. The only similarity is in the colors, and by the end he even forgot that there were colors in Cuba.

V: What he uses are the typical Italian palette. For the last fifteen years he used

browns and greens in the Elegguás he used to paint.

B: The Elegguás are some of the few elements in his work that remind me of Cuba. Because all those triangles were the shields and arrows used in Africa. I respect him a lot as a painter, and I wish I could buy one of his paintings; but when I looked at Santería from another perspective I started to recognize what the real Afro-Cuban elements were, and when I looked for them in Lam's work I did not find them. That is what I am referring to.

JUAN BOZA
BY RANDALL MORRIS

These are strange times. These are times when politics and economics make war on the spirit. It is a ridiculous battle of course. Spirit always manifests itself and perseveres. The spoils of a spiritual war are survival and metamorphosis. The losers are doomed to the harrowing, hollow echoing of their cultureless voices.

Therein is the crux. There is the first secret of power; spirit is always a voice of culture. It is nothing if not the underlying story of Africa, Latin America, and the Caribbean. Every generation has its seers. Every culture has those who work in two worlds. Juan Boza was one of those people. To work the world multidimensionally is a shamanistic vision. To be activated it must be understood. In order to persevere in a shamanistic vision, something must die and the soul must survive. Belief is never the question. Art becomes the medium of belief. The shaman travels into the Otherworld, giving up forever a sense of secular normality in order to retrieve information that will enrich culture. To travel multidimensionally, artist-priests attempt an even further manifestation, that of communicating the vision visually.

Juan Boza was an artist-priest. His altars and *tronos* spanned the Hudson River, the Caribbean, and ultimately culture itself. It is not enough merely to throw the correct configuration of objects together to take on the cloak of "artist." The world must be rebuilt each time. Lives must be reconstructed. It is chthonically wrapped in the concept of style and stylization. In the case of a *santero*, this makes sense for if we reach back to the original purpose of art, we will find the muse coming from that deeper place—the vortex of ancestry where nature and healing roll seamlessly on nonlinear points of endless power.

It is a paradox that no matter how conservative the form, one who makes spiritual art in contemporary society is somehow automatically on the edge. The irony is that sometimes the exercise of expressing the spirit distracts the artist from developing unique form. The genius of Bedia (a Cuban artist who draws upon and expands the meanings of Congo and Palo Monte religion), for example, is that he, like Boza, absorbs the universe and sprays it into his own forms, imbues it with his own spiritual style, a sign of a religion that continues to evolve and allows for innovation. He holds up a mirror to recycle the vision of society and comes out pleasing the spirit and the spirits.

Boza's challenge to himself was to find a style at once spiritual, universal, and ultimately Cuban. For his generation, the main artist who had attempted to use the orishas in art was Wifredo Lam. Anyone who wants to make Santería art in Cuba must deal with Wifredo Lam the same way one cannot advance ideas on the saxophone without encountering John Coltrane. Boza felt Lam tried to seek or express African ideas in European colors and trappings. But it is common knowledge that the modernist style had a problem with Caribbean syncopation and the colors of creolization. Lam had Africa, Lam had Paris, Lam had Lam; but Boza did not feel that Lam really had Cuba, and from this his creative path became known to him.

A major problem for all cultural artists is to enlarge, to be possessed by the call to universality in the work, and yet to develop a language that is informed by place and/or culture *and* to define one's imprint on the art world at large. The orishas don't play to Soho; they manifest and fluctuate in a slipstream described but not controlled by mankind. We dress them in the clothes we wear as a way of recognition, but in the heat of exaltation the vestments and accessories fall away and there remains only the restless energy of controlled power itself.

A cultural artist must choose to be one unless he or she is self-taught. Self-taught artists usually work from a vision unspoiled by academia, thus it is more common to find them reflecting their cultures. A trained artist must fight to regain the perspective of pure vision. The artist-priest must play to the world of the gallery and not lose authenticity in the temple. Secrets must be intimated; they must be intuited by the art audience who will reject them if they are too hermetically sealed or who will seek to place them in the context of the existing art agenda. The artist is always balanced between the secrets and the critics.

Boza was always wonderfully aware of the peripatetic nature of creolization. In his choices of materials he welcomed chances to use the nontraditional and the improvisatory. As we read altars and *tronos*, we learn that they are infinitely open to new interpretations, by both their makers and their viewers. Juan Boza was conscious of his role as a cultural language maker; that each piece he did, each altar he constructed, was a deliberate act of syncretization; that he was making and advancing a visual Cuban spiritual language: "During my childhood I learned to understand many of the different cultures that can be found in Cuba. My interpretations of these philosophies and a background of the 'old' together with the new universal influences are the fundamentals of my aesthetics and visual creation."[9]

He was aware that a dispossessed persona could be regrouped by contemplation and involvement with both secular and spiritual ancestry, and that one can hybridize oneself by reexploring the past, entering the doorways one may never have chosen previously to enter, chanting and finally understanding the songs one heard before. His sense of personality after Mariel was being restructured from memory; he thought

of the rites to the sun like it was done in ancient Egypt, to the moon, to the ocean, to rivers, and to the two waters, Ochún and Yemayá, where the river becomes one with the ocean. . . . The music as a common language, that made those who have been to heaven tremble and changed their consciousnesses to harmonious ones. The prophetic songs of the orishas, who sang until the voices disappeared and resurrected as circles of spatial ashes. Also, the popular, the rhumba in burning figures, the stories of *chicherikun*, a black child that appeared in the rivers, and the snakes and water that used to come out of turbulent rivers. The ceremonies to revive and attract the souls of infinite light in direct communication with all dimensions in a subjective narrative. Also the offerings of food, beverages, flowers, and everything that the dead family members used to like." [10]

186

The voyage may start as personal memory, but a brush with the orishas takes it further, takes it deeper into the arms of a people who are conscious of the importance of memory: preadolescence, prebirth, prehistoric.

Boza's death is a hard-to-understand death. There are cultures that believe in and forgive a gifted man's early demise. He becomes elevated to the status of cultural hero. But these same cultures also revere the aged teacher. There is no obvious reason why Boza was taken away. Being an artist is more than difficult in this country; being an artist who makes spiritual work is adding razor blades to the bath; and being an artist of color or an immigrant or refugee or all of these is a wet, warm invitation to hell in the North American art world. Boza escaped persecution, he escaped anonymity, but he did not escape the limitations of his own flesh—an irony that will never sit comfortably in the hearts of friends and admirers. His self-awareness was growing; his career was poised on an important brink.

How hard it is to understand that we live in a world of multiple perspectives. That the orishas inhabit Manhattan and Miami, Los Angeles and Kansas City. That the Hudson is as much La Sirene's and Yemayá's as the Caribbean is, that once diaspora begins, it never ends. Diaspora—whether begun as slavery, escape, or wanderlust—is the secret machine that guides the future of the world. Diaspora is the raven that Noah sent out to test the world and who never returned. Diaspora is the birthing ground of new art and art forms.

Juan Boza was in full possession of the true marks of the artist-priest: a sense of compressed compassion and irony that the seer wears like a velvet cloak. There are people who straddle two paths with their art: the one in which the material objects are merely reflective vessels for the power points of the spirits, and the other in which the work is contemplated aesthetically and sometimes spiritually by a general audience. It almost doesn't matter how aware the artist is of the second point as long as he or she remains permanently tuned to the first. To be intellectually, spiritually,

and emotionally aware of both paths and to remain authentic is a great challenge, one that Boza was absolutely well aware of.

Because of the timing of his death he becomes in our memories and in the light of later developments a tragic but heroic pioneer. The issues he confronted are still the driving issues of the field. Many will see Boza's footprints on the paths they are forging for years to come. There are still important articles to be written about his work itself, such as an examination of his reworking of everyday materials to define his viewpoints and his deliberate handling of hot mythopoetry itself in such a way as to rework the ways in which his own people first, and we as admirers second, would be allowed entry into the world of the orishas.

187

NOTES

1. Juan Boza, excerpt from interview with Ricardo Viera, 1986, *Outside Cuba/Fuera de Cuba* project.

2. Ileana Fuentes, *AHA News*, New York (April 1991).

3. Artist statement, *Cuba–USA: The First Generation*, exhibition catalogue (Washington, D.C.: Fondo del Sol, 1991–92), 53.

4. Ibid.

5. Robin Poyner, *Thunder over Miami: Ritual Objects of Nigerian and Afro-Cuban Religion*, exhibition catalogue (Miami: University of Florida, Center for African Studies, 1982), n.p.

6. Ibid.

7. David S. Rubin, introduction (from commentary by artist), *Contemporary Hispanic Shrine*, exhibition catalogue, Freedman Gallery (Reading, Penn., 1989).

8. The interview was translated from the Spanish by R. Viera with the assistance of Marilyn Rivera, then an intern at the Lehigh University Art Galleries.

9. Juan Boza, Final Statement, January 1991 (trans. R. Viera, ed. R. Morris).

10. Ibid.

MARY JANE JACOB

ASHÉ IN THE ART OF ANA MENDIETA

7

Ana Mendieta was an artist of her time. Born in 1948 in Havana, she died tragically at age thirty-seven in New York. As a student and an artist of the 1970s, she both learned from and contributed to this era of flux. A period in which there was license to explore multiple, avant-garde avenues of artmaking, this decade saw the development of personal, autobiographical forms expressed through the new genre of body art, performance, installation, and video. "Earth art," too, was a major force in defining the decade, joining these forms that took the practice of artmaking outside the traditional studio and did much to establish temporary and collaborative ways of working. The number of women on the scene also increased dramatically, thanks in part to the feminist movement; and it was with these exploratory media, unencumbered by a history dominated by male predecessors, that women artists made their greatest individual strides and have left their most lasting mark on contemporary art history. For those of other cultural groups, who had also been excluded from the mainstream of the art world, it was the beginning of the fight for representation that was more fully and effectively expressed in the multiculturalism of the late 1980s.

Influenced by these directions, Mendieta created her own style of body art and earth art that she called "earth-body sculptures" and are now known as her "Silueta" series (see pl. 10). These were her hybrid contribution to this decade of redefining art and her means of giving visual and tangible form to ideas that she found could not be sufficiently conveyed in painting. Like many of her contemporaries, she sought a medium that more closely resembled life than art.[1] Also, executing installation works or

investigating how video and photography could be both a document of an ephemeral piece and a work of art in itself, she was responsive to the most advanced aesthetic and intellectual ideas of her time. This was a moment of rapid change, experimentation, and excitement. Many of the young artists and critics who went on to become the most significant thinkers of the time visited the University of Iowa while she was attending. For Mendieta, who began working in an independent way in 1972 while still in school, her change of status from student to artist was imperceptible as she herself became an influencing force.

Most important, Mendieta found these new ways of working to be articulate modes for expressing her life's story and universalizing it. While many texts refer to her relation to the art world of the 1970s and acknowledge her Cuban heritage, the substantial body of work created by this vigorous innovator in only thirteen years has not been fully explored within its cultural context. This chapter focuses on one such subject key to her development as an artist, her interest in Santería.

Santería was a source of inspiration for Mendieta. In its precepts she found the basis for building a conceptual framework for her art that could contain her artistic, feminist, political, and cultural ideas. It was a means through which she could also express her relationship to Cuba, nature, and the spiritual realm. While the religion of Santería constituted a way of life for many in her native land, for Mendieta it was the primary route by which she reached her artistic goal. Although Santería, through the Cuban migration, is practiced in New York and Miami, and Mendieta came into contact with it in the United States, it is its identification with Cuba that was most important to her.

The impact of Santería on Cuban culture and society is reflected in the writings of Cuban author Lydia Cabrera, whose works Mendieta had in her library.[2] Cabrera's contribution was never fully appreciated because her subject—the culture of African descendants in Cuba—was considered to be marginal, and because her own nationality and gender were limiting in professional circles. But for Mendieta, Cabrera's writings were an important source of information on the Cuban world of Santería. Moreover, she could personally identify with Cabrera as an accomplished Cuban woman who, while studying and living in Paris (1927–38), took up in her work the subject of her heritage: "the world of her childhood, a world dominated by the inventions of Black nannies, cooks and seamstresses."[3] Also, like the artist, Cabrera was an exile of Castro's regime, having been forced to leave Cuba in 1960 just one year before Mendieta herself.

But long before her readings of Cabrera and rediscovery of her homeland through visits to Cuba beginning in 1980, Mendieta knew of Santería. She first heard its mysterious stories in her parents' household from the servants, African-Cubans and Santería believers. *Tatas*, or nannies, were well-known storytellers of

Santería lore and were often thought to have healing powers themselves. Mendieta spent afternoons in the kitchen or the servants' quarters listening to tales of the orishas, their powers, magic, and spells.[4] For many middle-class whites, Santería was a kind of children's culture, populated by spirits and boogeymen, which is how members of the famous Abakuá male society (derived from the African leopard society, Ngbe, of the Ejagham people and popularly called Ñañigo) were known to children because of their sacrificial practices conducted in strict secrecy. This world was highly fascinating to the artist as a child.

Mendieta reestablished contact with Santería in the 1970s, in part out of personal nostalgia and in part as a means of binding herself in a deeper and more thoughtful way to her ancestors and ancestral land. Santería also taught Mendieta that the earth is a living thing from which one gains power. Each orisha is identified with a force of nature. Nature is a manifestation of the gods, and through nature an individual has direct contact with the god. Mendieta came to understand this: "Now I believe in water, air and earth. They are all deities."[5] In this religion Mendieta found affirmation of the holistic belief in the harmony of the universe and came to base her art on "the belief in one Universal Energy which runs through all being and matter, all space and time."[6]

Santería also found a place in Mendieta's growing feminist consciousness of the early 1970s. She identified not only with women as an oppressed minority, but, being Cuban, she understood what it meant to be relegated to the category of disenfranchised peoples of the Third World. Yet, in some Third World cultures, there are female deities, and vestiges of matriarchal systems endure, sometimes even in ironic counterpoint to machismo and other male-dominated realities. This was the case in Cuban Santería culture in which there are male and female orishas, with some gods having both male and female aspects. *Santeros* (priests) have their counterpart in *santeras* (priestesses), and while some rituals are restricted to men, others are dominated by women. In this respect Santería departs significantly from Catholicism, the faith in which Mendieta was raised in Cuba and immersed upon her arrival in the United States when her parents sent her to be raised by nuns in Iowa. Hundreds of Cuban children at that time became subject to the Catholic Church's program to save children of the counter-revolution from communism by placing them in U.S. orphanages and foster homes. Thus her interest in Santería may even be viewed as a protest against the restraints of Catholic doctrine, particularly its attitudes toward women, sexuality, and the female body, as well as an act of rebellion against this western faith that had caused an irresolvable rupture in her family.

Shifting from the heavenly force that dominates Catholicism to an earth-centered Santería, Mendieta found a Cuban example with a relation to the goddess cult that she and other feminist artists turned to in the 1970s. They hoped to find in

these matriarchal precedents a celebration of the woman and of female, birth-giving sexuality, historical continuity with the past, and a renewed sense of power in the present. Mendieta's interest in archaeology brought her in touch with ancient cultures in which women had a place and power.[7] She was aware of the great goddess of prehistory who claimed fertility as her prime attribute. This life-giving force formed the basis for religious beliefs in regenerative cycles and, as a corollary to her role as nurturer, she was endowed with healing powers. The earth was the womb: Mother Nature. Mendieta believed these religions, like Santería, had "an inner knowledge, a closeness to natural resources. And it is this knowledge which gives a reality to the images they have created."[8] It is this sense of reality that she wanted to give to her art.

The loss of the matriarchal establishment to patriarchy[9] and the deposing of the goddess led to a change of attitude toward the female body and its powers, upset the balance between human beings and nature, and brought about a new sense of the "natural" relationship between men and women. The devastating effects of these changes can be found in such catastrophic events as the death of millions of women branded as witches or our present-day ecological crisis fueled by a disrespect for nature. The centuries-old male hierarchy has, especially in the West, implicitly meant domination over the earth and over women to the point of taking away women's ownership and control of their own bodies. This attitude has led to the rape of both land and the female body to the detriment of society as a whole. Feminists, and particularly women artists of the 1970s, searched out the goddess as a means of empowerment. Mendieta made her art in union with the earth in order to come in touch with the spirit of the goddess, to give women back their bodies, and to give them power.

As time went on, Mendieta's work took on the image of the goddess, moving away from the use of her own body in performances or her likeness in the *siluetas* to more generalized and archetypal figures recalling those of prehistoric times. Making art became a spiritual act, an act of magic. She was the conduit, the shaman, like the *olorisha* or one possessed who "has" the orisha. In making her earth-body sculptures, she enacted her own rituals, usually working alone to prepare the land, claim the territory, and make it sacred. But even before these signature works, Mendieta staged rituals inspired by Santería.

The rituals of Santería are intended to reinforce and strengthen the orisha while bestowing *ashé* on the believer. *Ashé* is power, divine power, the grace of god, the life force of god. Orishas are also the personification of *ashé*. In achieving a state of one with the god, that is, becoming possessed during a ritual by the orisha, one receives *ashé*. Blood has *ashé*. Blood also contains the potentiality of life and is a symbol of life. When an animal is sacrificed in a Santería ritual, the orisha's *ashé* is

strengthened by sprinkling its blood on the symbolic objects or sacred stones of the orisha. Blood on the head of the devotee purifies and bestows power. In 1972 Mendieta enacted *Bird Transformation* at Old Man's Creek, Iowa, in which she became the sacrificial rooster by rubbing herself with blood and then rolling in white chicken feathers. Particularly related to this art performance-ritual is the *plante* (initiation rites) of the Abakuá cult during which a white rooster is sacrificed; the initiate then parades with the animal's head in his mouth, letting the blood drip. (The rituals of this sect were evoked again in 1976 in *Burial of the Ñañigo*, a work in which her silhouette is described by candles.) In a related filmwork, Mendieta appeared naked holding a beheaded chicken that spattered blood on her as an act of cleansing rather than defiling.

Mendieta continued in 1973 the ritualistic use of blood in a contemporary, unholy sacrifice, a series of rape performance works. In these chilling *tableaux vivants*, staged in both her apartment and the plausible outdoor location of a secluded wood, a half-naked and bloodied Mendieta showed herself to an unsuspecting audience as if assaulted and raped. These works, made as feminist statements of protest, graphically depicted the horror and brutality of this everyday occurrence which is so ineffectively addressed by the police and legal system. Mendieta was not alone in expressing her outrage through such works and especially in finding the direct, confrontational, real-life quality of performance to be an appropriate vehicle. Women's rituals of the 1970s, in art and society-at-large, were attempts to build a feminist culture in which the mythic and universal were binding and transcended the personal and autobiographical.[10] In her reenactments of blood spilled in violence, she also understood the greater significance of this image: "I started immediately using blood, I guess because I think it's a very powerful magic thing. I don't see it as a negative force."[11] In these works Mendieta began to invest the image of blood with an ancient meaning and its more positive interpretation in Santería as the essence of life. Through Santería she recognized the capacity of blood to purify and empower. For Mendieta, too, these rape works were a means of personal and cultural exorcism of this brutal act. With these works she aimed to give women *ashé*, empowering them to regain control of their bodies.

In the November 1973 filmwork *Sweating Blood*, simulated blood dripped slowly from Mendieta's scalp down her forehead while the camera focused on her face, eyes shut in a trancelike state as if possessed. In other works, such as *Body Tracks* (1974), she used blood as a spiritual and primal ink for the making of marks, symbolic gestures.[12] Far from Yves Klein's use ten years earlier of the female body as a "living brush," a dehumanized and easily manipulated marker, Mendieta used her body to reaffirm the presence, place, and power of women. In December 1974 she lay immobile, arms slightly outstretched, bloodied under a sheet. Photographed

from above from the position of the feet, she is the victim in the police morgue, but also the dead Christ. This covering, and that of the mummy wrappings of her body in 1975, gave a sense of protection and evoked the healing side of Santería that is also an aspect of the ancient goddess. The more transcendent and spiritual state of these images was reaffirmed in July 1976 when, in a niche at the Cuilapan Monastery in Mexico, she hung a white sheet bearing her full body print in blood; a ceremonial arc of branches is nestled at her feet below this holy shroud. From that time forward, transcendent life forces pervaded all of Mendieta's work.

Blood and earth both give *ashé*. Mendieta subscribed to Santería's belief that blood carries life through all of nature, spirit, and matter. In nature goddess cults and Santería, blood is an aspect of both life and death, flowing through a never-ending, regenerative birth cycle. Images of women have been associated with the regenerative power of nature since prehistoric times. We are born of earth, buried in the earth, and reborn in the body of the mother: earth. This never-ending regeneration of life was key for Mendieta from the beginning of her *siluetas*. Of this life-giving female force, Mendieta said: "My works are the irrigation veins of this universal fluid. Through them ascend the ancestral sap, the original beliefs, the primordial accumulations, the unconscious thoughts that animate the world."[13] Frida Kahlo, an artist whom Mendieta admired, had also depicted blood as the replenishing, nurturant fluid of life in her painting *Roots* of 1943. In this work Kahlo connected human life and the living earth. Here she transcends self to become the universal woman as the embodiment of nature's life cycles. From her womb, nature grows as her blood courses through the veins of the leaves that sprout from within and into a root system beyond. Kahlo is situated in a stark Mexican landscape, since she, like Mendieta in her earth-body sculptures, used her art to establish her roots to her homeland.

Her interest in Kahlo and Mendieta's frequent trips to Mexico served as a surrogate in satisfying her desire to reestablish contact with her place of origin.[14] While her earliest attempts at earth-body sculpture took place in Iowa in 1972 when she had her naked body covered with newly mown grass, her first major work of this genre was *El Yaagul* (1973), created in Mexico in the Valley of Oaxaca. There she lay covered with white flowers in an ancient Zapotec stone grave. The overgrown site and the contrast of the fresh flowers gave the sense of new life sprung from the dead, literally from her body. The culture of Mexico, foreign yet accessible, which she came to know through nearly annual summer visits in the 1970s, afforded her the atmosphere in which to give her ideas form. There she made numerous ephemeral works at archaeological and other sites. But Mexico was more a spiritual than geographic location for Mendieta that brought her closer to her origins and fulfilled

a personal and artistic need in advance of her return to Cuba. "Plugging into Mexico was like going back to the source, being able to get some magic just by being there," she said.[15]

Like blood, nature embodies the gods. When Mendieta created her works in union with the earth, she partook of *ashé*. This use of her own body or its form in her extensive *Silueta* series reestablished a bond with nature as her image, in person or in effigy, underwent a ritual birth-death-rebirth in the life-affirming act that *was* her art. These earth-body sculptures were both individual, in the way that many women used autobiography as a feminist art genre, and transcendent of the self. They were also her way of making the gods and idols she had at first rendered in paintings take on the power she wished them to embody and for them "to be magic."[16] Through Santería, Mendieta understood that power must come from the spiritual realm; she learned that she "had to go to the source of life, to mother earth," the place of the orishas.[17]

In Santería there are sacred trees associated with orishas; spirits live in the woods, and the forest is the fertile womb of the earth. Like the Minoan snake goddess, others hold a tree of life in both hands, also serving as symbols of regeneration and rebirth in this gesture of blessing. Mendieta becomes the tree of life in *Arbol de la Vida* of 1977 (pl. 11). Woman and tree at once, she is the personification of the orisha; her hands are raised in a gesture of benediction or homage. To unify her body visually with the tree trunk, she bathed herself in mud. In Miami in 1981 she executed a work at a *ceiba* (silk-cotton tree) considered sacred by Santería believers. Participating along with others who came to make offerings there, she undertook an ultimate act of life as art. Mendieta made a figure on the trunk using human hair from barber shops in the Cuban district. In turn, art became life as her image was venerated by visitors. In other works she applied her silhouette in mud, flowers, cloth, moss, or burned in with gunpowder to the fallen trunks to create trees of life. This same motivation led to the more stylized, archetypal images carved and burnt with gunpowder into wood slabs or cut tree trunks, which were among her last works.

Of the major deities of Santería, Yemayá was especially important to Mendieta. She is the symbol of womanhood and maternity; she protects women. Her realm is the sea; she is associated with the moon and is syncretized with Our Lady of Regla (a manifestation of the Virgin Mary for a region in Cuba). Mendieta created at least five versions of Yemayá in her most powerful aspect as goddess of the depths of the ocean in *Incantations to Olokun-Yemayá*. In these she arranged lines drawn into the earth or made of planted grass around a silhouette inscribed within a tomblike or sacred, rectangular demarcation. In one version the carved-out image of the body was

195

filled with white flowers (flowers are sunk in the sea in a container in some rituals honoring Yemayá), echoing Mendieta's first major *silueta, El Yaagul.* In 1975 she created a silhouette in white flowers on a red velvet-covered raft which she set afloat in an Iowa river.[18] In other works, flowers were used to simultaneously create the figure and be an offering. In the material of her works, Mendieta seemed to present these works in the manner of a devotee bearing an offering to the orisha. And since in her works Mendieta was both maker and image, using her body to evoke the goddess, she became like the Santería believer possessed by the spirit of the deity.

In recapturing spirits close to her own origins, Mendieta also turned to Ix Chel, a Mayan deity considered to be Our Mother, the mother of the gods and the patron saint of women and goddess of childbirth. She is a parallel figure to Yemayá and the Virgin, and, like Yemayá, is associated with the waters. In a series of at least six transformations, from December 1976 to April 1977, Mendieta made the mummified image of the black Ix Chel. At first she placed the image within an inscribed sacred zone; then she defined the space with a white sheet on which hands or hands and arms were printed in a manner reminiscent of her *Body Tracks,* but more stylized and symbolic; finally, she made delineations in purple bands on the figure, using sacred signs including images of hands and arms.

Hands were an important part of Mendieta's imagery. Her silhouette is often seen with arms bent and hands raised in prayer, homage, invocation, or blessing. Mendieta believed that her energy went through her hands. She was fascinated by

FIGURE 7.1.

Ana Mendieta, *Silueta Works in Mexico.* 1973–77, 34.9 × 50.8 cm (13¼ × 20 in.). Courtesy of the Estate of Ana Mendieta and Galerie Lelong, New York.

the fact that each person's hand is unique, and she felt that one's whole destiny is in the palm of one's hand.[19] In May 1977 Mendieta drew an enormous hand on the earth as the sacred space for a figure of Yemayá (fig. 7.1). In her sketchbook of 1976–78, she drew the outline of her own hand indicating the lines of her palm. And in 1977 she had a branding iron made in the shape of her hand, which she used to burn her silhouette into the grass.

Anaforuana are the signs used by the Abakuá society to make a spot sacred. Mendieta used these devices when she designated the zone for Olokun-Yemayá, working in a manner that made reference to *ñañigo* ground-scripts (mystic ground drawings). Death is known through visual idioms, and these symbols are used to bring back the spirit of deceased ancestors. In a 1977 silhouette from what has been called her *Fetish* series, Mendieta drew in blood symbols similar to those of Santería funerary body painting and earth drawings at funeral ceremonies. At death the body is marked with an arrow pointing to the head to indicate the upward passage of life to the other world. This is called the *erikua* or arrow of farewell. (For the initiate, they are drawn on the body in chalk and point down to indicate the descent of life from the gods above.) Also that same summer she incised hands and body shapes atop rectangular clay beds. While not specifically linked to Santería inscriptions, this *Tomb* series continued her interest in mystic writings and Mexican votive forms, while drawing upon such diverse sources as Indian effigy burial mounds and medieval European effigy tombs.

Some of Mendieta's materials can also be linked to Santería. Gunpowder, which she intuitively began to use to burn her silhouette into the earth, trees, or rock, is employed in Santería rituals to make mystic ground drawings and summon the spirits. Fire, which is a regenerative element that both destroys and gives birth, was used by Mendieta as a mysterious, living element to create a sense of drama and emotional energy approximating that of religious ceremonies. The most important of these works is *Anima* (Soul) made in 1976 of fireworks. In Santería shells are used as divination systems; one of the emblems of Yemayá is seashells. Mendieta made female images in shells. For silhouettes made of cloth, sand, mud, flowers, and tree limbs, she often found a siting near the water's edge to be desirable. Water has a special meaning in Santería: rivers are one of the places where orishas live, and the sea is the domain of Yemayá. Moreover, water is the place from which life springs, the primordial element from which life emerges. Thus the meeting of land and water was an especially potent location for Mendieta to make her art. There the body form would also be eroded and washed away, returning to the earth and sea to be reborn. In such work, during the summer of 1976, Mendieta drew a figure in the sand and then filled her form with red flowers; in another, she created the negative form of a woman and placed red pigment in the cavity. In both cases the color was a reminder

198

of blood, which, like water, brings forth life; in both cases the image and color are washed away. As another influence on her use of water, Mendieta recalled an image from her childhood. She and her cousins had covered their bodies with sand on the beach at her grandmother's house—a connection to Cuba where, unlike her adopted inland home in Iowa, the sea played an important part in daily life.[20] When returning from her first trip back to Cuba, she brought with her some earth from Cuba and sand from Varadero, the place of her grandmother's house. Just before the end of her life she made a series of floor works in the image of the goddess, using mud and sand with binder to make permanent the type of materials she believed served a spiritual purpose.

By 1975 Mendieta had replaced the image of her body with elements from nature arranged in the shape of her own silhouette. The greater formal and conceptual possibilities this offered her is evident from the enormous number of images she made in the years that followed. By 1978 the *siluetas* began to give way to a more universal and timeless form that became her primary image. While still situated in nature, these prehistoric or ancient goddesslike forms were often carved in rock, incised in clay beds, or molded from mud, thus taking on a new, pronounced linearity. Internal markings, such as those derived from funerary body painting, gave way to stylized, abstracted shapes and lines, either of her own invention or ancient universal symbols, such as the labyrinth, associated with female fertility, rebirth, and the sacred space of the goddess. Their flat design quality and material allowed for her transition to the floor works of sand and earth in the early 1980s, while the *siluetas* endured in the tree trunk sculptures of her final years.

As Ana Mendieta moved from her personal associations with Santería to its universal implications, so too her art moved from the use of her body to more generalized archetypes. Mendieta made art in an attempt to effect change: "Art is a material part of culture but its greatest value is its spiritual role, and that influences society, because it's the greatest contribution to the intellectual and moral development of humanity that can be made."[21] She wished through her art, on a personal level, to identify with Cuba and to understand her own femaleness and spirituality. With her move toward universal forms, she also strengthened her interest in seeking to change society's relation to women and nature. Santería rituals take place so that the believer might obtain *ashé*; Ana Mendieta made art to get *ashé* and to give *ashé* to other women.

NOTES

1. "By using my self-image in my art, I am confronting the ever-present art and life dichotomy. It is crucial for me to be part of all my works. As a result of my participation, my vision becomes a reality and part of my experiences." Nancy Lynn Harris, "The Female Imagery of Mary Beth Edelson and Ana Mendieta," M.F.A. thesis (Louisiana State University, Baton Rouge, 1978), 55.

2. Petra Barreras del Rio, "Ana Mendieta: A Historical Overview," in *Ana Mendieta: A Retrospective* (New York: The New Museum of Contemporary Art, 1987), 29. Del Rio notes that Mendieta owned Cabrera's publications. Cabrera's studies include *Negro Stories of Cuba*, her first book published in 1936, and *The Mountain: Notes on the Religion, the Magic, the Superstitions and the Folklore of Creole Negroes and the Cuban People* (1954). Also among her many publications are those devoted to rites and deities evoked by Mendieta in her art: *The Secret Society Abakuá* and *Yemayá y Oshún*, the goddesses of the deep sea and rivers, respectively, each associated with manifestations of the Virgin Mary.

3. Ana Maria Simo, *Lydia Cabrera: An Intimate Portrait* (New York: Intar Latin American Gallery, 1984), 9.

4. Author's interview with Raquel Mendieta, New York, August 1, 1991.

5. Linda Montano, "An Interview with Ana Mendieta," *Sulphur* (Eastern Michigan University, Ypsilanti), 22 (Spring 1988):66.

6. Ana Mendieta, statement, in *Cuba–USA: The First Generation* (Washington, D.C.: Fondo del Sol Visual Arts Center, 1991), 56.

7. It is important to note at this juncture the frequent use of the word "power," which figures prominently in the concept of Mendieta's work and hence in this chapter. Power concerns ability and strength, connotes a position of authority lending a sense of respect and worth, but does not mean domination, that is, power over, as it has come to imply in patriarchal society.

8. Ana Mendieta, *Silueta Series 1977* (gallery sheet) (Iowa City: Corroboree, Gallery of New Concepts, 1977).

9. Mendieta herself came from a strong matriarchal family line dominated by her maternal grandmother, Elvira, the daughter of General Carlos Maria de Rojas, a leader in Cuba's war for independence (1895–98). Her grandmother's home, a historic landmark that had served as refuge for the general's soldiers, was situated on the coast at Varadero. Elvira kept the family traditions and history alive; her home was the gathering place for all the relatives on every family occasion. This house played a key role in Mendieta's developing identity with Cuba during her innocent early years, forfeited when she was forced to grow up quickly in a foreign place. In the United States she suffered the loss of her family home and of her grandmother who had bound generations to this house, to each other, and to Cuba. For Mendieta, who was nearly thirteen when she was sent away with her older sister Raquel, the separation from Cuba changed her life forever. Although her mother came to join her just five years later, by then the personal hardships and pain endured by all, the cultural differences that had developed, the change of environment, and Mendieta's own maturation as an adolescent were factors too great to restore the family. Moreover, the larger sense of family that she had known as a child could never be reestablished as the other members of the clan were inexorably divided between those who supported and those who opposed Castro.

10. Moira Roth, ed., *The Amazing Decade: Women and Performance Art in America 1970–1980* (Los Angeles: Astro Artz, 1983), 22–24. Of the many contemporary examples of rituals, two in which blood played a primary role were: *Ablutions* of 1972 staged by Judy Chicago, Suzanne Lacy, Aviva Rahmani, and Sandra Orgel, a performance in which two women bathed sequentially in a series of tubs of eggs, blood, clay; and *Three Weeks in May* by Lacy (1977), which recorded daily reports of rape and, in its concluding segment, "She Who Would Fly," also evoked a sacrifice in the image of a winged, flayed lamb hung over the

viewers' heads while four nude, blood-stained women crouched in the space above the door they had just entered.

11. Del Rio, "Ana Mendieta," 29.

12. In February and March 1974, respectively, she filmed *Blood Writing*, in which she dipped her hand in a bucket of blood to spell out on a wall "SHE GOT LOVE," and *Body Tracks*, where in one motion she made the sweeping mark of her blood-covered arms and hands on a wall as she went from a standing to a crouching position. This work was restaged and executed on paper during a performance at Franklin Furnace, New York, in 1982.

13. Ana Mendieta, "A Selection of Statements and Notes," *Sulphur* 22 (Spring 1988):72.

14. Mendieta discovered aligned myths that were consistent with the place of nature in Santería. For instance, the origin legends of the Mixtecs and Zapotecs, who inhabited the Valley of Oaxaca that Mendieta frequently visited, include one relating that the Mixtecs descend from a divine couple born of a tree, and some Zapotec stories claim that this group was born of rocks. In both cases nature and earth are the source of life. See Joseph W. Whitecotton, *The Zapotecs: Princes, Priests, and Peasants* (Norman: University of Oklahoma Press, 1977), 23.

15. Del Rio, "Ana Mendieta," 31.

16. Mendieta, "Statements and Notes," 70.

17. Ibid.

18. Mendieta was always finding corroborating information in other religions for her references from Santería. Her *siluetas* that were filled with flowers found such a parallel in an image she cut out from *National Geographic* and attached in her sketchbook of 1976–78. This photograph, from the December 1967 article entitled "Where Jesus Walked," shows a mass of rose petals atop a tapestry on a Calvary altar which were intended to symbolize the body of Christ. This is a Good Friday rite of Greek Orthodox Christians; on Easter these petals are scattered among the faithful as a sign of the coming Resurrection. Another photograph from that same article which she added to her sketchbook shows the pious at the Stone of Unction at the entrance to the Church of the Holy Sepulcher where it is believed Jesus was anointed and wrapped to prepare him for the tomb.

19. Author's interview with Raquel Mendieta.

20. Nereyda Garcia-Ferraz, "An Interview with Raquel (Kaki) Mendieta," *Sulphur* 22 (Spring 1988):59, 65 note 5.

21. Marcia Tucker, "Preface and Acknowledgments," in *Ana Mendieta: A Historical Overview* (New York: The New Museum of Contemporary Art, 1987), 6.

ARTURO LINDSAY

ORISHAS
LIVING GODS IN CONTEMPORARY LATINO ART

Spirituality and art are one and the same.
Works of art are prayers on the altar of life.

RAQUELÍN MENDIETA, 1994

In the last three decades, Latinos have created a major demographic shift in the population of the United States and forged unique barrios (neighborhoods) that are cultural *sancochos* of Latin Americans from various countries.[1] With ongoing interaction in these barrios has come a blending of common cultural elements while at the same time a preservation of distinct national identities that is unmatched anywhere in the world. Like *sancochos*, Latino barrios differ depending on the dominant group(s) and the specific cultural mix of their inhabitants. In these multinational communities, churches, social and political organizations, restaurants, bars, stores, playgrounds, and schools provide common experiences that are writing new pages in Latin American history and culture.

The result of this *mestizaje*[2] (cultural mixing) has become visible in the work of Latino artists who appropriate elements of their adopted U.S. culture and reconstruct them with elements of their native or barrio cultures, creating unique works of art that are reflective of their creolized world. Intrinsic to their art have been discussions addressing the polemic of their identity with spiritual or supernatural overtones. For many Latinos of African descent, there has been a tendency for a dual construction of identity. As art students attending colleges and universities in the United States, where they comprised the smallest ethnic group, they have equated the need to maintain their Afro-Latino cultural identity with survival. This is especially true given the emphasis on compelling ontological questions in this era of Afrocentricity and postmodernism in the United States. Santería, with its rich history of art and aesthetics dating back to the magnificence of early Yoruba dynasties, has become an important archetype for a new generation of artists.

FIGURE 8.1

Changó—Dios del trueno, el rayo, la lluvia, detail, late 19th–early 20th century. Collection of Casa de las Américas. Fernando Ortiz Collection, Havana, Cuba. Photo: Arturo Lindsay.

FIGURE 8.2.

Changó—Dios del trueno, el rayo, la lluvia, detail. Collection of Casa de las Américas. Fernando Ortiz Collection, Havana, Cuba. Photo: Arturo Lindsay.

SANTERÍA AESTHETICS

Art and aesthetics have long been central to the religious practice and daily life of the Yoruba and their New World descendants. Robert Farris Thompson explains: "The Yoruba assess everything aesthetically—from the taste and color of a yam to the qualities of a dye, to the dress and deportment of a woman or man. An entry in one of the earliest dictionaries of their language, published in 1858, was *amewa*, literally 'knower-of-beauty,' 'connoisseur,' one who looks for the manifestation of pure artistry."[3] In spite of the hardships of slavery and the punishment slaves endured when discovered making religious artifacts, evidence of nineteenth-century African religious artistry has survived as a testament of the unyielding drive of Yoruba-Cuban artist-priests to honor their orishas (deities) in their art (pl. 12; figs. 8.1, 8.2). As they were emancipated and their economic conditions improved, so too did the aesthetic embellishment of the altars and shrines of their orishas. According to Babatunde Lawal, "If a devotee attributes his success in life to his *òrìṣà*, he recip-

rocates not only with costly sacrifices but also by making its shrine as beautiful as possible."[4] In the United States, the altars and thrones of Cuban American *santeros* (practitioners of Santería) have become stunning and elaborate spectacles: yards of very expensive fabric, polychrome sculptures, porcelain vessels, beadwork, jewelry, crowns, feathers, food, and drink.[5]

AFROCENTRICITY

The Civil Rights movement of the 1960s and 1970s gave rise to black consciousness and Pan-Africanism, encouraging peoples of African descent nationwide to give prominence to their heritage by adopting African life-styles, taking African names, and wearing African clothing and hairstyles. Influenced greatly by the writings of Alaine Locke promoting an Afrocentric aesthetic during the Harlem Renaissance decades earlier, the work of U.S. African American[6] artists was transformed, assuming a new identity and role in fulfilling the needs of their community.[7] Artists organizations such as the National Conference of Artists, the Spiral Group, OBAC (Organization of Black American Culture), and Africobra emerged and promoted Afrocentricity in the arts.

Interest in African religious beliefs and practices also grew, with Yoruba and Santería evolving among the most investigated African religions in North America. This African revival contributed to a segment of the Latino artist community's turning to Santería aesthetics and iconographic images to inform their work while simultaneously honoring their African heritage, defining their cultural identity, and securing a place in the vanguard of the contemporary art scene.

POST-MODERNISM

In the last two to three decades, postmodern artists have been questioning the essence of art and reality and debating issues of political and cultural hegemony, identity, gender and cultural democracy, pluralism, and self-representation. These concerns ushered in new theories of art that broke with Modernism's formalist aesthetic dogma. In reaction to the commodification of art and the final "erasure" of Modern art by Pop art and Minimalism, the postmodern avant-garde "invented" new genre art forms such as body art, concept art, performance art, earthworks, and installations that were not intended to be sold, auctioned, or exhibited in the traditional sense.[8] This "new art" shifted the essence of art away from the object to the philosophical underpinnings inherent in the work. This anti-art, anti-gallery sentiment shocked the modernist art "establishment." In Third World communities nationwide, the modernist concept of "art for art's sake" was replaced with the Marxist adage "art for the people" as artists of color connected their art to their lives and communities in mural projects, mass-produced posters, and street-theater performances addressing national as well as international issues.

**CONTEMPORARY
LATINO ARTISTS**

These new art forms and theories provided a familiar forum for some Latino artists whose traditional cultures are rooted in manifesting spiritual and supernatural concepts in multidisciplinary performances of music, dance, costume, and spectacle. The action of Latino postmodern avant-garde artists was not unlike Renato Poggioli's description of the modernist avant-garde a century earlier "reconnoitering or exploring . . . that difficult and unknown territory called no-man's land."[9] It is precisely this "unknown territory," this no-man or no-woman's land, that Latino artists have been "reconnoitering." A generation after Wifredo Lam trailblazed with the orishas into a new aesthetic landscape, Cuban American artist Ana Mendieta defined the mission of a new generation of Latino artists best in her statement, "I wanted my images to have power, to be magic."[10] And power and magic they had, as Mendieta explored uncharted artistic territory. Mendieta's chosen path led her to mix the philosophy of the anti-art, anti-gallery movements of the 1960s and 1970s with feminist issues and aesthetic elements of Santería rituals (fig. 8.3). This aesthetic and cross-cultural hybridization brought her international recognition as an emerging pioneer of a new art form.

FIGURE 8.3.

Ana Mendieta, *Ceiba Fetish*. 1982. Black and white photograph of earth/body work with human hair and tree. Miami, Florida. 20.3 × 25.4 cm (8 × 10 in.). Courtesy of the Estate of Ana Mendieta and Galerie Lelong, New York.

FIGURE 8.4.

Juan Boza, *The Shadow of the Forest*. 1985. Multimedia installation. Courtesy of Ricardo Viera.

Cuban-born Juan Boza, a devotee of Santería, arrived in the United States as part of the Mariel migration and opened another innovative path by constructing secular facsimiles of Santería altars as art installations (fig. 8.4). Like Elegguá (orisha of the crossroads, owner of destiny, who is responsible for opening the doors to all possibilities), these artists opened new aesthetic territory that directly influenced the direction of the mainstream art world. Their efforts also gained recognition for other Latino artists exploring Santería aesthetics in their work. This increased interest in Santería-derived aesthetics made Santería and Yoruba literature required reading for any curator, critic, or museum director interested in contemporary art trends on the "cutting edge." Though the number of artists I have met and interviewed over the years who are working in this genre is substantial, this chapter will focus on a select group whose work is paradigmatic of the broader field.

ANGEL SUAREZ-ROSADO

(B. CAYEY, PUERTO RICO, 1957)

Like Juan Boza, Angel Suarez-Rosado operates from deeply held religious convictions and attempts to blur the line between sacred and secular art. He was introduced to the magico-religious world of Espiritismo[11] (Spiritism) by his grandfather who was a *santijuo* (healer) "who touched the body and aura of his patients in order

to heal them." [12] Suarez-Rosado had a special relationship with this grandfather whom he remembers as very African in appearance and a hard-working sugarcane cutter in the hills of Puerto Rico. The artist fondly recalls taking lunch to his grandfather while he worked in the fields. Although he never directly answered his grandson's questions about spiritual healing, Suarez-Rosado says his grandfather's knowledge and traditions were passed down to him visually. He recounts seeing his grandfather "making *amarres* (wrapped talismans) by attaching things with cable, wire, and at times thread to scare off evil, or as part of a healing practice." In addition, his grandmother was a "herbalist for [their] community," and Suarez-Rosado remembers seeing her "making *sajumerios* by boiling or burning plants and herbs for medicinal purposes, and making dolls to break evil spells."

Years later, as a student at the School of Visual Arts in New York City, Suarez-Rosado was both homesick and unhappy painting in a minimalist style. Juan Gonzalez, one of his professors, encouraged him to look to his culture to inspire his art. This advice led the artist to abandon painting, reinvestigate his childhood, and create a new body of work that included sewing tobacco leaves and tying discarded materials (a direct reference to his grandfather's *amarres*), and building altar installations. Living in a Brooklyn neighborhood rich with practitioners of New World African religions (among them Puerto Rican Espiritismo, Haitian Voodoo, Cuban Santería, Dominican Santería and Voodoo, and Brazilian Candomblé), he began attending *bembés* (Santería drumming ceremonies) and Espiritismo séances. He later returned to Puerto Rico to be initiated into Espiritismo and to reacquaint himself with his grandparents' traditions. Returning to the United States, Suarez-Rosado relocated to rural Pennsylvania and converted his house into a sacred shrine. He writes, "In Spiritism, the temple is known as 'el Centro Espiritista,' cult house of Puertorican devotion. As a sacred architecture I compare it to the Ile-Ifa in the Yoruba tradition." [13]

Suarez-Rosado discusses contemporary art using the Yoruba concept of *ashé* (divine life-force) as the most important criterion for evaluation. According to the artist, "art that has *ashé* communicates with color, shape, and space. In a space where there is *ashé*, things can grow . . . we can find a solution to heal the world." In his 1991 multimedia installation *Babalú Ayé*, he creates such a space for the orisha responsible for healing (pl. 13). In this installation, his grandfather's influence is visible in the wrapping and tying of discarded objects, and his ecological concerns for preserving nature and healing the world are addressed by recycling into art objects materials that would otherwise pollute the environment. The installation consists of images and symbols associated with the orisha Babalú-Ayé: old crutches, a photo of a dog and a boy, brooms, plastic beads, and baskets. There are natural and manufactured objects, mass-produced polychrome statues of San Lázaros (Babalú-

Ayé's Roman Catholic counterpart), and found and discarded objects that have been painted and given new life and meaning.

Suarez-Rosado performs in his installations dressed entirely in white as would an initiate of Espiritismo or Santería. In *The Warriors (Los Guerreros)*, an installation consisting of reclaimed "garbage" and dedicated to the warrior orishas (fig. 8.5), he recycles Santería and Espiritismo ceremonies into performance art rituals that often bewilder his audience as well as the critics. His performances usually begin with his singing the rosary and a ritual cleansing of his body (fig. 8.6). He often incorporates drumming and Pentecostal music. "I like to combine things," he says, "I will make a *Veve* (ritual Vodún ground painting) on the ground, then mark my body as if for initiation. I also use other performers, musicians, dancers, even people from the community."

207

RAQUELÍN MENDIETA

(B. HAVANA, CUBA, 1946)

Raquelín Mendieta has been on a journey of caring and healing all of her life. As the older sister of the more daring and venturesome Ana Mendieta, Raquelín's first responsibility was "keeping an eye" on her sister. Her earliest recollection of Santería was following Ana who "would slip down the back stairs to the kitchen or the servants' living quarters to hear them talk about the orishas."[14]

The uncertainties of the early years of the Cuban Revolution and questionable rumors of children being sent to the Soviet Union to become communists prompted

FIGURE 8.5.

Angel Suarez-Rosado, *The Warriors (Los Guerreros)*, detail. 1992. Multimedia installation. Photo: C. J. Gunther.

FIGURE 8.6.

Angel Suarez-Rosado,

The Warriors (*Los*

Guerreros), detail.

1992. Performance.

Photo: C. J. Gunther.

208

many middle-class families to send their children abroad to live in orphanages and foster homes as part of the Peter Pan Project that was sponsored by the Roman Catholic Church. The Mendieta sisters were sent to live in Iowa. The rupture from their country, family, and especially their family home, as well as the adjustment to an alien culture and environment during adolescence (Ana was thirteen and Raquelín fifteen), was traumatic for both, but was particularly burdensome for Raquelín who had the added responsibility of protecting her younger sister Ana.

In 1967, as a married undergraduate art student at the University of Iowa, Raquelín gave birth to her first daughter. Though it was difficult, she graduated in 1970 with a bachelor's degree in painting. Raquelín attempted to continue studying painting and art history in graduate school but withdrew in 1972, discouraged by the sexism she encountered. She remembers being told by a professor that she should "stay home and take care of her children." However, returning to school on a scholarship in the department of education, she completed a master of arts degree in 1977.

The 1985 brutal death (murder?) of Ana was devastating for Raquelín, who had remained very close to her sister. The following year, she traveled to Italy to recover

Ana's belongings. While in her sister's studio in Rome handling Ana's art materials, Raquelín felt an overwhelming urge to make art again after a twelve-year hiatus. Becoming the executor of Ana's estate began a new journey for Raquelín that bonded the sisters and renewed Raquelín's career as an artist. "When Ana died," she says, "I sort of became Ana. I had to make decisions for her. I had to decide what shows she should be in. I was asked to speak about her work. . . . I also had to install her work in some exhibitions." Driven by a desire to be true to her sister's artistic intent, Raquelín found herself reading about Santería from Ana's diaries, artist statements, and her extensive library on art and anthropology which included the works of Lydia Cabrera, Fernando Ortiz, and Migene González-Wippler. She explains, "You could actually say that after her death Ana formally introduced me to Santería."

As a result of Raquelín's intense involvement in Ana's life and work, she did not realize that the boundaries between their art were becoming blurred. Not until 1990, during the construction of *La Mesa de Yemayá-Olókun (The Table of*

FIGURE 8.7.

Raquelín Mendieta blowing cigar smoke on *Raices y Memorias*. 1993. Courtesy of the artist.

Yemayá-Olókun), did she experience an artistic separation from Ana. While the piece began as a portrait of Ana, it developed into a strong likeness of Raquelín. Additionally, in 1991 she lost a photograph of Ana that she had been using for portraits and was forced to rely on using a mirror, which caused her own image to appear more frequently in her work. Interestingly, the photo mysteriously reappeared the following year.

In *Raices y Memorias* (pl. 14), a 1993 multimedia installation, Raquelín's own image, power, ideas, and creativity appeared without Ana. This work began as a silhouette of the artist's body, but took the shape of the island of Cuba. As the work evolved, Raquelín says she felt the power of Oshún manifesting herself in the work. "I thought this was O.K. since Oshún is La Virgen de la Caridad del Cobre, Cuba's patron saint," she explains, and "of course, I always have Elegguá in my work . . . you know he always appears somewhere, you can't leave him out." Color symbolism is very important in Raquelín's work, and as a result the figure was painted yellow (Oshún's color) and the background red and black (the favorite colors of Elegguá).

Raquelín sees no line between art and spirituality. During a recent visit by Erena Hernandez, a Cuban critic and writer of contemporary Cuban women artists, Raquelín was asked if her blowing cigar smoke on the installation before the opening of the exhibition was a religious act similar to *santeros* who perform the same ritual over their religious altars (fig. 8.7). Raquelín answered that she saw no difference. For Raquelín Mendieta, "Spirituality and art are one and the same. Works of art are prayers on the altar of life."

OSVALDO MESA

(B. HAVANA, CUBA, 1960)

Osvaldo Mesa migrated to the United States with his parents at age three. Although he was baptized a Roman Catholic in Cuba, when his parents settled in Miami, they joined the Nazarene Church and sent him to a private Baptist school. Mesa grew up in Miami thinking of himself as "an average American . . . watch[ing] American TV, listen[ing] to American music, and learn[ing] in American schools."[15] According to the artist, although his parents wanted to avoid the "black thing"[16] because they wanted to *superar* (better themselves), they maintained a warm relationship and friendship with a *santera* they had known in Havana. This woman became a surrogate grandmother to Mesa, who explains "we were always at her house for Sunday dinner or to visit . . . we called her *Abuela* (grandmother)." He describes his experiences in Abuela's home: "She had a big shrine in her house. I would just stare at it for hours. . . . The thing that really attracted me was the mystery—the fact that every single thing meant something, but I just didn't know what. It was just fascinating." In addition, Mesa says, "my other early recollections are from smelling incense in *botanicas* (religious stores). . . . I have always associated incense with *bota-*

nicas. . . . My early experiences with Santería were really peripheral." However, "I didn't come to deal with Santería in my work until I came to grips with the fact that I am black, that I am African." Mesa adds that this did not happen until he left Miami to attend graduate school at the Maryland Institute of Art in Baltimore.

In Baltimore he began to research Santería seriously and to investigate his African ancestry in order to "recapture what [he] had lost." In many ways this was a search for two identities because he also felt cut off from his Cuban "roots." Santería, therefore, functioned as a means of "rooting" him in his African and Cuban heritages simultaneously. The mysterious collections of objects in meticulous arrangements that he found in Abuela's house are paradigms for the work Mesa is doing today. He is quick to say he's not trying to create obvious Santería references, but is more interested in creating a series of "magical objects." He explains: "The reason I started to do the things I do is because I was frustrated with painting. My painting wasn't aggressive enough." He began a new direction in his work by taking a very formal and intellectual approach to deconstructing his paintings by reducing them to their physical properties of wood, canvas, and paint. He then reconstructed new works of art by rearranging the basic elements of the painting by wrapping, hanging, and stretching painted canvas over objects. "Through a very obsessive act of wrapping canvas, I found myself bundling things up, [and] even then I could see there was something magical going on."

This early experimentation led directly to his current fetish series. *Fetish Bowl* (pl. 15), a 1993 wall installation, consists of a brightly painted red-orange piece of unstretched canvas draped over an ultramarine blue wooden support bar and acts as a backdrop for a blue dish holding his "magical objects." The dish is located on a support that is also draped with the bright red-orange canvas. These wrapped "magical objects" are both haunting and attractive. Although bright and apparently newly made, they possess a quality that transforms them into religious icons used in magical rituals. Mesa is also fascinated by relics and wants his work to "have the feeling of Santería, or magical relics without making direct references to them." He avoids these direct references, claiming "I am not a scholar, and I don't want to be one—I will probably get my facts wrong. I am more interested in just being an artist and making art."

ELAINE SOTO

(B. NEW YORK CITY, 1947)

As a young adult, Elaine Soto experienced a transformation that resulted in conflicts with her mother. She explains, "I was going through a rebirth, changes, a new form of development. . . . I was very upset and depressed . . . and my mother did what many families do when they see their kids upset and depressed. [She] contact[ed] a *santera*. . . . My mother contacted a *santera* in the Bronx who she'd heard was a holy woman who would see people for free." [17] According to Soto, the nationality of the

santera was not important, and she adds, "My mother was more concerned with getting someone who was right—good—holy, someone who wouldn't take advantage as some *santeros* do." Accompanied by her mother, Soto visited the *santera* who read her cards, told her about her past and her future. "It was a very touching experience," she noted, "a very beautiful experience that I never forgot." The *santera* gave Soto a *baño de flores* (spiritual bath) and special perfumes to protect her. Though this was the artist's first and only experience of visiting a *santera*, over the years the impression intensified as her predictions came true.

Elaine Soto's career as an artist began as a "self-taught painter" while working on her doctorate degree, taking occasional classes at the "Y" and at Taller Boricua in New York City. Soto is a practicing clinical psychologist with a masters degree in education from Harvard University and a doctorate in clinical psychology from New York University. After completing her doctorate degree, her interest in art intensified, and she enrolled at the School of Visual Arts to study with Rimer Cardillo, a master printmaker. She says her first paintings were based on "childhood memories and powerful dreams," yet experiences with Santería as a guest at religious "celebrations" became important influences in her work. She recalls attending a ceremony given by a devotee of Yemayá, a maternal orisha, to thank her for help she had given. Soto was fascinated by the huge altar, music, dance, offerings, decorations, food, candles, flowers, and festive atmosphere of the event. More important, however, she was touched by the overall spiritual experience which prompted her to begin seriously researching Santería.

The first orisha to appear in Soto's work was Osanyín, the herbalist and healer whose domain is the jungle, and with whom she identifies. Referring to the *pataki* (legend) regarding Osanyín's misfortune for not wanting to share his healing knowledge, she quips, "If as a healer you don't share, the Gods will find a way to make you share, so I thought 'Uhmm, I better work on that.'" In *Osanyín—Share* (pl. 16), a 1990 wood, canvas, modeling paste, and acrylic paint mixed-media work, the artist depicts the crippled orisha in his natural environment surrounded by leaves and herbs. After completing this painting, Soto felt sorry for Osanyín who "looked so alone," and painted *O's Bird*, the orisha's companion, to accompany *Osanyín—Share*. Soto is now completing a series of Black Madonnas and Earth Mothers based on Santería and Puerto Rican lore and religious iconography. While taking drumming lessons, she became familiar with Nuestra Señora de Monserrate, a Black Madonna revered in Puerto Rico. In Santería, Nuestra Señora de Monserrate is identified with the Yoruba orisha Yewá or Yegüa who is responsible for the process of decaying bodies in the cemetery. Soto's personal interest in La Monserrate, however, is in the madonna's Puerto Rican and Roman Catholic persona, known for her miracles in healing the lame and infirm; freeing prisoners, captives, and those un-

FIGURE 8.8.

Elaine Soto, *La Monserrate*. 1992. Encaustic painting. 27.9 × 21.6 cm (11 × 8½ in.). Courtesy of the artist. Photo: Sarah Lewis.

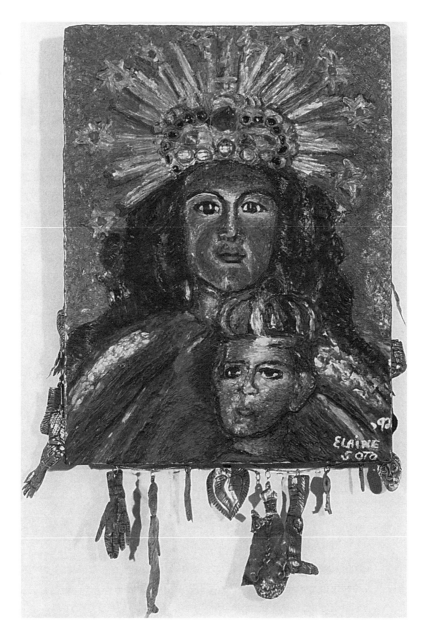

justly given life sentences; saving sailors; and resurrecting the dead. She says, "I went to Spain to do field research on her, and I found out that she was carved by Saint Luke in Palestine, and later hidden by Saint Peter in a cave [for protection]. The statue was discovered in the twelfth century . . . and a miracle occurred at the site" (figs. 8.8, 8.9).

Although Soto does not consider herself "religious," most of her work addresses religious or spiritual subjects. She believes that "the orishas are symbolic of

heroes that have gone before us in a very human fashion and have garnered the power necessary to overcome certain obstacles. We pray to them or invoke them as more evolved energies who have passed on to help us develop spiritually." As a clinical psychologist, Soto also encourages her clients to "talk about their spiritual side, or whatever they believe in, in order to get additional protection and help."

214

RENE DAVID CHAMIZO

(B. HAVANA, CUBA, 1963)

Rene David Chamizo is a multidisciplined artist accomplished in music, dance, performance art, and crafts. He began his professional career as a maritime transport engineer in the harbor of the town of Regla. As a means of supplementing his income, Chamizo began "making furniture, lamps, and sculptures out of natural materials." [18] He submitted his work to a conference for amateur craftspeople and was given an opportunity to study with Gretel Sanabria, an important traditional basket weaver and member of a famous family of traditional artisans. After an apprentice year, Chamizo obtained certification as a craft artist and became a member of the prestigious Cuban Association of Artists and Artisans.

Though a Marxist with little or no religious feeling or conviction at the time, a chance meeting with a *babaláwo* (a high priest in Santería) at a crafts fair led him to begin making baskets dedicated to the orishas. Chamizo was already familiar with the religion (his mother was a *santera*), but making baskets for the orishas required a deeper knowledge. As a result, he began to research Santería by reading as much as he could on it and talking with fellow workers in Regla where the religion is historically very strong. In addition, he began singing with Vocal Marfil, a group of musicians who retrieve and preserve traditional Yoruba songs, and studying tra-

FIGURE 8.9.

Anonymous, *La Virgen de Monserrate*. 1980s. Polychrome plaster sculpture. Collection of Dr. Arturo Lindsay and Ms. Melanie Pavich-Lindsay, Decatur, Georgia.

ditional Santería music and dance with the National Folkloric Company in Havana. As his interest in Santería grew, he asked his mother to introduce him to a *babaláwo* to begin his initiation into the religion. However, his initiation was interrupted when he emigrated to the United States. After settling in New York City, Chamizo began lecturing on Santería to accompany his performances, and says "My knowledge of the religion became more and more deep."

In New York, Chamizo was seeking a connection between his life, religion, and art. He says, "last year [1993] because of the way I was leading my life and the direction I was taking, I decided to create a new piece that was related to Obatala. I needed to be patient to get what I wanted, so I needed to work with Obatala who represents wisdom, patience, intelligence, clarity, purity, and creativity." He adds, "it was a difficult time because I was far away from the art, I was trying to sell real estate, looking for business—trying to survive in New York." Because his primary reason for coming to New York was to make art, he decided he should concentrate on being an artist, "then the money situation, everything would improve." Chamizo invested an entire year on *Obatala* (pl. 17), a large wall sculpture woven of reeds which he "manipulat[ed] into shapes usually seen only in the more traditional smaller basket[s] . . . [and] was only completed after [he] 'drew' with reeds on the borders." He believes, "This piece will make me famous."

JORGE LUIS RODRIGUEZ

(B. SAN JUAN, PUERTO RICO, 1944)

FIGURE 8.10.

Jorge Luis Rodriguez, *ORISHA/SANTOS: An Artistic Interpretation of the Seven African Powers*, detail. 1985. Steel. Courtesy of the artist.

Jorge Luis Rodriguez began research on Santería because "it is part of my culture, part of my background."[19] As a child, he was recognized as a spiritual medium, and between the ages of five and ten people came to him from his community for readings, cures, or answers to problems. He could see and talk to spirit beings, and says, "Spirits visited during different seasons when there was a tragedy or a death in the family." One particular spirit who visited only on rainy days was "an African spirit that dressed in a black cape or raincoat and would appear under [his] mother's sewing machine." Thirty years later he discovered the spirit was a person, an artist named Charles Abramson, who, growing up in Saint Croix, had experienced Rodriguez as a visiting spirit. Not surprisingly, Abramson and Rodriguez "became like brothers" in New

York. Moreover, Abramson had become a *santero*, "initiated into Santería through a Puerto Rican *madrina*."

In 1985 Rodriguez collaborated with Abramson to create an exhibition entitled *ORISHA/SANTOS: An Artistic Interpretation of the Seven African Powers* (pl. 18), at the Museum of Contemporary Hispanic Art in New York City. Loosely adhering to the colonial folk tradition of *santo*-making (an integral part of his Puerto Rican cultural heritage), Rodriguez created Catholic *santos* (saints) of steel (fig. 8.10). He says, "I wanted to mix as many traditions as I could in this installation, so I relied on the Puerto Rican tradition of *santo*-making." These *santos* were given both their Catholic and Yoruba names and installed in an environment created by Abramson that was rooted in the symbolism and iconography of the orishas.

216

JOSÉ BEDIA

(B. HAVANA, CUBA, 1959)

José Bedia is among the more recent Cuban artists who have migrated to the United States via Mexico. An initiate of Palo Monte (an Afro-Cuban religion based on the religious traditions of the Kongo people of central Africa), he acknowledges that like many Cubans he has experienced Santería.[20] Bedia claims that as a youth he was very interested in the cultures of Native Americans but did not have access to them. He turned to Afro-Cuban cultures which he found much more related to him as a Cuban. Bedia says his interest in the religion was "primero que todo como un reconocimiento mio de nacionalidades y de buscar unas raices que tuvieron vigencias en la vida Cubana que explican ciertas cosas de Cuba" (First of all as a recognition of my national identity and a search for strong roots in Cuban life that would explain certain things about Cuba).[21] He goes on to explain that to understand Cubans it is important to understand the island's African heritage. Therefore, Bedia's search "era un descubrimiento mio antropológico en mi propia gente, en mi propio pueblo" (was an anthropological discovery of [his] people, [his] community).

While Bedia admits his religious beliefs and practices influence his art, he makes a very clear distinction between his art and his religion. He was asked by Robert Farris Thompson to recreate a Palo Monte altar he saw in the artist's apartment in Cuba for the traveling exhibition *Faces of the Gods*. Bedia titled his altar installation *Lucero del Mundo* (*Star of the World*) (pl. 19), and claims, although the installation is a very realistic depiction of an altar, it is not a sacred altar: "it is clean, it has no power." While it is an exact replica of the altar in his apartment in Cuba, Bedia claims it is not the same because it was never consecrated. He goes on to say he is incapable of placing the sacred elements of his religion in a secular art installation.

ARTURO LINDSAY

(B. COLÓN, PANAMA, 1946)

Although Santería was rare in Panama prior to the migration of Cubans who fled the 1959 Revolution, its existence was common knowledge as was that of many other New World African religions from the Caribbean.[22] However, my first encounter

with Santería came in the 1960s in New York City, where I saw religious items in the windows of storefront *botanicas*; heard the drumming and chanting of celebrants at *bembés* in basements and apartments of large tenement buildings in Spanish Harlem; and, like millions, listened to and watched Ricky Ricardo sing *Babalú Ayé* on the "I Love Lucy" television show.

My first intimate experience with the religion was in the 1970s as a graduate art student and friend of a Puerto Rican *santera* whose family was Roman Catholic and practitioners of Espiritismo. My friend and I had rejected our Roman Catholic up-bringing for political reasons but deeply missed having a spiritual life. She had been initiated into Santería in New York City and found it compatible with her Pan-Africanist beliefs. She introduced me to Santería, and although I was not ready to be initiated at that time, I had selected Oshún (orisha of love and beauty) as my personal orisha and wore a yellow unblessed *eleke* (color-coded beaded necklace of the orisha). I built a small altar in my studio for Oshún and before working prayed to her for guidance and to bring beauty to my work. After working I would offer another prayer in thanksgiving. I also began extensive research on Santería and other African religious beliefs and traditions, and by the late 1970s I had acquired enough information on the religion to become the coordinator of the African Diaspora Program at the Museum of African Art in Washington, D.C. Through my work at the museum, I met Dr. Aleida Portuondo, a warm, intelligent, and devoted priestess of Oshún. Dr. Portuondo soon became my friend and *madrina* as I prepared myself for initiation.

During this period, I was recycling Yoruba, Santería, and other African images and iconography into a series of paintings I called the "Ancestral Ideograms Series," which was a depiction of a "secret language" I had developed for communicating with the ancestors and orishas. Although I was trained as a painter and do enjoy painting, I felt the medium was incapable of conveying the multilayered and multi-faceted concepts that interested me. By the 1980s I was incorporating my under-graduate training in theater with my street-theater experiences and my interest in Santería rituals into performance art and installations. In my early work I avoided obvious references to the orishas, not wanting to offend them or desecrate their religion. However, after lengthy discussions and assurances by *babaláwos*, I allowed the orishas and Santería iconography to assume a dominant role in my work and to take on other layers of meaning in my life.

Homenaje a Osanyín (pl. 20) is a large multimedia installation that was conceived as a "prayer" to the orisha for a cure for AIDS. A painting depicting Osanyín in a very colorful jungle hangs on the wall and acts as a backdrop for the installation. The portrait of the orisha adheres to his description as having one eye and one very large ear and a small one. A bird sits on Osanyín's shoulder talking into his

218

large deaf ear. As a tribute to Wifredo Lam, I painted a pair of shears like his and a red splash at the orisha's feet to mirror Lam's treatment of the orisha in *La Jungla* (see fig. 5.3). In front of the painting is a platform filled with bamboo and palm trees, flowers, Spanish moss, and an altar installation combining a statue of St. Joseph, one of the orisha's Catholic counterparts, a traditional Yoruba *Opa Osanyín* ritual staff, an *osun* (a small metal rooster staff of the herbalist), and an assortment of herbs and fruits. Integral to the installation is the scent of the flowers, herbs, and bamboo, as well as a recording of Santería religious music that continuously plays at very low volume. The extensive research I have conducted on Santería aesthetics over the years has led me to develop a dual career as artist and scholar.

While it is somewhat difficult to define categorically *the* Latino identity in the United States, it is not impossible to describe certain common tendencies and attributes since Latinos as a minority ethnic group maintain some degree of cohesiveness in order to gain social, cultural, and political clout. Defining Latino art is somewhat more elusive because, like most contemporary artists, Latino artists also operate with the modernist notion of wanting to be "the primitive" of their own style. In spite of these difficulties, there are commonalities that can be described as a neo-Yoruba genre of contemporary art. I prefer the term genre (meaning type, sort, or kind), as opposed to a school, which would imply ongoing communication between the artists supporting a single aesthetic, which is not the case.

The single factor that artists working in this genre have in common is the reliance on ethnographic research as a tool to gain a deeper understanding of the contextual meaning of Santería in order to enrich their art. In some cases artists have actually conducted field research. In conversations with the artists, the work of scholars such as Lydia Cabrera, Fernando Ortiz, Isabel and Jorge Castellanos, Migene González-Wippler, Babatunde Lawal, Robert Farris Thompson, Henry John Drewal, William Bascom, Joseph Murphy, Frank Willett, and William Fagg, among others, are used as resources to develop concepts in their work. Two factors that are consistently found in the work of these artists are the practices of appropriation and *mestizaje*. While it may be a new phenomenon for artists in the West to openly admit appropriating art and aesthetic ideas from different periods and cultures, it has long been a common practice for Latin Americans, especially among Central Americans and Caribbeans of mixed ancestry, who perceive their actions as borrowing from their cultural inheritance. Contemporary Latino artists do not regard Western European aesthetics as foreign, any more than they do the Yoruba, Santería, or Oriental art they research and use in their work. Afro-Latinos are as comfortable using Roman Catholic images and iconography as Euro-Latino artists are in using San-

tería. It could be argued that Latinos have embraced the postmodern concerns of pluralism since the beginning of the nineteenth century when Simón Bolívar, the Liberator of Latin America, espousing a Latin American *mestizo* identity, declared at the Congress of Angostura: "It is impossible to say to which human family we belong. . . . Europeans have mixed with the Indians and the [Africans], and [Africans] have mixed with Indians. We were all born of one mother America, though our fathers had different origins, and we all have differently colored skins. This dissimilarity is of the greatest significance."[23] Although problems of gender, ethnicity, race, class, sexual preference, and nationalism continue to inhibit the full realization of Bolívar's dream of a united Latin America, cultural *mestizaje* remains the choice of many Latinos in the barrios, as evidenced in popular music and speech.

Artist intent, belief, and degree of involvement in Santería vary among Latino artists and shape the presence of the orishas in their work into three categories: cultural identity, spiritual empowerment, and personal advancement. For most Cuban American artists, Santería aesthetics allows them to maintain essential aspects of their Cuban identity as they become acculturated to North American society. As the years pass and the process of North Americanization becomes more evident, the need to hold on to essential *Cubanismos* (Cubanness) is intensified. For other Latino artists, particularly those of Caribbean ancestry, Santería aesthetics represents a strong and resilient Afro-Caribbean retention that has survived and flourished with which they can identify and claim as their own as they too experience the intensified process of acculturation in North America. In many ways for these artists, Santería serves as a resistance mechanism to complete cultural assimilation in the United States.

In spite of religious, or lack of religious, convictions (most of the artists in this study claim to be spiritual but not religious), without exception, every artist who has had dealings with the orishas speaks of them as living gods. When discussing the presence of the orishas in their work, they retell anecdotal stories that invariably make reference to an orisha's personality or behavior that affected them or their work. Among the most talked about orishas is Elegguá. Accepting the orishas as tremendous powers that can control events in the natural world, the artists attempt to garner the *ashé* of the orishas for "power," "magic," or "mystery" to empower their work. The orishas also represent benevolent forces to be turned to in times of adversity, for advice, or for healing. It is at these moments that we see the artists perceiving their art as "prayers" or homages to the orishas.

The orishas have also been known to be generous in granting favors to those who honor them, and these artists are no exception. Latino artists working in this genre acknowledge the orishas as having been good to them personally and

professionally. For many Latino artists, experiencing dissatisfaction with the limitations of traditional art media or with the direction of their work, turning to the spirit world of the orishas meant dramatic changes. In many cases they abandoned single media (painting, printmaking, or sculpture) or modernist styles such as minimalism and abstract expressionism in favor of performance art, body art, earthworks, multimedia collages, or art installations. These changes, almost without exception, resulted in the careers of these artists experiencing significant growth. National recognition also followed as the contemporary art world has shifted toward new genre art forms, pluralism, and multicultural issues in the arts.

These shifts in the art world occurring at the fertile cultural crossroads where Santería aesthetics, Afrocentricity, and postmodernism meet have gained Latino artists the necessary currency to create a recognizable new genre of art that has been dispelling erroneous misconceptions of African religious traditions by opening a window through which the world can witness the *ashé* of the barrio.

NOTES

1. In this essay I use the term *Latino* to refer to Latin Americans living in the United States. A *sancocho* is a flavorful Latin American soup consisting of chicken, vegetables, herbs, and spices in which the ingredients maintain much of their consistency yet contribute to the rich flavor of the broth. For an expanded discussion of cultural mixing in the United States, see Lucy Lippard, *Mixed Blessing: New Art in a Multicultural America* (New York: Pantheon, 1990). See also Gerardo Mosquera's discussion of Fernando Ortiz' use of *ajiaco*, a Cuban soup, as a paradigm for Cuban culture (in this volume) and in "The New Art of the Revolution," in the exhibition catalogue *The Nearest Edge of the World: Art and Cuba Now* (Boston, Polarities, Inc., 1990). I prefer *sancocho* because the term is also used metaphorically in parts of Latin America for the random mixing of disparate elements.

2. I use the term *mestizaje* in its broadest Latin American definition to mean the mixing of all forms of cultural expression.

3. Robert Farris Thompson, *Flash of the Spirit* (New York: Random House, 1983), 5.

4. Babatunde Lawal, "Some Aspects of Yoruba Aesthetics," *British Journal of Aesthetics* 3 (1974):239.

5. See David H. Brown, "Thrones of the Orichas, Afro-Cuban Altars in New Jersey, New York, and Havana," *African Arts* 26(4) (1993):44–59, 85–87.

6. The use of the term *American* to refer exclusively to the citizens of the United States has long been viewed as cultural expropriation by many Latin Americans since the term rightfully belongs to all of the peoples of the Americas. The Spanish word *estadounidense* (referring to the people of the United States), although a tongue twister in English, is more accurate. The same can be said of the term *African American* since it refers to all Americans of African descent and not a specific ethnic group in one American nation. I use the terms *U.S. American* to refer to the people of the United States and U.S. African American to refer to U.S. Americans of African ancestry.

7. See Samella Lewis, "Political and Cultural Awareness 1960–1990," in *Art: African American* (Los Angeles: Handcraft Studios, 1990), 143–289.

8. For further reading on modernist and postmodernist aesthetics and criticism, see Terry Barrett, *Criticizing Art: Understanding the Contemporary* (Mountain View, Calif.: Mayfield, 1994).

9. Renato Poggioli, *The Theory of the Avant Garde*, trans. Gerald Fitzgerald (Cambridge, Mass.: Harvard University Press, 1968), 27–28.

10. Petra Barreras del Rio, "Ana Mendieta: A Historical Overview," in *Ana Mendieta: A Retrospective*, exhibition catalogue (New York: The New Museum of Contemporary Art, 1987), 29.

11. Espiritismo, or Mesa Blanca (white table) as it is also known, is a belief popular among many Puerto Ricans and is based on communication with the dead by means of séances. In many barrios in the United States, believers have blended it with elements of Santería. For further reading, see Migene González-Wippler, "Santería and Spiritism," in *Santería: The Religion, a Legacy of Faith, Rites, and Magic* (New York: Harmony Books, 1989), 274–81.

12. Unless otherwise indicated, all quotations in this section are from a telephone interview with the artist in March 1994. Other information is based on conversations with the artist since 1986, press material, exhibition catalogues, and brochures.

13. Unpublished statement, 1990, in the author's files.

14. Unless otherwise indicated, all quotations in this section are from a telephone interview with the artist in March 1994. Other information is based on conversations with the artist since 1991, press material, exhibition catalogues, and brochures.

15. Unpublished artist statement, in the author's files.

16. Unless otherwise indicated, all quotations in this section are from a telephone interview with the artist in March 1994. Other information is based on conversations with the artist since 1992, press material, exhibition catalogues, and brochures.

17. Unless otherwise indicated, all quotations in this section are from a telephone interview with the artist in March 1994. Other information is based on letters from the artist, press material, exhibition catalogues, and brochures.

18. Unless otherwise indicated, all quotations in this section are from a telephone interview with the artist in March 1994. Other information is based on conversations with the artist and his agent Jill Cotter since 1992, press material, exhibition catalogues, and brochures.

19. Unless otherwise indicated, all quotations in this section are from a telephone interview with the artist in March 1994. Other information is based on conversations with the artist since 1986, press material, exhibition catalogues, and brochures.

20. It is not uncommon to meet Cubans who are not only very familiar with both religions, but actually practice them. In December 1992, I visited Enrique, a very important *babaláwo* living in Guanabacoa, a small town outside Havana. In his home, Enrique has two separate rooms with Afro-Cuban shrines, one dedicated to Santería and the other to Palo Monte.

21. Unless otherwise indicated, all quotations in this section are from a telephone interview with the artist in March 1994. Other information is based on press material, exhibition catalogues, and brochures. All translations are mine.

22. Although I labored over including this discussion of my work, not wanting to appear self-serving, I finally decided to include it since the work was such an integral part of the

development of the symposium and now this book. Also, as I have been an ardent advocate of artists participating in the discourse of contemporary art with a discussion of their work, I felt it would be hypocritical not to discuss my own.

23. John A. Garraty and Peter Gay, eds., "Spain and Portugal in America," *The Columbia History of the World* (New York: Harper and Row, 1972), 658.

REFERENCES

Abiọdun, Rowland, Henry J. Drewal, and John Pemberton III. 1989. *Yoruba: Nine Centuries of African Art and Thought.* New York: Harry N. Abrams.

African Arts. 1993. Los Angeles: University of California, vol. 26(4).

Bay, Edna G., and Daniel F. McCall. 1975. *African Images: Essays in African Iconology.* New York: Africana Publishing Co.

Beardsley, John, and Jane Livingston. 1987. *Hispanic Art in the United States: Thirty Contemporary Painters and Sculptors.* New York: Cross River Press.

Beardsley, Monroe C. 1981. *Aesthetics: Problems in Philosophy of Criticism*, 2nd ed. Indianapolis: Hackett Publishing Company.

Benítez, Marimar, and Lydia Milagros González. 1992. *La tercera raíz: Presencia africana en Puerto Rico.* San Juan: Centro de Estudios de la Realidad Puertorriqueña e Instituto de Cultura Puertorriqueña.

Biebuyck, Daniel, ed. 1969. *Traditions and Creativity in Tribal Art.* Berkeley: University of California Press.

Bolivar Aróstegui, Natalia. 1990. *Los orishas en Cuba.* Havana: Ediciones Unión.

Buschiazzo, Mario, J. 1971. *Historia de la arquitectura colonial en Iberoamérica.* Havana: Instituto Cubano del Libro.

Cabrera, Lydia. 1986. *El monte*, 6th ed. Miami: Colección del Chicerekú.

Cancel, Luis. 1989. *The Latin American Spirit: Art and Artists in the United States, 1920–1970.* New York: Harry N. Abrams.

Cano, Margarita. 1984. *The Miami Generation/La Generación de Miami.* Miami: Cuban Museum of Arts and Culture.

Castellanos, Isabel, and Jorge Castellanos. 1992. *Cultura afrocubana 3: Las religiones y las lenguas.* Miami: Ediciones Universal.

Clearwater, Bonnie, ed. 1993. *Ana Mendieta: A Book of Works.* Miami Beach: Grassfield Press.

Cole, Johnnetta B., ed. 1988. *Anthropology for the Nineties: Introductory Readings.* New York: Free Press.

d'Azevedo, Warren L., ed. 1973. *The Traditional Artist in African Societies.* Bloomington: Indiana University Press.

Dickie, George. 1971. *Aesthetics: An Introduction.* New York: Pegasus.

Drewal, Henry J. 1980. *African Artistry: Technique and Aesthetics in Yoruba Sculpture.* Atlanta: The High Museum of Art.

Drewal, Henry J., and David C. Driskell. 1989. *Introspectives: Contemporary Art by Americans and Brazilians of African Descent.* Los Angeles: California Afro-American Museum Foundation.

Edwards, Gary, and John Mason. 1985. *Black Gods—Orisa Studies in the New World.* Brooklyn, N.Y.: Yoruba Theological Archministry.

Entralgo, Armando, ed. 1979. *Africa Religion*. Havana: Editorial de Ciencias Sociales.

Eyo, Ekpo, and Frank Willett. 1980. *Treasures of Ancient Nigeria*. New York: Alfred A. Knopf.

Foster, Hal, ed. 1983. *The Anti-Aesthetic: Essays on Postmodern Culture*. Port Townsend: Bay Press.

Garraty, John A., and Peter Gay, eds. 1972. *The Columbia History of the World*. New York: Harper and Row.

Gilbert, Rita, and William McCarter. 1988. *Living with Art*, 2nd ed. New York: Alfred A. Knopf.

González-Wippler, Migene. 1989. *Santería: The Religion. A Legacy of Faith, Rites and Magic*. New York: Harmony Books.

Hartt, Frederick. 1987. *History of Italian Renaissance Art*, 3rd ed. New York: Harry N. Abrams.

Hein, Hilde, and Carolyn Korsmeyer, eds. 1993. *Aesthetics in Feminist Perspective*. Bloomington: Indiana University Press.

Holcombe, Bryce, ed. 1982. *Yoruba Sculpture of West Africa*. London: Collins.

Ihde, Don. 1971. *Hermeneutic Phenomenology: The Philosophy of Paul Ricoeur*. Evanston: Northwestern University Press.

Jacob, Mary Jane. 1991. *Ana Mendieta: The "Silueta" Series*. New York: Galerie Lelong.

Mason, John. 1985. *Four New World Yoruba Rituals*. Brooklyn, N.Y.: Yoruba Theological Archministry.

Mosquera, Gerardo, and Rachel Weiss. 1990. *The Nearest Edge of the World: Art and Cuba Now*. Boston: Polarities, Inc.

Murphy, Joseph M. 1988. *Santería: An African Religion in America*. Boston: Beacon Press.

Pescatello, Ann M., ed. 1975. *The African in Latin America*. New York: Alfred A. Knopf.

Pignatti, Terisio. 1988. *The Age of Rococo*. London: Cassell.

Poyner, Robin. 1992. *Thunder over Miami: Ritual Objects of Nigerian and Afro-Cuban Religion*. Miami: University of Florida, Center for African Studies.

Reynolds, Gary A., and Beryl J. Wright. 1989. *Against the Odds: African-American Artists and the Harmon Foundation*. Newark, N.J.: The Newark Museum.

Smagula, Howard, ed. 1991. *Re-Visions: New Perspectives of Art Criticism*. Englewood Cliffs, N.J.: Prentice-Hall.

Thompson, Robert Farris. 1983. *Flash of the Spirit: African and Afro-American Art and Philosophy*. New York: Random House.

Vogel, Susan. 1988. *ART/artifact*. New York: The Center for African Art.

Wallis, Brian, ed. 1984. *Art after Modernism: Rethinking Representation*. New York: The New Museum of Contemporary Art.

Willett, Frank. 1971. *African Art: An Introduction*. New York: Praeger.

Zuver, Marc. 1991. *Cuba–USA: The First Generation*. Washington, D.C.: Fondo del Sol Visual Arts Center.

223

GERARDO MOSQUERA

ELEGGUÁ AT THE (POST?)MODERN CROSSROADS
THE PRESENCE OF AFRICA IN THE VISUAL ART OF CUBA

To *Lydia Cabrera's* eggun

In discussing the cultural effect of Africans on America, it is first essential to reject the indiscriminate and habitual use of such words as "influence," "impact," and other similar terms. In many cases it would be more appropriate to speak of *presence*. More than a question of terminological exactness, it is a matter of conceptual and ideological precision. "Influence" or "impact" refers to the effect exerted on one culture by another from outside. And often that is not what happens in the countries in the Americas formed mainly from cultures of the coastal regions with a strong demographic makeup of African origin (the Caribbean, Brazil), nor is it true in other countries with a sizable population of African descent, though to a lesser extent perhaps. The African culture was a constitutive ingredient of those nations, and continues to be present in the formation of a good part of the new American cultures. The paradigm of multiculturalism can carry with it the self-limitation of no longer recognizing how much effect Africa has had in the composition of generalized idiosyncratic and cultural traits in the United States, for instance. To acknowledge the sub-Saharan presence in certain "standardized" North American patterns can prove to be equally difficult for whites as for blacks. Some whites would repudiate such a genealogical stain, while some blacks would resist being linked with matters that they had usually considered to be 100 percent white. Overturning the "melting pot" as a fallacy of integration and participation, masking a discriminatory hierarchy, should not lead to renouncing, in favor of the WASPs, the credit due to the African participation in a general cultural dynamic, when in fact, without recognizing that participation, North American culture cannot be understood. An "inner" multiculturalism is imperative, as is a multicultural deconstruction of certain whitewashed stories.

226

The Africans who were brought to America suffered slavery, uprooting, loss of homeland, rupture from their institutions and kinship systems, commingling in the new context. All this hastened the process of creolization and made them and their descendants dynamic factors in the shaping of the new nations. In 1939 Fernando Ortiz, to characterize Cuban culture, proposed the felicitous paradigm of *ajiaco*, a rich stew or soup of different ingredients cooked until it makes a broth of synthesis.[1] This paradigm can be extended to the Caribbean and the new Latin American nations built upon the twin processes of separation from the original cultures and ethnogenetic mixing. The hybridized African proves to be the key to many of America's cultural expressions, not as intertextuality but as constitutive presence; not as inspiring element, and not even as something added, but as a Promethean ingredient in the formation of the new culture.

Such terms as "influence" or "impact" arise from a discriminatory tradition, often unconscious, that separates the African component from a sort of white formative trunk of the creole nations, in which the culture of African origin plays an active role but from outside. One cannot fail to recognize the African components in the various national cultures, and this evident fact is explained as "influence," a modification performed by an external nonwestern agent, whose capability of action is accepted. But at the same time such African presence is left conveniently separated as an entity apart, safeguarding, beyond so many "impacts," a certain European monocultural image in the new nations, thus denoting a control over the "influence" by the dominant European who receives it.

The paradigm of the *ajiaco*, as it refers to hybridization, is complemented by that of the *moros con cristianos* (Moors with Christians, a Cuban dish of rice and black beans cooked together), as it relates to multiculturalism, and both interconnect. You have to eat them together. Everywhere in America in multinational countries that do not wish to say their name, we find, hiding behind national narratives of synthesis, the presence, at times overwhelming, of indigenous peoples almost entirely excluded from national projects. In the case of Afro-Americans, it is rather a matter of adjusting the metaphor of the *ajiaco*, to point out that bones remain in the middle of the stew without dissolving although they contribute their marrow to the broth. Africans in America did not preserve their cultures as entities, nor did they form other new ones except in the case of the Djuka, the Saramaka, and other *maroon* peoples, who, protected by the forest, created new African cultures in communities based on ethnic self-consciousness. But they have maintained to this day in America religious-cultural complexes that shape the development of African religions, together with their panoply of music, dance, oral literature, visual manifestations, and so on. Among them are Santería, Candomblé, Shango, the Casa de Minas

(House of Mines), Palo Monte, and others. These religions establish spaces of African culture quite close to their origins, not diluted within the national cultures, although the practitioners are part of their respective national entities and within those boundaries consider themselves Brazilian, Cuban, Trinidadian, and so on. These I call Afro-Cuban, Afro-Brazilian, or Afro-American, to distinguish them from the Cuban, Brazilian, Caribbean, or Latin American as cultures of synthesis, within which the integrated African also functions.[2] The changes, interminglings, and readaptations that these religions have experienced derive from their reaction to the new milieu, strategies to insure survival and the ability to develop while keeping intact the fundamentals of their original philosophy, liturgy, and mythology.

The case of syncretic religions of African origin and dominance is very similar: new creations starting from the mixture of sub-Saharan religions, elements of popular Catholicism and spiritualism, along with creole inventions. In spite of such religions being the result of hybridization and reinvention, African foundations and structures prevail, either in those most African in all their construct, such as *voudun*, or in others more open such as Umbanda. In addition, there exist "unattached" cultural manifestations of African origin in the folklore, not forming part of a structured cultural system: music, dance, fables, reinterpretations, charms, words, and more.

More than survival, the real feat of the culture of Africa on the other side of the Atlantic is its story of flexibility, appropriation, and transformation from its own essential character as dynamic function, achieved under conditions of extreme dominance—an anti-fundamentalist strategy of taking advantage of the opponent's strength. For example, with Catholicism pushing at the door, the Africans simply opened it and Catholicism fell out the other side. Without prejudices or complexes, the Africans included it in a collage structure alongside their own religions (in Cuba every *santero* considers himself also a Catholic, and in addition he may be a Palero, an Abakuá, and a Freemason, without contradictions, in a system of coexisting fragments); or the Africans appropriated the elements of the new religion into the African axis, to make it efficacious in the new milieu, adapting it with the greatest of ease.[3] On this last point another word has been abused—"syncretism"—to designate something that corresponds more to the concept of "appropriation," in the sense of taking over for one's own use and on one's own initiative the diverse and even the hegemonic or imposed elements, in contrast to assuming an attitude of passive eclecticism or synthesis.

All of these strategies are clearer now, and more instructive, thanks to the consciousness called postmodern. Its dialogic sense between the plural and the particular is expressed as much in the makeup of the new cultures as in the dynamic preser-

vation of the cultural legacy of Africa. And today its effect is felt everywhere: from music to the way of speaking English to the spread of Santería and Umbanda, now in the process of becoming "universal religions."

The religious-cultural complexes of African origin possess an array of visual expressions[4] that extend from the preservation of the forms of origin—as in some ritual objects of Candomblé and Santería or the costumes of the masked Abakuá—to the purely creole inventions of Umbanda images, showing their absorption of mass culture. Aside from that evident presence, in the vernacular culture the African component operates from within, as a factor in creole visual expressions.

Here I will refer only to the African presence in the "high" plastic arts in Cuba, those found in galleries, or rather to those cases where that presence proves to be the foundation of the work. From the standpoint of modernism, a certain sensibility of African origin has had a structuring effect on the work of various artists, as an active part of a Cuban cultural expression sought by painters of the avant-garde since the end of the 1920s. But this essential presence would require another study, an arduous one, that would attempt to elucidate the characteristics of that Cuban expression in modern art as cultural event, not as artistic poetics. Before Wifredo Lam, the African presence appeared only as an ingredient of modernist sensibility, or as theme, reference, or anecdote, similar to what happened in Brazil, perhaps the country most like Cuba in this regard.

WIFREDO LAM (1902–82)

From the beginning of the 1940s Lam instituted a "Copernican revolution"[5] that, though not leaving a school in the sense of the Mexican muralist painters or the Taller Torres García in Uruguay, did open a perspective that was to make Cuba the paradigmatic country as far as the effect of Africa within western visual arts was concerned. Cuba assumed this role not only for the quantity, quality, and projection of its artists, but for being the place where a change of direction occurred: the use of modernism as space to communicate Afro-American cultural meanings.

Lam has not been assessed from this perspective, but rather as someone who introduced the "primitive" or Africanness firsthand into surrealism.[6] The Afro-American culture was seen as a function of modernism, not the other way around, because the Eurocentric eye had structured the discourses about art and governed its distribution and legitimation in a hegemonic manner. A deconstruction of those discourses and imposed assessments is imperative in a search for decentralized views, dialogic and contextualized, determined by cultural plurality and their interests. Multiculturalism has helped a great deal in this direction, but brings with it the danger of turning into a new totalization imposed from the center, by "exporting" from the North American milieu its problematic and strategies as general direction for the rest of the world. This paradoxical multiculturalist "imperialism" can prove to be

progressive in some contexts, totally out of balance in others, and almost always self-satisfied. What arose as recognition and potentiality of diversity can lead toward the outside away from one's own diversity, while no attempt is made to open oneself to diversity from elsewhere.

As George Yudice has said, "we are not the world";[7] the world possesses an endless number of diverse situations despite globalization. "Globalization" is one of those concepts, as is "multiculturalism," that has been much abused. Its plausibility for comprehending the contemporary sphere is becoming a sort of maxim that explains everything, denoting a certain generalized and transterritorial participation, a certain dissolution of the center—peripheral hierarchy, in the antipodes of a critical usage to analyze the mechanisms of power. This sense hides the true hegemonic structuralization in an axial web around the centers, extended throughout the planet.

Lam should be assessed as the first plastic artist in all the history of western art to present a vision from the African presence in America. This occurrence is not formal: his language always continued to be indebted to his academic training in Cuba and Spain, and his knowledge of the western classical tradition, to the epigonal methods of the Paris school and surrealism, to African geometrical figuration and, especially, to the direct influence of Picasso, Julio González, and Matisse. What was crucial was a change of sensibility, which responded to a different objective and the methodology necessary to reach it, leading the artist to reconvert the arsenal of modernism and the western pictorial cultural heritage, by means of changes that did not bring about the resurgence of a new language. Picasso and many modern artists were inspired by masks and traditional African imagery for a rather formal renewal of western art, while being completely unknowing of the context, functions, and meanings of those objects; at the same time they lent them legitimacy as "sculptures" in the western sense. Lam discovered African plastic art in Picasso's work, and Lam's paintings done in Paris between 1938 and 1940 employed African art in a similar manner. But his contact with surrealism, above all in Marseilles in 1940–41, impelled him to "extract" more freely from his inner self, which, joined to the modern interest in the "primitive" and the new prestige granted it, gradually brought his work closer to an expression based on his ethnocultural upbringing in Cuba.

Son of a Cantonese immigrant and a mulatto woman, Lam grew up in an Afro-Cuban atmosphere. His Catholic godmother was a very well-known *santera* in Sagua La Grande. Although he was never initiated, nor as a youth had any special interest in those traditions, his cultural experience was without any doubt conditioned by the context. His rediscovery of Cuba in 1941, when he returned fleeing from World War II, intensified the process toward an open celebration of the African

229

component present in his own cultural development, an outcome of his Caribbean *Weltanschauung* in relation to his natural and social surroundings. It was a "return to the native land" in the sense of Aimé Césaire's poem; his return was aided in large part by the Cuban folklorist Lydia Cabrera, who was his Virgil revealing to him the world of Santería and other Afro-Cuban religions. James Clifford has commented that "perhaps there's no return for anyone to a native land—only field notes for its reinvention."[8] From that moment on, Lam's work can be interpreted from this perspective, relating it to the *négritude* movement as a conscious and neological construction of a black paradigm. As a modern artist, he stopped working with African geometrical forms to attempt, for the first time in modern art, to work with the African sense, reinventing it in the propitious terrain offered by modernism.

African masks ceased to interest Lam for their lessons of synthesis—morphological instruction—to the benefit of their mystical representations—expressive and mythopoetical instruction—based on the former. Lam found inspiration in the semiotic imagination of the masks to reconstruct, on his own account, abstractly and within a personal imagery, what they achieved: the representation of the natural-fantastic, interwoven with an ambience and a conception of the world. This reconstitution was possible because of the cultural proximity. The African forms appropriated by modernism reactivated or recharged his symbolic language through a use of modernism from the standpoint of Afro-American culture. Afro-America as a plural entity facilitated this interconnection and multiple reconversion. The current thus flows from the traditional African plastic expression to modernism, to Afro-American culture, and once again to modernism. In a new space, the formal aspects become cultural.

Lam's figuration, deriving from Cubism, shifted away from the analytic breaking up of the forms, and their synthetic reduction, to move toward *invention*, with the aim of communicating, more than strictly representing, a modern mythology of the Caribbean. His figuration unfolded in a baroque display of natural and fantastic elements which were woven into a visual and signifying tapestry decoded by Desiderio Navarro[9] as symbolization of the unity of life, an idea proper for Afro-Cuban religions, where everything appears interconnected because all things—gods, spirits, humans, animals, plants, minerals—are charged with mystical energies and depend on and affect everything. In this direction many of Lam's paintings could be compared to the *ngangas* of Palo Monte,[10] receptacles of power where poles, grasses, earth, animal and human remains, pieces of iron, stones, signs, objects, spirits and deities are arranged in a sort of summing up of the cosmos.

Together with and implicit in this integral vision, Lam's art, with its interpenetrations of the terrible and the beautiful, the fruitful and the evil, the vital and the destructive, communicates a universe not governed by the good-evil, light-dark po-

larity of the Christian tradition that originated in the East. It corresponds to the plurality of the traditional Sudanese and Bantu religions, preserved in manifestations in America and in the new syncretic religions that fused here, in contrast to the dual extremism often found in the western consciousness.

Perhaps a link with Eleggúa also exists in Lam's discourse. He is the only god whose base-image Lam reproduced in his painting, as a recurring element in most of his canvases, without any traditional western critics, so illiterate in these questions, ever so identifying it despite the evidence. Although an explicit reference to the god appears in very few works, since it is used more as a customary component of his pictorial repertory, it is significant that it is the only figure or attribute that Lam adopted from all the paraphernalia of Santería, Palo Monte, Arará Rule, or the Abakuá Secret Society. His reference to Afro-Cuban imagery is very indirect. Almost no element is identifiable; even when the titles of the works refer to specific gods and their altars, they would remain unrecognizable even to the most erudite believer, since reinvention prevails over description. Lam's symbolism is very open; he himself has said: "I am not given to making use of exact symbology." [11] Eleggúa is the Yoruba and Ewe-Fon trickster, the uncertainty principle, diachronic, of change. Master of gates and crossroads, he opens and closes everything, but proves to be mischievous, unpredictable. The mutant sense of Lam's painting, where everything seems to transform itself into another unexpected thing, could be related to the god. The idea of metamorphosis seems to govern all his art. Also allied with Eleggúa is the displacement of perspective brought about by this art, regarding fundamental change itself and the cultural crossroads it represents.

Lam's painting is a "primitive"-modern cosmogony centered in the Caribbean, appropriating western methods of art and in the space opened by that art. He stated clearly his strategy when he declared he was a "Trojan horse." [12] Afro-American content thus penetrated the plastic arts of the West, setting off a battle to influence or be reified. This battle grew hot within the citadel of modernity, without the intention of setting it on fire but to take it by assault. The anti-colonial cut that the scissors of the personage of *La Jungla* proclaims (see fig. 5.3) does not seek a utopian rupture, but desires a displacement and simultaneously a synthesis capable of being legitimized by modernity, thus obtaining a nonwestern space within the West.

We are before a pioneering work that suffers from the contradictions proposed by its own strategy, for example, the permanence of a certain exoticism proper for the bedazzled western view, above all surrealistic, toward what is African and, in general, toward the "primitive," aestheticized as "mystery," "magic," "night," "darkness," "fantastic," and so on. But this work is not contradictory in itself, since it rests on assuming the complex contradictions of the postcolonial processes—evident in the biography of its author—in order to begin, along with work of other

231

Latin American modernists, the long road of a possible de-Eurocentralization of western culture, transforming it as metaculture of contemporaneity. Like Elegguá, it is a work of road crossings.

On his return to Cuba, Lam attained the expression that was to characterize him. He remained in the country between 1941 and 1952, achieving his most powerful work. At the time of his arrival, fifteen years had gone by since the appearance of modern art on the island, and it had already been completely consolidated. A second generation of the avant-garde gave the tone of the moment, with a vision that was *lighter* and more inward looking, different from the more direct and social focus of the first generation that had set the parameters for the decade of the 1930s and were still working with vigor. It formed part of the so-called Grupo Orígenes, with its essentialist, transcendental poetics based on metaphor, that followed a creole-white model in its construction of a Cuban identity, with the writer José Lezama Lima as its center. The profile of the painting of that time, above all in the work of the most typical artists, such as Mariano (1912–90) and René Portocarrero (1912–85), led Alfred H. Barr, Jr. to define a "School of Havana" distinguished by its liveliness and openness, in contrast to the "Mexican School." [13]

Lam fell onto the island as if from a parachute and did not fit into the scene very well. His painting coincided in formal ways with the painting then prevailing there, but such coincidences were contradicted by its aggressive and grotesque character and its being more in harmony with a vision from the standpoint of the Africanness in Cuba and the Caribbean, closer to the cultural ambience of the late 1920s and the 1930s, with the interest in black culture in literature (Alejo Carpentier, Nicolás Guillén) and music (Alejandro García Caturla, Amadeo Roldán), that was represented in the visual arts only in incidental or anecdotal form.

The avant-garde of that time was very refined and cultured, and knew how to appreciate Lam's work, even though it did not fit into their poetical-cultural scheme. But in the beginning neither the critics nor the artistic community valued the work to the extent it deserved. It is shocking that someone who had already exhibited together with Picasso—an idol for the Cuban painters—and whose work was shown regularly from 1942 on in a New York gallery, had no exhibit in his own country until 1946. His principal defenders were Lydia Cabrera and the anthropologist Fernando Ortiz, both of whom considered him an exile in his native land. [14]

Nevertheless, Lam exerted considerable influence over various Cuban artists during the 1940s and 1950s, and caused a move toward Afro-Cuban themes. Luis Martínez Pedro (1910–89) did a series of works superficially motivated by this approach. The major painter of the Grupo Orígenes, René Portocarrero, who admired Lam very much, internalized the strong impact he received from Lam. In two excellent series of the 1940s, *Figuras para una mitología imaginaria* and, above all, *Brujos*, Portocarrero inserted Lam into his personal poetics and, in general, into that of

the Grupo Orígenes. The result was like several Lams sweetened, harlequinized, de-sacralized, showing clearly the difference between the two world views, and between a living mythology and a carnivalesque version. Lam's influence, though widespread, was superficial, being assimilated more in its formal aspects and as a paradigm of imagery and fabulation than in regard to the change of direction it brought about, or even in the move toward a more introspective intuition of the Caribbean. He neither established any school nor left any followers, except in the case of Jorge Camacho (1934) from the 1950s—his principal adherent with his own method—and some epigonal figures at the beginning of that decade, when Lam had already achieved international renown.

ROBERTO DIAGO (1920–57)

That is not what happened in the case of Roberto Diago, a black painter and graphic artist who utilized Lam's influence in a personal manner, in works done between 1945 and 1949. He was the second artist in the history of the western visual arts to delve into the Afro-American presence in some of his work. But he did not concentrate in that vein; his work followed other paths at the same time, taking different courses, and was definitively interrupted prematurely by his suicide. His role in a modern expression of Africa in America remains debatable. Part of his production—*La silla* (1944), *Naturaleza muerta* (1946), and *El Oráculo* (1949)—may be seen as epigonal works of Lam. Another part, with its hues of 1948, could be related to that inner presence in the culture of the Caribbean of indirect traits of the African consciousness, derived from its world views, mythological thinking, and ethnopsychologies, which produced a natural bent for mythologization. Except for certain pieces, this might, in very general terms, color almost all of Diago's work. This latter phase became more explicit in the three *Cabezas de Elegguá* painted in 1949, despite the fact that they contain almost no reference whatever to the image, attributes, or symbols of the god, in a personal, very bewitching representation.

Orlando Hernández considers it more plausible to place Diago's use of Afro-Cuban elements among the attempts already mentioned of work by various painters—Portocarrero, Martínez Pedro, Mariano, Mario Carreño (1913), Cundo Bermúdez (1914)—during the decade "tending to find in the plastic representation of characters, musical instruments, clothing or ritual ambiances of the Regla de Ocha or the Abakuá sect [sic], the blessing of a utopian 'national style.'" [15] For a complete appreciation of this artist, quite forgotten, investigative research and exhibitions are urgently needed, above all, a retrospective of his work.

MATEO TORRIENTE (1910–66)

Mateo Torriente is a unique case of Lam's influence on the Cuban artistic environment: probably the only one to whom that influence gave rise to a direction for a personal poetics. Perhaps this is because the influence here was produced on sculpture by the painting, and from a world view of African dominance to another world

view that came from the rural countryside, itself "Africanized." Sadly, this mulatto sculptor is also quite forgotten. No investigative research has been done that might permit a rigorous interpretation of his work; not even a chronology of it exists.

He was born and worked in Cienfuegos, a port city, where a local artistic scene arose during the 1940s to 1960s with its special characteristics that spread throughout the central region of the island, inspired by the writer, painter, and folklorist Samuel Feijoo. He fostered an interest in nature and in the rural culture using an intuitive, festive, and open approach. Beginning in the 1950s he sponsored a movement of *naive* artists, stimulated also at the beginning of the 1960s by the folklorist José Seoane Gallo. This movement was at first characterized by creations of a bucolic creole atmosphere, and later by its power of popular fabulation thanks to its abundant fantasy and plastic ease, which was admired by Dubuffet.

From the end of the 1930s Torriente made female figures reminiscent of Maillol, a mode that Agustín Cárdenas would follow a decade later, as we shall see. Torriente's works showed greater ease, giving them a personal accent and revealing for the first time an aware searching for a Cuban expression in sculpture based on elements of our own nature. He was inspired in that direction by Feijoo, who pointed out that "there does not appear in any Cuban sculpture the trunk of a banana tree, nor the form of a *cangrejo moro* [black crab], nor the tiny head of a *zun-zun* [hummingbird], nor the belly of a *güiro* [bottle gourd]."[16] The female figures integrated elements of nature, generally marine motifs, in complex compositions, that became more and more abstract, in a language recalling soft sculpture, even when Torriente was working in stone or plaster. It is probable that this process was influenced by the *naive* painters and graphic artists, among whom a style of "automatic" drawing predominated, with sensuous, "careless" lines.

Apparently Torriente came under Lam's influence around the end of the 1940s and the beginning of the 1950s. The human figures disappear and his work concentrates on animal forms, particularly sea creatures, and vernacular musical instruments, becoming more and more abstract and "automatic," with sharper forms, but without ever losing the figurative origins. His poetics stayed within the creole-rural-white line of the cultural movement generated in Cienfuegos, but gradually bent more toward its fabulating side and a more "Antillean" vision, as one of his pieces was titled, a word that in the language of the time denoted a prominent place for components of African origin,[17] the vision determined by the presence of an Africanized aesthetic.

This process culminated in the *Güijes*, the title of some works probably done at the end of the 1950s, and others made in terracotta in the early 1960s. With this technique he achieved his most significant results, within a smooth and spontaneous rusticity, with a language of synthesis in which seeing examples of Arawac pre-

Columbian ceramics of Cuba must have also played a part. The *güije* or *jigüe* is a rural trickster of African origin alive in folklore, not in the Afro-Cuban religious systems: a black spirit, mischievous and lascivious, associated with rivers. He represents a point of contact between the culture deriving from Africa and the rural culture of European stock, a figure of infiltration of the former with the latter.[18] With the *Güijes* and a few other similar works, this contact takes place in the very inmost space of Torriente's sculpture, which opens to a natural, warm mythologization, and not only to an assimilation, also natural, of forms and sensibilities of African roots. The process, as in Diago, corresponds to that spontaneity for fabulation found in the Caribbean, linked with the active presence in the culture of living mythological systems of sub-Saharan origin.

AGUSTÍN CÁRDENAS (B. 1927)

Curiously enough, it is without Lam's influence, along a different road, that the second artist appears to establish a landmark in Afro-American plastic expression: the black sculptor Agustín Cárdenas. He received his academic training in Havana at the end of the 1940s, and worked in a studio executing commissions of an academic and Bourdellian style. Nevertheless, it was there that he saw plates with reproductions of the work of Arp, Brancusi, Moore, and other modern artists. Between 1949 and 1951 his personal work veered toward the monumental style quite widespread throughout the 1930s, with short round female figures, epigones of Maillol and of Picasso's "Pompeian" phase. Around 1951 these figures moved away from naturalism in search of a formal synthesis, seemingly under Moore's influence. In the midst of that process of breaking with the strictly figurative, he ran across a photograph of a Dogon carving in a book in 1952 or 1953, which made a profound impression on him, to such an extent that it gave rise to his personal style, which became abstract or semi-abstract with an organic reference. Strictly speaking, all of his work preserves a certain figurative reference, but carried to the limit of abstraction, and often the result of a spontaneous working of the material.

In those years he belonged to the group called Los Once, composed of eleven nonfigurative painters and sculptors who introduced abstract expressionism into Cuba, in contrast to the creole coloristic stereotype of the "School of Havana." In 1955 he received a grant and settled in Paris, where he has continued to work in wood, marble, and bronze within the great "artisan" tradition of sculpture.

The Dogon image seen, and later studied, by Cárdenas must have been a mythological ancestor figure, the theme of the plastic art of the Dogon people, whose typology can be perceived intertextually in the work of the Cuban sculptor. But in order to do so it is necessary to observe some of these carvings from behind. From the back the play of the masses has an almost abstract character, similar to the sculptures of Cárdenas. These mythological figures are sometimes a couple, repre-

senting the "Adam and Eve" of the Dogon people, and the theme is incorporated by Cárdenas in those years, with very similar treatment, as may be seen in *Los enamorados* (1956), the famous *Pareja antillana* (1957), and *La pareja* (1958).

To turn African sculpture around, to look at it *from behind*, was to become a metaphor for the pieces created by Cárdenas. Under the influence of some abstract modernist sculptors such as Arp, Brancuşi, and Moore, he internalized the formal and compositional play of a certain type of African plastic art while moving away from its figurative representation. Contrary to what had been done by the European modernists on the one hand and Lam on the other, Cárdenas appropriated the abstract-structural elements of African plastic art, not its solutions of figurative synthesis nor its cosmogonal and mythologizing representation. By this method he achieved a very personal nonfigurative work, endowed with an emphasized carnal sensuality, that constitutes the first appearance of a sensibility of African origin within the corpus of western abstract art.

No precise iconic references nor any meanings pointing to African or Afro-American cultural heritages exist in his work. There are indeed a few titles taken from Santería: *Ebó* (1956) (ritual sacrifice); *Iroco* (1968) (deity of the Ceiba, sacred tree, and of the Abakuá Secret Society); *El Cuarto Fambá* (1973) (place of cryptic ceremonies); *Senseribó* (1957) (a sacred drum). What Cárdenas introduces into modern sculpture is an aesthetic of African inspiration; over that axis he constructs all of his work, without thematic or even direct formal references. Indebted to Arp, Brancuşi, and Moore, to Arp most of all, it is the internalization of that aesthetic that differentiates him from them, giving him a special personality despite the closeness of the languages. These three sculptors, like so many modernists, sought and received inspiration from African plastic art, but they used their lessons as instruments for a western avant-garde poetics. Similar to the case of Lam, although in another direction, it was again a Cuban who internalized a cultural heritage of African origin to work from it within modernism. If the modernists renewed western ways of seeing thanks to, among other factors, the appropriations taken from "primitive" cultures, Cárdenas works—the expression is apt—from inside those "primitive" cultures as a modern formalist. Such a difference of direction, of sense, proves to be crucial in order to assess his historical importance. If indeed he contributed, as Lam did, to the renewal of western art, at the same time he helped to de-Eurocentralize it, moving it in the direction of plural and peripheral, multicentric or hybrid perspectives, from and toward the nonwestern, within spaces and practices of generalized western origin in the contemporary world, in contrast to the hybridized and syncretic forms from and for the West.

It is significant that Cárdenas should have been the only artist "whose name is known" shown in the section "La Hora de los Pueblos" (The Hour of the People),

dedicated to popular culture in the UNESCO journal, when it was directed by the Caribbean writer Edouard Glissant, a great admirer of Cárdenas' work.[19] In this surprising way a modern artist was associated with collective cultural manifestations. In the published text it was emphasized that art "is not an elitist adventure but a testimony rooted in the society that produces it."[20]

If this Cuban artist was able to internalize an African plastic sensibility and construct his work based upon it instead of only using it from the standpoint of modernism, it must be due to a cultural experience that made it easy for him to assimilate that sensibility naturally. As José Pierre says, "in discovering himself, Cárdenas discovers Africa."[21] He was educated in a black milieu in Matanzas, a city that has been called "the Afro-Cuban Mecca" for the abundance and preservation of sub-Saharan traditions, and at the same time is known as "the Athens of Cuba" for the splendor of its intellectual life, particularly in the nineteenth century. Although Cárdenas was never initiated into Santería or any other religion of African origin, and only one brother among his family members was a practicing member of Santería, the cultural surroundings of his childhood and youth must have made a deep impression on him, allowing him to recreate rhythms, structures, and sensibilities that did not seem foreign to him.

The path blazed by Cárdenas was followed from the 1960s and 1970s by the black artists Rogelio Rodríguez Cobas (b. 1926), Ramón Haití (b. 1932)—both of whom worked in wood—as well as other Cuban sculptors, each with his own imprint. Unfortunately, since then such work has been thoroughly cheapened by numerous carvers who make decorative Africanized objects destined for the tourist trade.

MANUEL MENDIVE (B. 1944)

With Manuel Mendive a third historic landmark was reached in the expression of African origin within western art. With Lam a change of direction occurred toward the communication of meanings of African origin within the propitious space of modernism, instead of the instrumental appropriation of its signifiers by modernism, but with Mendive came the first direct expression ever produced in Afro-American plastic art from within its religious-cultural space. Mendive is the first "cultivated" artist who works from the knowledge and vision given through religious initiation into Santería and Palo Monte. In addition, he comes from a mulatto family with a long tradition in Santería, where its practices have been customary.

Mendive also graduated from the Academia de Bellas Artes and studied art history. The look of his work should not be mistaken: we are not before a *naif* but before an artist with professional training who makes use of methods of "primitive" art, among others, along with appropriations from the plastic art of other cultures (e.g., ancient Egypt and Dahomey), as a strategy for transmitting the mythological

237

content of his world view. In contrast to what happened with Lam and Cárdenas, the intertextuality with African plastic art does not constitute a fundamental axis in Mendive's work. Perhaps only the stamp can be recognized, in the figuration and color of his first phases, from the canvases with appliqués and polychrome reliefs of the palace and temples of the Fon in Dahomey, and the Yoruba reliefs in wood. Something similar occurs with respect to the Afro-Cuban visual art: in those phases only a certain formal link may be noted with figures embroidered with conch and cowrie shells and segments of reeds on the *bandeles* (skirts that cover the drum Iyá, the largest of the set of *batá* drums, during important ceremonies) and on ritual garments and cushions used by the *santeros*. Later the reworking of the iconography of Elegguá and of some attributes of the orishas appears. He has also used from time to time some methods and techniques, such as stippling of colors, taken from motifs of body painting and from the markings of objects in Santería ceremonies. In addition, perhaps the ingenuous forms of representation that in Cuba were supplanting the original Yoruba iconography exerted a general influence.

In his case the decisive element is not the reworking and resemanticization of African or Afro-American forms. In this respect it is rather the use of basic methods of the religious plastic art of the sub-Saharan and other nonwestern cultures, of their structural and narrative peculiarities, among other things, rather than a grounding of his work on iconographic or morphologic considerations. It was to amount to the incorporation of an entire language expressing a vision of the universe.

Mendive takes advantage of a living mythological body of thought as a pathway for the representation of the world and a reflection on general problems of the human race. He does so with the naturalness typical of many Cubans when they interpret events and questions of contemporary life in a mythological manner, or when they use on a daily basis mystical means to influence such events and questions. And so Mendive projects the myth toward life, toward reality. That is why, in addition to presenting the pure Afro-Cuban mythology with a sense of universality (e.g., in *Endoko* [1969; fig. 9.1] the sexual act between Changó, god of fire and virility, and Ochún, the Afro-Cuban Venus, is accompanied by "impossible" acts of coitus between different animals and between animals and human beings, in a transcendental allegory of the union of the diverse), he concerns himself with historical, political, and genre themes as well as current events, all treated within a mythologizing interpretation. For him myths constitute only an artistic strategy to be used in applying a system of daily thought to art. For Mendive, as for an *aeda* (poet/performer) of heroic times, mythology is real in the widest meaning of the word.

It is important to emphasize that he does not produce religious objects but *paintings* in the current western sense of art as an activity autonomous of practical or religious ends, especially designed to communicate complex aesthetic-symbolic

FIGURE 9.1.

Manuel Mendive, *En-doko*. 1969. Oil on wood panel. Courtesy of the artist.

FIGURE 9.2.

Manuel Mendive, *Ob-
batalá*. 1968. Mixed
media. Courtesy of the
artist.

240

messages. Nevertheless, *Erí wolé* (1968) is a hybrid product. The canvas was a way
to explain mythologically an event in his life: a traffic accident in which he lost part
of his right foot. Here the painting is the instrument to interpret an event in accord
with the combined actions of gods, forces, ancestors, human beings, and objects,
discerned by means of its graphic representation. For such a purpose he has not used
religious means: he has made a picture in the modern sense. But this painting is a
very strange cultural object, because it lacks a ceremonial meaning in Santería, and,

at the same time, it has served as instrument and representation of a living, real mythological reflection, connected with acting gods. Mendive has never exhibited this work, which hangs in his house. The reverse process has also occurred: his paintings with representations of the orishas have been used as religious stamps, certain powers being attributed to them. Finally, his multidisciplinary works have included true ritual details, such as the bunch of bananas, offering to Changó, that hung in the Museo Nacional de Bellas Artes of Havana as part of the installations of his one-man show there in 1987.

The evolution of Mendive's work[22] might be seen as a process of internalization of myths as means of artistic investigation. In the mid-1960s he began with a very lively and profound vision of the myths of Yoruba origin as preserved and readapted in Santería, in what is still the moment of the highest artistic value of his trajectory. His depiction of the Yoruba god Obbatalá (fig. 9.2) is a good example of this so-called "dark phase": somber works, where painting and sculpture are fused, made with cast-off material, medals, charms, and human hair, burned with fire or subjected to acid, imbued with an impressive appearance of real mystical objects. A convergence takes place between the fetishization of the object proper to western art and that in turn to religion, or better yet its appearance. In these works we are in the presence of an artistic representation, in western terms, of the mythological *corpus* of Santería, but created from within, by a bearer of mythological thought who is at the same time a modern artist. His seriousness and commitment toward both sides moved him away from the least trace of the folkloric, and furthermore, his vision went beyond the anecdotal side of myth toward its generalizing reach, in a reflection about life, humanity, the world. With that personality so uniquely his own, Mendive was one of the main actors of the expressionist line where the best of Cuban plastic art of the second half of the 1960s was manifested, a line that also constituted one of the principal aspects of Latin American art at the time.

Beginning in 1968 Mendive's original orthodoxy began to break up and the "light phase" arose: a lessening of sculptural elements and collage in favor of painting, heightening of the color, stylization, and softening. Myth was opened to historical facts, everyday life,[23] to the *costumbrista*, and current political events, following the general trend of the 1970s in Cuba. But in the case of Mendive it was a question of an organic unraveling of his own creative axis, not a forced adaptation to an official task, a major cause of the poverty of Cuban art and literature at the time. Some of his works of the early 1970s still remain among the few worthy ones of that decade, precisely because they were not typical of it. After that moment, his painting was gradually emptied of meanings and fell into an oversweet decorative style that was to continue until the 1980s.

Trips to Russia and Bulgaria in 1981–82 motivated the beginning of a transi-

tion. Mendive, without any conflict whatsoever, applied his artistic vision to scenes of those countries, incorporating some local legendary personages, demonstrating clearly that his painting was not a result of myth as theme but as method, or, it would be more precise to say, as a shaping world view of a global nature in art, daily life, and existential orientation.

But it was starting with his trips to Africa in 1982 and 1983 that a new phase opened. An overflowing of fantasy took place that led him to a frenetic invention of fabulous beings not taken from or inspired by any myth at all, creatures of his personal imagination. If earlier he had represented, recreated, displaced, and interpreted the *patakis* (Santería myths), or life starting with them and their gods and forces, now he invented his own. The fabulating agitation went in tandem with a certain baroque quality that attenuated the somewhat more static aspects of his designs and yet gave them greater proliferation, dynamism, and complexity without breaking that orderly construction characteristic of them. The formal changes include a stronger inclination for muted and earth tones and now the use of chiaroscuro, transparency, and other more "pictorial" methods, which break with the flat colors and emblematic stippling of his style. There is a sort of drawing away from the decorative in search of the expressionist mode, and away from the "naive" toward the "professional."

Around 1984–85 the gods disappeared completely as did concrete references to daily life and history or current events. The images are more general, more abstract. Mendive likes to say that he simply shows us life itself,[24] and it is the most accurate statement he could make. His painting is a metaphor of the elemental forces of the world, an anthropomorphized world where man is not the main center but an element of the natural order, a "living nature" (in contrast to "dead nature," *naturaleza muerta*, the Spanish phrase for still life, according to a comment Ortiz made apropos of Lam),[25] where everything is animated in the most literal sense. As in Lam, we see an intuition of the universe as balanced transformation and interpenetration of all existing things. Animals, forces, plants, humans, and mountains commingle, lose their taxonomy, mix in a sort of vital continuum. More than elements, they are functions of a cosmos that is devouring itself, loving, communicating, some giving birth to others, in a chain that establishes the universal equilibrium. A "fantasmagoric ecology," in the words of Knafo.[26]

Myth has evaporated as anecdotal base, but has evolved as methodological foundation, in the direction toward which Mendive's work always pointed. Only Elegguá, just as in Lam, remains recognizable, precisely by being the god of communication, who opens and closes everything. The myth is now "underneath," facilitating the projection of Mendive's fantasy, a systematic imagination despite its exuberance. That is why it is not only the narrative character of this painting that recalls

the Nigerian Amos Tutuola novels, which are a lineal succession of actions with chimerical beings, closely linked to Yoruba folk tales, not with religious myths. Various painters of the "School of Oshogbo" (coming from that city of Yorubaland at the beginning of the 1960s, fruit of the free workshops created by the anthropologist Ulli Beier) have also given free rein to a fabulation proceeding from orality, by means of spontaneous, personal languages, with no direct connection with traditional Yoruba plastic arts.[27] The painting comes from the world view and sensibility of that culture, but from everyday folklore, not from "institutional" thinking. It seems to be a tendency common to many modern African artists without academic training.[28] The poetics of these artists is akin to that of Mendive.

I am speaking only of a similarity that their basic cultural slants may have. Mendive is a professional, but comes from a popular background, reared in surroundings that preserved the African religious and cultural heritage, which he continues and projects toward other spheres. Now he creates his own myths instead of representing those of the tradition, but his own are rooted in that tradition and are the offspring of mythological thinking, taken from a living, familiar, internalized mythogenesis. Moreover, he is a bookish expert on Africa, and from his beginnings has appropriated methods of African cultures, although naturally within the closeness that kinship offers. Every day this type of erudite reappropriation from Africa becomes more frequent, done by Afro-Americans who are both knowledgeable about these traditions and "educated" in western terms. It is a typical phenomenon of the multidirectionalism of today's cultural processes, and entails transformations in all directions. Mendive's work comes from and provides metaphor for the complex mélange of the Caribbean, its ethnocultural mixings and its blendings of time, but starting from the African presence, and all this can make room for transatlantic connections.

Since 1986 Mendive has been occupied with interdisciplinary works in which he paints the bodies of dancers and animals (pl. 21). It is a plastic art of movement and sound, a mixture of painting, sculpture, dance, music, pantomime, body art, song, ritual, spectacle, performance, carnival, and procession, where the new, the "cultivated," and popular forms are intertwined. These works correspond to the current projection of his painting, also lacking any literal references to Afro-American dances, ceremonies, or myths, all kept within a generalizing, only slightly allusive, representation. The Afro-American essence again acts like mortar in the use of the *batá* drums, Yoruba song, gestures and movements of dancers and musicians, the possible symbolism of animals and of other elements included. Unfortunately, the possibility of communication has been left on the sidelines as well as the popular participation that the work had in the beginning, with the result that it is involuntarily slanted toward providing a spectacle for foreigners.

THE NEW
CUBAN ART

Since the end of the 1970s, a new movement of artists began stirring in Cuba, trained entirely within the revolutionary period. In the 1980s they unleashed a movement that broke the dogmatism and cultural closure imposed during the previous decade; the visual arts were renewed and, through them, all of Cuban culture. The artists sought to make art without restrictions or impositions, to take advantage of the languages and methodologies developed since the 1960s in the West (especially conceptual art), to be receptive to information, and to defend an autonomous space, and an ethic, of artistic production. The show Volumen I opened in Havana in early 1981 and has remained a milestone marking this rupture that ushered in the moment of greatest energy in all the history of Cuban plastic arts, a "Cuban Renaissance," in the words of Luis Camnitzer.[29]

One of the crucial traits of this new art is that the majority of its protagonists come from varying popular groups of Cuban society, where they remained immersed until the massive diaspora of intellectuals that took place in the 1990s, the consequence of a new cultural closure and the crisis of the country.[30] This particular trait was the fruit of a new system of free and generalized art training in place since the early 1960s, and of the social dynamic of the revolutionary process in Cuba. Active bearers of folklore but at the same time being university-trained professionals, they make art that is "cultivated," "up-to-date," shaped from within by the values, sensibilities, and visions of the world of those various vernacular groups. It is a matter of constructing the "cultivated" from the standpoint of the popular, that, in fact, diversifies and de-Eurocentralizes the "cultivated" culture. It is not the "primitive" or the vernacular in the "cultivated," but practicing it.[31]

This change of centralities foretells processes of transformation in art and culture, originating in the subordinate world. Where it proves most radical is in the cases of artists who are practitioners of Afro-Cuban religions or brought up in surroundings with a long tradition in those religions. These young people constitute a fourth landmark in the expression of African origin in Cuban plastic arts. If Mendive works from within the Afro-Cuban focus, making use of myth and through "neoprimitivism," the younger artists give priority to the philosophical bases, the "cosmovisual," let us say, the Afro-Cuban thought in works of a conceptual type that attempt an interpretation of the world and the construction of an ethic from a nonwestern stance, with the aim of taking on contemporary problems. In some cases they modify the very character of art by bringing it close to a mystical-existential practice, within personal liturgical processes. The descriptive, formal, and mythological aspects are minimized in order to work with the content itself, from the interior of those world views, bringing a new spirituality to the art of the avant-garde.

It might be argued that these artists are making western culture from nonwestern bases, and therefore transforming the culture in a pluralistic direction. But at the

same time one might say that they are constructing postmodern Kongo or Yoruba culture. More than hybridization, there is a change of direction.

Such an intercultural option assumes the western metaculture as "international" culture of the contemporary world, but actively contributes to the process of de-Eurocentralization that is going on because of syncretism and, above all, recreating and using for itself elements that other cultures take from it. I like to point to the practical utopia that the Third World will make western culture, the reference being to the bud of a possibility of decentralization that flowers not only into a hybridization, but into a more aggressive action of the nonwestern as creator of contemporary culture from itself. It involves acting with components of European origin in conformance with the global metaculture, and at the same time dewesternizing and transforming the metaculture in a plural direction.[32]

JUAN FRANCISCO ELSO (1956–88)

Juan Francisco Elso has become the prophet of this perspective and of all the new Cuban art. White, from a Catholic family of popular background, initiated into Santería, Elso has produced work in which the African presence acts as structuring axis, together with Amerindian world views. Here that underlying framework is not explicit and neither can it be said to be strategy, sensibility, or mythology. It appears as a molding factor in all the work and as methodological mechanism, in combination with other cultural sources. Even when some evidence of it can be identified, for example, in the piece titled *Los contrarios* (1986), referring to Changó in the form of a double-bladed ax,[33] the discourse of the work regarding the union of opposites as generatrix energy alludes to the god only within very general meanings: his phallic, vital character, and so on.

For Elso, art was a mystical process of identification with the world through Latin American world views, as well as a process of ethical-existential orientation linked to his inner life, of direct significance for his own development. Thus some important ingredients are not made explicit in the works, which really represent final moments of certain parts of the process, codes by means of which Elso shared his insights. For example, in *Por América* (1986) the image of José Martí, the Cuban national hero and outstanding intellectual and writer, is "charged," in the manner of a Kongo *nkisi*, with the artist's own blood mixed with that of his wife, together with other elements hidden within the body cavity of the figure. The wood carvings that form part of the pieces *La fuerza del guerrero* (1986) and *El viajero* (1986) are also "charged" in their interiors in the African and Afro-American manner, with elements that give them power: a stone from the Andes, a conch shell from Africa, soil from various places, seeds. The spectators cannot see all this, nor are they informed about it. They are components that possess a ritual and symbolic character in a real dimension (as personal ceremony), and simultaneously act in another dimension as

artistic meanings. But they are hidden meanings that contradict the semiotic character of western art, whose function is to communicate aesthetic-symbolic messages. It is as if the symbolic force of those elements in Elso were to be of use only in a cryptic manner, like religion, as esoteric power of the image.

Let us remember that for African and Afro-American cultures the importance is not in the image, but in the force that has been made present in the image through ritual. In making art Elso used methods meant to be employed in making religious objects. On the one hand, this was a tropological figure in his art in western terms. On the other hand, it formed part of a personal and cultural mysticism that placed his works outside those terms.

In conception and method, Elso's art regressed somewhat to merge once again with the mystical procedures, the education, consciousness, and religious-cultural practice of premodern America, recycling its bases as ways to sense the cosmos and harmonize the human relation with it. Without ceasing to be art in a modern sense, it remained at the same time very much within nonwestern intuitions of the world; from those intuitions he began to conjecture with a contemporary perspective, although of transcendent breadth. This double-sidedness was made eloquently clear in the reception his work provoked. A Boston critic said: "These objects have a power beyond their craftsmanship, even beyond aesthetic means," [34] while another remarked that "they radiate a kind of sublime transcendence." [35]

More than an art of process, his was part of the process of the spiritual life of the one who made it. But the processes themselves were of the greatest importance in his works, to the extreme of going beyond the temporal in order to structure the spatial dimension: thus the materials, in addition to being elements of construction, and beyond possessing a symbolism within themselves, were principal agents of the process in which the works were participants. Elso said they consisted of ends, not means. With fresh clay he captured, really and ritually, the trace—the power—of an ear of corn, that thus returned to the earth from which it sprang, while its grains "charged" some other piece or sprouted right in the gallery.

Elso also used art as a path for transcendent knowledge and affirmation, based on the Latin American cultural heritage, from which he constructed an ethic. His art was also a kind of American mysticism where the magical and the political, the personal and the sacred, the present and the ancestral, the mythical and the historical were woven together. The epitome is the stunning image of Martí, at one time icon of revolutionary mysticism, seat of power in the African mode, baroque imagery of popular Latin American Catholicism, Odin sacrificing himself to himself.

The *babalso*, priest of divination in Santería, begins the ceremonial divinatory process of the oracle of Ifá by saluting the gods, and then the spirits of other deceased *babalsos*, and asking them for their collaboration, intoning the name of each

one. This is called *moyubar*. When Juan González does so, almost daily, in the village of Regla, he invokes the name of Juan Francisco Elso. González was Elso's *padrino* (godfather, sponsor) in Santería, but says that the artist was an extraordinary person, and that is why he now solicits his spiritual aid when calling on the oracle. In this way Elso, who veered away from the Afro-Cuban culture to structure his "high" artistic work which is exhibited in specialized circles, has returned in a surprising way to be part of the popular practice of Santería. This emphasizes the special significance of his personality and his scope.

JOSÉ BEDIA
(B. 1959)

The work of José Bedia has developed from the same perspective as that of Elso's—they were very close friends and, together with Ricardo Rodríguez Brey, shared the same interests—although Bedia's work has a more conceptual, analytical, and expository character. Also white and coming from a popular background, Bedia was initiated into Palo Monte in 1984 and has been involved with Santería.

He has always been very drawn to the "primitive" cultures, especially those of the Indoamericans. His first works were images of North American Indians painted in Pop art style, as well as Mayan motifs treated in calligraphic fashion, works more conceptual in nature, with objects inspired by American archaeological finds, and also collages on Indoamerican themes. His living contact with the Afro-Cuban culture drew his interests in that direction, and gradually modified the ethnographic character of his art, which had come from reading about the aboriginal cultures, and turned him toward an internalized expression of Afro- and Indoamerican world views. Up to the very year of his initiation he adopted a style of great simplicity that identified him, based on the iconography of the Plains Indians of North America, on the ingenuous drawings of practitioners of Afro-Cuban religions, and on comic strips. He also adapted texts written in irregular Palmer handwriting style, that in the future would appear in his works. With these methods he attempted Afro-American subject matter for the first time. From this moment on he defined his mode of expression, characterized by an ethical-philosophical-religious reflection concerning the relationship of human beings with the world, from Afro- and Indoamerican viewpoints, by means of a very personal graphic language used in drawing, painting, and installations together with objects of various types. His work has gradually become more and more indirect, and he now mythologizes contemporary affairs with greater freedom.

Bedia has proposed for himself a revolutionary strategy: a voluntary noncolonizing transculturation toward the "primitive." He has said, "I am a person with western training who through a voluntary, conscious, premeditated system of an intellectual order attempts an approach to the 'primitive' cultures in order to experience their influences in a transcultural manner. Both of us are thus midway between

'modernity' and 'primitiveness,' between the 'civilized' and the 'savage,' between 'western' and 'not western,' only we are coming from opposite directions and situations. From this recognition, and on this boundary line that tends to break, comes my work." [36]

Bedia's work is simultaneously, in the broad acceptance of the terms, cosmology, anthropology, and an ethic concerning the relationship of humankind with the cosmos: a vast poetical interpretation of the world as ecumenical and contradictory fabric, not dual, but one that affirms the possibility of equilibrium. In using as base, to a large extent, the living cultural heritage of African origin present in his own culture, for making art of an analytical type that is also very widespread internationally, Bedia is the agent of a response of the Kongo and Yoruba cultures to contemporaneity, and acts as constructor of "postmodern" Kongo and Yoruba cultures. This breaks the orthodoxy of the tradition to confront the contemporary situation from the standpoint of visions and values of subordinate cultures that cease to be traditional in order to become active components in the reality of today.

The breakup of monisms is manifested in all dimensions of his work, for example in the symbolic aspects. Orlando Hernández has referred to how difficult a positive reading of Bedia's codes are,[37] by virtue of a double problem underlying the simplicity of his images: on the one hand, placing very diverse signs, taken from dissimilar cultures, in relation to each other to organize meanings in each work; on the other hand, superposing multicultural symbolic keys in one sign. Something similar occurs on the constructive-formal plane. In his methodology, on the same hierarchical level, methods of the *mainstream* and techniques of popular artisanry converge, real religious objects and kitsch, cryptic signs and vernacular witticisms, materials taken from nature and technological products, all integrated in a completely natural way. It is not only a question of hybridization, but of transformation of functions and contents. For example, in availing himself of Afro-Cuban techniques he does not seek to reproduce their aims: he creates with them elements to articulate his own discourse and iconography. By means of the iconography he has given a face to sacred beings and forces that do not possess them in Palo Monte or in Santería. His poetics rests on a complex codification of materials and techniques. All this corresponds to that "panhumanism" pointed out by Hernández,[38] with his invocation of a plurality of discourses. In 1990 Bedia settled in Mexico and since 1992 has lived in Miami.

RICARDO RODRÍGUEZ (B. 1955)

A mulatto initiated into Santería and brought up in a family of practitioners, he has been identified by his conceptual drawings executed in a plastic elaboration of utmost delicacy. The paradoxical lyrical conceptualism of his drawings has served him to express simultaneously both the poetry and the concepts of world visions of Yoruba and Kongo origin. In these austere and infinitely subtle works there is noth-

FIGURE 9.3.

Luis Gómez. *Los gen-*
darmes del Umbral.
1992. Installation. 300
× 250 × 50 cm (118 ⅛
× 98 ⁷⁄₁₆ × 19 ¹¹⁄₁₆ in.).
Courtesy of the artist.

ing that recalls Afro-American visual stereotypes—especially those of the Carib-
bean—of color, rhythm, gaiety, and highly baroque style. His work is concentrated
on a very restrained poetical elaboration of the philosophic-poetic-religious foun-
dations of Santería and Palo Monte. Thus, in the drawings of 1987 Elegguá
does not appear in his avatars nor in his ritual effigy: he is reduced to the stone that
the initiate must search for in nature and that, after the god has placed himself in it,
will govern the initiate's personal path. God and stone are open to multiple mean-
ings in a poetical-conceptual discourse regarding the substance of the created and its
powers.

Until the mid-1980s he began to make installations where drawings merged with sculptural elements, to the point where the sculptural predominated, under Elso's influence. In some drawings a too literal influence of Elso was also noticeable. The installations have been moving away more all the time from all Afro-Cuban visual references for the benefit of a more indirect expression of their ambiences and general meanings. The emotive character is developed in detriment to the conceptual side. Commissions in Europe—the artist has lived in Belgium since 1991—has allowed him to make larger installations in specific environments, such as the installation done for the IX Documenta in Kassel in 1992, resulting in works where the Afro-American element acts on a more internal level, like a substratum of a particular spirituality expressed through art. In these works the Afro-Cuban mystery, from the unconscious, guides the construction of an artistic discourse that probes the religious emotion of the esoteric.

**LUIS GÓMEZ
(B. 1968)**

Gómez was closely connected with Brey and Elso, and was influenced by both of them and by Bedia. He is a mulatto and initiated into Santería. His personal line, characterized by the greatest restraint and plastic austerity, could be summed up as a sort of "minimalism" in work stemming from world views of African origin. He has concentrated to the greatest degree his most general meanings in drawings and installations that often come close to abstraction. But it is a "charged" abstraction, filled with nonwestern mystical connotations.

If Cárdenas introduced African aesthetics into the nonfigurative plastic expression of the West, Gómez has introduced its mysteries. It has to do with his use of cryptic signs, with the ritualistic character of painting with blood or smoke, within an aesthetic of great austerity. His installations with metal plates, carved wood, drawings, and signs constitute perhaps the highest degree of formal restraint and concentration of meanings achieved by a presence of Afro-American origin in the visual arts (fig. 9.3).

**SANTIAGO
RODRÍGUEZ
OLAZÁBAL
(B. 1955)**

Santiago Rodríguez Olazábal, on the other hand, refers in a direct manner to Santería. He comes from a white family with a long tradition in Santería, into which he was initiated. He is also a scholar of Santería who has studied it in depth, not as an anthropologist, but as a practitioner. Although unlike Bedia, Brey, Elso, and Gómez, there is a literal working with Santería, it is made, just as in the earlier works mentioned, with a conceptual sense, seeking to communicate its religious-cultural thinking, its fundamental meanings. It does not veer toward the formal or the mythological, as usually happens with most of the artists who treat Santería as a direct theme, and who at times fall into mere illustration or exoticism.

His work is a sort of artistic treatise on Santería, that comes out of his personal

FIGURE 9.4.

Santiago Rodríguez Olazábal, *Sin título*. 1984. Mixed media. Courtesy of the artist.

erudition. It includes ritual texts in Yoruba, numerical divinations from Ifá, signs, and so on, always from an interest in the meanings. At the same time he may use a figuration of the western tradition in his paintings, drawings, and installations. This has to do with a certain emphasis on the Catholic elements appropriated by Santería, an aspect not usually treated by artists. On the one hand there is a strictness in the Yoruba cultural heritage; on the other, a development of the Catholic side having to do with the orishas and certain liturgies. Often these works show a great visual array, sometimes with images taken from the history of art. The figure of Christ, especially, has very often been used by the artist (fig. 9.4).

At other times Olazábal cites the iconography of ancient Egypt and the East, as well as of other cultures. He does so not only as a formal method: he seeks to establish a relationship of the Yoruba people with other cultures, projecting Santería in an

ecumenical and universalist sense. This "universalism" does not rest, as in the cases of Bedia and Elso, on generalizations of a philosophical nature, which move away from the intrinsic specifics of Palo Monte or Santería. He starts from the specifics and attempts to metamorphize coincidences with other systems.

The artistic assumption of the Afro-American presence is manifested in Marta María Pérez in a unique manner. She has been the first to treat it on her own body and in relation to her feminine experience, using her own photographic image. She began from her experience of becoming a mother, starting with her pregnancy in 1986. In that way she has used her immediate life experience to make art in the series *Para concebir* (1986–87), regarding gestation, *Recuerdo de nuestro bebé* (1987–88), in the form of a photograph album about birth, nursing, and child raising, and a third series on the mother-child relationship. In these works she has allowed us to know a physical vision of maternity, consisting of infants' constant demands, fluids, and scars, stripped of its lyrical account. At the same time, she has linked that experience to popular beliefs, within a tense ambiguity. Her work possesses both testimonial and emotive aspects. The anti-romantic exhibition of maternity, based on the "objectivity" of the body, is communicated by visual tropes. In her art the physical throbs together with the imaginary, the personal with the mythifying. It is the only case of a "feminism" centered in world views of sub-Saharan origin. It constitutes a singular example of the internalization of these views in the new Cuban art, which uses them in a conceptual manner and in conjunction with other contents, to speak about experiences and situations of the world today, outside of "primitivistic" poetics.

In her first series, Pérez, a white believer, dedicated herself to contradicting the protective taboos of maternity, in real acts that put her own pregnancy in mystical danger. A very well-known image is her photograph in profile brandishing a knife, with her belly swollen in an advanced state of gestation. The union of the Afro-Cuban religiosity with the feminine condition experienced physically was evolving toward a recognition of the body in terms of Santería and Palo Monte views of the cosmos, together with a metaphorization of the body to express these intuitions of the world artistically.

In many works she proposes a re-mythification of femininity, treating her body as an altar (fig. 9.5). These are not studio photographs, in a setting with models, like those of Rotimi Fani Kayode, Mario Cravo Neto, or Gerardo Suter, with a very aestheticized, generalizing representation of the body and the sacred in relation to Yoruba traditions (Kayode and Neto) or Mesoamerican (Suter). Pérez stresses a testimonial, personalized character, availing herself of the documentary capacity of photography, not of its independent artistic potential.

FIGURE 9.5.

Marta María Pérez,

Caminos. 1990. Silver

print. 40 × 50 cm (15¾

× 19¹¹⁄₁₆ in.). Courtesy

of the artist.

In one series she alludes to how she has encountered twins in the numerous religious groups, after having had twins herself in reality. The integration between lived experience on its most carnal level with the mystic, always alive in her work, has now become the nucleus, as in the photograph in which she discovers the thorns of the Ceiba—sacred tree of Iroko and Changó in Santería, a living altar for the four Afro-Cuban religious-cultural complexes—born from her body like a safeguard that is simultaneously magical and physical.

One of the most significant pieces is the one where, lying on a gynecological examination table, she places a mirror over her genital area, an allusion to the *mpaka mensu* of Palo Monte, receptacles of power of Kongo origin made of an animal horn filled with religious substances and covered by a mirror that will produce, as Robert Farris Thompson would say, the flash of the spirit. Her internal organs are thus

FIGURE 9.6.

Marta María Pérez, *Macuto.* 1991. Photograph. 40 × 50 cm (15¾ × 19¹¹/₁₆ in.). Courtesy of the artist.

254

converted into a mystical cavity, creating an image that forges feminist, religious, existential, humanist, and vernacular discourses.

Similarly, in *Macuto* (1991; fig. 9.6), the name of another receptacle of power of Palo Monte, she gathers within the object the two dolls she has used in earlier works to represent her twin girls, using her chest as a hierophantic space, sacralized by means of one of those ritual drawings of Palo Monte that we see so often in Bedia's works. In this case it is the "sign of the four moments of the sun,"[39] sign of signs, foundation of everything: a graphic synthesis of *Yowa* or Kongo cosmogony,[40] which serves to activate the center of power, marking the very eye of the cosmos, unique privileged point where the object that is prepared may acquire force. The spines of the drawing over her skin indicate the axis of her body, and her arms complete the design that marks the center of everything, where the living and the dead, the sea and the land, are joined. To identify the center of the chest of a specific woman with the very center of the cosmos, in relation to maternity, is one of the most powerful images that Africa has offered within the confines of western art. Viewed from the other side, it could also constitute one of the most radical feminist statements. Something similarly daring is the linking of the personal with the sacred in works where she relates the image or the receptacles of power of the gods to her body, as in the one where her body emerges from an Elegguá, or even builds those receptacles with her body, as when she uses her own head to represent the calabash of Osain.

BELKIS AYÓN
(B. 1967)

I conclude this account with Belkis Ayón, a mulatto woman who works with the mysteries of the Abakuá Secret Society, the only case of a secret African masculine society reconstituted in America, with its masked members as personifications of spirits, their cryptic ceremonies, their organization into lodges, their fundamental mythology, and their power emanating from the possession of a mystic secret. Abakuá is an integrated version of the *ngbe* society of the Ejagham people and others related to the Efik, Efut, and other peoples of the area of Cross River. Ayón illustrates their myths by means of an iconography of her own invention, as Mendive and Bedia have done in representing Santería gods who lack an image in the religious service. In engravings of large format she attempts to evoke the mystical contents, not the attractive paraphernalia of the Abakuá ritual, whose signs and masks have been the only ones to inspire artists interested in their formal rather than their meaningful elements (fig. 9.7).

255

Given the fact that it is a matter of a society closed to women, it is curious that Ayón has been the only artist to concentrate on it in a profound way. Even more so when we think that it was another woman, Lydia Cabrera, who studied the society most carefully, and to whom the Abakuá revealed their secrets so that she might make them known.[41]

The examples discussed above correspond to the most significant artists for the theme undertaken here, not to an exhaustive overview. It suffices to show why Cuban plastic art proves paradigmatic as far as the presence of Africa in contemporary art is concerned. In it a displacement of perspective occurs that allows meanings of African origin to be expressed in and even *to be made* within modern art, opening the path to transformations that I am not sure "postmodern" will be able to tackle in its many complexities.

FIGURE 9.7.

Belkis Ayón, *La cena.*

1993. Colograph.

130 × 303 cm

(51 3/16 × 119 5/16 in.).

Courtesy of the artist.

It is true that all this takes place in "fine" art and its elite circles, so closely tied to the luxury market, and does not occur in the terrain of popular culture, from which the movement derives. This fact has produced a participation of the popular-nonwestern-secondary-peripheral in the "cultivated"-western-hegemonic-central, the two sides communicating toward "above" but not toward "below," which would close the circle and revolutionize in fact the present status of artistic practice.

In any case, it is an extremely necessary Pancho Villa type invasion of the periphery to the center, to help open the way toward the cultural decentralization of artistic products and the changes that might thus be made possible. The cultural transformations, ethical and even functional, that are slowly being produced, still without breaking the boundaries of gallery art, open windows in various directions and make an aseptic reification and tokenization difficult. Although perhaps Robert Farris Thompson let himself be carried away too much by enthusiasm when he stated recently: "Good-bye, Postmodernism; welcome, spirits."

256

NOTES

Translated from the Spanish by Cola Franzen.

1. Fernando Ortiz, "Los factores humanos de la cubanidad," in *Orbita de Fernando Ortiz* (Havana: Ediciones Unión, 1973), 154–57.

2. Gerardo Mosquera, "Africa dentro de la plástica caribeña I," *Arte en Colombia*, Bogotá, 45 (October 1990):42–49; "Africa in the Art of Latin America," *Art Journal*, New York, 51(4) (1992):30–38; "Africa en las artes plásticas del Caribe," *Anales del Caribe*, Havana, 12 (1992):73–94.

3. In today's situation it is vital that the historic figure of Andrés de los Dolores Petit be retrieved from exclusion so that his role as forger of the Cuban nation may be properly assessed. This "postmodern" character of the mid-nineteenth century opened the Abakuá Secret Society to whites, converting it into the "first popular integrationist society" in Cuba (as it was described by Israel Moliner, "Los ñáñigos," *Del Caribe*, Santiago de Cuba, 7[12] [1988]: 14–15), and revolutionized Palo Monte by incorporating the pantheon of Santería and elements of Catholicism. See Lydia Cabrera, *La Sociedad Secreta Abakuá narrada por viejos adeptos* (Havana: Chicherekú, 1959), 26–62.

4. Robert Farris Thompson has made the only general presentation in *Flash of the Spirit: African and Afro-American Art and Philosophy* (New York: Random House, 1983), and an exhibit of one of its principal manifestations: *Face of the Gods: Art and Altars of the Black Atlantic World*, Museum for African Art, New York, 1993. For Brazil we have Mariano Carneiro da Cunha, "Arte afrobrasileira," in Walter Zanini, ed., *História Geral da Arte no Brásil* (São Paulo, 1983), vol. 2:974–1033. See also Gerardo Mosquera, "Plástica afroamericana," *Art Nexus*, Bogotá, 9 (June–August 1993):100–102.

5. My interpretation of Lam has been set forth more completely in Gerardo Mosquera, "Modernidad y africanía: Wifredo Lam en su isla," in *Wifredo Lam*, Centro de Arte Reina Sofía (Madrid, 1992), 21–41, and in *Wifredo Lam*, Funcació Joan Miró (Barcelona, 1993), English version, pp. 173–81; "Modernity & Africanía: Wifredo Lam in His Island," *Third Text*, London, 20 (Autumn 1992):42–68.

6. The opposite view is beginning to make headway. Three examples are John Yau, "Please, Wait by the Coatroom: Wifredo Lam in the Museum of Modern Art," *Arts Magazine*, New York, 4 (December 1988):56–59; Charles Merewether, "At the Crossroads of Modernism: A Liminal Terrain," in *Wifredo Lam: A Retrospective of Works on Paper*, Americas Society (New York, 1992), 13–35; Julia P. Herzberg, "Wifredo Lam: The Development of a Style & World View: The Havana Years, 1941–1952," in *Wifredo Lam and His Contemporaries, 1938–1952*, The Studio Museum in Harlem (New York, 1992), 31–51.

7. George Yudice, "We Are *Not* the World," *Social Text*, New York, 10(2–3) (1992).

8. James Clifford, *The Predicament of Culture: Twentieth-Century Ethnography, Literature, and Art* (Cambridge, Mass.: Harvard University Press, 1988), 173.

9. Desiderio Navarro, "Lam y Guillén: Mundos comunicantes," in *Sobre Wifredo Lam* (Havana, 1986), 138–63; "Leer a Lam," in his *Ejercicios del Criterio* (Havana: Editorial Letras Cubanas, 1988), 151–68.

10. This is what Kongo religion preserved in Cuba is called, the only case in all of the African diaspora. See Lydia Cabrera, *Reglas de Congo, Palo Monte, Mayombe* (Miami: Chicherekú, 1979).

11. Cited by Max-Pol Fouchet, *Wifredo Lam* (Barcelona: Ediciones Polígrafa, 1964), 68. For an opposite interpretation see Alvaro Medina, "Lam y Changó," in *Sobre Wifredo Lam*, 26–62.

12. Fouchet, *Wifredo Lam*, 31.

13. Alfred H. Barr, Jr., "Modern Cuban Painters," *MOMA Bulletin*, New York, 11(5) (1944):5.

14. Lydia Cabrera, "Un gran pintor: Wifredo Lam," *Diario de la Marina*, Havana, May 17, 1942, p. 2; Fernando Ortiz, "Las visiones del cubano Lam," *Revista Bimestre Cubana*, Havana, 66(1–3) (1950):269.

15. Orlando Hernández, "Oscuridad de Roberto Diago," catalogue of the III Biennial of Havana (1989):224.

16. Samuel Feijoo, *Mateo Torriente* (Havana, 1962), 9.

17. This description was used for popular Cuban music, the poetry of Nicolás Guillén, Lam's painting, and so on.

18. In addition, it was almost a symbol of the taste for popular fantasy typical of the artistic and literary scene of the central part of the island related to Samuel Feijoo, who compiled information on the *güije* in his *Mitología cubana* (Havana: Editorial Letras Cubanas, 1986), 89–179.

19. *El Correo de la UNESCO* 37 (July 1984):2.

20. Ibid.

21. José Pierre, *La sculpture de Cárdenas* (Brussels, 1971), 9. This text, the most important presentation made of the work of Cárdenas, was reprinted in *Agustín Cárdenas, esculturas 1957–1981*, Museo de Bellas Artes (Caracas, 1982).

22. A detailed presentation of this process may be found in Gerardo Mosquera, "Manuel Mendive y la evolución de su pintura," in *Exploraciones en la plástica cubana* (Havana: Editorial Letras Cubanas, 1983), 232–310.

23. Nancy Morejón has referred to "entrada de lo cotidiano en lo mitológico" ("the entrance of the everyday into the mythological") in "El mundo de un primitivo," *La Gaceta de Cuba*, Havana, 76 (September 1969):10–12.

24. Erena Hernández, "Cuadros móviles, filosofía y 'mala rabia,'" *Cartelera*, Havana, 5(252) (December 25–31, 1986):3.

25. Fernando Ortiz, "Las visiones del cubano Lam," 259. Lam painted *El despertar de la naturaleza muerta* (1944), and Cárdenas titled one of his sculptures *Naturaleza viva* (1960).

26. R(obert) K(nafo), "Mendive's World," *Connoisseur*, New York (April 1986).

27. Ulli Beier, *Contemporary Art in Africa* (London: Praeger, 1968), 108.

28. Frank Willett, *African Art* (New York: Praeger, 1981), 258.

29. Regarding this movement see Luis Camnitzer, *New Art of Cuba* (Austin: University of Texas Press, 1994); Gerardo Mosquera, "Volumen I: Cambio en la plástica cubana," *Arte en Colombia*, Bogotá, 40 (May 1989):4851, and "The New Art of the Revolution in Cuba," *Art & Text*, Melbourne, 39 (May 1991):22–25; *The Nearest Edge of the World: Art and Cuba Now* (Boston: Polarities, Inc., 1990); *Cuba O. K. Arte Actual de Cuba*, Städtische Kunsthalle (Düsseldorf, 1990); *No Man Is an Island: Young Cuban Art*, Pori Museum of Art (1990); issue dedicated to Cuba by the journal *Poliéster*, Mexico City, 4 (Winter 1993), *Cuba Inside & Out*; Lupe Alvarez, "Radiografía de una infracción," *Arte: Proyectos e ideas*, Valencia, 1 (1993):117–27, and "Una mirada al nuevo arte cubano," in *Memoria*, Havana, 2 (1993):2 and 9.

30. Gerardo Mosquera, "Arte y diáspora en Cuba," *La Jornada Semenal*, Mexico City, June 27, 1993, pp. 34–36; and *Brecha*, Montevideo, September 10, 1993, pp. 22–23.

31. Gerardo Mosquera, "New Cuban Art: Identity and Popular Culture," in *Art Criticism*, New York, 6(1) (1989):57–65; "Plastic Arts in Cuba," in Rachel Weiss, ed., *Being in America* (Fredonia, N.Y.: White Pine Press, 1991), 61–70.

32. Gerardo Mosquera, "Tercer Mundo y cultura occidental," *Lápiz*, Madrid, 6(58) (1989):24–25, and in *Kunstforum*, Postfach 122 (1993):64–66.

33. The double-bladed ax (*oché*) is one of the attributes of the Yoruba god Changó.

34. Mary Sherman, "A Failed Artist but a Brilliant Craftsman," *Boston Sunday Herald*, March 17, 1991, p. 58 (the title refers to comments about another exhibit to which she contrasts that of Elso).

35. Tom Grabosky, "Arts Up," *Bay Windows*, Boston, March 21–27, 1991.

36. *Cartelera*, Havana, January 19–25, 1989, p. 3.

37. Orlando Hernández, "En la orilla de José Bedia," catalogue of the exhibit *Viviendo al borde del río: José Bedia*, Castillo de la Real Fuerza (Havana, 1989), n.p.

38. Orlando Hernández, "José Bedia: Introducción a una cosmografía," catalogue for the exhibit *La isla en peso: José Bedia*, Galeria Nina Menocal (Mexico City, 1993), 4.

39. Robert Farris Thompson and Joseph Cornet, *The Four Moments of the Sun: Kongo Art in Two Worlds*, National Gallery of Art (Washington, D.C., 1981), 43–52; Thompson, *Flash of the Spirit*, 108–16; Wyatt MacGaffey, *Religion & Society in Central Africa: The Bakongo of Lower Zaire* (Chicago-London, 1986), 42–51.

40. A. Fu-Kiau Kia Bunseki-Lumanisa, *Le Mukongo et le monde qui l'entourait: Cosmogonie Kongo* (Kinshasa, 1969); see esp. figs. 2, 8, 9, 11, 17–29.

41. Lydia Cabrera, *La Sociedad Secreta Abakuá*; *Anaforuana: Ritual y símbolos de la iniciación en la Sociedad Secreta Abakuá* (Madrid: Ediciones R., 1975); *Vocabulario Abakuá* (Miami).

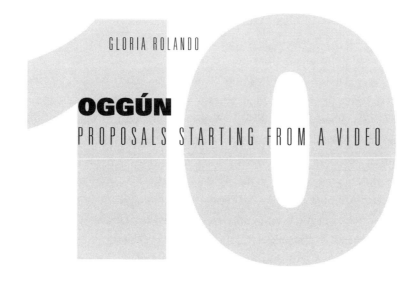

GLORIA ROLANDO

OGGÚN
PROPOSALS STARTING FROM A VIDEO

Once again the language of image and sound attempts to reveal the nuances that enclose human spirituality—a world so complex and beautiful in each culture that one has to love it first before being able to decipher it and understand all its clues.

I am proposing a full-length documentary film on the tradition of the songs and dances of Yoruba in present-day Cuba presented through the personality of Lázaro Ross, son of Oggún, a *cantante* (*akpwon*, or orisha praise singer), much loved and respected by the practitioners of Regla de Ocha. With Lázaro's testimony I suggest that we come close to a form of thinking as noble, as imperfect, and as original as the man himself. Lázaro talks of Oggún and other orishas who live together in the Yoruba pantheon with such familiarity that one is then able to understand what Lydia Cabrera wrote in her book *El Monte*: "The black conceives of the orishas and gods, personal, supernatural, and omnipresent, and of the spirits, in his own image and likeness. His passions are the same as those of the divinities whose protection he implores, so then they, god and man, have the same appetites and needs."

From the first version of the script, I never had any doubts about beginning the documentary with a story that would place the spectator immediately in the universe of the orishas. The love story between Oggún, the god of war, the master of metals, and Oshún, the feminine expression of love and mistress of the river, begins this incursion into the charismatic world of the African orishas. Oggún, to punish himself for committing incest with his mother, decides to live alone in the forest and to work day and night.

He turns into a morose and solitary man. But the people, or rather the civilized world, demand his presence because Oggún possesses the secret of how to construct and repair the tools necessary for man to dominate nature; for this reason the ancients decide to pardon him. Oggún does not wish to return to the village, and only Oshún, carrying *oñí*, the honey of bees, symbol of the sweetness of life, is capable of conquering the orisha warrior.

260

It is the artistic elaboration of one of the many ancient stories that have come down to the present via the oral tradition and that in the Lucumí language is known as *pataki*. It seems incredible, yet despite the cultural uprooting brought about by the slave plantation system, and all the repressive and discriminatory attitudes toward cultures of African origin in colonial society as well as later, it still was not possible to erase the collective memory of the African peoples who put down roots in Latin America and the Caribbean. This collective memory is transformed, reborn, and enriched in the broad complex of our *mestiza* cultures.

I remember the anxiety I felt while writing the script as I searched for a title that would guide me and sum up the spirit of the film. The words of the Haitian writer Jacques Stephen Alexis, in his novel *El Compadre General Sol*, gave me the key: "Africa does not leave black people in peace, no matter what country, no matter the place they come from or go to." This text serves as the beginning of the documentary and is the source of inspiration for the definitive title: "Oggún, un eterno presente" ("Oggún Eternally Present").

If in Africa the gods live in mysterious forests, in Cuba and in the rest of the Caribbean, the orishas inhabit the *monte* (the forest) in close communion with nature, the fauna and flora, because "*el monte* is the natural temple of the orishas." There, all the plants, grasses, vines, and fruits have a special enchantment because they are converted into attributes of the gods. One of the most revered trees in Cuba is the *ceiba*. The *ceiba* is a saint and belongs to all the orishas. Its majesty endows it with its sacred character, which is why I took this symbol as part of the natural scenery to reconstruct the dwelling place of Oggún. The work tools that identify the god of metals appear in natural size: the forge, anvil, machete, and hammer. It was not easy to find an appropriate style to integrate so many concepts and interpretations of a religious world so vital and respected. I wished to speak of the religion but without revealing the secrets or recreating images of animal sacrifice which in my opinion does not help in understanding religions of African origin. Finally, all the atmosphere that served to represent the *patakís* was attained—including other elements of a technical nature—by using a camera in slow motion in some cases, images that fade into others, extensive curtains of mist (created by the fog machine), and by taking advantage of the very soft light of dawn, and using musical themes composed especially for the film by the Cuban singer and composer Pablo Milanés.

All these ingredients contributed to revealing with a poetic sense the magic realism surrounding the exuberance of the Caribbean landscape. But most of all, it was the love and dedication of the production crew that made it possible for me to assume the task of directing my first documentary.

I will not be revealing a secret when I say that "Oggún Eternally Present" was conceived with a look of love toward the world of the orishas. My aesthetic proposal is permeated by that feeling that first arose for reasons of a personal nature (for example, the dedication to my mother and my grandmother), but goes on to approach assessments of an intellectual type. The interview with Lázaro Ross not only resolves an informative problem in the documentary. His way of talking interests me, his personal history, which, without going into details, sums up to a certain degree the feeling of other *babalochas* (priests of specific orishas) and *iyalochas* (wives or mothers of the orishas, priestesses), who, by way of the oral tradition and zeal for keeping the secrets of the religion, made it possible to bring the legacy of Africa down to our own days. The love is expressed in the final words of Lázaro Ross's testimony: "For me, Oggún has been and is my vital force; he is a gentle and simple god, and I love him greatly."

The structure of the documentary rests on the interview with Lázaro Ross, the scenes of recreations of the *patakís*, and the best moments of the *tambor* to Oggún filmed on Sunday, September 2, 1990. These images were the first to be recorded. The songs and the dances filmed in the colonial patio of Old Havana represent what is known as *tambor* (*añá* in Lucumí). A *tambor* is offered to an orisha in thanks or as a way of overcoming certain difficulties in life. The *tambor* is celebrated in houses with the doors open, and anyone who behaves respectfully may enter. Only the initiates have the right to dance before the sacred *tambores batá* (drums). In my opinion, this was the most difficult task for the crew (including the editing). Moreover, that atmosphere could not be repeated. The ceremony of the *tambor* appears in fragments throughout the documentary and is integrated with the different *patakís* that link Oggún with other orishas, as in the case of Oyá and Shangó. In order to enrich the symbolism of these dances, they are often combined in the editing with different "representations" of the orishas (shrines, and lidded vessels, tureens, or bowls where stones and other properties of the orishas are kept). No artist who attempts to approach the aesthetic values of Santería can ignore these expressions. The believers show their affection for their orishas with fruit, flowers, sweets, and different adornments; they "dress" them or drape them with cloths that correspond to the attributes or colors that identify them. Each person in his house (*ilé ocha*) keeps the corner or the room of their saints decorated according to their financial abilities and their particular taste, using their imagination and ingenuity. I had the privilege of being able to film some of those shrines; that is why at the end I include a text of

261

thanks to all the *babalochas* and *iyalochas* whose determination helped in making the film.

Finally, I would like to propose undertaking a voyage toward a world so abstract and complex that only faith and respect for the traditions make the close relationship between humanity and their gods possible. Even if one does not comprehend the complete significance of the songs led by Lázaro Ross, the believers do understand the sentiment that guides them. It is a way of invoking the orishas, of calling them to earth, and of demolishing the abyss between human beings and the world of the unknown.

Thus, in a spontaneous and collective form, a culture of African origin reaches us, a culture whose deep roots and many branches—like those of the majestic *ceiba*—spread out in an eternal present.

NOTE Translated from the Spanish by Cola Franzen.

HENRY JOHN DREWAL

SIGNIFYIN' SAINTS
SIGN, SUBSTANCE, AND SUBVERSION IN AFRO-BRAZILIAN ART

Histories of slavery, oppression, and racism have fostered distinctive strategies of survival and affirmation for peoples of African descent.[1] One way has been to cultivate *multiconsciousness*, the capacity to negotiate multiple evolving personas in social terrains where others attempt to impose identities (and therefore possibilities) in struggles of self-assertion. Another is a pervasive *transculturalism* in which persons live in the permeable space of many "cultures" (see Clifford 1988), shaped by and shaping specific social, economic, religious, political, and historical forces.

Such multiconsciousness and transculturalism have played roles in the actions of Afro-Brazilians who, whether Muslim, Christian, or devotees of ancestral deities such as the *òrìṣà* of Yorùbá peoples, managed to operate effectively within Catholic lay organizations known as *hermandades*, using them to their own advantage, for their own purposes (Poole 1992). This is not religious "syncretism," which suggests a sort of blending, homogenizing process. Rather it documents an openness to the simultaneous interplay of multiple beliefs and practices of persons whose histories demanded a refined, subtle, and effective flexibility. The nineteenth-century English visitor to Bahia, James Wetherell (1860:54, cited in Verger 1987:524) remarked on Afro-Brazilian greetings to people in the streets of Salvador: one greeting was in Arabic; another was in Portuguese; and a third was in Yorùbá—*occuginio* (*o ku jí ni o*): "hope you got up well!" Such persons moved easily among various linguistic/cultural worlds, operating in multiple social spheres with ease, negotiating and bridging multiple identities and realities.

Yorùbás speak of their culture as a "river that never rests." Such a metaphor stresses the dynamics of constant change. Yorùbás also recognize that some parts of rivers move slowly and run deep, while other more shallow parts may change rapidly and dramatically. Too, the countless tributaries, eddies, ebbs and flows, swirls, backwashes, and cross-currents over time (distinctive city-state histories, for example) or space (western Yorùbá realms such as Kétu versus southeastern ones like Ìjẹbu) can help us appreciate the remarkable diversities and unities in Yorùbá-speaking worlds. Dynamic qualities are both transformative and transforming. Extending this metaphoric image, I would suggest that Yorùbás regarded the Atlantic as just another river of culture, one that carried people (although against their will), their beliefs and artistic practices to new lands, to be continually renewed, transformed, and reinvented under very different conditions.

For Yorùbás in Africa and their filial and spiritual descendants in the Americas, art is evocative form that works to transform thinking and perception, to *move* artists and audiences. Devotion to the *òrìṣà* ("selected heads" or distinguished ancestors elevated to the status of divinities) has inspired much of this art's evocative qualities. In this chapter I first briefly outline Brazilian art history before exploring certain African and Yorùbá cultural currents in Afro-Brazilian art history, relating some of them to the African-American tradition of "signifyin'" which Henry Louis Gates has linked with the Yorùbá divine mediator and trickster, Èṣù (Gates 1988). I then turn to several themes in Yorùbá philosophical discourse that ground my interpretation of selected works by certain Afro-Brazilian artists, some who are engaged in reworking African sacred traditions and others who are distanced from them.

BRAZILIAN ART HISTORY

Brazil's history is one of colonization, whether voluntary, reluctant, or involuntary. Beginning in the sixteenth century, people came primarily from Portugal and Africa: an eclectic mix of adventurers, sons of noblemen, orphans, Africans captured and enslaved, priests, Jews fleeing the Inquisition, soldiers, mercenaries, criminals escaping the law, and convicts sentenced to exile. Add to this the indigenous Indian inhabitants of the land and, in the nineteenth and twentieth centuries, other Europeans as well as Asians. All have contributed to Brazil's artistic and cultural pluralism.

Identity, whether for nations, groups, or individuals, is a complex, unending process, especially problematic for those who have been colonized, as all Brazilians have in different ways for more than 350 years. As the Brazilian artist Roberto Barreto (1988) points out, "colonized people have colonized minds . . . they live with the monster of not being able to think . . . an inferiority complex is very powerful." In Brazil that powerful and lengthy colonial legacy still persists despite Brazil's stren-

uous efforts at modernization. Like the United States, Brazil for much of its history looked to Europe for its cultural and artistic models.

If forging an identity is difficult for colonized peoples, how formidable a task must it be for those *enslaved* within such colonies—persons denied their very humanity? For Africans, this had to be achieved against almost insurmountable odds, in a society not of their own choosing, in which they had very few options. Despite such seemingly impossible circumstances, Africans continued not only to shape their own life-styles but to contribute significantly to the fabric of Brazilian life and art from the very beginning, albeit in subtle and subversive ways.

Throughout the sixteenth and seventeenth centuries, Euro-Brazilian art and architecture replicated that of Catholic Portugal. Fortresses and public buildings were controlled by military and bureaucratic minds, while religious orders (primarily the Jesuits and Benedictines) determined the design of churches, where art was meant to "serve faith and transform the liturgy into a fascinating ritual capable of attracting people" (*Brazilian Art*: 3).

Yet despite such priestly supervision, Brazil's churches displayed other cultural (and religious) presences besides those of Iberian Catholicism. Those who did the actual artwork were Africans or Afro-Brazilians who introduced their own images and aesthetic preferences, turning grapes (symbolizing the Eucharistic wine and blood of Christ for Catholics) into pineapples, and lily-white Virgins and cupids into brown-skinned persons.

Such artistic inventiveness flowered most fully during the eighteenth-century Brazilian baroque. This unique style was epitomized in the work of Aleijadinho, often described as Brazil's greatest artist and architect. Aleijadinho, a man of color, created an exuberant and sensual expressiveness. He, together with a large group of craftsmen of African descent, transformed the Catholic architectural landscape in the State of Minas Gerais.

In the nineteenth century, another remarkable African architect transformed a church in a very different way.[2] The Church of Lapinha in Liberdade-Salvador was designed and built by Mestre Manoel Friandes (b. December 25, 1823; d. August 4, 1904) sometime around the 1860s–70s. Friandes was an Afro-Muslim or *Ìmàle*, the Yorùbá word for Muslim. He may have been a Yorùbá, for many African Muslims were either Yorùbá, Nupe, or Hausa, but we are uncertain. We know that he was a well-known and successful architect and builder who was commissioned to do a large number of commercial and ecclesiastic buildings including the Ordem Terceira de São Francisco in Salvador (Querino 1909: 206).

The Lapinha Church stands as a monument to nineteenth-century Afro-Brazilian religious and cultural resistance in architectural form. It is a monumental assertion of self-, ethnic, and religious expression in the face of hegemonic forces.

FIGURE 11.1.

Exterior of the Church
of Lapinha in Liber-
dade-Salvador de-
signed and built by the
Afro-Muslim Brazilian
Mestre Manoel Frian-
des ca. 1860s–70s.
Photo: Henry J.
Drewal.

Commissioned by the Catholic Church, which must have known he was Muslim, Friandes created an austere Christian exterior, relatively unelaborated compared to many Brazilian baroque structures (fig. 11.1). But within, he designed a forcefully exuberant Islamic presence (fig. 11.2): Moorish arches, decorative tiles, and, most striking of all, Arabic script etched into the walls over the arches and surrounding the nave that contained passages from the Creation (Genesis) of the scriptures.

Such a conjunction of elements raises many questions. How was such a building commissioned, conceived, financed, and constructed? How and why did Friandes obtain the patronage to design and construct this church? How did he negotiate the obviously Muslim interior design and combine it with the equally obvious Christian paintings, sculptures, and so forth. What were the responses of the Church hierarchy and parishioners, especially since the church was built while the memory of the

FIGURE 11.2.

Interior of the Church of Lapinha in Liberdade-Salvador designed and built by the Afro-Muslim Brazilian Mestre Manoel Friandes ca. 1860s–70s. Photo: Henry J. Drewal.

African *Ìmàle* revolutions throughout the first half of the nineteenth century (the last major one in 1835, and many smaller ones after that) would have been still fresh (see Reis 1987)? What did Friandes think and say about what he was doing, and how did it relate to his other architectural projects? Is this an example of subversive expression—an assertion of self-identity as a Muslim, as an African, as a cultured, sophisticated professional man? Or is it something quite different? We will probably never have precise answers to such questions, but the Church of Lapinha certainly stands as a monument to the enormously complex, seemingly incongruous, and fascinating juxtapositions of contesting religious ideologies, racial and class hierarchies, political possibilities, and economic forces which Afro-Brazilians had to negotiate in order to survive and, despite the enormous odds, to thrive. This is a hidden history, like so many others about Afro-Brazilians, that needs to be researched, analyzed, and told.

Black African, as well as Moorish and Portuguese, architectural traditions were also evident in the homes of the less privileged. The building method known as *taipa*—a combination of adobe, palm flax, pounded mud, bamboo, and refuse—was used to create thick-walled foundations for brick-walled houses with large white-washed rooms. *Taipa*'s humble, multicultural origins and adaptation to Brazil's frontier days stand as a kind of metaphor for Brazil's cultural pluralism, but even more for its very existence due to the enormous unrewarded labors of its African slaves and peasants.

In the early nineteenth century the French Commission on Art in Brazil introduced the then "modern" neo-classical style, to "Europify," that is, whiten, Brazilian art. But even this foreign imposition did not entirely extinguish a nascent Brazilian aesthetic infused with African sensibilities. Colorful tiles of floral and pastoral scenes decorated the facades of columned buildings, a feature termed *tropicalia* (*Brazilian Art*:10). Eventually, however, the Afro-Brazilian baroque exuberance of Aleijadinho, the Afro-Islamic imprint of Friandes, and the Afro-Moorish-Iberian *taipa* foundations faded as immigrants from Europe and Asia flooded Brazil in the late nineteenth and early twentieth centuries, shifting the emphasis to Modernism and international art movements. Only when Brazilian artists began to react to a "suffocating" internationalism fed by a growing mass media did the search for a national identity and a reevaluation of the country's uniqueness begin to produce distinctive works.

AFRO-BRAZILIAN RELIGIOUS ART

Suppressed, marginalized, and largely untold, the early phases of Afro-Brazilian art history emerged as part of the un-Catholic, outlawed underground African faiths that came to be known in Brazil as Candomblé, Macumba, Umbanda. These religious practices have continued unbroken since the first days of colonization and today count among their followers many Euro- and Asian-Brazilians. As one Brazilian writer put it, African culture "expelled through the front door, returned by the back door in its food and seasonings, in the music of the slave quarters and in the belief in . . . the African gods" (*Brazilian Art*:4).

The earliest examples of this religious art are now lost, but at the end of the eighteenth and early nineteenth centuries such sacred art traditions strengthened, with the massive influx of primarily Yorùbá and related West African peoples to northeastern Brazil, especially Bahia. Their presence reinvigorated African sacred arts which have had a profound impact on Brazilian culture and the work of many Brazilian artists ever since.

The performing arts made the strongest impact since they could be brought in the minds of persons raised in oral and performed traditions. The visual arts—dress, regalia, sculpture, masks, and so forth—were harder to sustain for these had to be

created in secret, since they were linked with religions banned in Brazil. Yet survive they did. As more and more Africans purchased their freedom during the nineteenth century, some returned permanently to Africa, while others returned periodically to Brazil as part of a new phase in transatlantic trade (Verger 1987) that included such religious items as masks (Drewal and Drewal 1983:243–44) and especially regalia, such as *òrìṣà* beads or amulets that appeared to authorities to be simply jewelry. According to the Candomblé metal artist Mimito (1974), Maria Julia do Oxoosi (Figueiredo) (d. ca. 1940), goddaughter of Obatosi, the head of the Candomblé Ilê Iyá Nassô founded about 1830, traveled to Africa and returned to Brazil bringing silver and gold regalia for use in Candomblé ceremonies. These may be related to *balangandans*, silver and gold pendants worn by Afro-Brazilians since at least the early nineteenth century (pl. 22).

269

Yorùbá sacred images serve to focus and intensify worship. They are *not* the objects of worship. As the Yorùbá diviner Kolawole Oṣìtọla (1982) once explained to me, "the gods do not come because of the images, the images come because of the gods." In Candomblé Nago, the Afro-Brazilian religion that most closely follows the traditions of Yorùbá peoples, the gods or *òrìṣà* were analogized with specific Catholic saints on the basis of their attributes and the interpretation of their iconography in popular imagery. Since Yorùbás and other Africans used art much as Catholics use saints' statues, Afro-Brazilians easily adapted them for use, along with African forms. Thus, for example, plaster statues for the twin saints Cosme and Damião were displayed openly on domestic altars, while carved Yorùbá-style figures for sacred twins (*ibéjì*) were often hidden. Afro-Brazilians saw no contradiction in this, since they concluded that both faiths recognized the spirituality of twins, only under different names and images. *Orixás* and saints were *not* syncretized, that is, fused or hybridized, rather they were juxtaposed, each maintaining its own identity and individuality.

But Afro-Brazilians studied and used the saints for other reasons as well—to camouflage their sacred art and worship. They had to disguise their personal beliefs and practices in order to sustain them. They adopted a pragmatic and effective strategy in a seemingly impossible situation, not unlike the African-American strategy of *signifyin'*, double-voiced rhetoric devised to comment upon, satirize, mislead, and critique supposed masters (Gates 1988).

Two Yorùbá concepts help us understand the dynamics of Afro-Brazilian religious art history: *ṣìre* and *àṣẹ*. *Ṣìre*, rendered in Brazilian Portuguese orthography as *xire*, is the notion of empowering improvisation. In both Africa and Brazil it most often refers to ceremonies for the gods which occasion an engaging, and engaged, playfulness. In a larger sense, *xire* embraces and encourages artistic innovations that open spaces for discourse and action.

Àṣẹ/axé (Yorùbá and Brazilian orthography) refers to the life-force that exists in everything—persons, gods, animals, objects, and words. It constitutes existence. As performative power, it is available for humans to use and manipulate as they deal with forces in the world, or beyond. It is a clearly articulated tenet of action and agency. Worship, combining the evocative arts of song, dance, music, and sculpture, activates and intensifies *àṣẹ* to honor and attract the gods. If such devotional and artistic evocations please them, they grace the occasion with their presence, possessing initiates and blessing their followers. The synesthetic effect of such performances activates and draws near the *àṣẹ* of the gods for the benefit of all.

Such artistic appeals use outer display to focus on inner being. The outer form can take on many aspects, as long as the constitution of *àṣẹ/axé* is appropriate. Thus the use of Catholic imagery in a Candomblé context does not connote capitulation or conversion, rather it represents a tactic of masking inner character with outer appearance—visual signifyin'.

The oppressive Brazilian context demanded creative maneuvers since African faiths were seen as subversive by the authorities. They were the target of police harassment over the centuries, which is why many collections of Afro-Brazilian sacred art are found, not in art museums, but in Brazil's police museums. Practiced in secret, they had to conceal in order to protect and sustain their true nature, and their icons. The situation is somewhat different now.

CONTEMPORARY CANDOMBLÉ ARTS
THE DOLLS OF DETINHA

Today the Brazilian authorities, rather than viewing Candomblé as subversive, see it as a useful commodity—exotic rites to attract tourists and their money. So while ceremonies can be practiced more openly, *terreiros* (Candomblé temples) must still obtain permits from the local police, unlike churches which hold services whenever they choose. Through all these changes, the artists who produce religious forms have continued to create images of praise and beauty for African gods. One is Valdete Ribeiro da Silva, better known as Detinha de Xangô.[3] She was born in 1928; her African ancestors had been bought by the Pimentel family. Her grandparents and father spoke Yorùbá (Nago), despite the beatings they received for not speaking Portuguese. When she was small she was obliged to attend Catholic mass, but did not enjoy it. Her father was a "son" (initiate) of the Yorùbá thunder god Ṣàngó/Xangô. He spoke Yorùbá and took her to ceremonies at the famous *terreiro* Axé Opô Afonjá, especially those for Ṣàngó/Xangô. She was initiated by two powerful religious elders: her aunt, Mãe Ondina and Mãe Stella, the present head of Axé Opô Afonjá. She says "I am very proud to have both their hands on my head: Mãe Ondina because she was the last pure African in my family and Mãe Stella because of her strength and respect."

Axé Opô Afonjá had a shop in the tourist market of Pelourinho (place of the

pillory, where Africans were whipped for rebelliousness during slavery), and De-tinha used to sell plastic dolls dressed in the clothes of the *orixá*. Tourists used to ask why she didn't make cloth dolls, so one day Detinha decided to try. She went to the market, bought cloth, and began to make them. Later Mãe Stella had her teach a workshop to instruct others and prepare a series of dolls for an exhibition. This turned out to be very successful, and now other members of her family (daughter, daughter-in-law, sister, and some other Candomblé initiates) help her make them. As Detinha de Xangô says: "The important thing about the dolls is to pass on the culture of my religion. The dolls for me are like people possessed by the *orixás*—each one I make I enter into the life of that *orixá*, as if I went back in time and relived what each has done." She creates the dolls to resemble her brothers and sisters in Axé Opô Afonjá as well as herself, so that "sometimes when I am alone, I look at them and laugh" (fig. 11.3).

271

FIGURE 11.3.

Valdete Ribeiro da Silva known as Detinha de Xangô with one of her dolls honoring the *orixá* Yemanja, goddess of the sea. Photo: Henry J. Drewal.

While the impetus for making these cloth dolls seems to have come from tourists and the commodification of Candomblé, the adaptation of European doll-making traditions, like the use of Catholic plaster saints' statues, was a strategic move to camouflage sacred sculptures for the *orixás* in the nineteenth century, both in Cuba (Mason 1994:242–43) and Brazil (Drewal, in press)—"playthings" to the authorities, but sacred forms in the celebrations for the gods of Africans, Afro-Cubans, and Afro-Brazilians.

SHINING EMBLEMS:
METALWORK FOR THE GODS

Candomblé ceremonies, *xire*, sacred parties infused with empowering improvisations, celebrate the *orixás* and ancestors and bring them into the world in order to bless and protect their devotees. When initiates go into trance, embodying their patron deity, attendants hold and support them, leading them into an antechamber where they are dressed in the cloth and regalia of the god before returning to dance and bless the assembled congregation. Metal implements (*ferramentas*) symbolic of the deity are a main component of this ritual attire: bracelets, armlets, swords, knives, fans, crowns, miniature bows and arrows, bags, metal-covered horns, double-bladed dance wands, staffs, spears, and so on. Miniatures of many of these decorate the altars or "seats" (*assentos*) of the gods. One of the most famous metal artists working for Candomblé is Clodomir Menezes da Silva, better known as Mimito. I met Mimito in 1974 on my first visit to Bahia, and then again many years later in 1993.[4]

He was born in 1923 in the Bahian city of Valenca. His father's parents were Africans from Ivory Coast, and his mother's were Portuguese. When he was two he had a serious skin ailment which seemed incurable. His mother took him to a spiritualist who said he should see a Yorùbá diviner (*babaláwo*) at the town of Cajaiba. That diviner prepared medicine with leaves called *erua-de-bicho* associated with the *orixá* Omolu, the god of skin diseases, pestilence. Within a short time he was healed and, as he explains, "that's how I was born into 'santo' [saint/*orixá*] at the age of two." His *orixá* name is *Omo Ajirera*. At the age of nineteen he was traveling with his godfather, Severiano Santana Porto when a storm came up and they stopped for shelter. Porto asked him to start making *ferramentas* because the *terreiros* in Bahia and elsewhere needed them. He began to teach himself, or rather, as he says, "it was my *orí* [Yorùbá reference to fate/destiny; literally, "head"] that taught me." His godfather Porto had a friendship with Mãe Menininha, the head of Gantois Candomblé, and it was she who helped him the most with commissions for work. Mimito became a part of her *terreiro*, going there for most important ceremonies.

Despite his age, he has the gentle smile and manner of a young man, and a twinkle in his eye. He is kind and generous—both to the gods and to humans. All

his works are exquisitely refined—shining jewels for the gods like the *opaxorô* staff of Oxalá (pl. 23). He began by making simple bracelets for the water deities Oxun and Iansã, but as he began to learn from the elders and devotees in various Candomblé houses—Yorùbá/Nagô, Jeje (Ewe-Fon/Aja), Angola, Ijexá, as well as other Afro-Brazilian faiths such as Umbanda—he began to develop a variety of distinctive forms and designs that can now be found throughout Brazil and internationally. He creates the primary implements of the gods such as hats, crowns, knife/sword, axe, fans, and the sounding forms that call the gods to ceremonies, the bells or *ajá*.

Within these object types, further distinctions relate to specific "roads" or "qualities" of the gods, each marked by a different shape, media, and color. For example, Mimito noted that there are at least twelve qualities of Xangô in Brazil, two of them being Airá ("lightning") Ibona and Airá Echinle. Airá Ibona uses "white," that is, silver metal for his ax or *oxé* and carries two spears with wide, harpoonlike blades (Mimito 1974). Airá Echinle has two axes. Another Xangô manifestation, Aganjú, uses one copper (red) ax whose blades curve up and outward. Other Xangô qualities have other shapes for the double blades—triangular or slightly curved with scalloped edges, for example. Each variation on the double-bladed ax signals a specific divine personality—some fiery or aggressive, some calm and composed, some outgoing and talkative, others reclusive and morose. Mimito explains that he must know all these variations because these "are what are brought to the head" of the devotee. The multiple qualities attributed to gods mirror the multiple consciousness cultivated by the living in order to endure the oppressive vicissitudes of slavery as well as the trials of contemporary Brazil.[5]

One of the young generation of artists following the path of Mimito is Eneida Assuncao Sanches, one of the first women to create metal images evoking the gods. She was born in Salvador in 1962 and at the age of four began taking classes at the innovative art school established by Rosita Salgado. Every afternoon there were classes in painting, *capoeira* (Afro-Brazilian martial arts and music tradition derived from Bantu African traditions), sculpture, modern dance, and drama. At Antonio Vieira High School she continued her art and won two prizes for film and painting before getting a degree in architecture at the Federal University of Bahia and participating in architecture workshops in Arizona and Scotland. She began working in metal in 1991 under the guidance of master artisan Gilmar Tavares who was also an *ogã* elder in a Candomblé house. Working with brass and copper, she began to create fans with mirrors (*abebé*), crowns (*adê*), knives/swords (*obé*), bracelets, and other *orixá* implements. Her works have delicate lines and softly curving reflective surfaces that glow with the love she brings to her work (fig. 11.4). While respecting the force of tradition, she also knows that inventiveness will keep it alive. With this

FIGURE 11.4.

Eneida Sanches'
pieces have delicate
lines and softly curving
reflective surfaces that
glow with the love she
brings to her work.
Photo: Henry J.
Drewal.

in mind, she continually reinterprets form and embellishment in order to infuse her own energies into the work. The sparkle of her warm personality shines in these forms, illuminating the spirit of divinities and igniting the intensity of worship.

In 1992 she held her first exhibits, one in Cachoeira and another in New York curated by C. Daniel Dawson for the Caribbean Cultural Center. In September 1993 she was invited to participate in the creation of altars for Ọbàtálá and Babalú-Ayé in the *Face of the Gods* exhibit curated by Robert Farris Thompson. Most recently she was made *abiyan* for the Candomblé Ilê Axé Opô Aganjú headed by Pãe Balbino de Paula, Obaraim.

Iron is another important metal medium for the gods, and José Adario dos Santos (Zé Diabo) is its master. He was born in 1947 in Cachoeira, an important center of Candomblé activity.[6] His mother was of Indian origin and his father African. Both were active in Candomblé, and his father held the title of *pegi 'gã* (altar custodian). José was taught how to make *ferramentas* for the gods by Milton Marciliano Prates, the son of Paulo Prates, a famous *ferramentas* maker from Cachoeira.

José explains how he got his nickname of Zé Diabo (José Devil). When he was

a young apprentice he would be sent to the market carrying a box of small iron sculptures for Exu, the divine mediator and provocateur of the Yorùbá, whom Brazilian Catholics associate with the devil, *diabo*. When José reached the market, people called to him saying, "Hey you, the one with the devils, come here." He would become angry and throw the box on the ground, but the name stuck and since then he is known as Zé Diabo. José makes a great variety of Exus and other iron sculptures for the gods—not only those in the Yorùbá tradition such as Ossâim, god of leaves, Ogún, god of iron, and the divine hunter Oxoosi—but also spiritual forces in Umbanda, a religion that brings together Kongo, Yorùbá, Indian, Kardecian, and Christian elements.

275

Fire, heat, sparks, and the sounds of metal striking metal—this is the world of Ogún and the studio of José as he battles to transform iron into visual praise poems to Ogún. When shaping the iron bird-staff for Ossâim, he begins with a long iron rod bent double. At the proper distance he creates two right angles and extends one

FIGURE 11.5.

Iron sculpture by José Adario dos Santos that is like a ritual signature (*ponto riscado*) drawn on the ground to attract divine attention and presence to ceremonies. Photo: Henry J. Drewal.

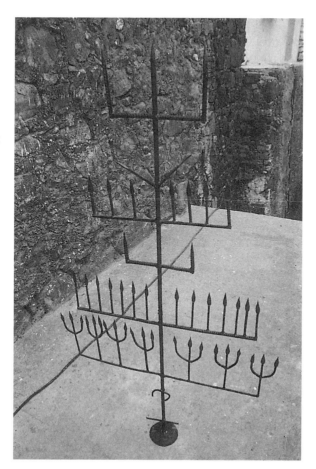

end outward to form flairing tailfeathers and the other to create the downward curving beak of a commanding bird. This is surrounded by a bundle of other shafts welded to the central shaft and then bent outward at a rakish angle. José completes the work by adding wings to the bird—form flies with spiritual presence. In a sense, José "writes" iron praise names to the gods, like the ritual signatures (*pontos riscados*) drawn on the ground in Umbanda practice to attract divine attention and presence to the ceremonies in their honor (fig. 11.5).

SWEEPING SACRED SPACES: BROOMS AND RAINBOW SERPENTS

Deoscoredes M. dos Santos, better known as Mestre Didi, is a multitalented artist—a writer, historian, and sculptor—as well as a devoted follower of the *orixás*. His ancestors were Yorùbá from Ọ̀yọ́, and as a titled son of Xangô he has been a major presence at the Candomblé Ilê Axé Opô Afonjá and also at the Egúngún ancestral masking society on the island of Itaparica. His multimedia works celebrate a variety of divinities (pl. 24). His primary media are tightly bound bundles of palmribs, fibers, and other materials evocative of straight and looped Yorùbá ritual brooms (*xaxará* and *ibiri*)—sacred implements used for purifying spaces, places, and persons and assuring well-being and good fortune. They symbolize deities associated with the curing of diseases (Omolu, Babalú-Ayé), the elderly matron Nanã Buruku, as well as the rainbow serpent deity Oxumare associated with riches. To these works he adds leather, cowrie shells, glass beads, and sometimes fiber skirts of various colors. In one complex work, his imagery fuses references to several *orixás* including serpents symbolic of Oxumare which swirl around the central shaft while a majestic bird floats above. There is a fluid elegance and delicacy in his forms—the flow of lines in space, the shimmering beads that punctuate his slender shapes, and the birds with outstretched wings. His evocations of spiritual forces make our imagination soar.

MANY PATHS: THE SACRED IN CONTEMPORARY AFRO-BRAZILIAN ART

The spiritual aura of Candomblé has spiraled outward to touch many Afro-Brazilian artists, though some have distanced themselves from it. And like the gods who have many qualities of personality, some artists work in different ways at different times. The following portraits suggest some of the possibilities being explored by Afro-Brazilian artists beginning with those most visibly inspired by African spiritual forces and then moving to those only distantly, obliquely influenced.

Terciliano Jr. asserts his Afro-Brazilian heritage in large paintings devoted to the ritual arts of Candomblé. His abstractions relate to the ineffable qualities of the gods and their *axé* as he explains, "I try to do work that is truly representative of black people, not caricatures of black culture." But a certain pragmatism emerges when he says he wants to "situate [his work] in a wider space, in a subtle and lyric way" (Terciliano 1988).

Terciliano grew up in a large, and poor, family. Over the years, he has had many jobs in order to survive—blacksmith's apprentice, fabrics salesman, receptionist, soap opera actor, and poet—before deciding to live by his art. His devout family has always been deeply involved in the Angolan Candomblé called Bate-Folha. It has always been a source of spiritual as well as artistic inspiration. Terciliano states: "As an artist, I see African religion in a different way from my family, not without the same respect, but also as a cultural source from where I can find elements for research and expression. . . . It is a strong form of resistance that survived slavery, racism, and still today struggles to maintain its identity" (Terciliano 1988).

His art has gone through major style changes over the years. His early work centered on genre scenes from Bahia: street and market scenes, the dress, movement, and color of Salvador. His figures were often simplifications of their sources, soft and loose, like quick glimpses of the life around him. All were very sensitively rendered, especially a tender portrait of his mother.

In the late 1980s he turned bold, transforming his partial figures into strongly colored solid ones, moving toward abstraction and overall pattern, and working on a large scale. This increasing abstraction has reasons. For one, he explains that he is exploring new ways to express the realities of Candomblé "to situate it in a wider space, in a subtle and lyric way, blending my art and life experience." Too, he is dealing with intangible ideas of the sacred: life-force/*axé*, goddesses and gods, religious rites and offerings.

Rituals—persons, actions, and objects—fill the works. A large, shallow wooden bowl known as *gamela* is an important and recurrent motif (pl. 25). Its uses are many in Brazilian life, but in the context of Candomblé it is a primary receptacle for offerings to the gods that express the love, respect, and devotion of the worshipers who contribute to the god's power as the deity in turn assures theirs. In these works on Candomblé, Terciliano celebrates his family, ancestors, and the generations of Afro-Brazilians who have kept the gods of Africa alive and well in the hearts and minds of Brazilians today.

Emanoel Araujo builds opaque colored crystals in the sky. His angular forms thrust upward and outward as they merge with and emerge out of each other, enclosing interior negative spaces and transforming exterior ones. Obliquely aligned forms cut through space, their colors dense and rich.

Araujo's work may appear to be solely nonrepresentational—plays of form and color—but appearances can deceive. His works are not only about significant form: they are forms with significance. Specific sacred entities are present, African gods who survive and thrive in contemporary Brazil. Araujo captures their essence. For example, Ogún, god of iron and war, embodies strength, force, quickness, and directness. Like his metal, Ogún is hard and sharp. He builds civilizations, or he de-

FIGURE 11.6.

Totem Ogún, a sculpture by Emanoel Araujo. From George Preston, *Emanoel Araujo—Brazilian*.

stroys them. All of these Ogún attributes reverberate in sculptures dedicated to his powers and presence. In one called *Totem Ogún* (fig. 11.6), Araujo builds bladelike forms on top of a pyramid, symbol of Egypt, Africa's most famous civilization. These shapes rise dramatically, first one way, then another, like a pivoting cannon or active phallus—both images supremely evocative of Ogún. Ogún's colors (dark blue and black) make the work appear heavy and dense like his metal.

Exu is another god present in Araujo's work. Exu is the divine mediator and trickster who serves as a messenger between gods and humans. He stands at the crossroads and thresholds and embodies action as well as contradiction. As one of his praises claims, "he can throw a stone tomorrow and kill a bird yesterday." Araujo's *Ritoexu* captures many of these aspects. Exu's colors—red and black—symbolize his unpredictability and the heat of his sudden transformations when he activates the *axé* contained in blood. The sprouting, rising forms recall Exu's primary icon, a projection at the top that refers to many things, among them the link between this world and the next (Drewal 1977). Volumes intersect at various angels like the roads guarded by Exu.

Emanoel Araujo captures the essence of these African gods in colors, forms, movements, and rhythms—not in realistic representations. As one colleague has written, Araujo's work is "Afro-Minimalism" (Preston 1987). A Yorùbá proverb says "only half a speech is necessary for the wise, in their minds it becomes whole." Emanoel Araujo demonstrates such wisdom.

Araujo manifests many of the attributes of the gods he evokes in his works. He

is clearly a man of action, probably one of the most successful and productive artists in Brazil, and now the director of the Pinacoteca Museum in São Paulo. His public sculptures can be seen all over Brazil, many of them, appropriately enough, at cross-roads and city squares. His outer calm and relaxed manner mask an inexhaustible energy. He is driven to achieve and make his mark in the art world beyond Brazil's shores. His style may therefore appear international and universal, yet its content, like the work of other Brazilian artists, is deeply rooted in Africa. Such seeming contradictions recall aspects of both Exu and Ogún, his invisible patrons and visible themes.

Like the man himself was, the art of the late Rubem Valentim is precise, meticulous, strong, and straightforward. He worked "with geometry," paintings, relief, and three-dimensional sculptures filled with an endless recombination of geometric, hard-edged shapes: triangles, spheres, arcs, stars, parallelograms, arrows. Most are strictly symmetrical, supremely balanced arrangements. They are rendered with extreme care, giving the sense of having been mathematically, scientifically created. The colors he used reinforce this impression. They are bold and flat, essentially primary and secondary hues juxtaposed with their complements to produce dramatic optical effects—again, science at work.

Yet, despite the impression of coldly objective forms presented for their optical effects, Valentim's works express spiritual matters. As he explained (1988): "Today physics approaches both religion and aesthetics . . . I am creating a new metaphysics." He achieved a true synthesis of the physical and the spiritual, for all these seemingly "meaningless" forms are in fact signs and symbols of spiritual forces at the heart of Afro-Brazilian Candomblé that was part of his childhood in Bahia, a region he described as "very strong in mysticism, religiosity." Even his working process was a synthesis of science and spirit. Every day, he began by making a large series of small studies or models in a very systematic and disciplined way which he described as both "laboratory experiments" and "devotions"—daily efforts to evoke and invoke spiritual forces that inhabited his thoughts, his world, and his work.

When one is aware of this metaphysical synthesis in Valentim's work, it takes on many unsuspected aspects. Forms become meaningful (pl. 26). The persistence of tripled motifs is not simply a matter of composition but a sacred number that invokes sacred forces. Blood-red color and hard-edged forms in some of his works signal the ax of Xangô. Such boldness strikes the viewer.

Other geometric motifs and colors reveal other Yoruba or African spiritual presences. Works bathed in whiteness signal the presence of Oxalá, lord of creation. Multitiered shafts evoke Oxalá's staff of authority, the *opaxorô* (see Mimito's *opa-*

xorô, pl. 23). Oxalá is a most appropriate subject for he is the divine artist who shapes all existence. Strong, stable forms and a cool color capture visibly and symbolically the essence of Oxalá.

While deeply rooted in African sacred signs and cosmological concepts, elements of Valentim's compositions visualize cosmic shapes and forces that come from other, universalizing intentions. He explained that he wanted to "popularize," that is, reach beyond specific symbolic, meaning-full systems to "signs" that were "pure" forms expressing "feelings and rhythms" universally. His work is often described as being full of Jungian archetypes, things stored in the human subconscious. Thus he was an artist who combined many seemingly contradictory attributes to create powerful images: science/religion/aesthetics to create a new metaphysics; a new visual language based on semiotics; and signs and symbols rooted in Africa and his early life as a Brazilian of color in order to create a universal imagery that could touch people everywhere.

Sidnei Lizardo (Lizar) creates art that is a love affair with the beauty and grace of the African martial art form of *capoeira*, brought to Brazil from central Africa in the sixteenth or seventeenth century. At various times it had to be camouflaged as an acrobatic dance set to music in order to survive, for the performance is usually accompanied by the African musical bow called *berimbau*.

Lizar explains that in the seventeenth century, when free African communities in Brazil like Palmares fought to survive, *capoeira* played an important role. "It is an Afro-symbol that still has power today." He does not want people to forget this symbol of "black cultural resistance." Since *capoeira* encompasses the arts of fight, dance, song, poems, and music, he can show culture through art, "not to picture *capoeira*, but to serve as a basis for creation" (Lizar 1988).

Those creations are color poems of flow and movement. They evoke speed and multiple rhythms through their lines and shapes. Parallel movements emerge in analogous hues and repeated shapes, while conflicting ones take on sharply contrasting colors and directions. All elements are strongly organic.

Color harmonies are fundamental to Lizar's work. In some works they are subtle plays of hues, muted and often translucent washes, one laid over the other. Others (fig. 11.7) are studies in bolder, more contrastive colors. Their juxtaposition segments, rather than unifies, the composition. The intensity of the colors pulls and pushes the forms against each other. All the compositions consist of two interrelated parts in which left and right portions weave in and out, twist and turn on each other. Lines echo the flowing curved shapes, providing a kind of echo-image that stresses movement.

Capoeira symbolizes much about the African presence in Brazil and in the work of its artists. Like Candomblé and other African-derived religions, *capoeira* had to

FIGURE 11.7.

A work by Lizar show-

ing bold, contrastive

forms that segment,

rather than unify, the

composition. Photo:

Henry J. Drewal.

go underground. African religions were seen as threats to Catholicism, and *capoeira* was even more feared since it threatened the very system of slavery. *Capoeira* expressed defiance, open resistance to an oppressive system. It has always been an indelibly black tradition that has now begun to spread to other parts of the Americas and beyond.

Lizar became a follower of the great *capoeira* masters of Brazil and turned the art of fighting into fine art. Whether realistically or abstractly rendered, his paintings capture the essence of *capoeira*: its grace and flow, its power, control, speed, and rhythm. The skill and dexterity of the artist matches that of the combatants as he plans and executes his visual strategies through the actions of his mind and eye. There is another parallel as well. *Capoeira* had to hide its true nature as a martial art form, but in doing so it added other artistic dimensions. In the same way, Lizar camouflages *capoeira* in abstractions in order to liberate our thinking and to reveal the evocative aesthetic qualities of color, line, form, and composition.

Edival Ramosa is a quiet, thoughtful person whose multiple origins surface in his work. His mother's family was African and Portuguese, while his father's was In-

FIGURE 11.8.

Edival Ramosa's work *Transparencies* displays horns, containers of power. From Drewal and Driskell, *Introspectives: Contemporary Art by Americans and Brazilians of African Descent*, 1989, fig. 12, p. 47.

dian. He grew up in an era when "racism existed . . . blacks tried to hide their color and African identity . . . by treating their hair to make it look like a white person's hair." His mother wanted him to become a priest, so he went to church three times a week. But she also took him to Umbanda ceremonies. Now he attends Umbanda more than church because, as he explains with a subtle smile, "it is more interesting—one can dance, smoke, and drink" (Ramosa 1988).

But these are not the only influences in his life and work. Edival is a nomad, frequently moving from place to place, like his Indian ancestors. From his travels in Egypt, he relates how "when I saw the pyramids, I decided to become an artist." From 1964 to 1974, Edival lived in Milan, Italy where he first exhibited. His residence in Italy brought key elements to his work, especially an interest in technology and machinelike precision. There are strong constructivist and futurist qualities as well: clean lines, polished metallic surfaces, bold geometric forms, all evocative of a high-tech world of speed and movement. But then he traveled in North Africa where he says he "rediscovered Brazil." He began to create works that included bamboo, earth, rock salt, wool, feathers, and leather—all evoking the Afro-Indianness of Umbanda.

Space is a primary concern in his work—open and expanding as in *Transparencies* (fig. 11.8), or closed and tightly interactive as in *Palmares Capsule II*. *Transparencies* recalls the geometric woven screens of Indians in its grids and over-

lapping circles suspended in space. The horns "enculturate" the work further. These evoke both Indian and African forms used in art and daily life.

Palmares Capsule II is much less ambiguous in its message. It celebrates the most famous seventeenth-century free community of Africans within Brazil, known as Palmares. Its warrior king was Zumbi. Sharp metallic spikes surround this impenetrable ball, like the quills of a porcupine prepared for any attack. Horns bristle from the top. They are, in the African and Afro-Brazilian context, containers of powerful substances for protection and aggression.

As this array of themes attests, Edival Ramosa's identity is complex and fluid. He declares that "I'm still searching, I am not sure. . . . I was not brought up in black traditions. Because of prejudice, people hid their blackness, . . . but it must be my soul that appears in my work" (Ramosa 1988).

Zumbi's praises are sung in another work, a 1988 collaborative installation at the Museum of Images and Sound, São Paulo, by the Afro-Brazilian artists Roberto Barreto and Lizar called *Project Zumbi—Brafrica—Negritude*. It was a large, multimedia piece: eucalyptus leaves spread on the ground for their scent, coconut shells and calabashes floating on water, bamboo stems, red, black, white candles in shells, multicolored cloth banners, broken glass, old copper pieces, painted ropes, leather, three large paintings, drums, and burnt wood. Small boys from the slums (*favelas*) of São Paulo built *taipa* walls, leaving their hand prints on the surface to evoke an *arte povera*, art created from cheap, cast-off materials by poor persons or slaves. As Barreto (1988) remarked, making *taipa* is "hard, dirty, tough." Barreto's great uncle and father were famous builders of *taipa* walls in Ipantininga, a town his ancestors built.

As Barreto explained the piece before its installation, "This is ritual art, it is African and Indian . . . the textures, boldness, and strong colors are all African, the space [water, cloth banners, the brightly colored triangles within triangles] is Indian . . . only the concept [the installation in the museum] is Occidental." *Project Zumbi* reminds all Brazilians of African and Indian struggles for freedom and cultural expression.

Juarez Paraiso and Edison da Luz have broadened their focus beyond Afro-Brazilian sacred themes. Their field of attack encompasses environmental and social issues affecting primarily the northeast of Brazil, but with implications for all parts of the country. Their works evoke the realities of the poor and their struggles to survive in a harsh and oppressive environment, both manmade and natural.

Over the years, Juarez Paraiso has been eclectic in his choice of media and style, but he is singleminded and powerfully expressive in his concern for the human condition. He rails against repression or injustice of any kind, including censorship, exploitation (of people or of the environment), or the suppression of sexual emotions

FIGURE 11.9.

Juarez Paraiso's 1988 untitled work has a heavy and foreboding quality to it. It evokes in its media—skulls, bones, and calabashes—the harshness and dryness of Brazil's northeast. From Drewal and Driskell, *Introspectives: Contemporary Art by Americans and Brazilians of African Descent*, 1989, fig. 10, p. 44.

284

by the Church. He explains that in Brazil there are three types of discrimination: political—against the left; racial—against blacks; and, most serious, economic—against the poor, most of whom happen to be black.

In one work, he used powerful black-and-white photographic images from the famine caused by the Biafran conflict in Nigeria in order to convey the horror of human inhumanity. More recently he created other photographic works concerned with the struggles, agonies, and despair of Brazilians, all poor and mostly black, who have flooded into the slums of Salvador and other cities trying to escape poverty, drought, and unemployment.

Censorship is the subject of several works. In one, a typewriter has spikes for keys. Juarez explains "it shows that an artist must be willing to suffer pain to speak the truth, truth hurts." Another is about exploitation. It shows an ugly man with a bird beak nose whose fingers are a smoking gun, a penis, and claws to show "the mutations in people when they become predators" (Paraiso 1988).

An untitled work in 1988 (fig. 11.9) has a heavy and foreboding quality to it. It evokes in its media—skulls, bones, and calabashes—the harshness and dryness of Brazil's northeast. Its rough textures, organic shapes, and interlocking masses and spaces seem to allude to skeletal qualities that are reinforced by its totemlike form. At the top, a cow's skull holds a human one to "show their relationship to each other and the death of both." These, together with the crossing bones, evoke Christian and medieval images. Life, suffering, death, and perhaps the hope of redemption, are central to this work.

Edison da Luz embodies the essence of Exu, the principle of uncertainty and action. He is always provocative, and often mischievous, the kind of person who relishes good fights—tests of wit and will. Like Exu too, he is fickle, moody, and restless. All of these attributes can be seen in his work, which ripples with energy. They have a raw power and strength about them, always vigorous and often tortuous, and tortured. His complex fibrous webs create tangled volumes that flow and twist. Everything is organic, alive with growth and movement.

Like most artists in Brazil, he has had to struggle. He lacked space to make and exhibit his environmental pieces so he moved to the countryside, where he has the natural materials, the massive vines that are meant to evoke the wild, rough and desertlike environment of the interior of northeastern Brazil. But he also says he would use industrial materials since they are part of modern Brazil and he does not want "to separate himself from reality." He believes that his work is very important to the formulation and "identity of Brazilian art . . . if there is any African influence in my work, it must flow naturally. . . . To force it would produce something fake" (da Luz 1988).

285

Change, chance, and intuition are at the heart of his creative process, just as they are the essence of his personality. He describes this process as a "ritual" in which the final creation must convey "its totality . . . including the artist's struggle and survival in order to produce the work." He begins with a broad theme and constructs his figures: humans, animals, things. As the ideas emerge and grow, so too the figures transform. They may change their outer form, composition, and details, but they also change their relationships to each other. The artist plays constantly with their juxtapositions. Each alteration brings new meanings, new expressive qualities: a seated figure holding a flower seems benign, but when a large knife replaces the flower, it turns sinister. The strength and vitality of his sculpted forms gives them transformative power, the power of *axé*.

His figures are thin and wiry to evoke the poor, hungry people of the northeast who struggle to survive the droughts and famines that have always plagued that land. They equally refer to Ethiopia's devastating famine and starving children. A reclining figure with a skull connotes stillborn children, while another expresses both pain and liberty, of "freeing oneself to fly, to dream for other things." One piece, *Saga of the Northeast—Birth Figure*, has a head thrown back, her mouth agape emitting a silent scream of pain, or joy, or both (fig. 11.10). He simply says "it represents a mixture of life and death." Sometimes he gives a "sacred sense" to his images by using Catholic references. Several evoke icons of the Virgin Mary and Child, or the crucifixion. This multiplicity of meanings thus universalizes his messages in order to give them, as he says, "a sense of eternity."

Life's lines are fundamental to the art of Maria Adair. For a 1982 series entitled *Constellations*, she wrote, "the curved line is a pleasure and a voyage to the eye. It is present in everything, wind and water . . . planets and stars. . . . The spiral lives in galaxies, in the pattern of the hurricane . . . and in our ears." In paintings, drawings, and sculptural constructions using wooden bowls (*gamela*), she defines flowing sets of colored lines that give the impression of both concave and convex surfaces. They touch and wrap around each other forming constellations, then they fly outward

FIGURE 11.10.

A 1988 piece by Edison da Luz, *Saga of the Northeast—Birth Figure*, has her head thrown back, her mouth agape emitting a silent scream of pain, or joy, or both. Photo: Henry J. Drewal.

again in new directions and in new guises. They evoke life forces and the structures of living organisms: the veins of leaves or humans, the womb of a woman, or the currents of the ocean.

Lines persist in her recent work, but their character has changed (pl. 27). They have become straighter, thinner, more gridlike, but no less active or alive. They waver precariously close to one another as though brushed by some unseen breeze. Forceful oblique directions cut through stable horizontals, activating the composition. The visual repetitions and variations create multiple, strong rhythmic patterns.

Grids of vividly colored lines are layered on top of each other, blue webs over red, black over white, green over yellow and white. They vary greatly: long and narrow, short and wide, translucent, nearly invisible, or solidly opaque. Medium reinforces message where painted grids echo the subtle weave of the linen.

Like her work, Maria Adair seems to be perpetually in motion. She is quiet yet firm in her convictions about the vitality of life. While there may be no explicitly African or Afro-Brazilian elements in her work, there are certain presences evocative of that cultural heritage. One is her use of the *gamela*, a key Afro-Bahian icon as seen in the paintings of Terciliano. Another may be an allusion to brightly tinted, woven strips of cloth, the famous *pano do costa*, cloth from the West African coast that was traded to Bahia, Brazil throughout the eighteenth and nineteenth centuries and worn everywhere. But perhaps her work is most African in its evocation of nature's life-force or *axé*. For Maria Adair, it is action and risk-taking.

In 1985 she did a series of works titled *long live risk* (*viva o risco*). *Risco* can mean danger, risk, sketch, or stroke, not unlike the *pontos riscados*, linear signatures to attract the gods. Every sense of that word *risco* sums up both the life and the work of Maria Adair.

Artists' strategies for survival and success are frequently embedded, rather than explicit, in their art. Some involve the transformation of certain visual aspects in order to mask or camouflage other dimensions, signifyin' with a play of images. Others express their concerns about global, human issues, or focus inwardly on psychological states of mind. As idealists, artists want their work to be judged primarily by its capacity to move audiences. Yet as realists/pragmatists, they also know that those viewers are creations of a culture in which racism is endemic. Since such racism cannot be ignored, various means must be employed to overcome, conquer, or neutralize it. They must be able to touch audiences in different ways if their work is to succeed.

The ways are as numerous as the styles represented by artists. The work of Brazilian artists presents us with a vast array of styles, media, and imagery. It ranges from explicit, focused assertions of African beliefs and practices, to obliquely referenced spiritual entities, to sweeping universalities. Such diversity is, by its very nature, an expression of artistic and personal freedom, the freedom to determine one's direction and identity and express it in whatever manner one chooses. There is no aesthetic dogma in Brazil. The artist Maria Magliani (1987) says, "the quality of the work is most important, we are not ideologists," and Juarez Paraiso (1988) remarks that "it is ironic that most 'black art' [images of blacks] is being done by whites, while we are doing many kinds of art." The work of Afro-Brazilian artists is the creation of independent, *un*colonized minds, of truly free persons. More than a hundred years after the abolition of Brazilian slavery, we are really celebrating four hundred years of creative assertions of Africans and their descendants, the strength, determination, and freedom of their human spirit that have created the works of Afro-Brazilian artists today.

NOTES

1. Research for this chapter was funded by the Aaron Diamond Foundation through the Schomberg Center for Research in Black Culture's Scholars-in-Residence Program.

When discussing Yorùbá culture in West Africa, I have used Yorùbá orthography as written in Nigeria. In discussions of Yorùbá/Nago traditions of Brazil, I have used Brazilian Portuguese orthography because language embodies the histories and processes of cultural hegemony and resistance that are central to all African diaspora studies.

Portions of this chapter appeared in *Introspectives: Contemporary Art by Americans and Brazilians of African Descent* (Los Angeles: California Afro-American Museum, 1989). I want to thank a number of individuals whose advice and counsel helped to shape this

287

work: Cesar Ache, Aurelia Brooks, Caetana Damasceno, C. Daniel Dawson, David Driskell, Hack Hoffenberg, Marcia Magno, Marie Ignez Montovani, Braulio de Oliveira, Mikelle Smith Omari, Dillard M. Poole, Donald Ramos, Joao Reis, Doran H. Ross, Eneida Sanches, Rowney and Tania Scott, Pierre Fatumbi Verger, and Rutila Weeks. C. Daniel Dawson was particularly helpful with editorial comments and data from interviews with four of the artists discussed. I thank especially all the artists who took the time to discuss their thoughts and work—*muito obrigado!* All interpretations (and any shortcomings) are of course my own. I also acknowledge with gratitude a 1992–93 Newberry Library/NEH Fellowship, a University of Wisconsin System faculty grant, and a Schomberg Center for Research in Black Culture Scholar-in-Residence Fellowship, which allowed me to pursue research on Afro-Brazilian and African diaspora art history.

2. I want to thank Snr. Cide Texeira for the suggestion to research this structure, and Pierre Fatumbi Verger for showing me brief biographical information on Manoel Friandes in his copy of Querino's 1909 book.

3. Information about Detinha is taken from a conversation with her by C. Daniel Dawson and Eneida Sanches in 1993 and kindly shared with the author.

4. The following discussion is based on my interviews with Mimito in 1974 plus notes on a conversation with C. Daniel Dawson and Eneida Sanches in 1993 and kindly shared with the author.

5. Babette Wainright, a Haitian painter living in Madison, Wisconsin, has talked about how Haitians use trance to enter an *associative* state for self-healing, which white society sees as a "psychotic" and "disassociative" state of illness.

6. Some of the information about José Adario dos Santos is taken from a conversation with him by C. Daniel Dawson and Eneida Sanches in 1993 and kindly shared with the author.

REFERENCES

Adair, Maria. 1988/1993. Taped conversations, February, March.
Araujo, Emanoel. 1988. Taped conversation, March.
Barreto, Roberto. 1988. Taped conversation, March.
Brazilian Art. 1976. São Paulo: Ministry of External Affairs.
Brissonnet, Lydie C. 1986. "Carnaval as Symbolic Production and Reproduction of Society and History: The Special Case of the Carnaval of Salvador, Bahia, Northeastern Brazil." Paper read at the Conference of the Society for the Study of Play, Montreal.
Clifford, James. 1988. *The Predicament of Culture.* Cambridge, Mass.: Harvard University Press.
Crowley, Daniel J. 1984. *African Myth and Black Reality in Bahian Carnaval.* Los Angeles: UCLA Museum of Cultural History.
da Luz, Edison. 1988. Taped conversation, March.
Drewal, Henry J. In press. "Art History, Agency, and Identity: Yoruba Currents in the Making of Black Brazil." Proceedings of the Conference on Black Brazil—Culture, Identity, and Social Mobilization, University of Florida-Gainesville, March 31–April 1, 1993.
Drewal, Henry J., and D. Driskell. 1989. *Introspectives: Contemporary Art by Americans and Brazilians of African Descent.* Los Angeles: California Afro-American Museum.
Drewal, Henry J., and M. T. Drewal. 1983. *Gelede: Art and Female Power among the*

Yoruba. Bloomington: Indiana University Press.

Drewal, Margaret T. 1977. "Projections from the Top in Yoruba Art." *African Arts* 11(1):43–49, 91–92.

Gates, Henry Louis. 1988. *The Signifying Monkey*. New York: Oxford University Press.

Lizar (Sidnei Lizardo). 1988. Taped conversation, March.

Magliani, Maria. 1987. Taped conversation, August.

Mason, John. 1994. "Yoruba-American Art: New Rivers to Explore." In *The Yoruba Artist*, ed. Rowland Abiọdun, Henry J. Drewal, and John Pemberton III. Washington, D.C.-London, pp. 241–50.

Mimito (Clodomir Menezes da Silva). 1974. Taped conversation, August.

Omari, Mikelle Smith. 1984. *From the Inside to the Outside: The Art and Ritual of Bahian Candomblé*. Los Angeles: UCLA Museum of Cultural History.

Oṣitọla, Kolawole. 1982. Taped conversation, May.

Paraiso, Juarez. 1988. Taped conversation, March.

Poole, Dillard M. 1992. "The Struggle for Self-Affirmation and Self-Determination: Africans and People of African Descent in Salvador, Bahia, 1800–1850." Ph.D. dissertation, Indiana University.

Preston, G. 1987. *Emanoel Araujo—Brazilian Afrominimalist*. São Paulo: MASP.

Querino, M. R. 1909. *Artistas Bahianos*. Rio: Imprensa Nacional.

Ramosa, Edival. 1988. Taped conversation, March.

Reis, Joao. 1987. *Rebeliao Escrava no Brasil: A Historia de levante dos Males (1835)*, 2nd ed. São Paulo: Editoria Brasiliense.

Terciliano, Jr. 1988/1993. Taped conversations, March and February.

Valentim, Rubem. 1988. Taped conversation, March.

Verger, Pierre. 1987. *Fluxo e Refluxo do Trafico de Escravos entre o Golfo do Benin e a Bahia de Todos os Santos dos seculos XVII a XIX*, 3rd ed. São Paulo: Editoria Corrupio.

GLOSSARY OF TERMS

ABANICO fan

ABEBE Yoruba word for "fan" used as a symbol of water-related orisas such as Yemaya and Oshun

ABEBE IDE a brass fan used by the priests of Osun

ABIYAN, ABIAN a junior title in Candomblé

ÀBÙDÁ essential nature of a creature

ACOBIJARSE/ACOBIJAMIENTO literally, "to cover one-self," this term refers to the rite of sacrificing a feath-ered animal; also used to refer to the desired result of ritual animal sacrifice

ADE Yoruba word for "crown"

AGBELE pedestal

AHIJADA(O) goddaughter, godson

AJA bell used for calling the gods to ceremonies

AJÁ handful of palm leaves used as a broom during religious rituals

AJAGUNA belligerent and bellicose warrior; one of many manifestations of Obatala

ALEYO non-initiate in the priesthood, yet can be a fol-lower of a particular orisha and have gone through mi-nor initiations or consecrations

AMARRES Nkangue. Wrapped objects or charms used to cast a spell with the intent to dominate someone

AMEWA knower of beauty, connoisseur

This glossary is provided to assist the reader in understanding the cultural context of some terms and defining for-eign terms. It was organized by reviewing the literature and consulting with several of the contributors to this vol-ume. Monique Curnen, curatorial assistant, High Museum of Art, Atlanta, compiled the entries and assisted in the editing.

ANAFORUANA signs used by the Abakuá society to consecrate a place

AÑÁ the orisha that lives in the sacred *batá* drum. One of the most important ceremonies of the *iyawó* (initiate) is the presentation of offerings to the orisha Aña in the *batá* drums.

ARA the physical (human) body

ARA ORUN, ARAORUN citizen of heaven

ARABBÁ, AYABBÁ orisha that resides in the *ceiba* tree

ARUGBA kneeling caryatid female figure

AṢE, ASHÉ, ACHÉ, AXE Yoruba word for life-force; divine authority; the power to make things happen

ASIENTO DE ORICHA consecration ceremony of an orisha

ASSENTOS altars considered "seats" of the gods

BABALAO, BABALÁWO high priest. Yoruba word for diviner, literally "father of esoteric knowledge/wisdom," "father of the secrets"; diviner/priest of Orunmila, the oracle deity in Yoruba/Lucumí religion

BABALOCHA, BABALOSHA priest, father of the orisha; one who has initiated someone into the religion; provider of spiritual as well as secular guidance

BABALUAYE, BABALÚ-AYÉ orisha controlling smallpox and all skin diseases

BALANGANDANS pendant/amulets of silver or gold worn by Afro-Brazilian women

BALDACHIN canopy of colorful fabrics above orisha altars

BAJAR AL SANTO to invoke an orisha in a religious ceremony of possession

BAÑO DE FLORES spiritual bath with flowers

BARRACÓN communal slave household where Africans of diverse origins shared religious and cultural traditions

BARRIOS Latino neighborhoods

BATÁ sacred drum

BEMBÉ an Afro-Cuban celebration of drumming, ritual chanting, and dancing; usually intended to please the deities and induce possession

BERIMBAU single string musical bow of African origin with gourd resonator

BOTANICA a store that sells religious articles and goods used in most New World African religions

BOZAL slaves arriving in the Americas directly from Africa as opposed to *ladinos* (Africans who had spent significant time in Europe and were familiar with European languages and customs); also refers to heavily African-accented Spanish (literally, wild and unruly)

CABILDOS legally recognized associations formed by Afro-Cubans from roughly the same ethnic background

CAMINOS paths of the orishas

CANDOMBLÉ general Brazilian term (probably of Bantu origin) for Afro-Brazilian religions and the places where they occur

CAPOEIRA Afro-Brazilian martial arts tradition with musical accompaniment

CEIBA silk-cotton tree sacred in Santería beliefs

COFRADIAS Roman Catholic brotherhoods

CRIOLLOS whites and blacks born in the colonies of the Americas

CHANGÓ, SHANGÓ, SANGO warrior orisha; god of fire, lightning and thunder, dance, music, and virility; a major orisha highly revered by all *santeros*

CHABA metal bracelet used by devotees of Ochosi and Ogún

DIABLITO member of the Abakuá secret society known for parading in elaborate costumes and masks

DILOGGÚN form of oracular divination using cowrie shells; also, cowrie shells consecrated for new priest/priestess

EBE prayers, supplication

EBO sacrifice

EBO EJE blood sacrifice; offering of an animal to a de-

ity in exchange for the orisha's protection or involvement in the affairs of the living

ÈDÁ a creature or its "essential nature"

EGUNGUN spirit of the dead

ELEDA the concept that an orisha/deity lives in a devotee's head; sometimes employed interchangeably with Ori-head

ELEGGUÁ, ELEGBA, ESHU trickster orisha of the crossroads, messenger of Olodumare

ELEGUN priest

ELEKES color-coded beaded necklaces of the orisha

EMI soul

ENIYAN human being

ERE ORISA altar statue

ERINLE patron orisha of fishermen

ERUA-DE-BICHO leaves associated with Omolu, the Yoruba deity (orisa) of skin disease and pestilence

ESPIRITISMO Spiritism

ETUTU ritual pacifier

EWA beauty

EWA INU internal beauty

EWA ODE external beauty

EWU OWO elaborate cowrie-embroidered vest worn by Sango priest when possessed

EYE popular bird motif in Yoruba art; alludes to supernatural powers; also metaphor for ase

FERRAMENTOS metal implements symbolic of deities

FINFIN the final stage of the Yoruba carving process when the carver uses a sharp knife to delineate and refine forms

FIRMAS/PONTOS RISCADOS ritual signatures drawn on the ground to attract divine attention and presence to the ceremonies in their honor

GAMELA large, shallow wooden bowl, used as a primary receptacle for offerings in Candomblé religion

GUIJES spirits/creatures who live near rivers in Cuba

HIJO DE SANTO devotee of an orisha; also considered the orisha's child

IBEJI patron orisha of twins

IBORI cone-shaped object wrapped in leather and adorned with cowrie shells where the spirit of the head is usually localized

IFÁ divination system used by the babalawos

ILE lineage; spiritual kinship

ILE-IFÉ Yoruba holy city in Nigeria; according to Yoruba legends, the world began at Ile-Ifé

ILE ORISA shrines

ILEWO/SASARA, EBIRI Yoruba ritual brooms used to purify places and persons

IMALE Yoruba word for Muslim; in Brazil, name given to African Muslims (Yoruba, Nupe, Hausa, etc.) who were leaders and participants in several nineteenth-century revolts in Bahia

(LOS) IMPROVISADOS those who cannot trace their spiritual lineage back in time

IRE AIKU PARI IWA immortality is the ultimate existence

IREMES, DIABLITOS member of the Abakuá secret society known for parading in elaborate costumes and masks

IRMANDADE Portuguese term for a Catholic lay organization usually consisting of both women and men, but occasionally of women only

IROKE carved ivory rattle

IROKO, IROKÓ orisha of abundance and fecundity who is worshiped at the foot of the *ceiba* tree

IRUKE whisk employed to symbolically cleanse the cadaver of earthly impurities

ISE OLODUMARE, AWAMARIDI Olodumare's action is unfathomable

ISIN worship

293

ITA the divination ritual that follows initiation

IWA existence, both physical and spiritual; character

IWA L'EWA character determines beauty

IWI OR IWIN spirit of person who has died before his/her time and cannot return to heaven until time stipulated in destiny is completed; known to lurk in desolate places and delight in scaring people and causing havoc

IWORO people who employ the aid of the *olosha* in times of crisis without becoming an adherent of the religion

IYALOSHA priestess, "mother of the orisha"

IYAWO an initiate of Santería, a novice or "wife" of the orisha

KELE a necklace of red and white beads worn by the priests of Sango

KEREWU OJE lead bangles worn by priests of Obatala

KEREWU IDE brass bangles worn by the priests of Osun

LÁMPARAS literally, lamps; ritual burning of oil and other elements, usually employing a pumpkin, squash, coconut, or other solid, hollow receptacle; used to supplicate a deity for a particular favor

LIBRETAS DE SANTO "notebooks" that contain prayers and narratives

LOA deity or spirit worshiped in Haitian Vodun

LUKUMÍ term used to refer to Yoruba religious practice in Cuba, synonymous with Santería

MACUMBA a New World religion developed in Rio de Janeiro, Brazil, consisting of influences from Kongo, Yoruba, Dahomeyan, Roman Catholic, Native American, and Spiritualist religious beliefs and traditions

MADRINA godmother; priestess who initiates a novice into Afro-Cuban religions

MAE Portuguese word for "mother"; in Afro-Brazilian religion, an honorific term for a priestess/wise elder

MESTIZAJE racial, ethnic, and/or cultural mixing in Latin America

MISA ESPIRITUAL spiritual mass; a spiritist rite employed by Kardecian spiritists in Cuba; may precede a Lucumí initiation

MONTE elevated area in a dense forest or jungle. Meaning much more than simply a wooded area, *monte* implies mystery, dwelling place of deities and spirits, as well as a place of refuge from the ordinary world. Many fugitive slaves escaped to the *monte* where they built fortified villages and sanctuaries.

(SUS) MUERTOS ancestors

MULTICONSCIOUSNESS the capacity to negotiate multiple evolving personas in social terms

NACIONES nations; term used to refer to the different African cultures in Cuba

NEGRITUDE Afrocentric movement of the twentieth century which relied on specific symbolism originating in the sacred and profane beliefs of African heritage

NGANGA also called *prenda*; receptacle made of clay or iron containing the magical powers of the *paleros*

ÑAÑIGO Abakuá male society derived from the Ngebe or African Leopard Society of the Ejagham people

OBATALÁ orisha of creation and purity

OBE Yoruba word for "knife"

OCCUGINIO Yoruba greeting meaning "hope you got up well!" (*o ku ji ni o*)

OCHOSI, OSHOSI patron orisha of hunters; brother of Ogún

ODO carved inverted mortar

OGÚN, OGGÚN orisha of iron and war; also the patron orisha of blacksmiths

OHUN OSO adornment, ornament

OJUBO altar of a major shrine

OLOKUN orisha of the deepest parts of the ocean

OLOSHA owners of orisha, collective term for priests and priestesses

OLÚGBANI guardian, protector, or defender

OMO child of deity; term referring to an orisha's devotee or initiate

ONA the Yoruba equivalent of the word "art"

ONI Yoruba word meaning king or ruler

ONI-YEMAYA The word *oni* denotes possession or ownership. When someone is an *oni Yemaya* or *oni Shango*, it literally means owner of Yemayá or Shango

OPA OSOORO iron staff rattle, emblematic of office for priests of Obatala

OPASORO staff associated with the elder aspect of the orisa Osala (Orisanla)

ORI spiritual head

ORI INU "inner head" which determines one's personality and destiny on earth; also mediates between the individual and the orisa

ORIATE officiating priest and master of ceremonies of the initiation rituals

ORIKI praise poetry

ORISA, ORISHA Yoruba word for "divinity"; literally, "selected head," that is, a distinguished ancestor who became deified and is often associated with a natural phenomenon, such as a thunderstorm, mountain, river, or ocean

ORISHAOKO, ORISHA OKO orisha of agriculture

ORUN BURUKU bad heaven

ORUN RERE good heaven

ORUNMILA orisha of divination

OSAIN, OSAYIN orisha of the forest, keeper of the secrets of herbalistic medicine

OSE Yoruba word for the "double-bladed ax/dance wand," symbol of various aspects of Sango, the thunder god

OSHALUFON feeble, absent-minded old man; manifestation of Obatala

OSHÚN, OSUN orisha of love and beauty; patron orisha of rivers

OSUN a small metal rooster staff of the herbalist; medicine staff belonging to the orisha Osain

OSUNGAGA iron staff

OTÁ the stones in which the orishas are consecrated and materialized in Yoruba/Lucumí practices

OUN T'OJE OJU NI GBESE something to which the eye is indebted

OUNJE OJU food for the eye

OYA orisha of tempest and tornadoes and third wife of Shangó

PADRINO godfather; priest who initiates a novice into Afro-Cuban religions

PALEROS followers of Regla de Palo

PALO also called las Reglas Congas. This Afro-Cuban religion originated in the Kongo and Angola and relies heavily on communication with the dead through spirit mediums.

PANO DA COSTA woven cloth from the west coast of Africa traded to Brazil

PATAKÍ, PATTAKÍ Afro-Cuban religious legends/oral history

PEPELE raised platform for display of various ritual objects

PIEDRAS DE SANTO also referred to as *otá*; the stones in which the orishas are consecrated and materialized in Yoruba/Lucumí practices

PRENDA also called *nganga*; receptacle made of clay or iron containing the magical powers of the *paleros*

QUIMBANDA Afro-Brazilian magic associated with Macumba

QUITAR LA MANO AL MUERTO a Palo Monte Mayombe funerary rite in which sacred objects are ceremoniously disposed

RABO fly whisks

REGLA DE OCHA synonymous with Santería; term used to refer to Yoruba religious practices in Cuba

REGLAS CONGAS another sect of African religious belief systems in Cuba, having distinct traditions and purposes from Regla de Ocha

SAJUMERIOS, SAHUMERIOS a purification rite that involves the burning of incense and other elements within a household

SANCOCHO a Latin American soup composed of a variety of ingredients; also used metaphorically to refer to diversity

SANTERA(O) practitioner of Santería

SANTIJUO, SANTIGÜO a healing process involving the use of a prayer or psalm, usually intended to cast out negative spirits; also used to refer to one who heals

SANTO saint; in Cuba and Brazil, a synonym for orisha or deity

SESE EFUN plain white beaded necklace, worn by priests of Obatala

SIRE Yoruba word most often used to refer to ceremonies for the gods which occasion an engaging, and engaged, playfulness; in a larger sense, connotes the idea of empowering improvisation

SOPERAS ceramic soup tureens used as containers to house the essence of the orishas

SYNCRETISM process of cross-cultural interaction often used inappropriately to imply a blending, homogenizing process

TAIPA a building technique (with Portuguese, African, and Indian elements) that uses a combination of adobe, palm flax, pounded mud, bamboo, and refuse in construction

TERREIROS sacred spaces/temples for the practice of Afro-Brazilian religion

TIBI, TIRE LA DA ILE AYE the world evolved out of good and evil

TINAJONES Spanish for large clay jars especially used in colonial times to store liquids. These jars later became vessels in which to store the emblems of water deities such as Oshún or Kalunga.

TOQUE DE TAMBOR ritual drumming ceremony to invoke an orisha

TRANSCULTURALISM mode of operation in which persons transcend specific "cultural" practices and live in the permeable spaces of a post-cultural world shaped by and shaping specific social, economic, religious, political, and historical forces

TROPICALIA term referring to an eighteenth-century Brazilian aesthetic infused with African sensibilities; colorful tiles of floral and pastoral scenes decorating the facades of columniated buildings

UMBANDA Afro-Brazilian magic associated with Macumba

VEVE Vodún ideographic ground drawings

VODÚN, VOODOO, VOUDUN New World African religion practiced in Haiti and New Orleans

WA the verb "to be" or "to exit"

YEMAYÁ, YEMOJA maternal orisha of the seas

YEWÁ, YEGÜÁ orisha that inhabits cemeteries; her primary responsibility is to deliver the dead to Oyá

CONTRIBUTORS

DAVID H. BROWN Assistant Professor of Art History, Emory University. Author of numerous articles on Santería arts and African American folk healing, including contributions in *Cuban Festivals* and *The Gods of the City*.

ISABEL CASTELLANOS Professor of Linguistics and Afro-Cuban Studies, Florida International University. Author of numerous works on Afro-Cuban themes, including *Elegua quiere tambor: Cosmovisión religiosa afrocubana en las canciones populares*; and, with Jorge Castellanos, *Cultura afrocubana* (4 vols.).

JOHNNETTA B. COLE President of Spelman College. Anthropologist and editor of *All American Women: Lines That Divide, Ties That Bind* and *Anthropology for the Nineties: Introductory Readings*.

HENRY JOHN DREWAL Evjue-Bascom Professor of Art History, University of Wisconsin, Madison. Author of numerous articles and books, including, with David Driskell, *Introspectives: Contemporary Art by Americans and Brazilians of African Descent*.

JULIA P. HERZBERG Art Historian and Independent Curator. Author of numerous studies of Wifredo Lam, including "Wifredo Lam: Interrelaciones entre el afrocubanismo y el surrealismo," which appeared in the exhibition catalogue *Wifredo Lam: obra sobre papel*.

MARY JANE JACOB Independent Curator. Former chief curator at the Museum of Contemporary Art in Chicago and the Museum of Contemporary Art in Los Angeles; organizer of some of the first retrospectives of major contemporary artists.

BABATUNDE LAWAL Professor of Art History, Virginia Commonwealth University. Former Dean of the Faculty of Arts, Obafemi Awolowo University; author of numerous studies on Yoruba art, including "Some Aspects of Yoruba Aesthetics."

ARTURO LINDSAY Artist. Associate Professor of Art and Art History, Spelman College. Developed and coordinated the first African Diaspora Program at the Museum of African Art, Washington, D.C.; author and lecturer on Santería aesthetics.

RANDALL MORRIS Co-owner of Cavin-Morris Inc. Author of many articles on the African American diaspora and on contemporary artists.

GERARDO MOSQUERA Former Head of the Research Department of the Centro Wifredo Lam and former Adviser for Visual Arts and Design at the Cuban Ministry of Culture. Leading critic and curator of contemporary art in Cuba and author of numerous books and articles on contemporary Cuban, Latin American, and African art.

MIGUEL "WILLIE" RAMOS Ilari Obà, priest of Shango and Obà Oriatè (director of ceremonies) for Afro-Cuban orisha initiations. Author of numerous studies on orisha worship and divination.

GLORIA ROLANDO Cuban film maker with the Instituto Cubano de Artes y Industria Cinematográficos (ICAIC). Major documentary films include *Oggún*, *Tumba Francés*, and *Desarrollo Pecuario*.

RICARDO VIERA Artist. Professor of Art and Director/Curator of the Lehigh University Art Galleries. Author of numerous studies on Hispanic-American and Caribbean contemporary art and photography.

298

INDEX

Page numbers in italics indicate illustrations.